MAKING

HISTORY

MAKING HISTORY

WU HUNG ON CONTEMPORARY ART

TIMEZONE 8
HONG KONG, CHINA

Published by Timezone 8 Ltd.
E-mail: info@timezone8.com
www.timezone8.com

Printed and bound in China.

Library of Congress Cataloging-in-Publication Data

Wu, Hung.
 Making History: Wu Hung on Contemporary Art / Wu Hung.
 p. c.m.
 Includes bibliographical references.
 ISBN10 988-99617-0-9, ISBN13 978-988-99617-0-1
 1. Art, Chinese—Modern. 2. Art criticism—History—20th Century. 3. Avant-garde–(Aesthetics)—
History—20th Century. 4. Art, Modern—20th Century.

First edition, 2008

Printed in China.

Editors: Angie Baecker, Peggy Wang, Lee Ambrozy ,Michelle Woo

Cover: Xu Bing, *Ghosts Pounding the Wall,* performance and installation, 1990.

TABLE OF CONTENTS

TRENDS

RUINS, FRAGMENTS, AND THE CHINESE MODERN AND POSTMODERN

This essay reflects upon the meaning of modernity and postmodernity in Chinese art from a particular angle. I have chosen *ruin*, and by extension *fragmentation*, as my focus for two reasons: first, it has been frequently noted that *fragmentation* characterizes both modernist and postmodernist art movements in the West, and a large body of literature has been devoted to this subject. Second, *ruin* and *fragmentation* are important concepts in twentieth-century Chinese art, but their implications, and hence the notion of the modern and the postmodern, must be understood in relation to China's cultural tradition and political experience.

Whether discussing classical ruins or modern photography, western criticism generally links *fragmentation* to artistic creativity and imagination. This positive attitude grew out of a long tradition in Europe, in which ruins were represented from at least the Middle Ages. Beginning in the sixteenth century, ruins, both actual remains and fabricated ones, were installed in gardens. In the eighteenth century, according to Kurt W. Forster, ruins "became an intriguing category of building in themselves: the more strictly specialized and type-cast architecture became, the more ruins—structures which have outlasted their usefulness—it was bound to produce over time."[1] Sentiment toward ruins penetrated every cultural realm: "They were sung by Gray, described by Gibbon, painted by Wilson, Lambert, Turner, Girtin and scores of others; they adorned the sweeps and the concave slopes of gardens designed by Kent and Brown; they inspired hermits; they fired the zeal of antiquarians; they graced the pages of hundreds of sketchbooks and provided a suitable background to the portraits of many virtuosi."[2] It was this tradition that led Alois Riegl to write his theoretical meditation on the "modern cult of ruins" at the turn of the century.[3] The same tradition also prepared many modernist and postmodernist theories which, taken as a whole, elucidate a progressive internalization of *fragmentation* from reality to art itself: the subject of *fragmentation* has gradually changed from the external world to the language, imagery, and medium of representation.

China's situation was different in two respects. First, in China, ruin sentiment was primarily a premodern phenomenon; in the modern era, ruins acquired a dominant negative symbolism. Second, even in traditional China, the aesthetization of ruins took place mainly in poetry; visual images of ruins virtually did not exist. I reached this second conclusion after an exhausting but unproductive search for "ruin pictures" and "ruin architecture."[4] Among all the traditional Chinese paintings I have checked, fewer than five depict not just old, but *ruined* buildings. As for actual "ruin architecture," I have not yet found a single premodern Chinese case in which a building was preserved not for its historical value but for its ruinous appearance, which would show, as Riegl has theorized in the West, the "age value" of a manufactured form.[5] There was indeed a taboo in premodern China against preserving and portraying ruins: although abandoned cities or fallen palaces were lamented in words, their images, if painted, would imply inauspiciousness and danger.

When this Chinese tradition encountered European "ruin" culture, two things happened: on the one hand, this encounter led to the creation of ruin images in Chinese art and architecture; on the other, these images, as modern memory sites, evoked the calamities that had befallen the Chinese nation. The first effort to document architectural ruins was made by European photographers beginning in the mid-nineteenth century. Their works mixed western sentiment for decayed buildings, orientalist fascination with "old China," and archaeological or ethnographic interests. Although these works can be generally characterized as "orientalist" or "colonialist," their impact on China can hardly be exaggerated because they initiated a modern visual culture. What ensued has been a separate history of ruins in China. Ruin images were legitimated, but what made them "modern"

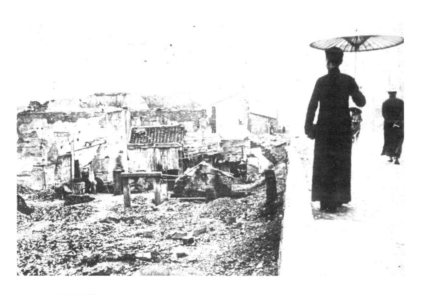

FIG. 1.1: *Untitled* (RUINED STREETS), CA. 1901.

(i.e. what distinguished them from classical Chinese ruin poetry) was their emphasis on the present, their fascination with violence and destruction, their embodiment of a critical gaze, and their mass circulation. These features characterize an anonymous photograph, which shows a street scene during wartime in the early twentieth century (FIG. 1.1). The subject of the picture is a devastating destruction. The ruined buildings are still "raw," not yet sunk into the depth of historical memory; we may thus call them "ashes" to distinguish them from those aestheticized ruin images in classical poems. Second, the picture poses as a snapshot and hence captures a fragmentary visual experience. As a photographic image, it self-consciously preserves the transience of the present in a stable and reproducible form. Third, although the photographer is unknown, the intrinsic gaze, embodied by the street onlooker in the scene, is Chinese.

The last of these features makes this photograph a meta-picture: the ruins are scrutinized and qualified by a Chinese gaze, and this gaze—a historic one I must emphasize—had already been thor-

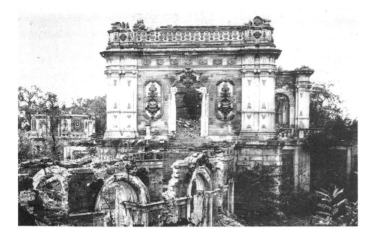

FIG. 1.2: RUINS OF YUANMING YUAN,
GARDENS OF THE MANCHU ROYAL HOUSE
OUTSIDE BEIJING, DESTROYED IN 1860.

oughly politicized by the time the picture was taken. In fact, the same gaze, created the first and most important modern ruin in China: the remains of the Yuanming Yuan Gardens outside Beijing, which were destroyed in 1860 by the joint forces of the British and French armies (FIG. 1.2). Only in recent years has the ruin been made into a public park. For most of the twentieth century, the images of the destroyed gardens were known to the public largely through photographs. Articles and poems accompanying these photographs emphasized the Gardens' symbolism as a "witness of foreign evils;" their anti-colonialist and nationalist sentiment separated them from traditional ruin poetry. In a more fundamental sense, these expressions signified the emergence of a modern Chinese conception of ruins, that architectural remains surviving from war or other human calamities were "living proof" of the "dark ages" caused by foreign invasion, internal turmoil, political repression, or any destruction of massive, historic proportions. This conception also made Yuanming Yuan a symbol shared by individuals and the state. After the establishment of the People's Republic, the remains of the Gardens were preserved as a "memorial to national shame in the pre-revolutionary era." But when the unofficial art group the Stars emerged after the Cultural Revolution, its members also painted Yuanming Yuan and held poetry readings among the Gardens' dilapidated stones (FIG. 1.3; in this picture, first published in 1982 in France, people's faces are covered to avoid identification and persecution.)

§

This new conception of ruins explains the wide appeal of fragmented images in contemporary Chinese art after the Great Proletarian Cultural Revolution, the most recent human calamity (commonly recognized as the most severe political persecution) in the country's long history. As in many other regards, the Stars' inclination for ruins anticipated a major direction of the '85 Art New Wave

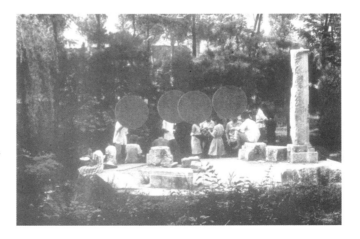

FIG. 1.3: UNOFFICIAL POETRY READING IN
THE RUINS OF YUANMING YUAN, C. 1981.

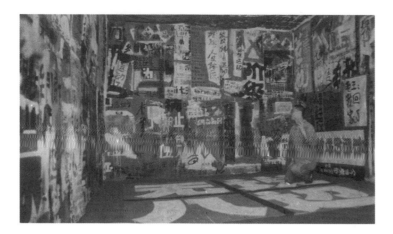

FIG. 1.4: WU SHANZHUAN,
Red Humor, INSTALLATION,
HANGZIIOU, 1986.

('85 *meishu xinchao*) movement, which surfaced in 1984 and soon spread across the entire country. The extraordinary significance and complexity of this "avant-garde" movement still awaits further discussion. What matters for this essay is that for the first time in Chinese art, ruin images were created with frequency and intensity in various art forms including painting, photography, installation, and happenings.

Wu Shanzhuan's 1986 installation *Red Humor (Some Paragraphs in Chapter Two of the Lengthy Novel "Red Characters")*, exemplifies one major tendency to evoke situations or experiences typical of the Cultural Revolution (FIG. 1.4). A windowless room covered by layers of torn paper and pieces of writing, this work alludes to Big Character Posters, a major form of political writing during the Cultural Revolution. This connection is visible not only in the work's general visual imagery, but also in medium (ink and poster paints on paper), color scheme (predominately red), production (random participation of the "masses"), and psychological impact (sense of suffocation produced by chaotic signs in a sealed space). But Wu was not simply restaging a vanished historical episode; instead he tried to create a new vocabulary of ruin images—forms which have been removed from the original context, conveying new social meaning. As Lü Peng and Yi Dan have observed, the words on the walls are not the revolutionary slogans fashionable during the '60s and '70s, but commercial ads that began to fill Chinese newspapers from the mid-80s. In Wu's simulation of Big Character Posters, therefore, ruins as remains of the past have become part of the present.

In this way, Wu Shanzhuan separated himself from the previous "wounded" artists, who attacked the Cultural Revolution through their realistic but sentimental historical paintings. While these artists single-mindedly criticized the past and finally merged with official propaganda, Wu found the past in the present. In a broad sense, his art represents a radical departure from the traditional conception of ruins. According to Stephen Owen, "the master figure [of classical ruins poetry] is synecdo-

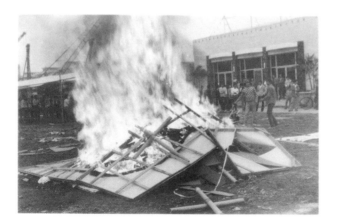

FIG. 1.5: ARTWORKS BY THE XIAMEN
DADA GROUP BEING BURNED AFTER
THEIR FIRST EXHIBITION, 1986.

che: the part that leads to the whole, some enduring fragment from which we try to reconstruct the lost totality."[6] Wu Shanzhuan's ruin imagery did not lead to the reconstruction of a "lost totality" in the imagination, but only to further fragmentation of the past as well as the present.

This critical spirit was shared by Huang Yong Ping but manifested itself in a different form. The name of the art group Huang and his colleagues formed in 1987, *Xiamen Dada* or "Dadaists of Xiamen," highlights their strategy of "quoting" (i.e. transplanting) names and formulas in a new context—a dislocation which critiques both the quotation and the situation. Their public burning of their works at

FIG. 1.6: MAKING IMAGES OF MAO DURING THE CULTURAL REVOLUTION.

the end of their first group exhibition may have been inspired by Dadaist nihilism; but the photographic record of the burning (FIG. 1.5)—the only surviving image of the event to reach a larger public—unmistakably recalled the burning of books and artworks during the Cultural Revolution. Huang's 1987 installation, *"The History of Chinese Art" and "A Concise History of Modern (Western) Art" after Two Minutes in the Washing Machine*, shifted the focus from destruction to a "still life" of ruins: a conglomeration of paper paste—the remains of the two books—piled on a piece of broken glass supported by an old wooden trunk. The washing machine is not shown and the destruction of the books is only implied. Again, this installation, when viewed in the post-Cultural Revolution context, delivers two overlapping messages: according to Huang himself, it expresses his negation of any formal knowledge, ancient or modern, eastern or western. However, viewers who had gone through the Cultural Revolution still remember clearly how "knowledge" was negated and how similar art books were destined to be destroyed during the political turmoil.[7]

Related to these ruin images was an intense interest among many '85 Art New Wave artists in disembodied *signs*—Chinese characters often, but also including isolated visual elements such as "standardized" colors, imprints, or figures. It is tempting to link this interest to the postmodern discourse on "language games" and the deconstruction of the "grand narrative" of modernity. Indeed some Chinese artists expressed their ideas with terms borrowed from theories of postmodernism introduced to China in the middle and late '80s. It should be emphasized, however, that the Chinese interest in the fragmentation of language had its indigenous origin in the Cultural Revolution. That decade produced innumerable copies of a few sets of images and texts—mainly Mao's portraits, his writings, and his sayings—in every written and visual form (FIG. 1.6). The chief technology of cultural production during that period was *repetition* and *duplication*—two essential methods used to fill up a huge time and space with limited images and words, thereby creating a coercive, homogeneous verbal and visual language in a most static form. The meta-language of the Cultural Revolution was therefore never a meta-narrative. Consequently, the target of "postmodern" deconstruction mobilized by young Chinese artists was not really a Marxist scheme of grand social evolutionism, but the cultural production and visual language of the Cultural Revolution.

7

In addition to written characters, other stuff material for repetition and duplication during the Cultural Revolution, including Mao's portraits, typical images in propaganda posters, and the color red, were reduced to isolated and hence illogical fragments. These forms were extracted from the original process of production and reproduction, distorted at wish for any possible formalist or ideological reason, and mixed with signs from heterogeneous sources. Such practices have become so common in Chinese art since the '80s that they transcend the differences between individual trends (e. g. Political Pop, Cynical Realism, or Critical Symbolism) and actually unite these trends into a single movement. In fact, from a broad historical perspective, we could call mainstream Chinese art from the late '70s to mid-90s "Post-Cultural Revolution Art," because the basic means and goals of this art were to recycle, criticize, and transform the visual language of the Cultural Revolution. An important component of this art, *fragmentation* is "an attitude as well as a technique, a perception as well as a procedure."[8] But with the gradual distancing of the Cultural Revolution, images derived from this era were increasingly used less for political criticism and increasingly more for visual, intellectual, or even commercial purposes.

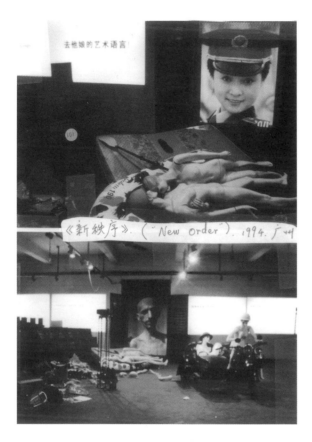

FIG. 1.7: XU TAN, *New Order,* VIDEO INSTALLATION, GUANGZHOU, 1994.

From the middle to late '80s, images "fragmented" from the Cultural Revolution repertory, such as Wu Shanzhuan's red stamps and flags (1987) and Wang Guangyi's *Mao Zedong No.* 1 (1988), still provided definite references to their prototypes. But gradually such references were complicated or disguised. Works of Political Pop, arguably the most dominant trend in the early and mid-90s, did not simply cite and deface Cultural Revolution images, but also distorted them and combined them with signs from heterogeneous sources: commercial trademarks and advertisements (Wang Guangyi), textile patterns (Yu Youhan), sexual symbols (Li Shan), computer images (Feng Mengbo), legendary and folklore figures (Liu Dahong), and family portraits (Liu Wei and Zhang Xiaogang). Although they largely mix and appropriate existing images, these works should not be simply equated with Jamesonian "pastiches,"[9] because in these works the Cultural Revolution images remain central, and because artists were still trying to forge a distinguishable "style" and an artistic individuality.

§

Political Pop marked the end of "Post-Cultural Revolutionary Art" and ushered in a recent change in Chinese art around the mid-90s: many artists have finally bid farewell to the Cultural Revolution and

all its visual and mental baggage. Their works directly respond to China's current transformation, not to history or memory. It is perhaps still too early to summarize the general tendencies of these works, but some of them reflect a clear attempt to document the ongoing fragmentation of Chinese society. The Guangzhou installation artist Xu Tan, for example, combines disfigured plastic mannequins, war souvenirs, and an enormous picture of a smiling policewoman in a work titled *New Order* (FIG. 1.7). Viewers are confused by the random mixture of media, the incoherent size relationship of images, and the casual association between fashion and violence. The illogicality of this installation, according to Hou Hanru, mirrors "the fact that reality is full of conflicts and incidents, while chaos, entropy and permanent precariousness are the real 'rules.'"[10]

An important aspect of China's transformation in recent years is the rapid growth of the city. At the same time, the city has become increasingly incoherent and incomprehensible; its growth is visible from the forest of cranes and scaffolding, the roaring sound of bulldozers, the dust and mud, all signifiers of a never-ending destruction and construction. Old houses are coming down everyday to make room for new buildings, often glittering high-rises in a so-called postmodern style. To some city residents, demolition means forced relocation; to others it means a deepening alienation of people from the city. The feeling of helplessness and frustration generated in this process is expressed in Zhan Wang's *Ruin Cleaning Project, '94* (FIG. 1.8): he chose a section in a half-demolished building for "restoration." He first washed it carefully and then painted doors and windows on it. But scarcely had he finished, when the building was razed to the ground.[11]

Uncertainty in the external world forces people to turn to a smaller, private space. Indeed "interior furnishing" (*shinei zhuangzhi*) has become one of the most profitable businesses in recent years. New shops selling western-style furniture, modern kitchen and bathroom equipment, and fancy light fixtures are seen everywhere in Chinese cities, and one can find all sorts of "interior decoration" guides in bookstores. The common wisdom of interior decoration, however, still centers on the notion of *jian* or "piece." A "big *jian*" means a piece of furniture or equipment that has acquired a conventional social meaning: it not only fulfills the need for convenience or comfort, but demonstrates the owner's sophistication, social connections, and financial status. A well-furnished apartment is essentially a collection of such "big *jian*," which are sought-after goods but often prohibitively expensive even for a family of middle-level income. The accumulation of these "pieces" thus demands long-term planning and hard work. This social practice has created a specific sense of interiority—a private environment in which

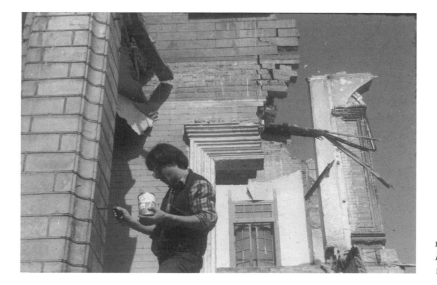

FIG. 1.8: ZHAN WANG, *Ruin Cleaning Project, '94*, PERFORMANCE, BEIJING, 1994.

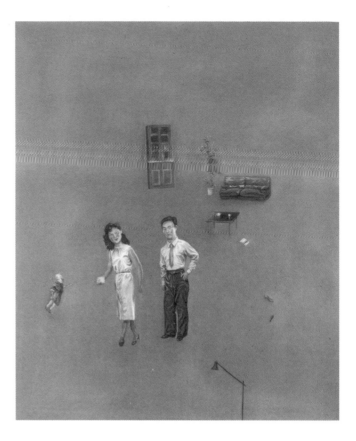

FIG. 1.9: ZENG HAO, *Thursday Afternoon,*
OIL ON CANVAS, 1994.

men and women are linked with (and identified by) their "fragmentary" belongings. This "postmodern" sense of interiority is the subject of a series of oil paintings that Zeng Hao created between 1994 and 1997 (FIG. 1.9). In each painting, isolated pieces of stylish furniture and audio-video equipment, like miniatures made for a doll house, are scattered on a flat background. Young urban professionals dressed in neat western-style clothes are randomly situated amidst these enviable belongings, staring blankly at the empty space before them. In an interview the artist relates these fragmentary images to his experience in Guangzhou: "Everyday you see, in home after home, everyone is filling his (or her) home with fancy stuff. It feels weird in such an environment."[12]

But to Zeng, what is weird—what has become fragmentary in present China—are not only space and objects, but also time and subjectivity. The title of each of his "interior" paintings indicates a moment: *December 31; Thursday Afternoon; Yesterday; Friday 5:00 PM*; or *17:05, July 11*. There is no continuity between these moments; and we do not even know which moment is earlier or later because the year is never given. These titles thus function as fragmented signifiers which fail to link experiences into a coherent sequence. As a result, the interior space, with its fragmentary figures and things, is always in a perpetual present.

Originally published in Gao Minglu, ed., *Inside Out: China's New Art* (New York and San Francisco, 1999), 59-66.

A CASE OF BEING CONTEMPORARY:
CONDITIONS, SPHERES, AND NARRATIVES
OF CONTEMPORARY CHINESE ART

Several years ago after I gave a talk on contemporary Chinese art, I was asked how Chinese art could also be contemporary. The person who asked the question obviously found these two concepts incompatible. To him, China or Chinese art was intuitively—and necessarily—situated in a time and place outside the realm of the contemporary. I pointed out the falsehood of this presumption, but also confessed that a systematic explanation had yet to be worked out to account for the creation and operation of a "local" or "national" contemporary art in today's world—not only contemporary Chinese art but also contemporary Iranian art, contemporary Indian art, contemporary Mexican art, and contemporary Algerian art—to name just a few.

The purpose of this essay is to develop this explanation. In this regard, it is a case study meant to shed light on a larger issue. The direct subject of my discussion is a kind of Chinese art that self-consciously defines itself as "contemporary" (*dangdai yishu*) and that is also accepted as such by curators and art critics worldwide, judging from their inclusion of this art in the many exhibitions they have organized to showcase recent developments in visual art. To be sure, many brands of "Chinese art" are produced today, but those in traditional mediums and styles (such as literati ink landscape or realist oil portraiture) are not conceived—nor do their creators label them—as *dangdai yishu*. "Contemporary art" in Chinese thus does not pertain to what is here and now, but refers to an intentional artistic and

theoretical construct that asserts a particular temporality and spatiality for itself. Therefore, the first step of my study is to map this temporality and spatiality in terms of art medium, subject matter, exhibition and circulation, and to trace the people and institutions involved in its creation and promotion. This initial investigation leads me to define certain general spheres for the production, exhibition, and collection of contemporary Chinese art, and to propose a model in interpreting this art in its various contemporary contexts.

The need for a new interpretation of contemporary Chinese art naturally arises from dissatisfaction with earlier interpretations which have often approached this art (or in a broader sense, any contemporary art from the so-called Second and Third Worlds) either exclusively in its domestic context or as a straightforward manifestation of globalization. The first approach follows a traditional art historical narrative defined by nations. The second privileges a totalizing, global perspective that stymies local angles of observation.[1] To this end, even the notion of a "local" contemporary art already implies this dilemma, demanding reconsideration. Deconstructing the global versus local dichotomy is a vital component of the new understanding of contemporary Chinese art I am pursuing.[2] In this essay, I argue that contemporary Chinese art is simultaneously constructed in different yet interrelated spaces, and that it subtly changes its meaning when artists and curators (or their works) traverse and interact with these spaces. Tracing such permutation enables us to develop a spatial model for contemporary Chinese art. This model further helps us interpret a burgeoning "international contemporary art" in today's world, which encompasses various "local" or "national" brands of contemporary art, as a unified field of presentation and representation. Generally speaking, instead of assuming that this type of contemporary art is linked with modern (and postmodern) art in a linear, temporal fashion and within a self-sustaining cultural system, this interpretative model emphasizes heterogeneity and multiplicity in art production, as well as the creativity of a new kind of artist. This new artist creates contemporary art through simultaneously constructing his or her local identity and serving a global audience.

A "CONTEMPORARY TURN" IN CHINESE ART

The Chinese art critic Lü Peng is the main author of two comprehensive introductions to new Chinese art (also known as avant-garde or experimental art[3]) which emerged after the Cultural Revolution (1966-1976). The first book, which he co-authored with Yi Dan and published in 1992, is called *A History of Modern Chinese Art: 1979-1989 (Zhongguo xiandai yishu shi, 1979-1989).*[4] The second book, which he authored alone, came out in 2000 under the title *A History of Contemporary Chinese Art: 1990-1999 (Zhongguo dangdai yishu shi, 1990-1999).*[5] The change in the titles from "modern" (*xiandai*) to "contemporary" (*dangdai*) was no accident. It is symptomatic of a general (but so far unnoticed) shift in the Chinese art world from the '80s to the '90s, which I call a "contemporary turn." Simply put, throughout the '80s, Chinese avant-garde artists and art critics envisioned themselves as participants in a delayed modernization movement, which aimed to reintroduce humanism and the idea of social progress into the nation's political consciousness (FIG. 2.1).[6] From the '90s onward, however, many of them abandoned, or at least distanced themselves from this collective undertaking. Looking back at Chinese avant-garde art of the '80s, some of its original advocates contrasted that exhilarating but chaotic era with the much more practical and diffuse period following it.[7] According to Li Xianting, a major voice of new Chinese art in both the '80s and '90s, artists of the '80s "believed in the possibility of applying modern Western aesthetics and philosophy as a means of revitalizing Chinese culture." Starting from the early '90s, however, many of them turned "against heroism, idealism, and the yearning for metaphysical transcendence that characterized the '85 Art New Wave movement."[8] Other critics and curators share this view and have used "modern" and "contemporary" to encapsulate the

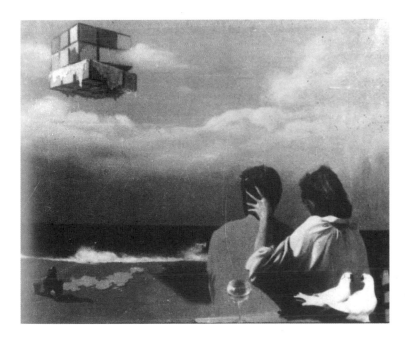

FIG. 2.1: YANG YINGSHENG, *White Pigeons Blocked by Rear Views of People and a Vanishing Rubik's Cube,* OIL ON CANVAS, 1985.

many differences between these two periods. For instance, they wrote books and articles in the '80s to promote "modern art," and titled the enormous exhibition that concluded the '85 Art New Wave *A Grand Exhibition of Modern Art (Xiandai meishu dazhan).*[9] In contrast, many books, art journals, and exhibitions since the early '90s have used "contemporary art" in their titles.[10]

Underlying this change was a major shift in conceptualizing new Chinese art over the past twenty-five years. Most importantly, the two terms indicate two different ways of contextualizing this art, one temporal and diachronic, the other spatial and synchronic. When avant-garde Chinese artists and critics called themselves "modern" in the '80s, they identified themselves, first of all, as participants in a historical movement which had been interrupted in China by Communist rule. Lü Peng and Yi Dan thus opened *A History of Modern Chinese Art: 1979-1989* with a passionate introduction, linking new Chinese art to the May Fourth Movement that started in 1919. In their view, although this early twentieth-century "cultural revolution" had the correct goal of bringing China into a modern era of democracy and science, its heavy emphasis on the social function of art and literature finally led to an extreme pragmatism, as realism willingly turned itself into political symbolism in the '60s and '70s to assist a "proletarian dictatorship." To regain the spirit of a genuine cultural revolution, therefore, their introduction exhorted "modern artists" of the '80s to not only uphold humanism as their fundamental ideology, but also to take upon themselves the role of cultural critic, "reexamining the relationship between art and society, religion, and philosophy in all possible ways."[11] Similar claims characterize many other writings from that period.[12]

In contrast to such spirited discussion of "modern art" in the '80s, no particular discourse has qualified the art of the '90s as "contemporary," even though the term has gained wide currency among Chinese artists and critics. What the term indicated in the early '90s was, above all, a sense of rupture and demarcation—the end of an era as well as the kind of historical thinking associated with it. This meaning is made clear in Li Xianting's writing cited above. But as veterans of the art movement of the '80s, Li and his colleagues perceived the art of the new era pessimistically as visual forms without genuine historical, political, and social engagement. Others writers explained the artists' break with history and ideology in terms of China's changing political situation. For example, Chang Tsong-zung, who sponsored and

13

co-organized the first major international exhibition of contemporary Chinese art in 1993,[13] attributed this change to the ill-fated June Fourth Movement (the pro-democratic demonstrations in Tiananmen Square in 1989): "In shock, artists came to a sudden realization of their impotence in the face of real politics. The idealism and utopian enthusiasm so typical of new art in the '80s met its nemesis in the gun barrels in Tiananmen."[14] Applying this understanding to visual analysis, he pointed out that two major styles in post-89 Chinese art—Cynical Realism and Political Pop—both translated idealism into sarcasm (FIGS. 2.2, 2.3).

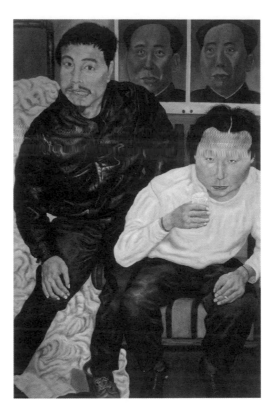

FIG. 2.2: LIU WEI, *Two Drunk Painters,* OIL ON CANVAS, 1990.

Chang's observation has a broader significance in alluding to a general pattern that distinguishes the development of postwar Chinese art from that of the West. It is a "pattern of rupture" caused by violent intrusions of sociopolitical events such as the Cultural Revolution and the Tiananmen incident. The result has been a series of deep ruptures as a general historical and psychological condition for artistic and intellectual creativity. Each rupture has forced artists and intellectuals to reevaluate and reorient themselves. Instead of returning to a prior time or space, the projects they have developed after each rupture often testify to a different set of parameters and are governed by different temporality and spatiality.

This pattern of response explains the sudden change in artists' attitudes after '89, and also enables us to see the "modern art" of the '80s and the "contemporary art" of the '90s not as two consecutive trends, but as disconnected endeavors conceived in separate temporal and spatial schemes. Earlier, I mentioned that avant-garde artists and critics of the '80s linked themselves with the May Fourth Movement, a cultural movement that aimed to transform China based on a western, Enlightenment model. It is therefore not surprising that these artists and critics also developed a strong desire for cosmopolitanism, eagerly seeking inspiration in western modern art, art theory, and philosophy. This desire became both the cause and the result of an "information explosion" in the '80s. From the start of the decade, all sorts of "decadent" western art forbidden during the Cultural Revolution was introduced to China through reproductions and exhibitions; hundreds of theoretical works, from authors such as Heinrich Wölfflin to Ernst Gombrich, were translated and published in a short period. These images and texts aroused enormous interest among younger artists and greatly inspired their work. It was as if a century-long development of modern art was simultaneously re-staged in China. The chronology and internal logic of this western tradition became less important; what counted most was its diverse content as visual and

intellectual stimuli for a hungry audience. Thus, styles and theories that had long become past history in the West (such as surrealism or Wölfflin's categorization of artistic styles) were used by Chinese artists as their direct models. The meaning of their works as "modern art" was located, therefore, not in the original historical significance of the styles and ideas, but in the transference of these styles and ideas to a difference time/place.

Like any transference, this dislocation of modern art was based on the idea of precedents. Although separated by time and historical experience, Chinese artists of the '80s saw themselves as direct followers of great modern philosophers and artists in the West. A historian of western contemporary art may be shocked to find that in Lü Peng and Yi Dan's *A History of Modern Chinese Art: 1979-1989*, the most influential figures on Chinese artists in the '80s were, in fact, "Arthur Schopenhauer, Friedrich Nietzsche, Jean-Paul Sartre, Sigmund Freud, Carl Jung, Albert Camus, and T. S. Eliot."[15] But it makes perfect sense if we understand these artists' longing to rediscover their modernist roots. This situation changed completely after '89. These grand names suddenly became infinitely remote, and few Chinese artists, if any, continued to seek guidance from them. Rather, the sharp historical gap created by the Tiananmen incident distanced them from the previous era, enabling them to develop a radically different relationship with history and with the surrounding world. In this process, they also disengaged themselves from *yundong*, the Chinese term for large-scale political, ideological, or artistic "campaigns" or "movements."

Although seldom analyzed by historians and sociologists, *yundong* was one of the most fundamental concepts and technologies in modern Chinese political culture until the '90s. This was especially true for the period from the '50s to the '70s. Upon ascension to power, the Chinese Communist Party mobilized various *yundong* to realize both short-and long-term projects, and to unify the "revolutionary masses" against internal and external enemies. Three major characteristics of a *yundong* include a definite and often concrete political agenda, a propaganda machine which helps define and spread this agenda, and an organization which helps forge a cohesive "front" among participants. *Yundong* became the norm. It is therefore not surprising that a *yundong* mindset continued to control artists' thinking even after the Cultural Revolution had ended. The persistence of a *yundong*

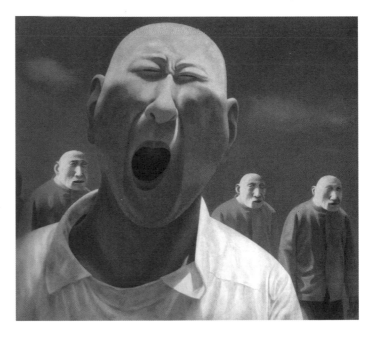

FIG. 2.3: FANG LIJUN, *Series 2, No. 2,*
OIL ON CANVAS, 1991.

mentality is clearly seen in the avant-garde art of the '80s: while attacking official ideology and art policies, the advocates of this art tried hard to galvanize experimental artists into a unified front and to develop this art into an organized "movement." (In fact, they called their collective activities a *yundong*.)

It took a hit as hard as the Tiananmen tragedy to disengage Chinese artists from this *yundong* mentality. Almost overnight, they were transformed from soldiers in a heroic struggle into lone individuals facing an alien world. The unfamiliarity of the world in the early '90s, however, had less to do with the Tiananmen incident as with two simultaneous, contemporary happenings. First, China had entered a new stage in a profound socioeconomic transformation. Beginning in the late '70s, a new generation of Chinese leaders led by Deng Xiaoping had initiated a series of socioeconomic reforms, but the consequences of these reforms were only fully felt in the '90s. Major cities such as Beijing and Shanghai were completely reshaped. Numerous private and joint ventured, including privately-owned commercial art galleries, had appeared. Educated young men and women moved from job to job in pursuit of personal well-being, and a large "floating population" entered metropolitan centers from the countryside looking for work and better living conditions. As I will discuss below, many changes in the art of the '90s were related to this larger picture.

FIG. 2.4: WANG JIN, *To Marry a Mule*, PERFOR-MANCE, LAIGUANGYING VILLAGE, BEIJING, 1995.

Second, China had also entered a new stage of globalization. If the "modern art" of the '80s was predominately a domestic movement linked closely to the country's internal political situation at the time, "contemporary art" since the '90s has unfolded across multiple geographical, political, and cultural spheres. Consequently, my discussion will now turn to the three most important spheres of this art, which overlap but do not constitute a coherent framework for a continuous narrative. These are: 1. China's domestic art spaces, 2. the global network of a multinational contemporary art, and 3. individualized linkages between these two spheres created by independent artists and curators.

THE CONTEMPORANEITY OF CONTEMPORARY CHINESE ART

1. Contemporary Art as a Domestic Avant-Garde

In the domestic sphere, the term "contemporary art" conveys a strong sense of avant-gardism and signifies a range of experiments that aspire to challenge established art institutions, systems, and forms. Over the past ten to fifteen years, most of this experimentation has been conducted in three areas: art medium, subject, and exhibition.[16]

A simple but powerful strategy employed by many avant-garde Chinese artists to make their works explicitly "contemporary" is to subvert traditional art mediums. The trend of subverting painting

FIG. 2.5: SONG DONG, *One More Lesson: Do You Want to Play With Me?*, PERFORMANCE, 1994.

emerged in the '80s. (Before this, independent artists, even the most radical ones, still worked in the domains of painting and sculpture). But it was only from the mid-90s onward that new art forms, such as installation, performance, site-specific art, and multi-media art, prevailed (FIGS. 2.4-2.6). An increasing number of younger artists abandoned their former training in traditional or western painting, or only made paintings privately to finance their more adventurous but less marketable art experiments. One can draw interesting parallels between them and an earlier generation of westernized Chinese artists, who abandoned the traditional Chinese brush for the "modern" medium of oil painting. But if those artists in the early twentieth century chose between different types of painting, their successors in the present choose whether to abandon painting altogether.

As I will discuss in the following section, new, experimental art forms provide contemporary Chinese artists with an "international language." Inside China, however, these forms have served to forge an independent field of art production, exhibition, and criticism outside official and academic art. In denouncing painting, artists can effectively establish an "outside" position for themselves, because what they reject is not just a particular art form or medium, but an entire art system, including education, exhibition, publication, and employment. Such a break is sometimes related to an artist's political identity. But it can also be a relatively independent artistic decision, as these artists find new art forms

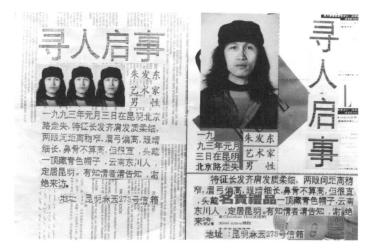

FIG. 2.6: ZHU FADONG, *Looking for a Missing Person*, SITE-SPECIFIC INSTALLATION, 1993.

both liberating and challenging. On this level of individual experimentation, these artists negotiate with painting in different ways: some of them squarely reject painting, while others subvert painting and calligraphy from within, and still others reframe painting as a component of installation or performance.

Contemporary Chinese artists have also distinguished themselves in the domestic sphere by developing site-specific projects and "experimental exhibitions." One type of site-specific project can be called a *counter-monument* or *anti-monument*. Set in important political spaces such as the Great Wall or Tiananmen Square, a counter-monument or anti-monument transforms such spaces into a stage for individual expression (FIGS.

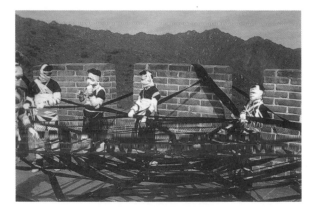

FIG. 2.7: SHENG QI AND OTHERS, *The Concept of the 21st Century*, PERFORMANCE AT THE GREAT WALL, BEIJING, 1988.

2.7-2.10). Additionally, the pursuit of contemporaneity has given rise to many "ruin images," which comment on or interact with the drastic transformation of Chinese cities. Over the past ten to fifteen years, one striking aspect of a major Chinese metropolis like Beijing or Shanghai has been its never-ending destruction and construction. This situation furnishes both the context and the content of a large group of works, which represent "demolition sites" or take place in such places (FIGS. 2.11-2.14). I have

discussed some chief characteristics of these images and site-specific projects, especially the skewed temporality and spatiality contained in them.[17] A demolition site in real life is a place that belongs to everyone and to no one. It belongs to no one because the breakdown it effects between private and public space does not generate a new space. Captured by contemporary artists, a demolition site signifies a kind of "non-space" outside normal life. Its suspended spatiality is further linked to its suspended temporality. The contemporaneity of these ruin-related projects should be distinguished from the concept of the present, conceived as an intermediary, transitional stage between past and future. As the subject of contemporary art, demolition sites break the logic of historical continuity, as "time" simply vanishes in these "black holes." The past of these places has been destroyed and few people know their future. Unlike war ruins, however, demolition sites inspire not only anxiety but also hope.

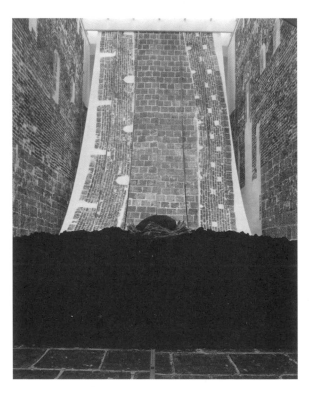

FIG. 2.8: XU BING, *Ghosts Pounding the Wall*, PERFORMANCE AND INSTALLATION, 1990.

Some artists and curators have staged exhibitions at demo-lition sites. In doing so, they have identified their projects as "experimental exhibitions," which shift the focus of experimentation from the content of an exhibition to the exhibition itself: its site, form, and social function.[18] These issues loom large in present-day China because of an intensified conflict between a rapidly developing, aggressively active contemporary art and a backward official system of exhibition. Since the late '90s, independent curators and artists have tried to discover new exhibition spaces and to transform old exhibition spaces into venues for contemporary art. Most significantly, they have organized a

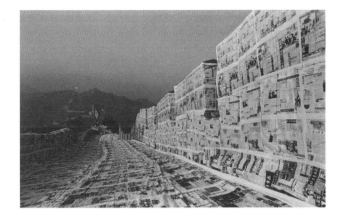

FIG. 2.9: WANG YOUSHEN, *Newspaper Series 1993*, SITE-SPECIFIC INSTALLATION AT THE GREAT WALL OUTSIDE BEIJING, 1993.

considerable number of contemporary art exhibitions that have taken place in versatile, non-exhibition spaces, bringing works of contemporary art to the public in a dynamic, guerilla-like fashion. That many such site-specific exhibitions have used commercial spaces reflects their curators' interest in mass commercial culture, which in their view has become a major force in contemporary Chinese society. While affiliating contemporary art with this culture, their exhibitions have also provided channels for artists to comment on it.

2. Decontextualization as Contemporaneity

The close relationship between the development of contemporary Chinese art and China's sweeping transformation has encouraged the compilation of a kind of macrohistory, which interprets this

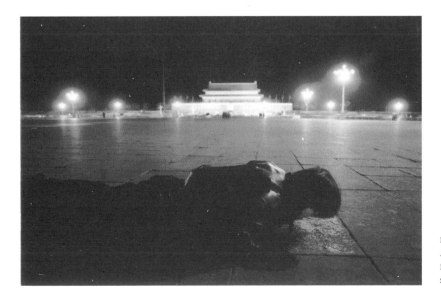

FIG. 2.10: SONG DONG, *Breathing*, PERFORMANCE AND PHOTOGRAPH, TIANANMEN SQUARE, BEIJING, 1997.

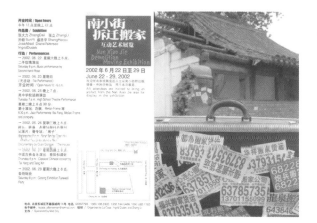

FIG. 2.11: *Nan Xiao Jie Demolition Moving Exhibition*, BEIJING, 2002.

FIG. 2.13: ZHAN WANG, *Temptation: An Outdoor Display*, SITE-SPECIFIC INSTALLATION, BEIJING, 1994.

FIG. 2.12: RONG RONG, *Untitled*, PHOTOGRAPH, 1996-1997.

art in light of domestic social and political movements. This history, however, fails to document or explain the global presence of contemporary Chinese art and its growing contribution to a burgeoning international contemporary art. We cannot simply expand the domestic context of contemporary Chinese art into a global one, because these two spheres are governed by different forces and present different problems. Neither can we study contemporary Chinese art in the domestic or global spheres in complete isolation. Our task, I propose, is to observe and analyze how this art negotiates with these two spheres and how it changes its roles and aims in responding to different spaces and audiences.

Most important, as part of an international contemporary art, the relationship between contemporary Chinese art and contemporary China becomes submerged. Such decontextualization is coupled with a recontextualization of this art in a different socioeconomic network. The beginning of this twofold process of decontextualization and recontextualization can be dated precisely to the early '90s, when contemporary Chinese artists first appeared in the 45th Venice Biennale and were featured in mainstream western art magazines (FIG. 2.15).[19] Around the same time, contemporary Chinese art became a global commodity, promoted by transnational commercial galleries and collected by foreign

FIG. 2.14: SUI JIANGUO, *Ruins,* part of the project *Property Development,* BY THE THREE MEN UNITED STUDIO, SITE-SPECIFIC INSTALLATION ON THE FORMER CAMPUS OF THE CENTRAL ACADEMY OF ART, BEIJING, 1994.

collectors and museums (FIG. 2.16). Direct ties between Chinese artists and western art institutions were then forged both inside and outside China, as international curators flocked to the country to search for new talent, and as Chinese artists increasingly participated in international exhibitions and workshops, some of them immigrating abroad for good.

These facts are well-known and need little elaboration, but the question of their impact on the meaning of contemporary Chinese art remains. In other words, the recontextualization of this art should be thought of as a reconstruction of its definition and identity. While the term "contemporary Chinese art" remains the same, its purposes and strategies have undergone crucial changes. On the most basic level, displacement and translation already alter a work's significance. For example, I discussed earlier how in China, new art forms such as installation, performance, and site-specific art convey a strong social message to subvert established norms. This significance largely disappears when these works are displayed in international exhibitions (such as the many biennials and triennials staged extravagantly around the world) that feature endless installations and multi-media work. Contemporary artists from China contribute to these events by immersing themselves in the kind of "international contemporary art" that these transnational exhibitions promote. Unlike oil and ink paintings, installation, performance, and multi-media art defy a rigid cultural identity. What they provide to Chinese artists on these occasions is an "international language" that not only confirms their own contemporaneity, but also allows them to incorporate indigenous art forms, materials, and expression into contemporary art. In so doing, they can maintain their identity as Chinese artists within international contemporary art.

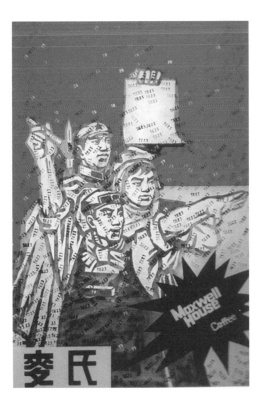

FIG. 2.15: WANG GUANGYI, *Great Criticism: Maxwell House Coffee,* OIL ON CANVAS, 1991.

21

FIG. 2.16: AN AUCTION OF CONTEMPORARY CHINESE ART IN HONG KONG, 1993.

Such immersion inspires creativity as well as simplification and misinterpretation. On the one hand, some of the most compelling works of contemporary Chinese art have been created in the global sphere, where they reflect on current international and intercultural issues through genuine artistic innovation (FIGS. 2.17, 2.18).[20] On the other hand, international art exhibitions encourage the tendency to reduce a local tradition into ready-made symbols and citations. The wide circulation of contemporary Chinese art brings it to a global audience, but such circulation also removes this art from its roots and erases its original, historical significance. On the one hand, the new context challenges Chinese artists to compare themselves with the best contemporary artists around the world. On the other hand, they can seldom avoid the audience's expectation of finding Chineseness in exotic, self-orientalizing forms.

The advantages and disadvantages of such decontextualization and recontextualization is best demonstrated by the changing meaning of Cynical Realism and Political Pop, two contemporary Chinese art styles that are best known in the West (see figs. 2.2, 2.3). As discussed earlier, both styles were invented in the aftermath of the Tiananmen incident to express, among other things, artists' disillusionment with their own political engagement. But when paintings in these two styles appeared in a series of international exhibitions in the early '90s (including the *45th Venice Biennale, China Avant-Garde* in Berlin's Haus der Kulturen der Welt, and *China's New Art, Post-1989* in Hong Kong, all organized in 1993), they were immediately taken as representatives of an "underground" or "dissident" art under a Communist regime. Ironically, such an interpretation based on a Cold War logic led to the artists' commercial success and changed their status in their home country. Soon thereafter, some of these artists built large villas outside

FIG. 2.17: CAI GUO-QIANG, *Cry Dragon/Cry Wolf: The Ark of Genghis Khan*, MULTIMEDIA INSTALLATION, GUGGENHEIM MUSEUM, NEW YORK, 1996.

22

FIG. 2.18: WENDA GU, *Monuments of the United Nations: The Millennium Monument*, INSTALLATION, 1999.

the Chinese capital in order to live an affluent lifestyle in a tightly guarded environment, painting largely for an unfamiliar, overseas audience.

On a methodological level, the decontextualization and recontextualization of contemporary Chinese art implies a shift in interpretation from historical context to broad theoretical implication that can be applied to works created anywhere. The numerous self-portraits by contemporary Chinese artists lend themselves to both types of interpretation. Historically, these images signify a desire to reconstruct the self through visual representation. This desire comes from an absence: self-portraiture disappeared entirely in China during the Cultural Revolution. In a period when every action and thought had to be directed by a collective ideology, self-portraiture was naturally identified with bourgeois self-indulgence and was therefore counter-revolutionary. On the other hand, the art of portraiture was given an exaggerated importance by reducing it to the mass production of the image of one man.

The desire to represent the self resurfaced after the Cultural Revolution was over. But the form and logic of these representations have been conditioned by both the country's recent past and present. Instead of representing one's personal appearance and emotional state, a more common tendency among contemporary Chinese artists has been a conscious denial of explicit self-display. Numerous "self-portraits" by these artists demonstrate a voluntary ambiguity in their self-images, as if the artists felt that the best way to realize their individuality was to make themselves simultaneously visible and invisible (FIGS. 2.19-2.21). These ambiguous, fragmentary images express their anxiety, frustration, and dilemmas in a rapidly changing society, and are therefore still concerned with the authenticity of the self. Displayed in an international exhibition, however, these images are given a broad rhetorical significance related to a general redefinition of the self in the contemporary world, and are used to exemplify how in our time, the traditional view of a fully integrated, unique, and distinctive individuality has been increasingly compromised, causing the fragmentation of the self and a decline in the belief of the individual as a legitimate social reality.[21]

FIG. 2.19: WU MINGHUI, *Narcissus,* SINGLE CHANNEL VIDEO, 1996.

3. Artists as Mediators of Contemporaneity

This section focuses on the third sphere of contemporary Chinese art, comprised of individualized spaces and channels generated by artists and curators through their independent projects and physical movement. Although the domestic and global spheres of contemporary Chinese art are connected on an institutional level, either through a transnational commercial network or through government-sponsored art exhibitions, the main linkage between the two spaces, I would suggest, is provided by contemporary Chinese artists themselves. Thus, they function not only as creators of contemporary Chinese art, but also as mediators among the multiple identities of this art. Many of these artists have become world travelers in the past decade. Some of them have returned to China after spending several years abroad. Others maintain a residence in New York or Paris but have become increasingly involved in domestic exhibitions. The majority of artists never officially emigrate, but it is not unusual for them to spend several months per year outside of China, traveling from one exhibition to another. Some thoughtful artists have created site-specific works for locations outside China, or have expressed their experience as global travelers in their works.[22]

Because of the unsystematic nature of such movement and activity, it is difficult to generalize about these artists. The channels opened up by these activities remain highly fluid and flexible. The "sphere" that they constitute vaguely encompasses the domestic and international spaces of contemporary Chinese art, but again in an unsystematic and undefined way. Despite its elusiveness, however, this sphere is most intimately connected with individual artistic innovation, the result of an artist's internalization of broad social and cultural issues (FIG. 2.22). This recognition demands close analyses of individual artists and their works. Unlike traditional "biographical"

FIG. 2.20: YUE MINJUN, *Untitled*, OIL ON CANVAS, 1996.

FIG. 2.21: ZENG FANZHI, *Mask Series No. 8*, OIL ON CANVAS, 1996.

FIG. 2.22: YIN XIUZHEN, *Portable City*, SOFT SCULP-
TURE, 2001.

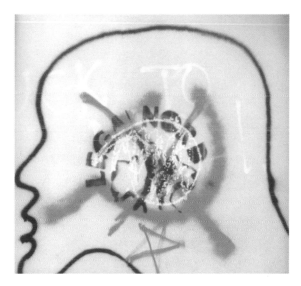

FIG. 2.23: ZHANG DALI, *Dialogue*,
GRAFFITI, BOLOGNA, ITALY, 1994.

FIG. 2.24: DISCUSSIONS OF
ZHANG DALI'S GRAFFITI IN
BEIJING'S NEWSPAPERS.

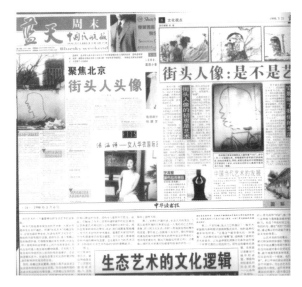

studies in art history, however, such analyses must show how contemporaneity is constructed through an artist's personal engagement with the domestic and global spheres.

Many Chinese artists can and should be discussed this way. For example, Zhang Dali, the most famous graffiti artist in Beijing in the '90s.[23] Like many other contemporary Chinese artists, his life has been filled with unexpected turns. To make a long story short, he grew up in northeast China and studied traditional painting at a top art school in Beijing. He graduated in 1987 and then immigrated to Italy in 1989, after the pro-democracy student movement in Tiananmen Square ended in bloodshed that year. In Italy, he first made Oriental-style commercial paintings for a living, but later became a spray-can graffiti artist and forged the image of a bald head as his trademark (FIG. 2.23). He continued to paint the same head after moving back to China in 1995, and by 1998, he had sprayed more than two thousand such images all over Beijing. These images, which he created secretly at night, eventually became the focus of a public controversy and were widely discussed in Beijing's newspapers and magazines (FIG. 2.24). It was only then that Zhang Dali revealed his identity as the creator of these images. In one interview he explained his art: "This head is a condensation of my own

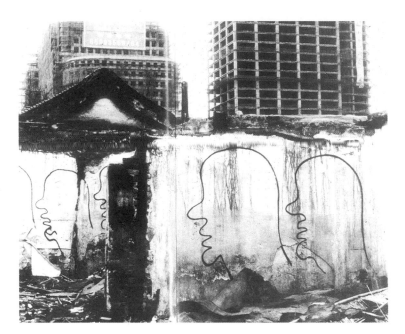

FIG. 2.25: ZHANG DALI, *Dialogue*,
PERFORMANCE AND PHOTOGRAPH,
BEIJING, 1998.

likeness as an individual. It represents to me a communication with this city. I want to know everything about this city—its state of being, its transformation, its structure. I call this project *Dialogue*."[24]

Zhang Dali's basic technique in developing such "dialogue" was to fill in a half-demolished, empty house with his own image. He was therefore able to "reclaim" an abandoned site, however temporarily. The locations he selected for such a project always highlighted certain contrasts between different political identities and social spaces. Sometimes, he juxtaposed the graffiti head with an official monument; other times, he juxtaposed a preserved traditional building (a palace) with a half-demolished one (an ordinary residence). But most of the time he contrasted urban destruction and construction. This mode is forcefully demonstrated in a 1998 performance/photograph (FIG. 2.25). In the foreground of the picture, standing amidst scattered garbage, are some broken walls as the remnants of a demolished traditional house upon which Zhang Dali has sprayed a row of his famous heads. Two huge modern buildings rise behind this wasteland. Still surrounded by scaffolding, one of them already advertises itself as the future "Prime Tower" and offers the telephone number of its sales department.

Many aspects of Zhang Dali's artistic experiments in the '90s are related to the notion of contemporaneity. These aspects include art medium and form (he abandoned painting in favor of performance, site-specific installation, and photography), social function and audience (his graffiti images became part of Beijing's public space, encountered by Beijing residents everyday), and identity. Regarding this last aspect, by inscribing his own image on old Beijing houses, Zhang Dali defined a specific space around which he could construct his identity as a "local artist" opposed to globalization and commercialization. But this identity contradicted his other identity as an "international artist" working for a global audience. (Since 1999, his photos have been shown in many art exhibitions outside China and have been collected by foreign collectors and institutions.) We should not simply consider such contradiction negatively. As I have suggested, tensions between various spheres of contemporary Chinese art problematize straightforward answers to complex problems. Partly responding to the commercialization of his "graffiti" images, Zhang Dali has developed a new project in recent years, making sculptures directly from the bodies and faces of migrant workers from the

countryside—people who are rebuilding Beijing but who remain anonymous, deprived laborers in the Chinese capital (FIG. 2.26).

Zhang Dali's example supports one of my methodological proposals, that a general sociological contextualization does not automatically reveal the contemporaneity of contemporary Chinese art. If such contemporaneity has anything to do with China's social transformation and globalization, these external factors must be *internalized* as intrinsic features, qualities, intentions, and visual effects of specific art projects. This interpretative strategy discourages the broad reduction of contemporary Chinese art to either its domestic or global contexts, but encourages us to forge micronarratives that emphasize artists' individual responses to common social problems.

FIG. 2.26: ZHANG DALI, *Chinese Offspring*, INSTALLATION OF A GROUP OF SCULPTURE, IN THE LEFT HAND AND RIGHT HAND EXHIBITION, BEIJING, 2003.

CODA: CONTEMPORANEITY AS INTENSIFICATION

In a seminar held in Beijing in 1999, a well known European curator confessed that he actually knew little about the history of contemporary Chinese art. He nevertheless decided to include some twenty young Chinese artists in his forthcoming exhibition because he found "the intensity of creative energy in their works irresistible." I told him that although I did know something about the cultural background and sociopolitical circumstances of this art, I was attracted to contemporary Chinese art for exactly the same reason. I then wondered what this "intensity of creative energy" actually meant—a feeling shared by two observers with very different backgrounds and experiences that seemed to capture the essence of new Chinese art at that moment.

If intensity results from intensification, then contemporary Chinese art is a consequence of a double intensification. In other words, this art not only responds to China's startling transformation over the past ten to fifteen years, but further enhances the feeling of speed, anxiety, and theatricality inherent in this external transformation through artistic representation. The strength of this art certainly does not depend upon the solitary perfection of individual masters over a prolonged time span. What makes it "irresistible" is the speed and depth of the artists' internalization of the sweeping changes around them—changes that have altered Chinese cities and the country's economic structure in a short period, transformed people's lifestyles and self-identities, and made China a major economic power in

the world. Similar transformations took place years ago in other parts of the world; China's ambition is to accomplish a century of development in the West within one or two decades. The same desire and urgency, often combined with self-doubt and uncertainty, is found in many works created by contemporary Chinese artists. As a result, many of these works strike viewers as containing something "real" and raw—ambition, rage, struggle, yearning, hope. The rapidly changing art mediums, styles and subjects further generate a sense of constant happening. All these characteristics contribute to a particular kind of contemporaneity in art, which is often lacking in works produced in peaceful, "normal," and more individualized societies.

This observation, however, also implies a predicament: as China's explosive development eventually slows down, and as contemporary Chinese art is eventually "normalized" to become a routine aspect of social life, the "intensity of creative energy" in this art will diminish. From such a historical perspective, therefore, the kind of contemporaneity described in this essay can only be a momentary quality of contemporary Chinese art. But this only proves that instantaneity and simultaneity are inseparable from the conception of contemporaneity, which inevitably involves the condensation of time.

Originally presented in the "Modernity and Contemporaneity: Antinomies of Art and Culture After the Twentieth Century" conference, held on November 4-6, 2004, at the University of Pittsburgh.

A DECADE OF CHINESE EXPERIMENTAL ART, 1900-2000

As the title of the First Guangzhou Triennial indicates, the main purpose of this exhibition is not just to showcase a group of Chinese experimental artwork from the '90s; it is, more importantly, to *reinterpret* this art through various means.[1] These means include selecting works for the exhibition through a comprehensive review of Chinese art in those ten years, developing an interpretative structure for the exhibition to highlight major themes and trends, and especially compiling this catalogue, which frames individual artists and their works with an overview of the experimental Chinese art of the '90s in this section.[2]

A reinterpretation always reacts to and revises existing interpretations. In this case, however, our purpose is not simply to replace one opinion with another. The organizers of this project share the understanding that Chinese experimental art in the '90s is at once a highly significant and extremely complex phenomenon; any serious interpretation or reinterpretation of this art and cinema must respond to both historical and methodological challenges, as the interpreter needs not only to expand research materials but also to reexamine analytical standards and approaches. It is on this basic level of scholarship that we question previous interpretations of this art, which often lacked research basis, expressed the interpreter's self-interest, or both. Especially, the simultaneous introduction of this art to the West through exhibitions and publications is itself a complex phenomenon in the '90s. While these exhibitions and publications helped globalize this art, their organizers and authors often had limited knowledge of contemporary Chinese artists and the social/cultural context of their works; their promotion of this art often reflected their own tastes and biases. In China, experimental art has been condemned by orthodox art critics. But even supporters are divided by different views and ideological positions; some of them oppose cultural and stylistic hybridity—an important feature of Chinese experimental art in the '90s—from a nationalistic stance.

Envisioned as a collective effort rather than an individual expression, the *reinterpretation* pursued through this exhibition and publication project has an important goal in establishing a platform for group research and discussion. The fourteen essays following this introduction focus on

various aspects of the experimental art of the '90s, from various art mediums and genres to the changing status of artists, and from broadening exhibition channels to overseas reception. The authors of these essays include seven Chinese art critics and curators, a Chinese experimental artist and a filmmaker, a British curator and critic residing in Beijing, and four scholars living and working outside China.[3] No attempt was made on this editor's part to unify the narratives and approaches of these authors. On the other hand, although resulting from independent research, these essays complement each other and together depict a larger picture of the experimental Chinese art of the '90s. The inclusion of four essays on Chinese experimental cinema in the '90s reflects our hope to study experimental art in conjunction with contemporaneous artistic phenomena. Through exploring the parallels and connections between experimental art and other art forms, we can better understand the general tendencies in Chinese art and culture during this period.

Methodologically, these essays exemplify three types of analyses, which are essential to any study of Chinese experimental art of the '90s. The first type contextualizes this art both synchronically and diachronically, exploring its relationship with the experimental art of the '80s on the one hand, and with China's transformation and globalization in the '90s on the other hand. The second type of analysis traces the development of Chinese experimental art during the ten years from 1990 to 2000. By investigating changes in content, style, function, and intention of experimental art, such study reveals a dynamic process of constant renewal. The third kind of analysis responds to questions concerning the relationship between experimental art and the surrounding world: How did this art create its "public" and how was it perceived by various kinds of interpreters—critics, curators, and historians—both inside and outside China?

This introduction does not summarize these essays. Rather, it intends to provide these more specialized discussions with a common basis by focusing on three general issues: 1. the concept of "experimental art" as understood in the Chinese context, 2. the historical background of the experimental art of the '90s, and 3. the changing roles and status of experimental artists in the '90s. This introduction and the fourteen essays constitute part of our attempt to reinterpret Chinese experimental art in the '90s. Part Two of this catalogue continues this discussion on a more concrete level, and analyzes specific examples of this art in three thematic sections centered on "memory and reality," "self and environment," and "global and local."

THE NOTION OF "EXPERIMENTAL ART"

It is necessary to first explain the concept of "experimental art" (*shiyan meishu*)—the subject of this exhibition and publication. Many books and articles correlate this type of contemporary Chinese art with more familiar concepts and historical categories, especially the western avant-garde that aimed to subvert existing art traditions and institutions. On the other hand, scholars have noted that because of the special experience and socio-political context of contemporary Chinese art, such general correlation can only provide initial entries to closer observations and interpretations. Instead of understanding contemporary Chinese art according to a readymade western model, it is crucial to define the experimental or revolutionary nature of this art historically and contextually. We agree with this second approach.

The applicability of the term "avant-garde" to contemporary Chinese art is the subject of ongoing debate. Some scholars, mostly specialists in European modernism, argue that historical avant-gardism is strictly a western phenomenon and so the term "avant-garde" should be used only in its original historical context. Other scholars, typically writing on contemporary Chinese art, hope to apply the concept of avant-garde to this art by broadening its definition.[4] A third position, however, is to get away from this

debate: instead of putting too much pressure on "naming" a specific tradition in contemporary Chinese art, it is perhaps more productive to find a more flexible designation for this tradition. The purpose of such a designation is not to bring interpretation to a closure, but to encourage fresh observations and to open up new spaces for historical and theoretical inquiries. The term "experimental art" offers such a possibility. It is interesting to note that while *xianfeng* and *qianwei*—both meaning "avant-garde"— enjoyed overwhelming popularity among unofficial Chinese artists in the '80s, these artists increasingly called their art "experimental" in the '90s.[5] The reason, as I will suggest later in this introduction, is that while the experimental art of the '80s closely followed western prototypes, experimental art of the '90s developed its own characteristics and demanded an independent identity. A parallel movement is found in Chinese cinema: compared with the Fifth Generation directors of the '80s who were eager to bring their creations to the world, independent filmmakers of the '90s placed individual experimentation over audience reception. The term "experimental cinema" (*shiyan dianying*) became more frequently associated with new types of documentary and feature film, and filmmakers like Jia Zhangke call their teams "nuclear experimental groups" (*shiyan xiaozu*).

To historians and critics, the concept "experimental art" allows them to analyze a larger body of materials and to contextualize radical artistic expressions of avant-garde types. It is an established view that experimental art is related to but never equals avant-garde art. Renato Poggioli, for example, states in his *Theory of the Avant-Garde* that although the "experimental factor" is crucial to any invention of avant-gardism, the desire to experiment is not limited to avant-garde artists, nor must an experiment result in a revolutionary style or concept. Thus he distinguishes avant-garde experimentalism from other kinds of experimentalism.[6] Similar differences are found within contemporary Chinese experimental art. Some artists exhibit stronger antagonism and nihilism toward society and fit a conventional western notion of the avant-garde more closely; other types of experiments may focus more on stylistic or technical matters. The subject of experimentation can also go beyond art per se and can include the manner and method of art exhibition and publication, and even the social role and position of the artist. An "experiment" can be undertaken either by individuals or by groups.

On the other hand, although it may be said that experimentation is essential to any kind of artistic invention, what we call "Chinese experimental art" is a specific historical phenomenon defined by a set of specific factors. Chronologically, this art started from the late '70s, when unofficial artists, art societies, and exhibitions emerged in post-Cultural Revolution China. Sociologically, this art claims an "independent" or "alternative" status domestically, and allies itself to international contemporary art. Artistically, it shows a penchant for new art mediums and novel styles; its "experiments" often challenge conventional methods and languages of artistic expression. Among these defining factors of experimental art, the most essential one is the artist's self-positioning in a rapidly changing society. Unorthodox styles and content, or new types of medium and exhibitions, are concrete means of consolidating the artist's "alternative" self-identity. In other words, Chinese experimental art is the art of Chinese experimental artists.

But who are the "experimental artists" (*shiyan yishujia*) in post-Cultural Revolution China? In the most fundamental sense, what makes a Chinese artist an "experimental" one is the artist's determination to place himself or herself at the *border* of contemporary Chinese society and the art world. This determination is often sustained by a sense of mission to enlarge frontiers and open new territories in Chinese art. By taking up this mission, however, an artist must also constantly renew his or her own marginality and must constantly re-position himself or herself on the *border* in order to be continuously "experimental." Thus, the notion of "border" is crucial for understanding Chinese experimental artists and their art. Here a "border" refers to a political, ideological, or artistic space around which a particular type of identity is developed and articulated.[7] A border evokes self-consciousness. By placing themselves at a real or fictional frontier, experimental artists identify

themselves as an oppositional force against various kinds of cultural hegemony. While an established art tradition or institution (e.g., academic art or a "global" exhibition system such as the Venice Biennale) often relies on fixed agendas and guarded territories, experimental art favors pluralism and cultural crossing; the borderland it opens up deterritorializes conventional cultural and political spheres. It is thus understandable why this art presents a constant threat to art establishments. "A border maps limits," writes Alejandro Morales. "It keeps people in and out of an area; it marks the ending of a safe zone and the beginning of an unsafe zone. To confront a border and, more so, to cross a border presumes great risk."[8] A border is always policed and a border-crosser faces the danger of repudiation. But such risk is unavoidable because, as explained earlier, a self-imposed marginalization is one of the most important characteristics of Chinese experimental art, while a sense of danger inspires heroism and camaraderie among experimental artists.

Although in theory experimental artists must constantly re-position themselves to escape from becoming mainstream, not many artists can keep meeting such a challenge. In many cases during the past twenty-five years, Chinese experimental artists of a given period lost their edge after having acquired social positions and secured financial status for themselves. In other cases, unorthodox art styles and mediums were accepted by mainstream art and thus lost their "experimental" qualification. As a result of these and other situations, while some artists have indeed made courageous efforts to renew their alternative identity, the development of Chinese experimental art in general has produced "generations" of artists and filmmakers, whose works have responded to different tasks at different times, and whose activities have been associated with various phases of contemporary Chinese art and cinema.

DEPARTING FROM THE '80s

Such "generation shifts" are most clearly seen in contemporary Chinese filmmaking. It has often been said that the experimental movement in this field started from the Fifth Generation of filmmakers, that is, the first class to graduate from the famed Beijing Film Institute after the Cultural Revolution in 1982. From 1983 onward, they made a series of controversial films challenging orthodox representations of China's history and the Chinese people. Almost immediately, their impressive works won international applause, partly because of their unorthodox ideology and partly because of their grand melodramatic style and stunning visual effects. By the end of the '80s, however, this type of film had largely been popularized and lost its experimental edge. Beginning in the early '90s, the Sixth Generation of filmmakers initiated a new line of experimentation by focusing on contemporary Chinese urban life, and so it is also known as the "Urban Generation." Reacting against the earlier generation, they redefined the role of a filmmaker from that of a master storyteller to that of a participant in spontaneous events. Their fragmentary cinematic style showed clear impact from the "on-site" (*xianchang*) documentary film, another important branch of experimental Chinese cinema of the '90s.

In the domain of experimental art, we can roughly divide its development during the past twenty-five years into four phases or trends: 1. the emergence of alternative, unofficial art in China from 1979 to the early '80s, 2. the '85 Art New Wave and *China/Avant-garde* exhibition from the mid-80s to 1989, 3. post-89 art and the internationalization of Chinese experimental art from the early '90s, and 4. a "domestic turn" from the early and middle '90s, a movement in which experimental art increasingly conveyed social and cultural critiques. The last two trends overlapped each other during most of the '90s and represented two main directions of experimental art during this period. Because both trends appeared as conscious departures from the experimental art of the '80s, to understand their significance and historicity we need to look into their relationship with the '85 Art New Wave.

The '85 Art New Wave began with the spontaneous appearance of numerous unofficial art groups: according to one statistic, more than eighty such groups emerged in 1985 and 1986, scattering across twenty-three provinces and major cities.[9] The members of these groups were mostly in their twenties; a considerable number of them had just graduated from or were still studying at prestigious art schools. Compared with earlier alternative artists such as the members of the Stars Art Society (Xingxing Huahui), experimental artists of this new generation were more knowledgeable about recent developments in western art, and their works often showed unmistakable influence from it. In fact, almost all major styles of western modern art invented over the past century could be found in these works. Such stylistic pluralism—one of the most important features of Chinese experimental art of the '80s—was closely related to an "information explosion" at the time, when a large quantity of western philosophical, literary, and art historical writings were translated into Chinese, and when images of modern and contemporary western art also became available to young Chinese artists.[10]

From 1986 on, local and individual groups of experimental artists began to contact one another to organize joint exhibitions and activities.[11] This then paved the way for a nationwide network of experimental artists, a development facilitated by a group of art critics committed to promoting experimental art in China. Their plan of organizing a national exhibition of experimental art in Beijing was finally realized in 1989, when the *China/Avant-garde* exhibition took place in the National Art Gallery. Looking back at this exhibition and '85 Art New Wave, some of these critics commented in the early '90s on the idealistic tendencies of experimental art of the '80s, and contrasted this exhilarating but chaotic period with the Chinese experimental art that followed it.[12] According to them, experimental artists of the 1980s "believed in the possibility of applying modern western aesthetics and philosophy as a means of revitalizing Chinese culture." From the early '90s on, however, many of these artists turned "against heroism, idealism, and the yearning for metaphysical transcendence that characterized the '85 Art New Wave movement."[13] One finds a similar ideological shift in cinema at the time. In Zhang Zhen's words, "While the mythic, larger-than-life icon of the repressed peasant woman (embodied by Gong Li) dominates Fifth Generation's glossy canvas in the era of reform, the subjects that populate the new urban cinema are a motley crew of plebeian but nonetheless troubled people on the margins in the age of transformation—ranging from aimless bohemians, petty thieves, taxi drivers, KTV bar hostesses, disabled people, migrant workers, and other marginalized subjects at the bottom of society."[14]

Another important transformation within Chinese experimental art from the '80s to the '90s is a shift from "collective experiments" to "individual experiments." Chinese experimental artists and filmmakers of the '80s were deeply engaged in historical thinking: their art bore memories of the bygone Cultural Revolution and expressed their yearning for a future utopian society. Many of their works aimed to rediscover the roots of Chinese civilization; others were allegories staged in the past or in remote geographical settings. Experimental artists were particularly historiographically self-conscious: recognizing how much they had "fallen behind" art history and theory, they rushed to bring themselves to the current stage of contemporary art by reliving a century of western art history in a few years. In contrast, experimental artists and filmmakers of the '90s were more "spatially" oriented, as they had secured their positions in the international art world, and as their art increasingly responded to the changes taking place around them, especially the transformation of the city and urban life. Different artists and filmmakers of course had different aspirations and developed different styles, but all of them were attracted to the notion of *contemporaneity*: they had to embody this notion to make their art new and exciting. To a large extent, their art is "experimental" because it is self-consciously "contemporary."

Contemporaneity (dangdai xing) differs from "contemporary art": it does not simply pertain to the prevailing styles and techniques here and now, but is an intentional construct of a particular

subjectivity. To achieve this construct an artist pushes everything before him into "history," and his method is to substantiate the present—an unmediated time in the common sense—with "contemporary" references, languages, and points of view. In the experimental art of the '90s, Chinese experimental art and cinema, the most common and immediate visual signifier of *contemporaneity* was the artists' adoption of art mediums, materials, and genres that were new to the Chinese art world. This also means that to realize their contemporaneity, these artists and filmmakers had to subvert established art mediums and genres, such as painting, sculpture, and conventional documentary and feature film. Historically speaking, this trend indicated a deepening stage of the Chinese experimental art movement. Experimental artists before the mid-80s, even the most radical ones such as the members of the Stars, still worked with conventional forms of painting and sculpture (FIGS. 3.2, 3.3). From the mid-80s and especially during the '90s, however, an increasing number of young artists abandoned their former training in traditional or western painting, or only made paintings privately to finance their more adventurous but less marketable art experiments. Installation and performance became two of the hottest art forms in contemporary Chinese art (FIG 3.1, 3.4-5). Experimental films of the '90s often deliberately abandoned the artistry and careful planning of earlier cinema; their general style as unscripted, spontaneous records of real life was related to their independent productions as well as the popularity of portable camcorders and digital technology.

On the surface, such a penchant for contemporary art mediums and visual techniques can be explained by the growing influence of western contemporary art and cinema in China. But a more essential reason for the popularity of installation, performance, and multi-media art must still be found in the fundamental purpose of the experimental art movement itself, which is to forge an independent field of art production, presentation, and criticism outside official art and academic art. Through denouncing conventional representational systems, experimental artists and filmmakers of the '90s effectively established an "outside" position for themselves, because what they rejected was not just a particular art form or medium, but an entirely new system, including education,

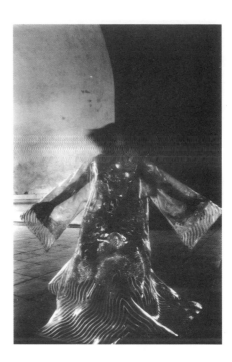

FIG. 3.1: WANG JIN, *A Chinese Dream*, PERFORMANCE AT THE MING ROYAL MAUSOLEUM OUTSIDE BEIJING, 1998.

FIG. 3.2: WANG KEPING, *Silence*, WOOD SCULPTURE, 1978.

FIG. 3.3: MAO LIZI, *Hesitating*, OIL ON CANVAS, UNDATED.

production, exhibition, publication, and employment. Such a break from the art establishment was sometimes related to an artist's political identity. But it could also be a relatively independent artistic decision, as these artists routinely found the new art forms both liberating and challenging, encouraging them to express themselves directly by using whatever means at their disposal. It is on this level of individual experimentation that the new art mediums and visual techniques not only signifed a general sense of contemporaneity, but also facilitated the creation of genuine and original artistic expressions.

FIG. 3.4: QIU ZHIJIE, *Assignment No. 1: Copying "Orchid Pavilion Preface" a Thousand Times,* PERFORMANCE, 1990-95.

FIG. 3.5: ZHU JINSHI, *Impermanence*, INSTALLATION AND PERFORMANCE, 1996.

EXPERIMENTAL ARTISTS OF THE '90S

China underwent a profound socioeconomic transformation during the two decades after the Cultural Revolution. Starting in the late '70s, a new generation of Chinese leaders initiated a series of reforms to develop a market economy, a more resilient social system, and an "open door" diplomatic policy that subjected China to foreign investments as well as cultural influences. The consequence of this transformation was fully felt in the '90s: major cities such as Beijing and Shanghai were completely reshaped. Numerous private and joint-venture businesses, including privately owned commercial art galleries appeared. Educated young men and women moved from job to job in pursuit of personal well-being, and a large "floating population" entered metropolitan centers from the countryside to look for work and better living conditions.

Many changes in the world of experimental art and cinema were related to this larger picture. Among these changes, two phenomena especially gave this world a different outlook in the '90s. First, although a majority of experimental artists received formal education in art colleges and had little problems finding jobs in the official art system, many of them chose to become freelance, "independent artists" (*duli yishujia*) with no institutional affiliations. The same situation was found in the field of experimental cinema: independent filmmakers appeared and were exemplified by the documentary filmmaker Wu Wenguang, who made "the first independent film in PRC" from 1989 to 1990 about four bohemian artists (FIG. 3.6). There were, of course, artists who still wished and even struggled to maintain their jobs in other public institutions. But toward the end they were often forced to give up such options because of their unconventional lifestyle and irregular travel schedules, if not because of their unorthodox artworks and approaches. To be "independent" also meant to become "professional"—a move which changed not only these artists' career paths but also their social status and self-perception. On the surface, freelance artists were free from institutional liabilities. But in actuality, to support their livelihood and art experiments they had to submit themselves to other kinds of liabilities and rules. It was in the '90s that experimental Chinese artists learned how to negotiate with art dealers and western curators, and how to obtain funding from foreign foundations to finance their works. Not a few of

them developed a double persona, supporting their "unsalable" experiments with money earned from selling paintings and photographs.

Second, starting from the late '80s and especially during the '90s, a large number of experimental artists immigrated from the provinces to major cultural centers, especially the country's capital Beijing. The result was a situation that differed markedly from the '80s: in the '85 Art New Wave, most "avant-garde" art clubs and societies emerged in the provinces and were active on the local level, while Beijing maintained its traditional position as the stronghold of official art and academic art. (Similarly, the powerhouse of the Fifth Generation films from 1983 to 1989 was the Xi'an Film Studio in Shanxi.) In the '90s, however, Beijing became the mecca of young experimental artists throughout the country. Local experimental communities, of course, still existed. In particular, artists in several large cities, including Guangzhou, Shanghai, Chengdu, Taiyuan, and Nanjing, formed close working relationships to produce interesting works. Other experimental artists continued their individual activities in Hangzhou, Changchun, Ji'nan, and Yangjiang. But Beijing emerged above all these places to become the unquestionable center of experimental art, mainly because it constantly attracted talented young artists from all over the country. These immigrant artists, mostly in their twenties, emerged after the '80s. To this new generation of experimental artists, the Cultural Revolution had become the remote past, and their works often responded to China's current transformation, not to its history and memory. They found such stimuli in Beijing, a city most sensitive to the social changes and political tensions of the '90s.

A direct consequence of these two changes was the emergence of residential communities of experimental artists, known as "artists' villages" (*huajia cun*). The first of such communities was located in Beijing's western suburbs, near the ruins of the former imperial park Yuanming Yuan (FIG. 3.7). Avant-garde poets and painters began to live there as early as the late '80s, but it was not until 1991 that the place became known as an artists' village. It attracted media attention in 1992, as reports of its bohemian residents stimulated much popular interest. Around the same time it was also "discovered" by art dealers and curators from Hong Kong and the West. The place established its reputation as the "window" into Chinese experimental art in 1993, after Fang Lijun, who was then living there, appeared in three large international exhibitions that year, including the *China's New Art, Post-89* in Hong Kong, *Chinese Avante-Garde Art* in Berlin, and the *45th Venice Biennale*.

FIG. 3.6: WU WENGUANG, *Bumming in Beijing: The Last Dreamers*, DOCUMEN-TARY FILM, 1990.

In a broader sense, the artists' community at Yuanming Yuan introduced a particular lifestyle and set up a model for later "villages," including the one in Songzhuang, east of Beijing. Located in rural settings, these communities are also close enough to downtown Beijing so they can maintain close ties with the outside world. The initial reason for artists to move into such places is mainly economical: it is cheap to buy or rent houses there and convert them into large studios and residences. But once a community has appeared it brings additional benefits to its members. First of all it generates a sense of comradeship: the residents share the identity of independent artist, and some of them are close friends who have known one other for a long time. Living in close proximity promises convenience for socialization and occasions for entertainment. Visitors, including important foreign curators and art dealers, can see works of a dozen or so artists in one day; there is no secret that such visits are crucial to obtaining global fame and financial gain. On the other hand, such possibilities necessarily imply social stratification: some of the artist-villagers are internationally renowned while others still struggle for basic living. Although artists in such a community are subjected to mutual influences (especially by those "successful" styles and subjects), they rarely form close groups based on common social or artistic causes. Such lack of shared commitment explains these communities' ambiguous artistic characteristics: while a "village" attracts a large number of experimental artists to a single location, it does not necessarily inspire new ways of thinking and expression.

To this general situation there was a noticeable exception: from 1992 to 1994, the so-called East Village (Dongcun) in Beijing became the base of a group of immigrant artists, who worked together closely and initiated a new trend in experimental art. Also unlike the communities at Yuanming Yuan and Songzhuang, the East Village artists developed a closer relationship with their environment—a polluted place filled with garbage and industrial waste—as they considered their moving into this place an act of self-exile. Bitter and poor, they were attracted by the "hellish" qualities of the village in contrast to the "heavenly" downtown Beijing. This contrast inspired them: all of their works during this period were energized by a kind of intensely repressed desire (FIG. 3.8). The significance of the East Village community also lies in its formation as a close alliance of performing artists and photographers, who inspired each other's work by serving as each other's audience. This alliance was later broken under the allure and pressure of commercialism: when photographs of "East Village performances" became valuable, an argument about their authorship turned old friends into enemies.

Whether in Beijing or in the provinces, experimental artists and filmmakers of the '90s were preoccupied with two interrelated issues, one about their participation in the international art scenes and the other concerning the "normalization" of experimental art in China. The second issue became increasingly urgent when tension grew between artists' international standing and their domestic status. Here once again we find a huge difference between the '80s and the '90s: '85 Art New Wave was predominately a domestic movement closely linked with China's internal situation at the time, but experimental artists of the '90s articulated their images and developed their characteristics in an international context. (The globalization of experimental cinema accrued

FIG. 3.7: ARTISTS IN A YUAN-MINGYUAN VILLAGE COURTYARD, PHOTO BY XU ZHIWEI, 1992.

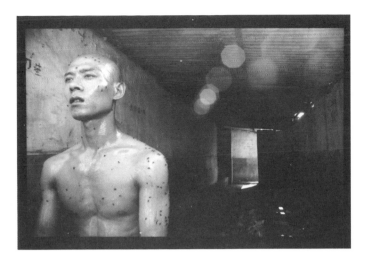

FIG. 3.8: ZHANG HUAN, *12 Square Meters*, performance, EAST VILLAGE, PHOTO BY RONG RONG, 1994.

earlier, as indicated by the international attention received by the Fifth Generation films from the mid-80s onward.)

At least four factors helped construct the global context of the experimental art of the '90s. First, even before Chinese experimental art attracted wide international attention, the diplomatic community in Beijing played an important role in supporting this art and spreading information about it. From 1992 to 1993, commercial galleries based in Hong Kong, Taiwan, and the West began to represent Mainland Chinese experimental artists. This channel of globalization was further strengthened when privately owned art galleries, often backed by foreign money and aimed at a foreign clientele, appeared in major Chinese cities. Also from the early '90s, some influential individuals and institutions in Hong Kong, Japan, and the West began to systematically collect Chinese experimental art; their interest encouraged the market of this art and directed international attention to experimental Chinese artists.

Second, from 1993 onward, experimental Chinese artists and filmmakers increasingly appeared in important international exhibitions and film festivals. Curators of these exhibitions and festivals made regular trips to China to discover new talents. Foreign media interest in Chinese experimental art also started from 1993, when cover articles in *Flash Art* and *The New York Times Magazine* introduced this art to a global audience.[15] While these early introductions to Chinese experimental art often presented this art as a post-Cold War curiosity in a Communist country, more serious research-oriented exhibitions and publications were attempted toward the later part of the decade. Generally speaking, the '90s were a crucial period in the history of Chinese experimental art, during which this art finally established its position as a vital component of international contemporary art. An important mechanism that enabled this advance was the network of biennales and triennials around the world, which regularly presented Chinese experimental art from 1993 onward. The *48th Venice Biennale*, held in the last year of the '90s, featured works by twenty Chinese artists, more than the combined number of American and Italian participants.

Third, a considerable number of experimental Chinese artists moved to Europe and America in the '90s, and some of them established international fame there. Their "success stories" had mixed responses in China: many artists (especially younger ones) admired them and took them as role models, but other artists and critics saw their successes as calculated results of a self-Orientalizing, hybrid identity. Regardless of these conflicting receptions, in the '90s this group of artists provided a crucial link between Chinese experimental art and international contemporary art, because no matter where they lived, to their global audience they were always "Chinese artists," and because their works owed

much to their experiences in China and consciously reflected upon their cultural origins (FIG. 3.9). Similarly, Chinese art critics and curators who immigrated to the West also helped bridge Chinese experimental art and international art. Although they wrote in English or French, they maintained close ties with artists and critics in China. It is significant to note that since the mid-90s, these scholars and curators have played an increasingly important role in introducing Chinese experimental art to the West, and have also returned to China to organize exhibitions there.

Finally, as for Chinese experimental artists, filmmakers, critics, and curators who decided to remain in China, they were also thoroughly "globalized." It would be a mistake to consider them "local" based on their residency. Throughout the '90s, they traveled frequently to various exhibitions and film festivals around the world, and dealt with foreign museums, foundations, galleries, curators, scholars, and visitors almost on a daily basis. Compared with experimental artists of the '80s, they were vastly more familiar with the international art scene—not just with fashionable names and styles but with the international art network and standardized practices. They had become, in fact, members of a global art community; but they decided to act locally.

FIG. 3.9: XU BING, *A Case Study of Transference*, PERFORMANCE AT HAN MO ART CENTER IN BEIJING, 1994.

In sharp contrast to their popularity among foreign curators and collectors, throughout the '90s Chinese experimental artists and filmmakers were still struggling for basic acceptance at home. Although books and magazines about avant-garde art were easy to find in bookstores, actual exhibitions of this art, especially those of installation, video art, computer art, and performance, were generally discouraged by the art establishment, including state-run art galleries and schools. Even worse, misunderstanding and antagonism caused frequent cancellations and early terminations of experimental art exhibitions. (Independent experimental filmmakers faced even greater difficulties because of the much stricter control of film production and showing. A large percentage of experimental films made since the mid-80s were banned in China or were shown only in controlled situations.) This reality led experimental artists and curators to consider the "normalization" of experimental art the most pressing issue they faced in China. In their effort to bring this art into the public sphere, exhibitions not only served as test cases for their legal rights, but also provided crucial means to realize their rights to practice experimental art.

A prevailing view among advocates of experimental art in the early and mid-90s was that this art could be legalized only when it could realize its economic potential. They therefore launched a campaign for this purpose. The most important event in this campaign was the *First Guangzhou Biennale* opened in October 1992, which showed more than four hundred works by three hundred and fifty artists. Sponsored by private entrepreneurs, the exhibition had the self-professed goal of establishing a market system for contemporary Chinese art. Two other exhibitions held in Beijing in 1996 and 1997, called *Reality: Present and Future* and *A Chinese Dream*, respectively, had the same general goal but served a more specific purpose to facilitate domestic auctions of experimental art. The fact that these two shows both took place in "semi-official" exhibition spaces—the Yanhuang Art Gallery and the Beijing International Art Palace—represented another new phenomenon in the '90s.

Through these and other exhibitions, "independent curators" (*duli cezhanren*) began to play the leading role in the "normalization" of experimental art. Usually not employed by official or commercial galleries, these individuals organized experimental art exhibitions primarily out of personal interest. Although they found their models in the curators of large international exhibitions, their main avocation was to develop experimental art in China. From the mid-90s, many exhibitions they organized indicated a new direction: these curators were no longer satisfied with just finding any available space—even a primary space such as the National Art Gallery—to put on an exhibition. Rather, many of them organized exhibitions for a larger purpose, which was to create regular exhibition channels and eventually a new "exhibition system" in China. To these curators, it became possible to pursue this goal because of the new conditions in their country. They believed that China's socioeconomic transformation had created and would continue to create new social sectors and spaces to be exploited for developing experimental art. Their campaigning of a new exhibition system involved multifaceted social experiments: working with official and semi-official museums to renew or revolutionize their programs, advising private companies and enterprises to support experimental art, and organizing exhibitions in various kinds of non-exhibition spaces—shopping malls, bars, abandoned factories, and the street. This last effort is especially significant because it resulted in a series of "experimental exhibitions," which aimed at inventing new forms, spaces, and dynamics for public showing of experimental art.

The effort to normalize experimental art, on the other hand, also brought an identity crisis to this art. When large and small exhibitions were organized to show experimental art to the public, some curators and artists began to voice their concerns about the danger of losing their alternative identity. In their view, excessive efforts to publicize experimental art would inevitably compromise its revolutionary spirit. While this rhetoric was not new, its actual consequence in China was worth noting: a counter-movement emerged in the late '90s to make private exhibitions more extreme and "difficult." The trend of using living animals and human corpses to make art emerged as part of this counter-movement: since these experiments would almost certainly be prohibited by the government and denounced by the public, they justified the necessity of closed exhibitions planned exclusively for "insiders" within the experimental art circle. A debate about the artistic merit and moral credibility of these extreme "experiments" divided experimental artists and curators into two camps. The Third Shanghai Biennale in 2000 further brought these two camps into a direct confrontation: one group of experimental artists and curators took this official exhibition as a decisive victory of their reformist agendas, while other curators and artists organized "alternative" exhibitions to counter it.

CODA: FRAMING THE DECADE

The Third Shanghai Biennale marked the end of Chinese experimental art of the '90s, just as the *China/Avant-garde* exhibition in 1989 brought a closure to the experimental Chinese art of the '80s. A brief comparison of these two exhibitions helps highlight many of the important changes that took place in the ten years between them.

China/Avant-garde was an unofficial exhibition resulting from a grassroots movement. It followed the logic of a mass movement action called *duoquan*—"taking over an official institution"—derived from the Cultural Revolution. The show was permeated with a kind of tragic heroism, as the long black carpets extending from the street to the exhibition hall bore the emblem of the show—a "No U-turn" traffic sign signaling "There is no turning back." The exhibition was a purely domestic event because it only featured works by Chinese artists. But, because most of these works were not new, the exhibition realized its "avant-garde" intent in posing itself as an extraordinary, collective "art happening." It was shut down three times by the authorities, but such disturbances only helped unite artists with different

intentions and stylistic identities, who found themselves in a single camp and shared the excitement of a social revolution. The common agendas of the exhibition, actually a collective social and artistic experiment, transcended any individual expressions.

The Third Shanghai Biennale also realized its significance by staging itself as a "historical event."[16] But the engineer of this event was a state-run institution, and the purpose of the event was for this institution to join the global club of "world-famous biennales and triennials."[17] This purpose determined not only the exhibition's content but also its curatorial method. Its content was international contemporary art represented by carefully selected examples. For the first time, experimental Chinese art was presented as an official representative in an international convention. Following a convention in organizing international biennales and triennials, the museum invited two independent curators to design the show. But because many compromises had to be made between these curators and the museum, no clear lines could be drawn between independent decisions and the government direction. The exhibition was a huge success for all parties involved, not only the museum and the curators but also the participating artists. But as I have stated earlier in this introduction, the most fundamental determinant of experimental art is its self-marginalization. Thus, although the Third Shanghai Biennale represented a new stage in the normalization of Chinese experimental art, to maintain its creativity this art must transcend the standard that the exhibition set up.

The First Guangzhou Triennial—*Reinterpretation: A Decade of Experimental Chinese Art (1990-2000)*—sets up a third model for a large exhibition of experimental art in China. On the one hand, although its curators are independent in status, their goal is not to take over an official space for a short period, but to initiate a long-term exhibition and research program of experimental art in a large public art museum, and for this purpose they must work closely with the museum's directors and staff members. On the other hand, although it derives its model from a large international contemporary art exhibition, it focuses on Chinese experimental art and hopes to lay a new basis in studying this art. Featuring the most significant works created in the ten years from 1990 to 2000, the exhibition's title also highlights the organizer's intention to provide a systematic interpretation of these works in their artistic, cultural, social, and political context. The fourteen essays in this section focus on various aspects of the experimental art of the '90s, from art mediums and genres to artists' changing status, and from broadening exhibition channels to overseas receptions. In so doing, these essays complement each other and together depict a larger picture of Chinese experiment art in this important decade.

Originally published in Wu Hung, Ed., *Reinterpretation: A Decade of Chinese Experimental Art (1990-2000)* (Guangzhou and Chicago: Guangdong Museum of Art and Art Media Resources, Ltd., 2002), 10-19.

THREE THEMES OF EXPERIMENTAL CHINESE ART IN THE '90S

*R*einterpretation: *A Decade of Experimental Chinese Art* (1990-2000)—the First Guangzhou Triennial organized by the Guangdong Art Museum—provides a comprehensive survey and attempts a systematic explanation of Chinese experimental art of the period. The three main themes of the exhibition—"Memory and Reality," "Self and Environment," and "Global and Local"—encompass most experimental works from that decade. This essay discusses some of the works under these themes.

MEMORY AND REALITY

*R*eflecting on China's historical experience, expressing collective and individual memories, and forging dialogues between the past and the present, experimental art works created in the '90s present important signposts for emerging individual subjectivity in Chinese art.

Some of these works, often large-scale performances, were undertaken at historical sites. The most prominent of these sites is the Great Wall, which attracted many experimental artists to conduct art projects there during the '90s. Whereas all these artists designed their works to communicate with the Wall—arguably the most important symbol of Chinese civilization and the modern Chinese nation—these works reflect different historical visions and artistic aspirations. For example, in 1990 Xu Bing carried out his *Ghosts Pounding the Wall (Guidaqiang)*. With a crew of students and local farmers, he labored for twenty-four days to make ink rubbings from a thirty-meter-long section of the wall. The project was conceived as a grand performance: the crewmembers wore uniforms printed with Xu Bing's "nonsense" characters, and each stage of the project was recorded on film and video. When the rubbings are assembled into an installation for exhibition, the audience members find themselves encountering a paper Great Wall, which transforms the solid national monument into its volumeless shadow. Zheng Lianjie, on the other hand, transformed the Great Wall itself into a spectacular work of

art. Also assisted by local farmers, he used red cloth to tie tens of thousands of bricks broken off from the Wall, for the project he entitled *Binding Lost Souls: Huge Explosion* (FIG. 4.1). The message is two-fold: on the one hand, the artist planned the project as a shamanistic performance to heal the historical wounds of the old Wall, with each of the broken bricks standing for a "lost soul." On the other hand, with its enormous scale and stunning visual effect, his site-specific installation reinforces the glory and mythology of the Great Wall, which to Zheng continues to symbolize China and its future.

FIG. 4.1: ZHENG LIANJIE, *Binding Lost Souls: Huge Explosion*, PERFORMANCE AND SITE-SPECIFIC INSTALLATION, GREAT WALL, BEIJING, 1993

Deconstructing historical authority is also the purpose of Chen Xinmao's and Qiu Zhijie's works in this exhibition. Chen Xinmao's *Historical Text: Blurred Printing Series* features incomplete and partially smeared woodblock prints, the results of deliberate misprinting. The blurred images appear fragmented, as ruins or traces of some canonical books from the past. The ambiguity between textual and visual expression is heightened by the contradictory use of the ink, both to reproduce texts and to make texts illegible, sometimes even burying characters under richly-textured, spreading blots. Qiu Zhijie's *Assignment No. 1: Copying "Orchid Pavilion Preface" a Thousand Times* can be seen as a postmodern deconstruction of traditional Chinese calligraphy, an art form linked to China's unique cultural heritage. For three years from 1992 to 1995 he kept writing "The Orchid Pavilion Preface," the most celebrated masterpiece of Chinese calligraphy, over and over on a single piece of paper, and continued to write on it even after the entire paper was pitch black with ink. Traditional calligraphic training is based on the repetitive copying of historical masterpieces, and "The Orchid Pavilion Preface" has served as a primary model for this practice. By making "repetition" ("remembering" in a broader sense) the subject of his art project, however, Qiu Zhijie rejected the conventional purpose of this calligraphic practice.

In contrast to these sweeping philosophical contemplations on China's nationhood and cultural origins, some experimental works created in the '90s resurrect dark, painful memories from the country's past. Wang Youshen's *Washing: The Mass Grave at Datong in 1941* (FIG. 4.2) remains one of the most poignant examples in this genre. In this installation, the newspaper pages on the wall report the discovery of the pit: the discoverers found the remains of tens of thousands of Chinese who were buried alive by Japanese soldiers during World War II. Below the wall, photographic images of the unearthed human remains were placed in two large basins under circulating water. "The water washes the image away," the artist explains, "just as time has washed people's memories clear of this atrocity that occurred fifty years ago."[1] The vulnerability of printed images—and hence the impermanence of the history and memory that they represent and preserve—is a central theme in works by Wang Youshen and other experimental artists such as Zhang Xiaogang. In some paintings that Zhang Xiaogang created in the early '90s, an infant child lies before a dark background comprised of eroded and scratched archival photographs, which, as physical remains of the past, have also become symbols of historical memory itself.

Zhang Xiaogang's paintings, whether the earlier *Red Characters* or the later *The Big Family*, are always invested with his memories of the Cultural Revolution (FIG. 4.3). Indeed, as mentioned in the introduction to Part One in this catalogue, even in the '90s, the Cultural Revolution continued to stimulate experimental artists to create original works, but their different memories of the Cultural Revolution explain the differences between their works. Some artists, such as Ye Yongqing and Zhou Tiehai, evoked the image of Big Character Posters to encapsulate that bygone era. Other artists, such as Liu Dahong and Yang Jiechang, resurrected communist heroes and heroines but turned them into characters of highly individualized narratives. Memories of the Cultural Revolution also inspired symbolic representations of political power, such as Ma Xuhui's *Patriarch*, Geng Jianyi's *Hole*, and Zhang Hongtu's *Studs* (FIG. 4.4). The last work imitates the shiny red door of an imperial gate in the Forbidden City. According to the artist, a door like this has had an overwhelming significance in China because it simultaneously exhibits and conceals political power. Both functions help the power-holder control Chinese people. Iconoclastic in essence, his gate mocks this political philosophy: in the place of glamorous, golden bosses on an imperial gate are ugly metal rivets, like rows of phalluses in various degrees of impotence.

FIG. 4.2: WANG YOUSHEN, *Washing: The Mass Grave at Datong in 1941*, MIXED MEDIA INSTALLATION, 1995.

Zhang Hongtu is one of the experimental Chinese artists who combined their memories of the Cultural Revolution with a pop art style. The result of this collective exercise was the appearance of Political Pop (*zhengzhi popu*) in the early '90s. Generally speaking, Political Pop signaled a deepening

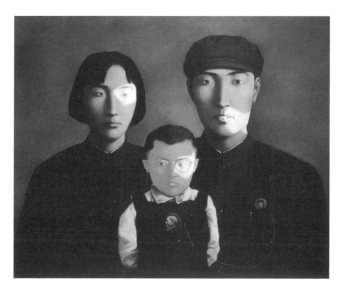

FIG. 4.3: ZHANG XIAOGANG, *The Big Family*, OIL ON CANVAS, 1994.

stage of deconstructing a previous political visual culture. Unlike painters of "scar art" (*shanghen meishu*) in the '80s, Political Pop artists had no interest in depicting tragic events from previous decades. Rather, they derived specific visual references from the Cultural Revolution but erased their original political significance. A typical method of realizing this goal was to distort the references and to juxtapose them with signs from heterogeneous sources: commercial trademarks and advertisements (Wang Guangyi), textile patterns (Yu Youhan), sexual symbols (Li Shan), and computer images (Feng Mengbo). As an important trend in the experimental Chinese art of the '90s, Political Pop brought Post-Cultural Revolutionary art to an end: its radical fragmentation of Cultural Revolution images finally exhausted the source of its pictorial vocabulary and reduced it to a number of pre-conceived compositional formulas. This interpretation corrects a misunderstanding often found in western introductions to contemporary Chinese

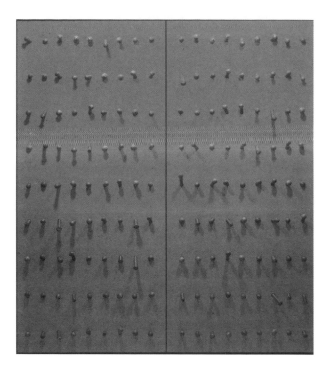

FIG. 4.4: ZHANG HONGTU, *Studs*, INSTALLATION, 1992/2002.

art, which identify Political Pop as a "dissident" political art under a Communist regime. In fact, most Political Pop artists were protesting against any ideological and political commitment; their intention was to de-politicize political symbols, not to reinvest them with new political meaning. Genuine social and cultural criticism did exist in Chinese experimental art in the '90s, but it was related to artists' observation and representation of reality, not history.

Reality, however, can never be separated entirely from history, and what links the present to the past are often personal memories. Looked at from this angle, Chinese experimental artists of the '90s demonstrated an unmistakable interest in forging such "memory links" through their works. Hai Bo, for example, customarily juxtaposes two photographs taken several decades apart. The first, an old group photo, shows young men or women in Maoist or army uniforms; their young faces glow with their unyielding belief in the Communist faith. The second picture, taken by Hao Bo himself, shows the same group of people—or, in some cases, the surviving members—twenty or thirty years later. In an almost graphic manner, the two images register the passage of time and stir up viewers' recollections of certain moments in their own lives. Differing from these photographs that frame a temporal duration with a beginning and an end, the subject of Wang Gongxin's *Old Stool* is time itself. This succinct video installation consists of only a small black-and-white video screen attached to an old-fashioned wooden stool. The single image on the screen is a moving index finger. Scratching the stool's worn surface, the finger's motion alludes to the movement of time, leaving its traces on furniture.

Wang Gongxin's work is allegorical, but other representations of the passage of time in the experimental art of the '90s have more concrete subjects, sometimes biographical in intent. An outstanding example in this group is the installation *Women/Here* by Sui Jianguo, Zhan Wang, and Yu

46

Fan. The creation of this work, actually an "experimental exhibition" in its own right, responded to an important event: the Fourth International Women's Congress held in Beijing in 1995. Although many leaders of women's movements around the world traveled to China to participate in the event, they were largely kept separate from Chinese people. The three artists' answer was to hold a different "congress" in the form of an art exhibition, which would create an alternative space where, in their words, "an ordinary Chinese woman could become part of the international event and the contemporary movement of women's liberation."[2] What they did was to make their mothers the "artists" in the exhibition, while reducing their own roles to that of an editor of readymade materials, mostly their mothers' private belongings and personal mementos. Compiled into chronological sequences and displayed in a public space, these fragmentary materials told the lives of three Chinese women, unknown to most people beyond their families and work units.

Women/Here demonstrated that by the mid-90s, Chinese experimental artists had largely freed themselves from the baggage of the Cultural Revolution. Their art now directly and forcefully responded to contemporary issues in Chinese society. Indeed, a close examination of Chinese art from the late '80s to the early '90s shows a steady increase in representations of contemporary subjects. But before 1993, the two art forms that were most sensitive to this change remained photography and oil painting. (After 1993, performance, installation, digital imaging, and video became increasingly prevalent.) A whole generation of independent photographers emerged in the late '80s and early '90s. Reacting against the doctrine of socialist realism, they took it as their mission to represent real Chinese people, often the nameless and injured. Zhang Haier's portrayals of urban prostitutes are among the earliest examples of this genre. Yuan Dongping photographed patients in many mental asylums around China. Taken from eye level and deliberately unpolished, these pictures convey social criticism in a photojournalistic style. Liu Zheng's *My Countrymen* (FIG. 4.5), on the other hand, resulted from a further development of this tradition in the late '90s. Although his subjects are again "stigmatized" people—disabled and impaired, old and sick, homosexual and transsexual, beggars and wanderers—he abandoned the earlier informal journalistic approach in favor of technical perfection and visual monumentality.

In the field of oil painting, a turning point was the "New Generation" (*Xinshengdai*) exhibition, held in 1991 at the Museum of Chinese History next to Tiananmen Square. Artists in the exhibition included Liu Xiaodong, Yu Hong, Song Yonghong, and Wang Jinsong, all presented in this catalogue (FIGS. 4.6-4.8). The brightest products of China's best art colleges in the early '90s, these young painters still hoped to represent the "spirit" of their time; what distinguished them from orthodox socialist realists was their specific understanding of this spirit. Instead of depicting revolutionary masses and a broad historical drama, they developed a penchant for representing fragmentary and trivial urban life. Their works reject grand narrative and symbolism, but are devoted to seemingly meaningless scenes they found around them: beauticians with exaggerated fake smiles, lonely men and women in a sleeping car on a train, a group of yuppies taking a picture in front of Tiananmen.

They claimed that their paintings were devoid of deep meaning because life itself no longer had deep meaning. It may be said that *superficiality* has become the real

FIG. 4.5: LIU ZHENG, *My Countrymen: Young Itinerant Rural Performers*, PHOTOGRAPH, WUTAI MOUNTAIN, SHAANXI, 1998.

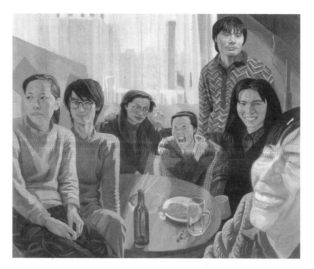

FIG. 4.6: LIU XIAODONG, *Joke*, OIL ON CANVAS, 1991.

subject of New Generation art. The painted scenes—beauty salons, escalators, night markets—are the most common "surface" phenomena in a metropolis. These scenes are selected for depiction not because they are part of reality but because they best signify the concept of the superficial, which is also understood in terms of emotion and mood. New Generation paintings neither represent nor demand strong feelings like love or hate. Some of them are lightly humorous or affectionate; others carry darker connotations of resentment or indifference. The boundary between New Generation painting and Cynical Realism is thus a blurry one. In fact, although Cynical Realism is much better known in the West, it was actually a branch of New Generation painting in the early '90s. Cynical realist artists like Fang Lijun and Liu Wei have the same educational background and paint in a similar painting style as New Generation artists, but are distinguished by their self-identification as *liumang* (rogues) and their attitude of malaise.

The impact of New Generation painting is strongly felt in Chinese experimental art created in the middle and late '90s, which continued to represent contemporary social life but often in a more exaggerated or distorted manner. The oil painter Zeng Hao, for example, depicts well-dressed young professionals and their material possessions as toy figures and furniture; the figures' miniature forms heighten the sense of dislocation and objectification. Yang Fudong's comic portrayal of *The*

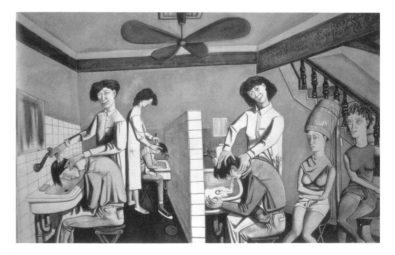

FIG. 4.7: SONG YONGHONG, *Professional Smile*, OIL ON CANVAS, 1993.

First Intellectual likewise comments on the vulnerability and insecurity of the emerging generation of yuppies—a byproduct of China's social and economic reforms. Wang Xingwei's *Again Not the Perfect Score* explores the illogicality of the visual culture of today's well-to-do Chinese. The Sichuan performance artist Luo Zidan conducted many projects amidst actual urban spaces. The subject of his *Half White Collar, Half Blue Collar* is people's confusion about their identities as they try to fit in the new socioeconomic system.

Staged on Chengdu's street, this performance enabled Luo Zidan to interact with his audience in the open. Indeed, the increasing popularity of performance among experimental artists in the '90s was to a large extent related to the artists' desire to engage in public issues and with the public itself. In their search for new visual languages to further such engagement, they found in the art of performance endless possibilities to interact with society directly and unambiguously. A forerunner of such experiments is Wang Jin, who conducted a series of powerful performances from 1993 onward to address public issues. One group of these performances, including *Red Flag Canal* and *Beijing-Kowloon*, focused on the relationship between past and present in modern Chinese history. Another group responded to the rapidly growing capitalist economy in China. *Knocking at the Door* in 1993, for example, consisted of seven old bricks from the walls of the Forbidden City, each bearing on its uneven surface a supra-realistic depiction of an American currency note. Over the following years, Wang Jin continued to paint such "cash bricks" and used them to "restore" damaged sections of the palace wall. Other projects in this group expressed, again in ironical forms, the growing material "desire" in contemporary Chinese society. For example, a new catchword in colloquial language for "making a fast buck" is "stir-frying money" (*chao qian*). Making the verbal expression literal, in 1995 Wang Jin rented a space in a night market in central Beijing and set up a food stand. With all the aplomb of a master chef, he fried a wok full of coins for his customers. The action project was called *Quick Stir-frying Renminbi*.

SELF AND ENVIRONMENT

Among all branches of contemporary Chinese art in the '90s, experimental art most sensitively responded to drastic changes in the environment—the vanishing of traditional landscapes and lifestyles, the rise of postmodern cities and new urban cultures, and the large-scale immigration of populations. This art also most sensitively responded to changes in the artist's livelihood and social role: during this period, a large number of experimental artists moved from the provinces to major

FIG. 4.8: WANG JINSONG, *In Front of Tiananmen*, OIL ON CANVAS, 1991.

49

cosmopolitan centers, where they reinvented themselves as independent artists working for international exhibitions and a global art market. Not coincidentally, these artists were intensely concerned with their identities; their own images became a constant subject of their work. The result was a large group of self-representations in all forms of visual art—painting, photography, performance, installation, and video. Taken together, these works reflect an urgent quest for individuality in a transforming society.

Underlying the heightened interest in representing the environment and the artist's self was a "generational shift" in experimental art. Most artists who favored these subjects came to the forefront in the early and mid '90s. Many of them started from the initiatives of the New Generation artists, but their more active engagement with social issues led them to abandon the impassionate pictorial realism of New Generation painting. Their works, often taking the forms of installation, performance, and photography, document their direct and sometimes aggressive interaction with China's current transformation. An important aspect of this transformation, one that attracted much of their attention, was the rapid development of the city. A striking aspect of a major Chinese metropolis like Beijing or Shanghai in the '90s was a never-ending destruction and construction: the forest of cranes and scaffolding, the roaring sound of bulldozers, the dust and mud. Old houses were coming down everyday to make room for new hotels and shopping malls. Thousands and thousands of people were relocated from the inner city to the outskirts. In theory, demolition and relocation were conditions for the capital's modernization. In actuality, these conditions brought about a growing alienation between the city and its residents: they no longer belonged to one another.

FIG. 4.9: RONG RONG, *Untitled No. 1*, PHOTOGRAPH, 1996.

This situation is the context *and* the content of many works in the experimental art of the '90s. Zhan Wang's *Temptation*, for example, is about the disappearance of the human subject—a basic phenomenon associated with any form of demolition and dislocation. The installation consists of a group of "human shells" made of clothes and glue. The extremely contorted gesture of each torso gives the impression of passion, pain, torture, and a life-and-death struggle. But there is neither a subject struggling nor an object to struggle against. Empty and suspended, these human forms are created not as self-contained sculptures, but as individual "signs" of desire and loss that have the infinite potential to be installed in different environments. A specific location is what gives specific meaning to the general signification of these manufactured forms. Suspended on scaffolding, they gain a heightened instability and anxiety. Placed on the ground, they are associated with dirt and evoke the notion of death. The most dramatic installation is to scatter these hollowed mannequins in a demolition site. Both the ruined houses and the mannequins testify to a fascination with torn and broken forms and a shared

attraction to destruction and injury, although it is by no means clear what is actually wounded other than the buildings and the empty shells themselves.

Rong Rong's photographs of Beijing's demolition sites are also devoid of human figures, but he has filled the vacancy with images left in the half-destroyed houses. They originally decorated an interior but which has now become the exterior. A pair of dragons probably indicates a former restaurant; a Chinese New Year painting suggests a similarly traditional taste. The majority of such "leftover" images are various pin-ups from Marilyn Monroe to Hong Kong fashion models (FIG. 4.9). Torn and even missing a large portion of the composition, these images still exercise their alluring power over the spectator—not only with their seductive figures but also with their seductive spatial illusionism. With an enhanced three-dimensionality and abundant mirrors and painting-within-paintings, they transform a plain wall into a space of fantasy. These works can be viewed together with photographs by Zhang Dali, the most famous graffiti artist in China, who developed a personal "dialogue" with Beijing through his art. From 1995 to 1998, Zhang Dali sprayed more than two thousand images of himself—the profile of a shaven head—all over the city, often in half-destroyed, empty houses. He thus transformed these urban ruins into sites of public art, however temporarily. The locations he chose for his performance and photography projects often highlight three kinds of comparisons. The first kind contrasts a demolition site with an official monument. The second contrasts abandoned residential houses with preserved imperial palaces. The third contrasts destruction with construction: rising from the debris of ruined houses are glimmering high-rises of a monotonous, international style.

Zhang Dali's interest, therefore, lies not simply in representing demolition, but in revealing the different fate of demolished residential houses from buildings that are revered, preserved, and constructed. His photographs thus serve as a bridge from Rong Rong's "urban ruin" pictures to another popular subject of the experimental art of the '90s: representations of the emerging cityscape. Ni Weihua's *Linear Metropolis*, for example, registers the artist's fascination with the intricate, abstract patterns of new types of buildings and roads—patterns that stimulate sensations never before experienced in Chinese visual culture. The new Chinese city seems deliberately to rebel against its predecessor: whereas a traditional Chinese city has the typical, orderly image of a chessboard-like space concealed inside a walled enclosure, the new city is sprawling yet three-dimensional, fast and noisy, chaotic and aggressive. It refuses to stay quiet as a passive object of aesthetic appreciation, but rather demands the artist's participation to capture its vitality. Whereas Ni Weihua interacted with this city through his excited gaze, Zhao Bandi enriched the city's image with his "public welfare" art, and Lin Yilin and Liang Juhui—two members of Guangzhou's experimental group Big-tailed Elephant—made their art part of the city's very movement. Lin Yilin conducted his 1995 performance *Safely Crossing the Linhe Road* (FIG. 4.10) on one of the busiest streets in

FIG. 4.10: LIN YILIN, *Safely Crossing Linhe Road*, PERFORMANCE, GUANGZHOU, 1995.

Guangzhou. He first built a freestanding brick wall on one side of the street, and then took away bricks one by one from the wall to build a second wall next to the first. He continued this process many times, until the wall "moved" to the other side of the street. While simulating simultaneous construction and destruction, this performance interrupted Guangzhou's traffic, and hence posed itself as an integral feature—and problem—of the city. Liang Juhui also synchronized his performance *One-Hour's Game* with the city's movement, but moved vertically instead of horizontally: he played computer games for a whole hour in an exposed elevator of a future high-rise.

The emerging city attracts experimental artists not only with its new buildings and roads but also with its changing population—an increasingly heterogeneous people living in an increasingly crowded place. To Chen Shaoqiong, another member of the Big-Tailed Elephant, a heterogeneous city resembles the stage of a plotless tableaux; what unites its characters is the place they share. This notion underlies his photographic installations collectively entitled *Streets* (FIG. 4.11), which are conceived and constructed exactly like a series of puppet theaters. Representing a street or square in Guangzhou, each installation consists of two detached layers: in front of a large panoramic photograph are cut-out miniatures—passersby, shoppers, and policemen amidst telephone booths, traffic lights, different kinds of vehicles, trees, and anything one finds along Guangzhou's streets. These images are crowded in a tight space but do not interact. The mass they form is nevertheless a fragmentary one, without order, narrative, or a visual focus.

Similarly, the Tianjin artist Mo Yi learned his city through studying its residents. This research started in the late '80s, after he was criticized for his "detached, lonely, and suspicious" images of Tianjin people, which the critic considered a reflection of the photographer's anti-social mentality. This criticism propelled him to conduct an experiment to eliminate his subjective intervention in photographing the city. Tying the camera behind his neck or hanging it behind his waist, he used an extension cord to take pictures on the street—he could therefore separate the camera lens from his gaze, and see what people and the city look like when they were not subjected to his eyes. The experiment grew into a multi-year project, producing a large group of random photographs that have acquired a unique anthropological significance. Most interestingly, these images record the gradual changes on people's faces over the years, from expressionless and apathetic to a measure of moderately relaxation and animation. Mo Yi has thus titled the series *Expressions of the Street* (FIG. 4.12).

There is no doubt that the experimental art of the '90s owes a great deal to the transformation of the city and the emergence of new urban spaces and lifestyles. The city also realized its impact on artists in a negative way: sometimes, the chaos and high pressure associated with urban life drove artists to

rediscover nature through their art. Thus, when Wang Jianwei made a video about continuous cycles of planting and harvesting crops, or when Song Dong tried to affix a seal on the surface of a river, they were not imitating ancient literati or Zen monks. Rather, these and other attempts to engage with nature all symbolize the artists' return to a different time and space—a departure from the time and place to which they actually belong.

The examples discussed above make it clear that experimental representations of the environment are inseparable from the artists' self-representations. Such a close interrelationship, in fact, sets experimental art apart from other branches of contemporary Chinese art. For example, although academic painters also depict landscape and urban scenes, they approach their subjects as belonging to an external, observed reality. Experimental artists, on the other hand, find meaning only from their interaction with the surrounding world. When they document such interaction they customarily make themselves the center of a photograph or video, as seen in Zhang Dali's *Dialogue* or Song Dong's *Water Seal*. Zhu Fadong's performance and video project *This Person Is for Sale* (FIG. 4.13) again exemplifies this representational formula. The video presents him as a member of the "floating population"—people who have left the countryside and entered large cities for jobs. It records the many trips Zhu Fadong took in Beijing during 1994: every morning he went out, with two lines written on his back: "This person is for sale; please discuss price in person." As we follow him, we travel all over Beijing: Tiananmen Square, a McDonald's restaurant, the National Art Gallery, Beijing University, the East Village of experimental artists, and a labor market where he mingled with other members of the floating population. This video thus brings a city, a population, and the artist into a single representation, but the artist remains at the center.

When we shift our focus to artists' self-images, we find four basic modes frequently employed by experimental artists in the '90s to represent themselves. The first is an "interactive" mode discussed a moment ago: the artist discovers or expresses himself or herself through interacting with the surroundings. The subject of interaction, however, includes not only the environment but also people, as seen in Zhuang Hui's *Group Portraits* and Chen Shaofeng's *Dialogue with Peasants of Tiangongsi Village*. Both works, the former a series of large-format photographs and the latter a huge assembly of oil portraits, are "preformatted" in nature. To Zhuang Hui, taking a group picture of an entire crew of 495 construction workers, or of the 600-strong employees of a department store, requires patient negotiation as well as skilled orchestration. Such interaction with his subjects is the real purpose of his art

FIG. 4.12: MO YI, *Expressions of the Street*, PHOTOGRAPH, 1988-1990.

experiment, whereas the photograph, in which he always appears way over to the side, merely certifies the project's completion. Chen Shaofeng developed a similar approach in conducting his interactive project: when he was painting portraits of more than three hundred men, women, and children from Tiangongsi village, he also invited his sitters to sketch him at the same time.

The second mode of self-representation discourages explicit depiction of individual likeness. Rather, artists express themselves through symbolic images and objects. Zhan Wang's *Temptation* discussed above is one such representation, as the hollowed "human shells" imply the artist's own disappearance. To Cai Jin, the image of the banana plant is deeply associated with her personal life and memory, and she has painted this image on canvases as well as on various objects. Yin Xiuzhen's *Suitcase* (FIG. 4.14) offers another outstanding example in this genre. Folding her old clothes and packing them into a suitcase of her own, she then seals the clothes with cement mortar. The performance is therefore a symbolic burial of her past symbolized by her "relics," now unseen underneath solid concrete. Cang Xin's performance *Trampling on the Face* takes a different form but conveys a similar sense of self-sacrifice: covering a courtyard with plaster masks made from his own face, he and his guests step on them and smash them into pieces.

At the opposite spectrum of these symbolic representations, the third mode demands an explicit display of the body, which the artist employs as an unambiguous vehicle for self-expression. This body art emerged in Beijing's East Village, where artists like Zhang Huan and Ma Liuming developed two types of performance characterized by masochism and gender reversal. Exemplifying the second type, Ma Liuming invented his female alter-ego, Fen-Ma Liuming, as the central character in his/her performances (FIG. 4.15). Masochism is a trademark of Zhang Huan's art: almost every performance he undertook involved self-mutilation and simulated self-sacrifice.

FIG. 4.13: ZHU FADONG, *This Person Is for Sale*, PERFORMANCE, BEIJING, 1994; VIDEO DOCUMENTATION COMPLETED IN 1998.

In some cases he offered his flesh and blood; in other cases he tried to experience death, either locking himself inside a coffin-like metal case or placing earthworms in his mouth. By subjecting himself to an unbearably filthy public toilet for a whole hour, he not only identified himself with the place but also embraced it. With the same spirit, Yan Lei photographed his beat-up face in 1995. Masochistic self-representation acquired an even more extreme form in the late '90s, as

represented by several works in *Infatuated with Injury*, a private experimental art exhibition held in 1999 in Beijing.

The fourth and last mode of self-imaging is that of self portraiture, which constitutes an important genre in the experimental art of the '90s. A common tendency among experimental artists, however, is a deliberate ambiguity in portraying their likeness, as if they felt that the best way to realize their individuality was through self-distortion and self-denial (FIG. 4.16). A particular strategy for this purpose—self-mockery—became popular in the early '90s, epitomized by Fang Lijun's skinhead youth with an enormous yawn on his face. A trademark of cynical realism, this image encapsulated a dilemma faced by Chinese youth in the post-89 period, and introduced what may be called an "iconography of self-mockery," which many experimental artists followed in the second half of the '90s. Another method of self-denial is "self-effacement": making one's own image blurry, fragmentary, or in the act of vanishing. Many works in the 1998 exhibition *It's Me* fall into this category. More than one third of the self-portraits by experimental artists in a recent publication, *Faces of 100 Artists*, also use this formula.[3] The same idea underlies Jin Feng's self-portrait in this catalogue, entitled *The Process in Which My Image Disappears No.2* (FIG. 4.17). It shows the artist writing *en face* on a glass panel; as his handwriting gradually covers the panel, it also blurs and finally erases his image.

FIG. 4.14: YIN XIUZHEN, *Suitcase*, PERFORMANCE AND INSTALLATION, 1995.

GLOBAL AND LOCAL

The dialogue between global and local was one of the most powerful driving forces for the development of Chinese experimental art in the '90s: it stimulated experimental artists to explore their self-identity, to expand their visual vocabulary, to make Chinese concepts and forms part of global contemporary art, and to recontextualize international art trends amid domestic concerns. My essay "A Decade of Experimental Chinese Art" in this volume has explained the political, socioeconomical, and intellectual context of this dialogue; the present discussion focuses on its impact on the content and form of artistic expression.

Globalization of Chinese art did not start from the '90s, of course. But for a long time it was equated with the Westernization of Chinese art. From the early twentieth century onward, many Chinese artists abandoned the traditional Chinese brush. Some traveled abroad to study Western oil painting and sculpture first hand, but those who remained home also had ample opportunities to learn

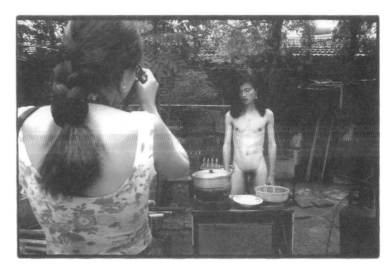

FIG. 4.15: MA LIUMING, *Fen. Ma Liuming's Lunch*, performance, 1994, PHOTO-GRAPH BY RONG RONG.

foreign art forms and techniques. The establishment of the People's Republic of China did not stop this historical process, but restricted the model of academic learning to social realist art of the Soviet Union. For more than three decades this particular "Western" style dominated contemporary Chinese art, but it became history after experimental art grew into a national movement through the '85 Art New Wave. Participants in this movement embraced all brands of modern western art developed outside the canon of realism (including, for example, surrealism, dadaism, abstract expressionism, conceptual art, body art, and pop art). More importantly, they began to bridge the gap between eastern and western art, which had existed as a fundamental conceptual framework in which artists and historians envisioned modern Chinese art. Although the dominant influence of the '85 Art New Wave came from the West, it gave experimental Chinese artists the freedom to discover their own potential. Some of the best-known works from this period, such as Xu Bing's *Book from the Sky* and Wenda Gu's pseudo calligraphy, employ traditional Chinese idioms but reject their conventional meaning. No one disagrees that these are among the most original works of global contemporary art of the '80s, even though they were made in China by artists who had never been abroad (several years after creating these works, the two artists immigrated to the West).

FIG. 4.16: LIN TIANMIAO, *Plait/Braid*, VIDEO INSTALLATION, 1999.

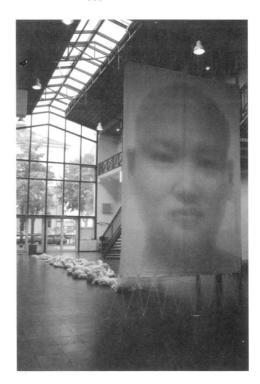

The identity of Chinese experimental art has long been a contested issue. It is routinely caricatured by official Chinese critics as a local imitation of "decadent western contemporary art." Within the pro-experimental art camp, some critics have divided experimental artists into two groups based on where they live. Taking a nationalist stand, they have coined the nickname "banana people" (i.e., people who have

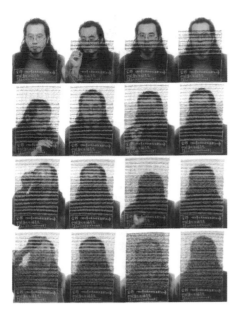

FIG. 4.17: JIN FENG, *The Process in Which My Image Disappears No. 2*, PHOTOGRAPH, 1998.

yellow skin but are "white" inside) for those artists who have immigrated to the West and gained fame there. Many western critics tend to emphasize the relevance of Chinese experimental art to China's internal politics. Even though the art itself has transcended the East-West or global-local dichotomy, such views continue to inform discourse on the subject in different ways. Some critics based in Southeast Asia and Australia have tried to link Chinese experimental art to transnational phenomena such as the Chinese diaspora, but in so doing have often treated this art merely as a social movement.

There is no question that Chinese experimental art is related to all of these—post-Cold War politics, global commercialization, and the diaspora—but the kind of reinterpretation pursued in this exhibition and catalogue is, first of all, an art historical one. To return to the '85 Art New Wave, this domestic movement makes it clear that from its beginning, Chinese experimental art was a branch of global contemporary art—an identity determined not by where artists live but by the concepts and forms of their works and by their intended audience. On the other hand, this movement also makes it clear that being global does not exclude experimental Chinese artists from remaining local; the question is how they can internalize these two geo-cultural identities productively. The historical significance of the '85 Art New Wave lies not only in its bridging of East and West, but also in its initiation of numerous experiments that highlighted individual voices in global and local communication as a whole. The experimental art of the '90s developed against this background.

Four important developments in the '90s brought the global versus local dialogue in Chinese experimental art to a new level. First, experimental Chinese artists became regular participants in international exhibitions; many exhibitions of Chinese experimental art were also organized abroad.

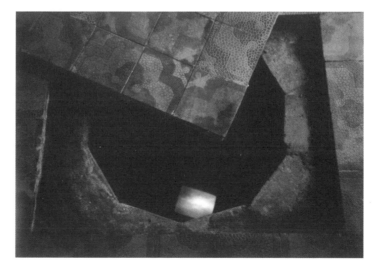

FIG. 4.18: WANG GONGXIN, *Brooklyn's Sky*, VIDEO INSTALLATION, BEIJING, 1995.

FIG. 4.19: CAI GUO-QIANG, *Bringing to Venice What Marco Polo Forgot*, PERFORMANCE, XLVI VENICE BIENNALE, 1995.

Second, promoted by transnational commercial galleries inside and outside of China, this art became a global commodity. Third, a considerable number of experimental Chinese artists immigrated to other countries; "domestic" artists also frequently traveled to foreign exhibitions and created works around the world. Fourth, toward the end of the decade, some official Chinese museums began to develop exhibition projects that framed Chinese experimental art as part of global contemporary art.

With these changes, the global/local relationship became a constant stimulus, resulting in works that reflected different ideas and approaches. Critics have often attributed such differences to an artist's place of residence, arguing that overseas artists and those who remained in China do not have the same self-identities and points of view. But the real situation is often much more complex: during the '90s, not only did so-called "local" artists spend increasing amounts of time abroad and deal directly with foreign institutions, curators, and audiences, "overseas" artists also made frequent trips back home to create and exhibit their works there. It is more plausible to assume that both groups of artists developed global and local dialogues in their works based on specific situations, not on the official

FIG. 4.20: HU YOUBEN, *Great Ink Image*, MIXED MEDIA INSTALLATION, 2000.

FIG. 4.21: ZHOU CHUNYA, *Taihu Rocks,* OIL ON CANVAS, 1999-2000.

place of residence written in their passports. *Therefore, instead of taking global and local as two external frames of classification, we should consider them as internal experiences and perspectives.* The key to understanding these artists and their works is to discover how such experiences and perspectives were negotiated through specific art forms invented at a specific time and place.

For this exhibition, Wang Gongxin has recreated his 1995 video installation *Brooklyn's Sky* (FIG. 4.18). Wang went to America in 1987 as a visiting artist at the State University of New York at Cortland and Albany, and afterwards took up residence at Brooklyn, New York. Starting from the early '90s, he and his wife, artist Lin Tianmiao, embarked on a nomadic lifestyle, traveling between Beijing, New York, and other international cities year-round, hoping to create art that would convey their experiences. *Brooklyn's Sky*, which resulted from this desire, was inspired by an American folk belief that if a person dug a deep enough hole, he would emerge on the other side of the world in China. However, since Wang Gongxin is Chinese, he started his fantastic journey from Beijing, by digging a well in his small apartment there. At the bottom of the well he installed a small video monitor. As if looking through a transparent window, the visitor could see on the screen a piece of sky—the sky above Wang Gongxin's Brooklyn home.

Personal experience also propelled Zhu Jinshi to create *Impermanence* in 1996. The materials used in this striking installation included fifty thousand sheets of *xuan* paper, a standard medium for traditional Chinese painting and calligraphy. Without leaving a single stroke on the sheets, however, Zhu wrinkled and stacked them into a spectacular fortress-like structure, with a narrow passageway to the interior. The intricate construction struck spectators as being both massive and fragile. When the exhibition ended, Zhu splattered ink on the sheets and burned them outside the exhibition hall. It is significant that the artist, who had immigrated to Germany in the early '90s, created this work twice in 1996 as two parts of a single project. He first installed the paper-fortress in Beijing's Contemporary Art Gallery and later repeated it in Berlin's Georg Kolbe Museum. The idea seems obvious: since the installation itself derives many elements from traditional Chinese art and philosophy, by creating it both inside and outside China the artist acquires an independent, transnational identity without losing sight of his own cultural heritage.

FIG. 4.22: AI WEIWEI, *Ming-Style Furniture*, WOOD, 1996-98.

59

FIG. 4.23: XU BING, *Square Word Calligraphy Classroom*, INSTALLATION AND PERFORMANCE, 1994-96.

Cai Guo-Qiang is another artist who has made the global/local dialogue a central theme of his art. His well-known contribution to the 1995 46thVenice Biennale, *Bringing to Venice What Marco Polo Forgot*, featured his arrival with bags of Chinese medicine in a sailboat at a theatrical setting, the Palazzo Giustinian Lolin, a seventeenth-century merchant's home (FIG. 4.19). The supposed starting point of his symbolic journey was Quanzhou, Cai's hometown in southeast China and, coincidentally, the port from which Marco Polo left China for Venice seven hundred years ago. Through this project Cai Guo-Qiang makes a powerful statement that he, an artist from China, is reversing the direction of the east-west traffic, and that what he brings to the West with him are not just goods and stories, but an "eastern view of the cosmos" that has escaped the attention of Western travelers. One should not take this as a nationalist, anti-Western approach, because Cai has staged similar performances in China to "bring things to" his native country. The ambitious *Extend the Great Wall of China by 10,000 Meters: Project for Extraterrestrial No. 10* is one such example. When Cai returned to China from Japan in 1993, he traveled along the Great Wall to its western limit. There, assisted by local people, he laid down a 10-kilometer-long fuse in the Gobi desert. Its simultaneous explosion created the spectacle of a "wall of fire," as if the Great Wall had suddenly come to life and grown to an unprecedented length.

Besides these performance-oriented projects imbued with the artists' transnational experiences, many works in experimental Chinese art of the '90s conduct global and local dialogues by juxtaposing visual signifiers—art motifs and mediums, objects in daily life, or written languages—from heterogeneous sources. Zhang Jianjun and Hu Youben both use traditional Chinese to make "anti-traditional" installations. Zhang Jianjun, who resides in New York, made his *Fog Inside* in 1992 in Warsaw. The work is minimalist in spirit—a large, flattened cylinder filled with ink-infused water. Although the form of the installation recalls a steel sculpture, the ink water inside generates a sense of impermanence that is reinforced by the steam that slowly rises from the liquid and dissipates. The subtle movement of the steam has a meditative quality, reflecting an organic and wholesome understanding of the cosmos that the artist finds in Chinese philosophy. Thousands of miles away in China's Hebei province, Hu Youben fashioned huge installations that show nothing but layered black paint on a wrinkled surface, negating not only painted images but also the concept of painting (FIG. 4.20).

Scholar's rocks and Ming-style furniture—two conventional symbols of traditional Chinese

culture—are given new meaning in Zhou Chunya's and Ai Weiwei's works. In a series of paintings, Zhou, a German-trained artist, depicts scholar's rocks as living things in various stages of transformation (FIG. 4.21). The animated quality of these images, enhanced by sculpted surfaces and fluid brushwork, owes its inspiration both to German Expressionism and to the traditional Chinese *xie yi* (inscribing the mind) style. Ai Weiwei, on the other hand, deconstructs actual Ming-style furniture in a Chinese way: with techniques derived from a traditional Chinese carpenter, he takes tables, chairs, and stools apart and reassembles them into dysfunctional, post-modern sculptures (FIG. 4.22). Wang Luyan has also found an iconic object for deconstruction, albeit from more recent Chinese history—the bicycle. Although China is still "the country of bicycles" to outsiders, contemporary Chinese citizens increasingly associate this vehicle with the Maoist era, when it provided billions of Chinese with the most basic means of transportation. This is perhaps why Wang Luyan often paints his remodeled bicycle red. But he does more to the bicycle than merely painting it: with two small wheels added to the rear axle, the vehicle becomes a work of conceptual art, moving backward when pedaled forward.

The Chinese written language offers experimental artists a special signifier for their cultural origin. Among these artists, Xu Bing and Wenda Gu have both continued their language-based experimentation since immigrating to America in the early '90s. Xu Bing's latest project, *Square Word Calligraphy*, involves the creation of a unique writing system that renders English in Chinese writing: using components of Chinese characters for English letters, he is able to transform an English word into what looks like a Chinese character. While his "square words" can be considered a perfect fusion of eastern and western cultures, Xu Bing's ultimate goal is to create a device that can be of real service to people—he hopes that his system will allow people to learn from one another while maintaining their own cultural heritage (FIG. 4.23). Thus, classrooms are set up at his exhibitions, complete with writing tables and tools, in which English speakers can practice Chinese calligraphy in English, and Chinese speakers can learn English by practicing Chinese calligraphy. By employing language-based signs, Wenda Gu executed many monumental projects in the '90s in pursuit of a universal symbolic system. His *United Nations*, a series of spectacular installations made of human hair—represents different peoples, nations and countries of the world. The global and local dialectic remains the central concept of these works, but the artist posits himself as a universal spokesman for all cultures in the world.

As demonstrated by these examples, many experimental Chinese artists are idealistic in attempting to mediate global/local perspectives and experiences; the assumption is that globalization, if freed from imperialistic and nationalist ambitions, can assimilate local creativities in a dynamic and

FIG. 4.24: HONG HAO, *World Maps*, SILKSCREEN PRINT, 1992-96.

FIG. 4.25: *Chess Match of the Century: Stone Stele*, OIL ON CANVAS, 1998.

productive way. This optimistic attitude, however, disappears in work that takes international power struggles as their subject, and problematizes globalization in this particular context. *World Maps*, a series of silkscreen prints created by Hong Hao from 1992 to 1996, is one such work (FIG. 4.24). The artist has cleverly created an optical illusion where each map has the appearance of the open leaves of a traditional Chinese thread-bound book. Each map reflects a pessimistic vision of the world: "The Division of Nuclear Arms Map" shows missiles stationed in every corner of the world, including Antarctica, which has been divided into segregated political territories. "The New World Order Map" changes the locations and shapes of different countries. "The New Geological World Map" switches sea and land. "The New Topographical World Map" alters the sizes of each country according to its military and economic power. "The Latest Practical World Map" renames cities with trendy expressions in popular culture and tosses economic charts around the earth. Fantastic and absurd, these pictures depict a world governed by violence and greed, a frightening image of the globe that the artist finds himself unable to escape.

If Hong Hao's pictures are satiric, Xu Jiang's images are tragic. His *Chess Match of the Century* depicts destroyed cities, broken monuments, and crumbling architectural spaces—products of human civilization that humanity itself has turned into ruins (FIG. 4.25). Floating over these scenes are the disembodied hands of two chess players. Cast in relief, the hands symbolize the competing historical forces behind the destruction of civilization. Starting in the late '80s, Xu began to use the game of Chinese chess to signify both tension and method. A chess match is motivated by the desire for control: behind a subtle, prolonged negotiation is a hunger for power and a determination to kill. A chess match is both spatial and temporal: it is never static, but consists of numerous movements on a geometric map. A chess match is both highly rational yet passionate: while following a set of rules, a player must manipulate these rules in order to win. For Xu Jiang, these are implications that make the game of chess an ideal metaphor for politics as well as for art.

Originally published in *Reinterpretation: A Decade of Chinese Experimental Art (1990-2000)* (Guangzhou and Chicago: Guangdong Museum of Art and Art Media Resources, Ltd., 2002), 142-45, 252-55, 396-99.

MEDIUM

REINVENTING BOOKS IN CONTEMPORARY CHINESE ART

"Read thousands of books, travel thousands of miles" (*Du wan juan shu, xing wan li lu*) is a much repeated literary expression by modern Chinese artists in describing two main sources of their creative inspiration. Originally formulated by the Song neo-Confucian scholar Liu Yi (1017-1086) as a general prerequisite for a cultivated gentleman, it became linked with artistic learning by the influential Ming painter and theoretician Dong Qichang (1555-1636). In his *Notes from the Painting-Meditation Studio (Huachanshi suibi)*, Dong claims that the most essential quality of a good painting, known as "animation through spiritual consonance" (*qiyun shengdong*), is endowed by heaven and cannot be acquired through human effort; what an artist can do is "read thousands of books, travel thousands of miles," because in doing so he will "transcend the dusty and polluted world. Hills and valleys will naturally emerge in his mind and instantly form beautiful scenery like those of Juan and E. Freely expressing this with a brush, his work will be able to transmit the spirit of natural landscape."[1] Elsewhere, Dong wrote: "Without reading thousands of books and traveling thousands of miles, how can one become an original painter?"[2]

It was not until the early twentieth century, however, that "Read thousands of books, travel thousands of miles" became an essential maxim among Chinese artists. The reason for this unexpected development lies in the renewed significance of the expression. Whereas traditionalists used it to express their commitment to literati ideals,[3] modernists such as Xu Beihong (1895-1953) and Liu Haisu (1896-1994) connected it with their global experiences. Liu cited the idiom in an essay he wrote after traveling to Switzerland in 1929.[4] Xu used it when giving advice to the young Fu Baoshi (1904-1965), who in 1931 was still struggling to find new ways of thinking about painting: "Your achievement in depicting landscape is already quite remarkable and you should have a bright future as an artist. I would suggest that you study abroad to broaden your views. Read thousands of books and travel thousand of miles—you will surely become a great painter."[5] Following this advice, Fu went to Japan two years later to study studio art and art history.

Two reasons have prompted me to begin this introduction with a reflection on "Read thou-

sands of books, travel thousands of miles." First, this popular expression demonstrates the extraordinary importance of the book to both traditional and modern Chinese artists. This importance can be explained from a number of perspectives. In terms of art criticism, throughout the history of Chinese painting, intellectual quality has remained a primary criterion in evaluating an artist's achievement. This quality cannot be acquired from artistic training alone, but has to be achieved through the artist's broad engagement with literature, philosophy, and history. Because books are principal sources of such knowledge, "reading" becomes mandatory to any artist unsatisfied with mere technical excellence.

In terms of artistic identity and practice, painters since the emergence of scholarly painting in the Han dynasty have always played multiple roles in cultural production, not only as visual artists but also as poets, essayists, playwrights, and calligraphers. Their works often combine images and texts, and are subjects of both viewing and reading. After literati painting became the mainstream expression of Chinese art after the Yuan dynasty, the artistic persona implied in this practice grew into a standard model for all educated artists to follow. Finally, in terms of formal characteristics, reading conventions, and viewing conventions, books and paintings have much in common. For example, two major formats of traditional painting—the handscroll and the album—are also used for writing and printing books, and there are abundant books accompanied by exquisite illustrations, sometimes designed by famous painters. As a result of all these factors, paintings and books have enjoyed a unique relationship in Chinese culture, a relationship which is so fundamental to the artist that it has transcended enormous changes in Chinese art over the past two thousand years.

Second, the continuous currency of the expression "Read thousands of books, travel thousands of miles" in the twentieth century indicates an important aspect of modern Chinese art, which is its intense negotiation with China's cultural heritage. Indeed, it can be said that this negotiation played the most crucial role in shaping modern Chinese art as an independent twentieth-century artistic phenomenon with its own intrinsic logic and patterns of development. It is a shared understanding among art historians that the Westernization movement in Chinese art did not eliminate traditional art, but rather drew traditional art into a constant dialogue with it. As Michael Sullivan has observed, "In spite of the artistic controversies that enlivened the twenties and thirties, Chinese artists on the whole avoided the violent oscillations between acceptance and rejection of the West that had shaken Japanese art since the Meiji restoration of 1868."[6] Many of these artists took the "West" and the "past" as two parallel sources of styles as well as ideas, from which they could draw useful elements for creating a new type of Chinese art.[7] As "Read thousands of books, travel thousands of miles" was reconnected with this trend of thinking, Dong Qichang's age-old teaching obtained a new, modern meaning.

A similar pattern has been found in contemporary Chinese art since the '80s: whereas the book maintains its importance to today's experimental artists,[8] its role in artistic creation has changed again. Most importantly, positioning themselves at the margin of mainstream Chinese culture, these artists have developed a complex love-hate relationship with the book. They recognize the bond connecting themselves with the book, but also attack the book for its manipulative power in politics and its banality in commercial culture. Moreover, contemporary art mediums, such as installation, video, and digital photography, have enabled these artists to "reinvent" books through a large number of book-related artistic experiments. The frequency of such projects during the past two decades is unparalleled in the world. Since these experiments betray no direct influence from western art, they provide important evidence for understanding distinct characteristics of contemporary Chinese art and strongly refute a criticism repeated by official Chinese critics and some Western critics that experimental Chinese art as a whole is "derivative" and lacks indigenous roots.

This exhibition offers the first serious examination of this aspect of contemporary Chinese

art. The more than thirty works in the show are selected from a large pool of examples and reflect a wide range of artistic experiments. The florescent forms and divergent thematic orientations of these works make one immediately aware of their originality. In fact, no two items in this show are alike. Some artists use books as readymade materials; others have created unique books either as independent art objects or as components of large installations. Some artists deduce abstract concepts from traditional books; others have refashioned books into diverse, contemporary forms. Organized in two broad sections, these works substantiate "contemporary Chinese art"—a general and vague concept—with specific, individualized meaning.

Subtitled "Reimagining Tradition," the first section of the exhibition includes works that reflect the artists' desires to engage the past in a contemporary dialogue. A number of these works derive essential elements from traditional Chinese books and painting/calligraphy albums—including format, reading or viewing conventions, and painting and printing styles and materials. Instead of continuing established traditions passively, however, the artists have self-consciously developed different strategies to problematize their relationships with China's cultural heritage. Deconstructing traditional forms in order to express new concepts and ideas is a common strategy. Thus, works in this section demonstrate a constant interaction between past and present, and between preservation and renovation.

The second section, "Negotiating History and Memory," relates more closely to the historical experiences of contemporary Chinese artists. Some works in this section are imbued with vivid personal memories of the Cultural Revolution; other works demonstrate a strong iconoclastic impulse, questioning the roles that books have played in standardized education and political propaganda. Several works in this section deal with urgent issues in today's world, including globalization, war, peace, and the relationship between East and West. This section also includes a site-specific project by the artist Qiu Zhijie. Surrounding a communal area outside the gallery spaces, it reminds the audience of the omnipresence of books in people's daily lives (FIG. 5.1).

Instead of analyzing these works as isolated examples, the rest of this introduction will situate them within the historical context of post-Cultural Revolution China and connect them with several large issues, including historical and cultural memory, the dialogue between past and present, East-West relationships, the artist's self-identity, and the pursuit of novel visual forms. Because these are among the most crucial and controversial issues in contemporary Chinese art, it is hoped that this discussion, as well as the artists' statements included in this catalogue, will contribute to a deepening understanding of this art as an important component of global contemporary art.

FIG. 5.1: QIU ZHIJIE, *Bookshelf No. 1,* PHOTOGRAPH INSTALLATION, 2004/2006.

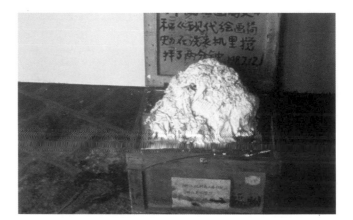

FIG. 5.2: HUANG YONG PING,
*"The History of Chinese Art" and
"A Concise History of Modern Art"
after Two Minutes in the Washing
Machine*, INSTALLATION, 1987.

A NEW BEGINNING

The year 1987 witnessed the creation of two seminal works of experimental Chinese art: Huang Yong Ping's *"The History of Chinese Art" and "A Concise History of Modern Art" after Two Minutes in the Washing Machine* (FIG. 5.2) and Xu Bing's *Book from the Sky* (FIG. 5.3). Both employing books as central components, these two projects emerged at the height of the '85 Art New Wave, the first major contemporary art movement in post-Cultural Revolution China.

The '85 Art New Wave surfaced partly as a reaction to the Sixth National Art Exhibition held in 1984, which led to a direct confrontation between official and unofficial positions. Artists whose works were rejected by the government-sponsored exhibition criticized the exhibition committee for its unfair selection process and went on to hold their own show entitled *Exhibition of the Works which Have Failed to Enter the Sixth National Art Exhibition*. Numerous unofficial art groups appeared spontaneously in 1985 and 1986: according to one statistic, more than eighty such groups appeared across twenty-three provinces and major cities during these two years.[9] The members of these groups were mostly in their twenties; a considerable number of them had just graduated from or were still studying in art schools. Compared with earlier unofficial artists such as the members of the Stars Art Society, this new generation of experimental artists were more knowledgeable of recent developments in Western art, and their opposition to official art was more radical, sometimes verging on iconoclasm. Their work, as well as their speech and writing, often consciously demonstrated an "avant-garde intent."[10] Following the mode of a *qunzhong yundong* (mass campaign), separate local groups soon joined together into a national network and began to envision a national exhibition of experimental art in the country's capital. But when the show, known in English as *China/Avant-garde*, finally took place in Beijing's National Art Gallery of China in 1989, it also marked the end of the '85 Art New Wave. Held in February that year, it anticipated the student demonstrations in Tiananmen Square two months later that would end in bloodshed.

When Xu Bing's *Book from the Sky* was shown in the National Art Gallery in October 1988, this enormous project was still only half completed; it was not until two years later that he would finish carving a total number of four thousand "fake characters" to print four hundred books of nonsense texts. The composition, printing, and binding techniques of these books were strictly traditional. In the 1988 exhibition, multiple copies of the books lay on the floor in rows; their open pages formed, at least to one viewer, "a kind of metaphysical landscape, similar to a Zen garden or to a vast and unlimited plain or the sea from a bird's eye view" (FIG. 5.3).[11] Large paper sheets printed with the same characters

FIG. 5.3: XU BING, *Book from the Sky*, INSTALLATION, NATIONAL ART GALLERY, BEIJING, 1988.

covered a wall and hung from the ceiling, constituting a visual environment for the "sea of books." While the vertical sheets on the wall reminded people of traditional hanging scrolls, the graceful curve of the suspended long strips evoked the movement of horizontal handscrolls. A fourth component of the installation consisted of two sets of the *Book from the Sky*, including individual volumes and a wooden case. Placed on low platforms made of solid timber, each set bestowed the installation with a visual focus and a feeling of solemnity, "as if it were an altar with relics, or a commemorative gravestone."[12]

In comparison, Huang Yong Ping's *"The History of Chinese Art" and "A Concise History of Modern Art" after Two Minutes in the Washing Machine* involved no such painstaking effort to create artistic objects; in fact, its purpose was to refuse any constructed system of knowledge by destroying the principal carrier of such knowledge—the book. Among the two volumes Huang machine-washed, the first was by the senior Chinese art historian Wang Bomin and had been used widely as a standard textbook in Chinese art schools; the second book, by American art historian Herbert Read, was well-known in the Chinese avant-garde circles in the '80s, partly because it was one of the few introductions to modern Western art available in Chinese translation at the time. Putting these two books through a two-minute wash cycle in a washing machine, Huang Yong Ping produced a pile of paper pulp—the remains of the books—which he then displayed on a broken glass panel atop a used wooden box. According to him, this was his response to an enigmatic question that had preoccupied generations of modern Chinese intellectuals and artists: how to position oneself between tradition and modernity and between East and West? Instead of providing another idealistic solution, Huang's installation challenges the premise of the question by eliminating the binary concepts. The paper pulp, as the joined remains of the two books, can be considered an art product that erases the conventional dichotomy between tradition and modernity, and between East and West.

Since their first exhibitions in 1988 and 1989, these two works have attracted wide attention both in China and abroad. Art critics now generally consider them among the most important examples of contemporary art from the '90s, not just in China but also in the world. Pablo J. Rico, for example, wrote in 2004 about the *Book from the Sky*: "a work which, following several presentations in China, Japan and the United States, was eventually exhibited at the 45th Venice Biennale (1993) to critical acclaim, bringing Xu Bing widespread recognition as one of the most singular artists of his generation."[13] As for Huang Yong Ping's installation, Fei Dawei recently claimed that "it is not only a

milestone in contemporary Chinese art but also a rare international contemporary art masterpiece."[14]

Few writers, however, have talked about a central element in these two works: the book. Why did Xu Bing spend years to make hundreds of elegant but unreadable volumes? Why did Huang Yong Ping choose two popular textbooks as the subject of destruction? An investigation of the two artists' careers shows that their interests in books were neither random nor coincidental, but were related to their personal experiences as well as their views of culture and society at large. Xu Bing recalled his childhood memory in an interview conducted for this exhibition:[15]

> My generation has a very awkward relationship with words and books. In my personal experience, for example, I grew up in a culturally rich environment because of my parents' employment. Both of my parents worked at Beijing University, so I spent a lot of time at the library there. Because they were often very busy, they would let me stay in the library stacks. I was very young at that time, though, and I couldn't read any of the books. I would just page through the reference books, for example, texts on bookbinding, calligraphy styles, typesetting, the history of books, etc. I would also look at the different ways in which books were bound. I became very familiar with the books' exteriors, although I didn't know any of their contents. By the time of the Cultural Revolution, I could read, but there weren't any books available. The entire country read only one book: Mao's "Little Red Book." We read and memorized that book all day. At the end of the Cultural Revolution, I returned from the countryside to Beijing to study. Because I was starving for culture and was in the midst of the general cultural fever at the time, I read so many different types of books. But after reading so much, I didn't feel well. It was like being overstuffed. It was at that time that I made the Book from the Sky. It's the very awkwardness of this relationship with books and words that drew my interest to this subject.[16]

Such a personal relationship with the book explains why so many of Xu Bing's projects have focused on this artifact—not only on text and script, but also on the form and materiality of the book. These works include *A, B, C...* (1991), *Post Testament* (1992), *Wu Street* (1993), *Cultural Animal* (1993-1994), *A Case Study of Transference* (1994), *Silkworm Books* (1994-1995) (FIG. 5.26), *An Introduction to Square Word Calligraphy* (1994), *Body Outside Body* (2000), and the many "books" in the *Tobacco Project* (2000-2004). Although each work has its specific purpose, a common tendency running through these projects can be summarized as a simultaneous destruction and construction of books. We can again trace this tendency to the *Book from the Sky*. While it violates a thousand-year-long Chinese literary convention by making the book incomprehensible, it also derived the means to enact this violation from the Chinese cultural tradition. These means—woodblock carving and book printing—mimic the formative process of Chinese literary culture, and in Xu Bing's art they become the primary sites of meaning.[17]

In Huang Yong Ping's case, *"The History of Chinese Art" and "A Concise History of Modern Art" after Two Minutes in the Washing Machine* was also one of his many book-related art projects dating from the '80s and '90s. This corpus of works started out from a project entitled *A Book Collection* in 1984. In that year, he traded one of his paintings with a foreign student for a copy of *The Story of Modern Art*. He then glued the book together page by page, "turning it into a brick in order to 'lock up' modern art history."[18] Thus, he had already developed a radical "anti-art history" attitude three years prior to *"The History of Chinese Art" and "A Concise History of Modern Art" after Two Minutes in the Washing Machine*. Approaching the history of art as a process of competition, control, and holocaust, he also found a basic means to counter this history of control by "containing" standard art historical books, either locking them up or washing them with water.

According to Huang Yong Ping himself, he made his first "book washing" project in early 1987 in his home in Xiamen: "I put the books from the bookshelves into the washing machine and switched it on, then put the entire pulp mixture back onto the shelves" (FIG. 5.4). While this experiment led to

FIG. 5.4: HUANG YONG PING,
A "Book Washing" Project,
PERFORMANCE, XIAMEN,
EARLY 1987.

23, 1987年. 在我家里,
我把书柜一书籍33分
没在机里搅拌, 之后
重新回到书柜, 厦门.

the creation of *"The History of Chinese Art" and "A Concise History of Modern Art" after Two Minutes in the Washing Machine* later that year, the latter project was again followed by *A Humid "Critique of Pure Reason"* in 1988, in which he washed Immanuel Kant's *Critique of Pure Reason* and *Book Cabinet.* After Huang immigrated to France in 1989, his large-scale performances and installations continued the "book washing" theme. These projects included *Reptile* (1989, Centre Georges Pompidou, Paris), *Should We Construct Another Cathedral?* (1991, Galerie Fenster, Frankfurt), *Unreadable Humanity* (1991, Carnegie International, Pittsburgh), *House of Oracles* (1992, Galerie Froment & Putman, Paris), *Library Canteen* (1992, Bibliothèque, Forney, Paris), *Kiosk* (1995), and *Floating Kiosk* (2000, Musée Moderne de la Ville de Paris). While all these projects featured the destruction of books as a symbolic gesture to subvert established systems, the decision to stage such destructions in prominent Western cultural institutions signified Huang's intensified desire to challenge the dominance of eurocentrism.

Although brief, this discussion of Xu Bing and Huang Yong Ping's book-related projects demonstrates a central role for the book in contemporary Chinese art. It also reveals four fundamental concepts or paradigms, which are crucial not only to understanding these two artists, but also to interpreting the contemporary Chinese artists' general engagement with books. The first is an artist's intimate relationship with books through personal experience and memory. The second is the significance of books to collective ideology and cultural identity. Third, the formal and technical features of books as sources of artistic imagination and creativity. The fourth is the role of books in the interlocution between past and present and between local and global. These concepts intersect with each other, providing contemporary Chinese artists with a broad basis for conducting wide-ranging artistic experiments which address artistic, intellectual, political, and personal issues.

OBJECT OF INTIMACY

We have interviewed many invited artists for this exhibition. Although we anticipated that they would connect their works with personal experiences, we have nevertheless been surprised by the richness of their reminiscences of the roles that books have played at different stages in their lives (see the artists' statements in this catalogue). It seems that the topic of the "book" opened a hidden door, allowing them to speak about their art in a personal, intimate voice. Earlier I cited Xu Bing's description about how, as a young child, he was initiated into the world of books in the stacks of the Peking University Library. Zhang Xiaogang, another leading contemporary Chinese artist, also developed a "book complex" early on, as he recounts in an interview:

I have loved reading books and buying books since my childhood. When I was young, however, some books were very hard to come by, so we had a habit of making handwritten copies. This practice also functioned as a learning process. I think my affection for books must also be related to the '85 Art New Wave movement; during that period of time, everyone loved to read. In my mind's eye, then, books are sacred, but also dangerous. There was also a period, beginning in the '90s, when I hated books—I felt that they were useless. In a way, this has to do with the fast-paced changes in China: there's no longer any time to read, particularly Western literature or philosophy. Books are our friends, but sometimes they are our demons. I harbor such contradictory feelings towards books: on the one hand, I am very suspicious of them, but on the other hand, I can't be without them.

Although Zhang Xiaogang is best known for his oversized portraits of anonymous figures during the Cultural Revolution, this autobiographical account strikes at a deeper core in his art: books became central images in his paintings long before the portraits and have recently returned to his repertoire in a series of "visual diaries" called *Amnesia and Memory*. It is true that he has also depicted other daily objects such as the telephone, the television, a knife, a burning candle, a flashlight, and so on, either for their sentimental value or for their symbolic significance, but none of these images are more frequent and consistent than books. The reason is that, as he reveals in the interview, books best encapsulate his ambivalence toward himself and the world. In many of his paintings dating from the late '80s to early '90s, books stood for admonition and repression but were also imbued with deep emotion. This dual significance of books is related to his personal crisis at the time as well as the tragedy of the June Fourth Movement.[19] A series of paintings shown in this exhibition, titled *Private Notes* and executed in watercolor and oil on paper, is an important example from this period. The seven compositions in the

1991 series constitute a metaphorical diary over a week; a numbered calendar on the back wall indicates the sequence of the seven days (FIG. 5.5). Books and dismembered body parts are two central motifs in the compositions, interacting with each other in various ways to suggest a continuing narrative. These images—a yellowish hand holding a pen to write on a piece of paper, a red hand pointing at a sentence in a book, a broken arm laying on pages covered with tiny characters—seem to convey traumatic experiences and signify yearning and desperation; their dark mood conflates memories of the Cultural Revolution and the June Fourth Movement.

The strong symbolic overtone of *Private Notes* continues to characterize *Genesis*, which Zhang Xiaogang created in 1992. The two paintings in this mini-series depict two newborn babies in the center, each lying above a desk next to an open book. One baby is reddish and raises his

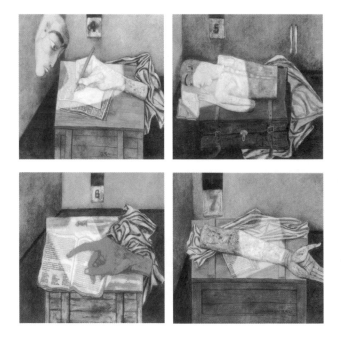

FIG. 5.5: ZHANG XIAOGANG, *Private Notes: Four*, NOS. 1-7, OIL ON PAPER, 1991.

head to stare into the onlooker's eyes. The other baby is yellowish and turns his head toward the book, reading the text under the guidance of a disembodied red hand. Old photos painted in the background offer clues for understanding the meaning of each composition. The photos on the top row behind the first baby represent Communist pioneers, including the founders of the Chinese Communist Party. The baby may thus symbolize the original inspiration of the revolution and the awakening of the Chinese people—a significance reinforced by the baby's alertness and "revolutionary" color. The photos in the other painting show "revolutionary students" during the Cultural Revolution, either marching in mass rallies or being reeducated through labor in the countryside. The passive and obedient baby in front of these pictures seems to typify the experience of this generation, which received Communist ideology as unfeeling dogma dictated by an impersonal, faceless power.

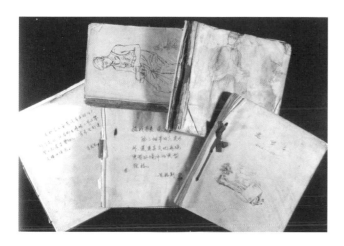

FIG. 5.6: GU XIONG, *Cultural Revolution Sketch Books*, INK AND PENCIL ON PAPER, 1972-76.

What one finds in these paintings, therefore, are "memory images" resurrected from history and from the depth of the artist's psyche. Influenced by Surrealism and Expressionism, Zhang Xiaogang devised a private iconography, in which the book stands for bygone experiences as well as a persistent dilemma in the present.[20] Gu Xiong's work in this exhibition exemplifies a different mode of intimacy with books: instead of representing memory, it preserves history in its original form (FIG. 5.6). The work consists of a series of sketchbooks, handmade by the artist during the Cultural Revolution when he was sent to a mountainous area in southwest China to receive reeducation. Day after day, month after month, he covered the pages of the sketchbooks with drawings of revolutionary heroes and heroines, figures and stories in newspapers, and people and things surrounding him. To a researcher of the Cultural Revolution, these sketchbooks offer a rare body of materials for understanding the prevailing visual culture during that period: unlike propaganda posters issued by the government, these were created by a teenage amateur artist for self-fulfillment and reflected his private visual sensibility. In an interview, Gu Xiong recalled his experience at the time and explained why he had decided to make facsimiles of the sketchbooks for this exhibition: only when the audience members actually "touch" these books can they share his intimate feeling towards them.

> I went from the excitement of the Cultural Revolution to the remote countryside and began to reflect on the conditions of the revolution. Despondency about the realities of my life and the unpredictability of the future lingered and went back and forth in my mind. These all compelled me to draw. Every morning, I would carry my sketchbooks with me. When we took a break from physical labor, I would pull them out and draw images of the peasants or the scenery. At night, I would sit under a kerosene lamp and recollect my experiences from the day. I would find what was meaningful from that day and draw it. In those four years, I produced about twenty or so sketchbooks...

At the time that I made these sketchbooks, they were a way of recording reality. I think that the book, particularly if you make it yourself, is an extremely individual and unique format. When this personal format reaches the public, even if the audience has had different experiences, it will still resonate with them. When you touch a book, you can really feel that it has existed in history, in a cultural space. You can pick it up and take part in some of its temporal and spatial experiences. Even if I make a new copy of a sketchbook for viewers to touch, it will itself become a meaningful work. It will no longer be a piece just for me, but will be something used and read by a broader public. When it returns to me, it will have been transformed.

Interestingly, when Gu Xiong's drawings are reproduced for this exhibition in their original format, they will change their identity from private records of an artist's inner dialogue to public reading materials—from sketchbooks to books.

"Intimacy" also offers a key to understanding several other works in this exhibition, including Qin Siyuan's (Colin Chinnery) *Self-Portrait Book* (FIG. 5.7), Liu Dan's *Dictionary* (FIG. 5.8), Xiaoze Xie's *Chinese Library No. 1* (FIG. 5.9), and Yuan Chin-t'a's *Piling Up Books* (FIG. 5.10). Each page of Qin Siyuan's *Self-Portrait Book* shows a photographic detail of the artist's body and face, and the pages all together make up a complete image of his body and face. A portrait as a spatial art form is therefore transformed into a temporal representation, and the conventional way of "viewing" a portrait is channeled into a sequential "reading" of fragmentary facial and bodily features. As I will discuss later in this introduction, the intrinsic temporal quality of the book has inspired many contemporary Chinese artists to conduct art experiments. Qin Siyuan's *Self-Portrait Book* is special in combining the experiences of "reading" and "touching":

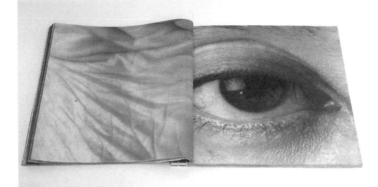

FIG. 5.7: QIN SIYUAN, *A Self-Portrait Book*, A THREAD-BOUND BOOK OF PHOTOGRAPHS ON TRADITIONAL CHINESE PAPER, 2003.

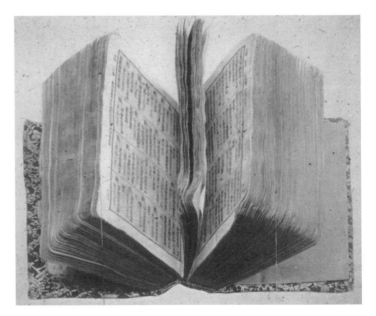

FIG. 5.8: LIU DAN, *Dictionary*, WATERCOLOR ON PAPER, 1991.

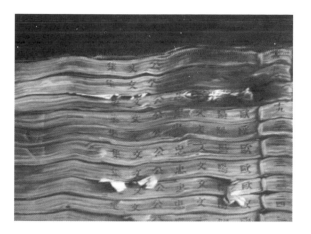

while turning the pages, the viewer must physically touch the images. ("There's a kind of intimacy to it," Qin says in an interview, "but also a slightly strange sensation.") To enhance such a sensation, he made the book with a special kind of *xuanzhi*—a traditional Chinese paper which is supple and soft, and has a texture similar to skin. He also insists that unlike a rarified art object, this book should be handled by viewers without gloves on. Although such physical contact will unavoidably damage the work, this will only prove its identity as a real book.

Whereas Qin Siyuan transformed a still image into a book, Liu Dan turns a book into an iconic image (FIG. 5.8). The central concept remains intimacy, however. Measuring two hundred thirty by three hundred thirty centimeters and entitled *Dictionary*, Liu's painting in this exhibition magnifies an old dictionary to a monumental scale. Interestingly, several artists have mentioned their special feeling toward dictionaries. Among them, Qiu Zhijie's account best articulates such an attraction:

The book that has had the greatest impact on me has been the dictionary. Ever since I was a child, I've repeatedly read the dictionary. . . Reading classical dictionaries allows you to trace your origins; you feel like you can see the most fundamental things. When you're done reading, it's like you've discovered everything, as if the whole world were only composed of these things.

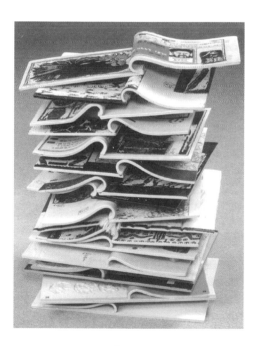

Like the natural world, a dictionary offers raw materials—words and definitions, not digested discourses and narratives. Reading a dictionary resembles exploiting a mine or excavating an archaeological site, activities which evoke the feeling of "going down to the bottom," of making original discoveries and regaining one's roots. We can thus understand why this type of book is especially favored by avant-garde artists, who by nature resist both canonical teaching and common wisdom. Indeed, the dictionary is arguably the most important type of book in the world and also has the longest shelf life, as one can never finish "reading" a dictionary but will endlessly return to it for help. Liu Dan's painting captures all these sensibilities. By enlarging an ordinary dictionary hundreds of times its original size, he bestows it with the status of a monument.

By depicting the dictionary with a painstaking, photo-realistic style, he stresses its vulnerability to time and to human touch: the book's yellowish paper and worn pages arouse nostalgia, testifying probably to a life-long intimate relationship with a human subject.

AGAINST THE BOOK

But do all the artists in this exhibition approach books as intimate objects invested with personal memory? The answer is clearly "no." In fact, several works emphasize a meaning of the book that is entirely opposite to intimacy. Instead of attaching sentimental values to books, their creators display various negative attitudes—suspicion, cynicism, iconoclasm—toward books. An implicit argument shared by these artists is that because books are made by men, they cannot avoid being used by political and religious authorities to advance their ambitions. A grave lesson these artists learned from the Cultural Revolution was exactly the alarming capability of a single set of books to control millions of people (FIG. 5.11). Books are full of lies and are also battlegrounds of different politics, religions, and ideologies. This dark side of the book is the central theme of Wei Guangqing's *Black Covered Book: Desert Storm* (FIG. 5.12). The book is entirely black. A metal instrument on its open left-hand page contains photographs of Saddam Hussein and George Bush, commanders in chief of the first Gulf War. Miniature warriors and military vehicles are scattered around, covering the rest of the pages. Fifteen years after this book's creation, we can now bet-

FIG. 5.11: ZHANG JINRONG AND YU HUALI, *Spring Wind Bringing Warmth,* CULTURAL REVOLUTION POSTER, EARLY 1970S.

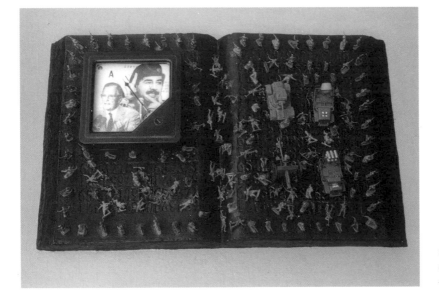

FIG. 5.12: WEI GUANGQING, *Black Covered Book: Desert Storm,* PAPER-MACHE AND MIXED MEDIA, 1990-91.

76

ter appreciate the artist's prophetic vision: as the revived war in Iraq drags on, this "black book," made in 1991, continues to comment on current international politics.

Many contemporary Chinese artists also attack books for their "contamination" of culture. In their view, most books are commercial items disguised as educational tools. A majority of books, especially best-sellers, are empty in content and poor in taste. Still many other books cannot even realize their commercial value, as they travel directly from production lines to waste stations, leaving no impact on society. It is clear that in making such judgments, these artists are actually commenting on the general conditions of contemporary culture, but the book offers them a sharp focus to deliver such criticism. Their arguments also imply that they are not opposed to *all* books. In fact, their rage and sarcasm is often induced by their care for books. This seemingly contradictory attitude is revealed by several interviews, in which the artist abruptly shifts from condemning books to revealing his debt to them (a typical example is Yue Minjun's statement in the catalogue of *Shu: Reinventing Books in Contemporary Chinese Art*). When using art to attack those books they consider manipulative, shallow, or superfluous, their typical strategies include ridiculing them, exposing their emptiness, and rendering them meaningless. We have observed these tendencies in Xu Bing's *Book from the Sky* and Huang Yong Ping's *"A History of Chinese Art" and "A Concise History of Modern Art" after Two Minutes in the Washing Machine*. Several other examples in this exhibition further demonstrate the wide variety of art experiments made along these lines.

Yue Minjun's *Garbage Dump* ridicules books (FIG. 5.13). Combining sculptures and readymade materials, it shows six identical figures squatting in a circle, staring at a pile of books while laughing hysterically. Yue purchased the books from a refuse station. The books include philosophical treatises and textbooks on various subjects, popular literature, how-to manuals, among others. Some were used, but many have never been opened. The only factor that unites them is their shared identity as trash. To Yue Minjun, this random collection of books "hints at the enormous amount of cultural garbage present in modern society, all of which work to bind and fetter people's spirits."

The six squatting figures are all based on the artist's own physiognomy and can thus be considered self-portraits. Instead of contemplating the books, they exude a kind of frenzied excitement that is at odds with the context. Yue Minjun says that he deliberately juxtaposes the books with this image of himself, which "is the exact opposite of those images that one always sees of scholars and their attitudes towards books." The real subject of the work is therefore the self-representation of the artist. In fact, one can easily imagine the installation would maintain its basic meaning even if other objects replaced the books, because what the figures are laughing at are not just books, but the entirety of contemporary culture.

This mode of self-representation originated in Cynical Realism—a style that became popular in contemporary Chinese art around the early '90s and was first exemplified by Fang Lijun's skin-head youth with a gaping yawn on his face. Like Fang's distorted self-image, Yue Minjun's figures encapsulate a dilemma faced by a generation of Chinese artists. As Li Xianting has noted, these artists "have lost faith in the dominant ideology, but also have no intention of making any effort to oppose this ideology and replace it with a new one. Finding no way out, they have developed a practical and self-serving attitude. Boredom is the most effective means of these cynics to free themselves from any shackle of responsibility."[21] These artists, however, have made an important contribution to contemporary Chinese art in forging an "iconography of self-mockery." In a sense, the distorted face in this iconography is a mask—a "false facade" (*jiamian* or *mianju*) as a means of both performance and disguise. If Yue Minjun's figures are still self-portraits, what they portray is no longer a real human subject but an autonomous figure. Encountering the pile of books, the figures' exaggerated excitement only masks the artist's true feeling towards these objects. As he continues in the interview: "Books are very important to my production process... [But] to

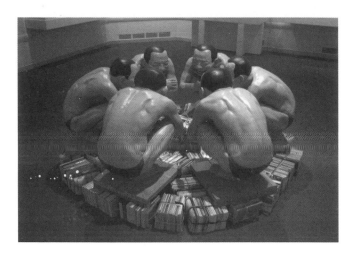

FIG. 5.13: YUE MINJUN, *Garbage Dump*, ACRYLIC ON FIBERGLASS, BOOKS, 2005/2006.

extract from this immense tide of books the meaningful ones, the ones that you rely on your own consciousness to understand, is extremely difficult."

Yue Minjun's visual strategy is reversed by Wang Jin in his *New Ancient—Stele of Zhang Qian* (FIG. 5.14). Instead of juxtaposing real books with a distorted self-image, Wang distorts books to expose their identity as mechanical productions. His method uses PVC, a transparent, durable industrial material, to copy delicate ink rubbings bound in a traditional book format. He explains:

> There are so many books today that cannot be read. Books are an industry, and reading them isn't important. Reading a book is like eating a hamburger. It's okay not to eat a hamburger, and it's okay not to read. This is not a society that needs or depends on books...

> Books are also extremely stubborn. Even if you don't read them, they are still there, challenging you. Books have a certain ambience about them. Even without reading a book, you can feel it. It's like a magnetic field. I feel that the natural properties of PVC and books are very similar. They are both stubborn. They will not decay over the course of hundreds of years. Wood, metal, and paper will deteriorate over time, but PVC will not. It might change in color or texture, but it will still be there. Books, too, possess these properties of preservation and continuity.

FIG. 5.14: WANG JIN, *New Ancient—Stele of Zhang Qian*, POLYVINYL CHLORIDE BOOKS, 1998.

Wang Jin's *New Ancient—Stele of Zhang Qian* cannot be read or used for studying ancient calligraphy; instead it resembles a three-dimensional sculpture which can only be appreciated visually. We can "see through" the pages from cover to cover and observe the overlapping layers of words. Thus, his PVC book thus does not merely illustrate his statement that "books are an industry," but also translates sarcasm into artistic imagination. This strategy of simultaneously destroying and reinventing visual forms is employed by several other artists in the exhibition. For example, each character in Geng Jianyi's *Misprinted Books* is formed by superimposing layers of characters (FIG. 5.15). As such, these books dispel any idea of significance, and, in Johnson Chang's words, "play havoc with the traditional notion that a book is a record of valuable information."[22] When these books were first shown in the *China's New Art, Post-1989* exhibition in

FIG. 5.15: GENG JIANYI, *Misprinted Books,* 18 HARDCOVER BOOKS, EARLY 1990S.

1993, they appeared together with a group of three paintings based on popular images during the Cultural Revolution (FIG. 5.16). In the central composition, Geng Jianyi painted the head of a giant panda inside the circle of a Red Sun—the place reserved for Mao's portrait. Paired with this painting, the *Misprinted Books* had a strong political implication as the artist's blasphemy of the sacred doctrine of the Party. But, even in that context, the work still evoked formal appreciation, as line after line of misprinted characters assumed an aesthetic quality, generating a visual rhythm with a hypnotic power.

Chen Xinmao's *Historical Text: Blurred Printing Series* also features distorted texts—incomplete and partially smeared woodblock prints as a result of misprinting. The blurred characters appear dilapidated, as if they were "ruins" or "traces" of some canonical books from the past. According to the artist, the basic concept of the work is that "over thousands of years, the transmission of texts has led to the deterioration of meaning." Ironically, the distortion of historical texts in these images provides a means to explore new visual sensibility. The ambiguity between textual and visual expression is further heightened by the varied use of ink, which assumes contradictory roles: reproducing texts and making texts illegible, sometimes used to print characters and sometimes burying characters under richly-textured, spreading blots.

We may say that these works all reveal an effort to "empty" the content of the book for the sake of making art. Thus Wang Jin created his "transparent" volumes of ink rubbings, and Geng Jianyi and

FIG. 5.16: GENG JIANYI, *Untitled,* OIL ON CANVAS, EARLY 1990S.

Chen Xinmao made their paintings and installations with the "misprinted" texts. Song Dong designed his *A Room of Calligraphy Model Books* for a similar purpose (FIG. 5.17). He used scissors to cut the pages of calligraphy model books into strips. Assembling the destroyed volumes into a "carpet" on the floor under running electric fans, he created an impression of wind blowing on a grass field of ink rubbings. In making this installation he was inspired by a tragic event in Chinese history, in which a scholar during the Qing was put to death because he wrote this poetic couplet: "Gentle wind, you cannot read, so why do you turn the pages?" (*Qingfeng bushizi, hebi luan fanshu*). Because the character "qing" was also the name of the dynasty, the Emperor suspected that the couplet was a slur against his regime.

FIG. 5.17: SONG DONG, *A Room of Calligraphy Model Book*, INSTALLATION, 1995/2006.

This historical episode seems to capture Song Dong's ambivalence toward the book, which transmits knowledge but does not guarantee its authenticity. Unlike the inscription on a stone stele, he argues, the rubbings reproduced in a calligraphic model book only offer fragmentary signs; the act of copying them can hardly help people understand the original text. He said in a recent interview: "I didn't shatter the stone into pieces. It is the publication of its rubbings that needs to be reformed. Over the years, people have copied these rubbings. Some people become geniuses, but most are circumscribed by tradition." Such suspicion toward received knowledge must have deep roots in his thinking, because his

FIG. 5.18: HONG HAO, *Mexico-Huun-Amate*, PAINTED BOOK, 2004.

first public exhibition in 1994 already aimed to "empty" books. Called *One More Lesson: Do You Want to Play with Me?*, this exhibition transformed the gallery into a classroom, in which some students read wordless textbooks. The local authorities canceled the show the day it opened.

The notion of a "wordless book" has never left Song Dong, however. In the interview, he disclosed that his favorite book actually has only blank pages, and that he has been reading this book now and then since 1994. The same idea must have also inspired his *Water Diary*, in which he writes words everyday on a slab of stone with a brush dipped in pure water. Hong Hao's *Mexico-Huun-Amate* offers another example of a wordless book in contemporary Chinese art (FIG. 5.18). Completely devoid of text, it seems to only feature empty pages of coarse paper. Upon minute examination, however, one finds that the fibers on the pages are actually painted by the artist with a tiny brush, and the paper's "handmade" quality actually results from pictorial illusionism. The book is therefore both absent and present. Or, the absence of its literary content leaves the viewer to concentrate on its visual and material presence.

Like Xu Bing, Zhang Xiaogang, and Song Dong, Hong Hao has been a dedicated "book artist"

since the '80s. This is not to say that he has dedicated himself to making "art books" during these years. Rather, the idea of the "book" has stayed at the center of his art experiments, whether he is making prints, photographs, or actual books. His first group of "book images" represented art catalogues. He explains that at the time he was very impressed by imported catalogues, which "seemed to symbolize a level of achievement." While a student in the Printmaking Department at the Central Academy of Art, Hong Hao found a way to attain such glory and satirize his own vanity: he made a series of *trompe l'oeil* prints of art catalogues that featured his works.

FIG. 5.19: HONG HAO, *Selected Scriptures II,* SCREEN PRINTS, 1988-2000.

This early series paved the way for *Selected Scripture*, a large collection of prints which took Hong Hao twelve years to realize. In a sophisticated illusionistic style, each print represents a picture in a large encyclopedia; its page number indicates its position in the book (FIG. 5.19). The encyclopedia, however, remains a mental construct and is never realized in a material form. The diverse subjects of the prints/illustrations, the random use of multiple languages, and the heterogeneous origins of pictorial motifs further defy any rational structure and coherent layout. The meaning of this book lies in its illogicality. Hong Hao knows this better than anyone else:

> We use books for specific purposes. When we go to the library or bookstore, we look for books that we need. If you're looking to learn a foreign language, you will buy a foreign language textbook. Here, however, I have taken away the functionality and contextual continuity of the book. Although all of these pages are supposedly from one book, you don't actually know what this book is about. In real books, the first page is related to the second page, etc. In my book, however, the contents of each page are independent of each other. I've revised the structure so there is no longer a sense of continuity. Although I've used the format of the book, I've taken away what one thinks a book should be. This book can't be used to find answers. This same principle applies to the maps: the longer you use them, the more confused you will become. I spent about twelve years, from 1988 to 2000, to make prints for this book.

Ironically, as "illogicality" is taken as a serious goal of art making, it begins to produce a "logic" for understanding Hong Hao's various projects. Planning an exhibition of his new works in 2004, he conceptualized the gallery as a fictional reading room in which every book made by him would challenge normal "reading" in a unique way.[23] When the exhibition opened, it appeared as a laboratory of "anti-books." There was the *Mexico-Huun Amate* with painted fibers on its empty paper. Another book called *AiA* was created by eliminating components from a published book, hence the meaning of this work in the form of an incomplete copy of an issue of *Art in America.* A third book combines images

scanned or removed from several hundred books. While none of these images are related in content, they were carefully arranged by Hong Hao on opposing pages according to certain "visual codes" of a conventional catalogue. The book is neither readable nor unreadable. Its authorship is equally blurry. "Catalogues abide by certain standards and rules," Hong Hao announces, "but mine defy the function, structure, and production expected of books."

<center>NEGOTIATING TRADITION</center>

Throughout the twentieth century, a Chinese painter had to choose between the traditional medium of ink on paper and the "Western" medium of oil on canvas. He had to make such a choice because twentieth-century Chinese painting was predicated on the dichotomy between *guohua* (national painting) and *xihua* (Western painting), which determined the structure of education, the criteria of art criticism, and the artist's professional identity and self-image. This dichotomy also provided a basis for a persistent debate around two questions: how can "national painting" be modernized and "Western painting" become Chinese? Answers were sought in both theory and practice, but rarely challenged the dichotomy itself. An oil painter might derive aesthetic principles and technical elements from traditional art, and an ink painter might enrich his work with color and shading. But they were still *youhua* (oil painting) and *guohua* painters. Some artists tried to cross the boundary by making both types of paintings, but this only demonstrated their ambidextrous skills, not a dismantling of the system.

> This situation changed in contemporary art. With the introduction of new art forms in the '80s and '90s, contemporary Chinese artists have finally transcended the dichotomy of guo-hua and xihua. This is because compared with oil and ink painting, these contemporary art forms—installation, performance, site-specific art, multi-media art, body art, etc.—are not culturally-specific. Although these forms in the '80s and '90s conveyed a strong desire to subvert established norms in the domestic space, they did not constitute a direct counterpart to either traditional or Western art. Moreover, in the global art space, these forms provided artists from different countries and traditions with an "international language," allowing them to address both local and global issues in a highly versatile, individualized manner.

This new condition explains the creation of many works in this exhibition. On the one hand, these works are typical examples of contemporary art; on the other, they demonstrate the artist's effort to reengage with Chinese cultural traditions. Some of these artists have fashioned new types of book based on traditional art forms; others have derived abstract concepts from traditional book culture in making installations and multi-media works. Far from rejecting China's cultural heritage (as critics of contemporary Chinese art customarily claim), these works indicate new ways of carrying tradition into the future.

<center>REINVENTING BOOKS</center>

This exhibition includes four sets of "books" made separately by Lü Shengzhong, Hong Lei, Zhan Wang, and Xu Bing. Interestingly, in making these works the four artists have derived visual languages from four divergent traditions in Chinese art: folk art, urban crafts, literati aesthetics, and modern commercial art.

Among established contemporary Chinese artists, Lü Shengzhong is unique in his quest to express contemporaneity through paper-cutting—a vernacular art form associated mainly with illiterate peasant women. His first major exhibition in 1988 transformed Beijing's National Art Gallery into a solemn temple filled with totem-like images, footprints suspended in mid-air, and silhouette patterns accompanied by illegible writing. The grand spectacle of the show astonished Chinese art critics, but Lü Shengzhong sensed no victory

and kept describing his art as "a lonely struggle along a desolate path."[24] In an explanation of the exhibition he wrote:

> Exerting the utmost strength, I squeeze out of a marketplace filled with contentious crowds and find a silent, forgotten little path to walk on. Intrigued by unfamiliarity and longing, I follow it to retrieve original characteristics of humankind that have been filtered out by civilization, to summon images of lost souls in the polluted air, to understand the spiritual pursuit of mankind in its infancy, and to search for the deep connections linking my native land with the rest of the world. All my effort is to nourish the empty, worn heart of modern man with the unspoiled blood of an ancient culture. Thus suddenly I gain confidence, because in my mind I have paved a spiritual path for today's art.[25]

Since then, Lü Shengzhong has continued to walk this "lonely path." The central motif of his works has remained "little red men" (*xiao hong ren*), an image transmitted by folk artists from ancient shamanism. His *The Book of Humanity* in this exhibition consists of two series, each featuring ten volumes of "red books" or "black books" (FIG. 5.20). He cut out red figures for the red books; the leftover scraps then became the content of the black books. The work as a whole thus embodies the most important principle of traditional Chinese cosmology—the opposition,

FIG. 5.20: LÜ SHENGZHONG, *The Book of Humanity*, TWO SETS OF THREAD-BOUND BOOKS, 2002-2004.

interdependence, and transformation of *yin* and *yang*. Indeed, this principle seems to lie at the heart of paper-cutting, which always produces positive and negative forms simultaneously. Because of this significance, paper-cutting provides Lü Shengzhong with an ontological model enriched by countless metaphors: body and soul, image and text, substance and emptiness, and male and female. We can thus understand why he has titled this work *Book of Humanity*.

In contrast to Lü's rudimentary, primitive "little red men," Hong Lei's images in his the *Three Compendia of Songs* are exotic figures made of exquisite embroidery (FIG. 5.21). Accompanied by embroidered lyrics, these figures represent love and desire in three masterpieces of traditional Chinese literature—*Golden Lotus, Dream of the Red Chamber,* and *Peony Pavilion.* According to Hong Lei, by synthesizing traditional thread-bound books, ancient painters' albums, and the art of embroidery, these compendia represent his "memory" of the literary works and his imagination stirred up by such memory. "If I have 'remade' books in any way," he says, "it is because I have interpreted the essence of these three canonical novels from a modern person's perspective. I believe that all of man's memories are derived from texts. The desire to prolong these memories can only depend on the imagination. Thus, my work serves as a type of continuation, a dream walk through traditional memories."

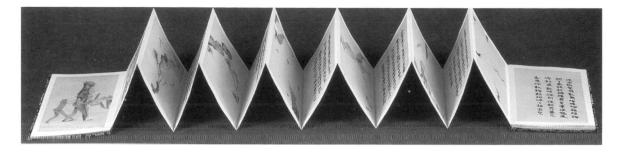

FIG. 5.21: HONG LEI, *Three Compendia of Songs,*
BOOKS MADE OF EMBROIDERY, SILK, 2006.

If the thread-bound book and the painting album are conventional symbols of traditional Chinese culture, Hong Lei's use of embroidery is more closely related to his family background and personal experience. A descendant of an elite family in Changzhou, one of the old towns along the Yangzi River, he is drawn to the place's refined culture and lifestyle and has enjoyed southern music, story telling, and garden culture from childhood. In the early twentieth century, a type of embroidery was invented in the region to combine an illusionistic pictorial style imported from Europe. Hong Lei became fascinated with this type of embroidery when he worked in Changzhou's Institute of Arts and Crafts from 1989 to 1994. To him, such work testifies to the dynamic nature of Chinese art in absorbing new and foreign elements. He connects his own pursuit with this aspect of Chinese art because his goal is also to fuse ancient aesthetics and contemporary sensibility.

Since 1995, Zhan Wang has made many stainless steel rocks. By applying a pliable sheet of steel over a traditional ornamental rock and hammering it thoroughly, he could achieve a form which reproduces every minute undulation on the surface of the stone. Ranging from miniatures to monuments, his stainless steel rocks have entered various private collections and have been erected in public spaces around the world. His purpose in making these works, as he wrote in a 1996 statement, is to transform a symbol of ancient literati culture into a contemporary cosmopolitan expression:

> Placed in a traditional courtyard, rockery satisfied people's desire to return to Nature by offering them stone fragments from Nature. But huge changes in the world have made this traditional ideal increasingly out of date. I have thus used stainless steel to duplicate and transform natural rockery into manufactured forms. The material's glittering surface, ostentatious glamour, and illusory appearance make it an ideal medium to convey new dreams [in contemporary China].[26]

Rather than satire or mockery, therefore, Zhan Wang sees his stainless steel rocks as "authentic" representations of Chinese culture in the postmodern world. The work he made for this exhibition continues this approach but also marks a new stage in his art: his *New Suyuan Rock Manual* will catalogue the stainless steel rocks he has made and sold (FIG. 5.22). One of the most famous manuals of ornamental rocks in Chinese history, *Suyuan shipu* (Suyuan's compendium of ornamental rocks) was compiled in 1613 by the Ming dynasty scholar-collector Lin Youlin. Zhan Wang considers this type of publication a vital component of traditional rock culture. Adopting the format of *Suyuan shipu* to document his stainless rocks—recording both his motivations in making them and the histories of their collection, he is able to renew this tradition and bring it into contemporary culture.

A fourth set of "books" in this exhibition was created by Xu Bing for his *Tobacco Project*,

FIG. 5.22: ZHAN WANG, *New Suyuan Rock Manual,* PRINTED BOOK IN STEEL CASE, 2006.

FIG. 5.23: XU BING SPRINKLING TOBACCO INSECTS ON HIS *Tobacco Book,* PERKINS LIBRARY, DUKE UNIVERSITY, DURHAM, 2000.

held in 2000 at Durham in North Carolina, the center of the American tobacco industry since the nineteenth century. The main focus of the project was the relationship between James B. Duke (1865-1925)—the famed Durham tobacco tycoon—and the local economy, politics, and education. At the same time, because Duke's tobacco company was the largest cigarette producer in China in the early twentieth century, his relationship with China also inspired Xu Bing to design works for the project. This second focus is most clearly manifested in a series of "books." The centerpiece of the *Tobacco Project* was an enormous book called the *Tobacco Book* the Chinese title is *Huangjinye shu* (Book of Golden Leaves). Six feet wide and four feet long, it was made of dried tobacco leaves, on which Xu Bing printed a text recording the expansion of the American tobacco industry in China (FIG. 5.23).[27] Other "books" use images of cigarette advertisements that Duke's company produced in Shanghai, the design of Chairman Mao's favorite cigarette as well as excerpts of Mao's writings, the *Daode jing*, and Tang dynasty poems. These works are "polycentric" in both content and image: Xu Bing neither planned them as a coherent visual display nor pursued a consistent social or political theme. Instead, tobacco inspired him to create these "books" as disparate objects, each pointing to a specific memory or meditating on the implications of the cigarette to Chinese culture.

CONCEPTUALIZING THE BOOK

Almost all examples discussed so far demonstrate a dual emphasis on the contemporary Chinese artists' engagement with the book: to abolish its literary content and to transform it into a visual, material, or aesthetic object. This emphasis also underlies the last group of works I will discuss in this introduction. Instead of taking the book as a direct subject of destruction or construction, the artists of these works distill the essential elements of traditional books and use them in conceptualizing new art projects, which may not at first glance seem related to books.

To the ancient Chinese, paper and ink—the two basic materials for printing books—were themselves aesthetic objects. Compendia have been written from the tenth century on to record and evaluate different types of paper and ink, their ingredients and methods of manufacturing, formal char-

acteristics, qualities, and histories.[28] This tradition of connoisseurship and appreciation has continued to this day.

The finest paper and ink have been named after their inventors and esteemed as works of art. Two of these inventors were Xue Tao (758?-832) and Li Tinggui (10th century). Xue Tao was a Tang courtesan famous for her beauty and literary talent. It is said that Wei Gao, the governor of Sichuan, was impressed by her poetry and recommended her for a government position of *jiaoshu*, or "collator." Although the recommendation fell through, people began to refer to her as Lady Jiaoshu. After Xue Tao accumulated sufficient resources to buy her freedom, she launched a career in paper-making. Her most famous product, known as Xue Tao Paper, was valued for its extremely fine texture and delicate pink color, and soon became a sought-after item by scholars and collectors.

Born into an ink maker's family in north China, Li Tinggui (whose original name was Xi Tinggui) escaped to the more peaceful South after the fall of the Tang dynasty. Learning that the Yellow Mountains were populated by thousand-year-old pine trees—the ideal material for making fine ink—he made Shezhou (later renamed Huizhou) his home. There, after repeated experiments, he finally discovered a recipe to make the best inksticks; the ingredients included pearls, drugs such as *tenghuang*, *badou*, and *xijiao*, and the burned soot from the Transparent Lacquer Oil on pine trees deep in the mountains. Known as Li Tinggui Ink, the inksticks made with this recipe were fine-textured and produced subtle shades that no other ink maker had ever achieved. The emperor of the Southern Tang heard of this and requested two pieces. After painting some carp with the ink, the emperor was so pleased that he offered the humble craftsman his own surname, thus making Li Tinggui a member of the royal family. Even today, inksticks from Huizhou are still considered the best in the country.

FIG. 5.24: WENDA GU, *Tea Alchemy*, MIXED MEDIA INSTALLATION, 2002/2006.

Only by recognizing this long history of "ink and paper" culture in China can we understand the two works by Wenda Gu in this exhibition (FIG. 5.24). Titled *Tea Alchemy* and *Ink Alchemy*, respectively, these are tokens of two much larger installations. The original installation of *Tea Alchemy* consisted of thirty thousand sheets of "green tea paper." While the method used in making the paper is traditional (Gu commissioned the best paper makers in China to produce the sheets), the material he selected—four thousand pounds of tea leaves—is unique. Slightly greenish and delicate to the point of being semi-transparent, the paper emits the fragrance of the tea. To a connoisseur of traditional arts, such paper and its products (such as the accordion-style album displayed in this exhibition) are special art objects, not merely materials for writing and painting. As art objects, they convey a particular taste associated with south China (where Gu comes from) and evoke the ancient legend of Xue Tao, who made extraordinarily fragile paper with flower petals.

86

The creation of *Ink Alchemy* followed the same logic. Again, Wenda Gu commissioned the best ink factory in China to manufacture this work, but replaced the common material of pine resin or *tong* oil with a highly unconventional one—the charcoaled powder of human hair. It took Wenda Gu two years to negotiate with the factory to finally produce the few items in this exhibition: several inksticks and test tubes containing powdered hair. Asked why he chose human hair as the material for his ink, Gu answered: "I think the hair ink is more authentic than traditional ink because it's from Chinese people. It has Chinese DNA. In this way, I feel like it has broken past traditional ink, yet it is still deeply rooted within tradition."

Like Wenda Gu, Qin Chong also considers paper not only an art medium, but also a "cultural thing":

> When I first began [making] art, I used paper for painting. But, at that time, I didn't have the concept of paper that I have now. Paper is white, a blank slate; it has nothing on its surface. The process of painting on it or filling it with something is very interesting. But, I think paper itself has its own meaning, too. Many developments throughout human history have been accomplished through paper. Moreover, I feel that the way that Western people and Eastern people use paper and think about paper is different. In China, for example, when someone dies, we burn paper; it's used for paper-cuttings, it can be used as a window pane, we often make things out of paper, etc.—it can serve many different functions. In the West, I feel that it is more associated with printing and writing.
>
> If you use a piece of gold to make something, the material itself is very expensive. If you use a piece of paper, perhaps it doesn't have the same worth. But, as an artist, I think that how you treat the material determines its role. If you bestow paper with the value and ideas that you give to gold, then perhaps that piece of paper can be a piece of gold. If you don't bestow anything on the gold, then it just remains a piece of gold.

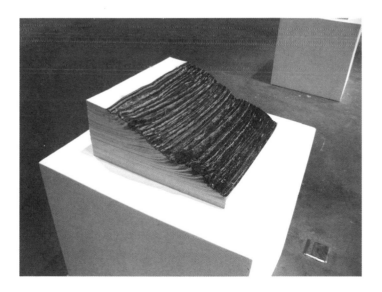

FIG. 5.25: QIN CHONG,
Birthday I, II, III, IV,
PAPER INSTALLATION OF
4 UNITS, 2002.

Qin Chong's *Birthday*—a series of four paper installations in this exhibition—amply demonstrates this approach (FIG. 5.25). Each installation is made of hundreds of paper sheets arranged in a neat pile. The sheets are pure white; the only image they bear is a charcoaled trace of burning. Forming a faint thread or a darkened circle, each trace has a distinctly formal characteristic and evokes a different emotional response. A Chinese viewer would immediately associate such traces of burning with the repeated destructions of books throughout China's long history, from the time of the First Qin Emperor to that of the Cultural Revolution. Qin Chong's el-

egant, seemingly abstract installations are therefore rich in cultural and historical meaning. They may even be considered "anti-books" because what they represent is erasure. "While books are a medium for history and memory," he reflects, "I think that this work might touch upon an opposite effect: the part that remains is blank, whereas the part that no longer exists is that which has been recorded."

Erasure is also a central element of Yang Jiechang's paintings, but it is achieved through an opposite means. To create his *100 Layers of Ink—Vast Square*, a work in this exhibition, Yang obsessively applied layers and layers of ink, creating abstract "black holes" with shining surfaces. This and other works in the *100*

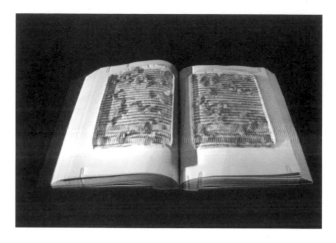

FIG. 5.26: XU BING, *Silkworm Book II*, VIDEO PROJECTION ON BOOK, 1994/2006.

Layers of Ink series resulted from the artist's ambivalent relationship with traditional Chinese art and culture. On the one hand, to quote Martina Koeppel-Yang, Yang's painting "shows an anti-traditional, anti-cultural attitude" in eliminating images and brushwork. On the other hand, "the elimination of skill, imagery and personality is nothing less than the sublimation of the self, the ultimate aim of the cultivation of personality the Chinese literati practiced through painting and calligraphy."[29] Yang's succinct statement about the *100 Layers of Ink—Vast Square* further reveals his intention in distilling and reusing essential elements of traditional art. As he says: "It is a conceptual work related to time, space and the material of ink. An important factor is repetition, the aspect of multiple layers." These elements are also fundamental to the art of the traditional Chinese book.

The concept of time leads us to two other interesting works in the exhibition: Xu Bing's *Silkworm Book II* (FIG. 5.26) and Cai Guo-Qiang's *Wokou: Japanese Pirates of the Middle Ages* (FIG. 5.28). Xu's work is a sequel to his earlier *Silkworm Book*, an installation/performance project during which silkworm moths laid numerous eggs on the blank pages of a book. The eggs hatched into thousands of tiny silkworms that crawled on the pages, leaving the stained book as evidence of this biological metamorphoses (FIG. 5.27). Xu Bing's current video installation restages this project. The stained book now functions as a "screen," onto which a video of the silkworms' metamorphoses is projected. In so doing, this installation restages a past

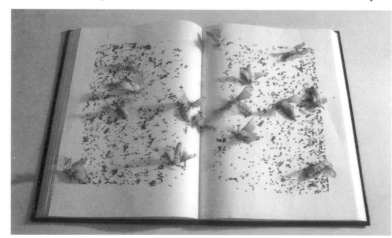

FIG. 5.27: XU BING, *Silkworm Egg Book*, PERFORMANCE, INSTALLATION, 1994.

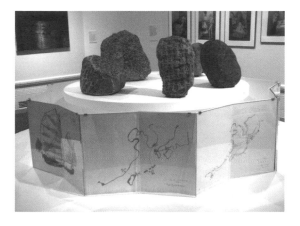

FIG. 5.28: CAI GUO-QIANG, WOKOU: *Japanese Pirates of the Middle Ages*, INSTALLATIONS, 1995/2006.

performance in real time, but also translates an actual event into a visual representation.

Cai Guo-Qiang's installation in this exhibition, on the other hand, represents the concept of a large, temporal project that was never realized. Originally commissioned by the Naoshima Contemporary Art Museum in Japan, Cai conceptualized the project as a revisit to an episode in East Asian history, when *wokou*, or Japanese pirates, became a shared threat to the countries and cities in the region. According to the original plan, he was to purchase a large boat and start his journey from his hometown Quanzhou in southeast China; on board would be a rock carved with the Chinese definition of *wokou* at the time. The boat would sail to Kaohsiung, Taiwan, and then to Korea. In each place, Cai would obtain another rock, and inscribe it with the local definition of *wokou* on it. When the boat finally reached Japan, he would also inscribe the Japanese definition of *wokou* on a rock found there. In his vision, "this boat would, essentially, constitute a seafaring museum. While docking at different ports in Asia, it would collect information on *wokou*, and allow an audience to view the differing histories and culture of these people."

In the end, the plan was canceled due to its possible political impact. What remains is an accordion-style album in which Cai had illustrated the project as it was originally conceived. Invented in China, this kind of portable, book-like album enables painters to make sketches and write down their thoughts on individual pages in a sequential manner. When the album is fully open, the interconnected pages also form an extended horizontal composition. Because of these characteristics, the album became especially popular among literati artists of the Ming and Qing dynasties (1368-1911), who favored an intimate mode of expression and were accustomed to writing poems alongside images. It is apparent that in making his album Cai Guo-Qiang followed this ancient tradition. It begins from Quanzhou, the starting point of the proposed journey. Images on the following pages illustrate activities at the subsequent seaports, as well as Cai's descriptions and comments. The combination of words and images, as well as the sequential reading of the album, unmistakably link the work to a traditional mode of representation.

In the installation, it is not just the album that is connected to the traditional book, however. Cai Guo-Qiang also considers the inscribed rocks a type of book: "In China, an entire mountain can be a book... For example, in Quanzhou, there is a mountain whose cliffs are inscribed with maritime stories, such as historical accounts of Zheng He's (1371-1433) travels to the Western Ocean. In this way, even nature can be considered a medium for writing books." (FIG. 5.29) He thus hopes "that the audience [of his installation] can understand these different types of Chinese books: the album, the rock, etc."

§

To sum up, this essay has demonstrated three main aspects of the close relationship between books and contemporary Chinese art. First, many book-related works in contemporary Chinese art are

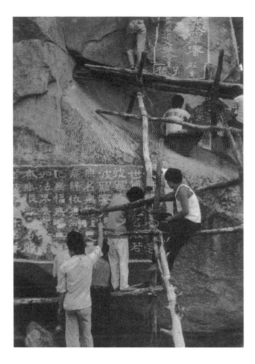

FIG. 5.29: WORKERS MAKING INK RUBBINGS FROM BUDDHIST SCRIPTURES INSCRIBED ON A MOUNTAIN CLIFF. CULAISHAN, SHANDONG.

rooted in the artists' personal experiences. More than any other object, books awakened their curiosity about the surrounding world. The first signs of their artistic talent were often drawings in their hand-made sketchbooks. When they were growing up, diaries and other types of personal records concealed intimate memories as well as traumatic experiences during the Cultural Revolution and other political campaigns. As we have seen, such memories and experiences have motivated artists like Zhang Xiaogang, Gu Xiong, Song Dong, and Xu Bing to create deeply emotional works.

Second, to many contemporary Chinese artists, books can also be the most dangerous things in the world because they providse the most effective tools for political and religious brainwashing. Although these artists are not necessarily opposed to all books, their rebellion against orthodoxy has prompted them to cast the book as a general symbol of the repressive power of political authority. Other artists see the enormous number of books produced in the world as commercial garbage and use this phenomenon to show the decline of contemporary culture and human value. Both attitudes have led to iconoclasm or sarcasm. As attested to by many of the works in this exhibition, when books are taken as subjects of artistic destruction, a set of persistent strategies is invented to blaspheme and "empty" these sacred objects.

Third, because of its significance as a major transmitter of traditional knowledge, the book has become a primary site for contemporary Chinese artists to rediscover their cultural heritage and to enrich their experimental projects with their finds. Such discovery and use of tradition can be obvious or subtle. Some artists have reinvented the book as a new contemporary art genre; others have drawn inspiration from traditional books in designing installations and multimedia projects. Neither Eastern nor Western, these works derive their meaning from transgressing conventional cultural boundaries.

Rather than isolated tendencies, these three aspects are often intertwined in a single work, intensifying its complexity and historical significance. Through uncovering such complexity and significance, we hope that this exhibition can contribute to the study of contemporary Chinese art by increasing the "depth" of interpretation. This is an urgent task because now that contemporary Chinese art is becoming rapidly globalized, it is also losing its definition and individual voice. Even if works by Chinese artists are now shown in many biennales and triennials worldwide, they cannot be automatically "inserted" into the existing history of modern and international contemporary art because they are indebted to specific inspirations and conditions. By focusing on the relationship between contemporary Chinese art and the book, this exhibition explores an indigenous narrative of contemporary art in a global context, thus offering an explanation for why contemporary Chinese art is both "contemporary" and "Chinese."

Originally published in Wu Hung ed., Shu: *Reinventing Books in Contemporary Chinese Art* (New York: China Institute Gallery, 2006), 1-23.

BETWEEN PAST AND FUTURE:

A BRIEF HISTORY OF CONTEMPORARY CHINESE PHOTOGRAPHY

During the past twenty-five years, Chinese artists have reinvented photography as an art form. Before 1979, and especially during the Cultural Revolution (1966–1976), publications and exhibitions of photographs served strict propagandist purposes; unofficial photography remained private. The appearance of the first unofficial photo club and exhibition in Beijing in 1979 fundamentally changed this situation. Since then, many such clubs have emerged and numerous photo exhibitions have been organized by independent curators and artists. In the process, contemporary Chinese artists' use of photography has evolved from imitating Western styles to developing an original language and character.

From the '80s to the '90s, a host of photography journals and magazines were published in China, introducing the major schools and masters of Western photography to an eager audience. Western techniques as well as social and artistic aspirations influenced a generation of young Chinese photographers, who made images for their aesthetic appeal and as authentic records of historical events and human lives. Many artists produced documentary-style photographs during the '80s and early '90s, creating works with a strong political agenda. They either explored the dark side of society or glorified an idealized, timeless Chinese civilization unspoiled by Communist ideology. This period, which Chinese critics described as the Photographic New Wave (*sheying xinchao*), laid the ground for

the next generation of photographers to undertake wide-ranging artistic experiments beyond realism and symbolism.[1]

The new types of image-making, often referred to collectively by Chinese artists and art critics as experimental photography (*shiyan sheying*),[2] became closely linked with an ongoing experimental art movement in the '90s. Whereas experimental photographers found inspiration in performance, installation, and multimedia art, painters, performers, and installation artists have routinely employed photography in their work, sometimes even reinventing themselves as full-time photographers. As a result of this dynamic exchange, photography has played a central role in recent contemporary Chinese art. Photography's openness to new visual technology and its ability to challenge the boundaries between fiction and reality, art and commerce, object and subject, have inspired and permeated various kinds of art experimentation in China.

Containing roughly one hundred and thirty works created by sixty artists from 1994 to 2003, the exhibition *Between Past and Future: New Photography and Video from China* showcases this most recent chapter of contemporary Chinese photography, whose continuous, exciting development over the past decade has been characterized by nonstop reinvention, abundant production, multifaceted experimentation, and cross-fertilization with other art forms. To provide the exhibition with a historical context, this essay covers a broader period, outlining the major trends, stimuli, and developmental stages of Chinese photography over the past twenty-five years. A review of the period from the late '70s to '80s establishes the starting point of this development—a "ground zero" against which documentary and "fine art" photography reemerged with rigor and a sense of mission. The following discussion focuses on two aspects of experimental photography since the '90s: its relationship with China's social transformation and the artists' changing self-identity, and the interaction between experimental Chinese photography and postmodern theories, conceptual art, and other new forms of contemporary art such as performance and installation. Integrated into a single narrative, these two focuses will address the dominant concerns of experimental Chinese photographers and the basic direction of their experiments.

THE RISE OF UNOFFICIAL PHOTOGRAPHY (1976–1979)

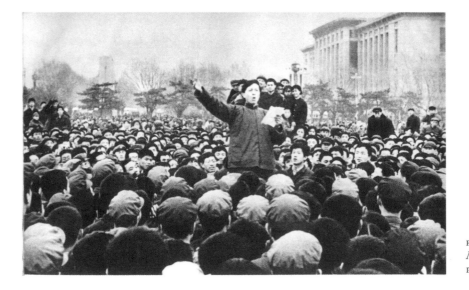

FIG. 6.1: LUO XIAOYUN, *Mainstay*, black-and-white PHOTOGRAPH, 1976.

Three consecutive events from 1977 to early 1979 together constituted a turning point in the history of contemporary Chinese photography. First, a group of amateur photographers formed an underground network, compiling their private records of a suppressed political movement into volumes for public circulation.

This movement—the mass mourning for Premier Zhou Enlai in 1976—was the first large-scale public demonstration in the capital of the People's Republic of China. Toward the mid-70s, Zhou had become the remaining hope for many Chinese, who saw him as the only person able to save China from the disasters that the Cultural Revolution had inflicted upon the country. With Zhou's death in January 1976 this hope seemed to have vanished. Even worse, the extreme leftist leaders of the Cultural Revolution—the Gang of Four headed by Mao's wife Jiang Qing—condemned Zhou and prohibited people from mourning him. All the anxiety, frustration, disillusion, and anguish that had troubled Beijing residents for more than a decade merged into a shared feeling of grief, from which a grassroots movement began to take shape.

On March 23, a single wreath of white paper, the traditional symbol of mourning, was dedicated to Zhou at the foot of the Monument to the People's Heroes in Tiananmen Square. It was immediately removed by Beijing's municipal government, which was controlled by the Gang of Four. But the prohibition only brought more wreaths, mourners, and finally a protest on April 4, the day of the Qingming Festival (the traditional day for holding memorial services to the dead). One hundred thousand people gathered in Tiananmen Square on this and the following day. By this point, white wreaths had been covered by red flags and slogans, and weeping had turned into songs, the beating of drums, and poems condemning the Gang of Four's evil deeds. Then, on the night of April 5, some ten thousand armed police and worker-militiamen rushed into the Square, beating and arresting the demonstrators. Terror continued for months afterward: numerous arrests were made, photos and tapes recording the mass gathering were confiscated, and people who refused to surrender these records were threatened with the death penalty.

Such extreme repression only hastened the fall of the Gang of Four. After Mao died in October that year, the new leader Hua Guofeng arrested Jiang Qing and her colleagues. After Deng Xiaoping returned to power in 1978, Mao was openly criticized, and nearly three million victims of the Cultural Revolution were rehabilitated. But the political situation remained unstable, and it was by no means certain that Deng's reformist faction would eventually win the battle. Because photographs of the April Fifth Movement—as the mass mourning for Zhou Enlai is called—most effectively evoked people's

memories of the event and strengthened their will to pursue a better future, these images played an important role at this critical moment in contemporary Chinese history.

Most of these photographs were taken by amateurs. Some of them, such as Wang Zhiping and Li Xiaobin, would later become the leaders of the Photographic New Wave in the 1980s. But, in 1976, they were beginners with little knowledge of the art of photography; what they had were cheap cameras and a burning desire to record the mass demonstration for posterity (FIGS. 6.1, 6.2). Working individually, each of them took hundreds of photos in the Square throughout the April Fifth Movement, and preserved the negatives during the subsequent political persecution. They became friends and comrades only later, when they saw each other's April Fifth photos and embarked on a collaborative effort to publicize these private records to represent public memory.

Before this, some of them had compiled individual photo albums of the movement and presented them to Deng Xiaoping and Deng Yingchao (the latter was Zhao Enlai's widow and a veteran revolutionary leader in her own right).[3] Now they decided to compile the most powerful photos of the movement into a single volume and publish it nationwide. A seven-member editorial committee was established in 1977 to collect and select images.[4] Because the April Fifth Movement was still labeled an anti-government movement, they worked secretly and relied on very limited resources. It remains unclear how many negatives they actually collected, but according to Li Xiaobin, prints they enlarged from these negatives numbered between twenty thousand and thirty thousand.[5] Some five hundred images were selected for the volume, which eventually came out in January 1979 under the title *People's Mourning (Renmin de daonian)* (FIG. 6.3).[6]

FIG. 6.3: COVER OF *People's Mourning*, 1979.

Published after the rehabilitation of the April Fifth Movement, however, this volume was no longer a private undertaking as the editors had planned, but became an official project endorsed by China's top leaders. While no authorship of the individual photos is explicitly identified, the volume's title page bears a dedication by Hua Guofeng, then the Chairman of the Chinese Communist Party. The volume thus helped Hua gain public support and legitimated his mandate. This official patronage also brought unexpected fame to the editors, whose "heroic deeds" were reported in newspapers, and who were invited to join the mainstream Association of Chinese Photographers. No longer considering themselves

94

FIG. 6.4: FIRST *Nature, Society and Man* exhibition, SUN YAT-SEN PARK, BEIJING, 1979.

amateurs, they now took photography seriously as a lifelong pursuit. Disillusioned by the official hijacking of their project, however, they turned away from political involvement to the pursuit of an artistic photography outside the government's agendas. Li Xiaobin recalled that right before the publication of *People's Mourning*, he and Wang Zhiping took a trip to the Old Summer Palace (Yuanming Yuan) to photograph the famous ruins there. While there, Wang suddenly turned to him and said: "Let's stop making a career in politics. Let's just create art and organize our own exhibitions!"[7] This idea soon spread to other members of the group, and in early 1979, they established the April Photo Society. The club's first exhibition, *Nature, Society and Man*, opened in April.

Two photographic groups or "salons" in Beijing formed the core of the April Photo Society. One group—most of whom had taken part in the *People's Mourning* project—met regularly in Wang Zhiping's small apartment in the eastern part of the city. The other group, formed as early as the winter of 1976, had thirty to forty members who gathered every Friday evening in the dorm of the young photographer Chi Xiaoning in the western part of the city (the dorm belonged to the Northern Film Studio). The spiritual leader of this second group, known to its members as *Xingqiwu Shalong*—the Every Friday Salon—was Di Cangyuan, a special effects photographer working in Beijing's Science Film Studio. Di's younger followers admired his extensive knowledge in the history of photography, and he served as the main lecturer in the group's meetings. Other photographers, film directors, and artists were also invited as guest speakers, attracting young artists citywide, among whom Wang Keping, Huang Rui, Gu Cheng, and A Cheng would soon emerge as representative avant-garde artists and writers of their generation. In addition to these gatherings, the members of the group took photographing trips together to various sites around Beijing, and displayed their works in Chi Xiaoning's dorm.[8]

Organized by the April Photo Society, the *Nature, Society and Man* exhibition opened in Beijing's Sun Yat-sen Park on April 1, 1979. Consisting of two hundred eighty works by fifty-one artists (many of whom called themselves amateurs), this unofficial exhibition created a sensation in China's capital.[9] The audience packed the small exhibition hall from morning to night (FIG. 6.4); enthusiasts visited the show multiple times, copying down every word that accompanied the images. According to a report, two thousand to three thousand people visited each weekday, while more than eight thousand people showed up on a Sunday. Curiously, introductions to contemporary Chinese art rarely mention this exhibition even in passing. Instead, their authors have paid much attention to another unofficial exhibition held the same year in Beijing: the *Stars Art Exhibition (Xingxing meizhan)* organized by a group of avant-garde painters and sculptors. The *Stars* exhibition openly attacked Mao's dictatorship, while the apolitical, formalist works in *Nature, Society and Man* challenged the Party's control

FIG. 6.5: JIN BOHONG, *The Echoing Wall*, black-and-white photograph, a work in the first *Nature, Society and Man* exhibition, 1979.

over visual art mainly in the domain of aesthetics. This difference in focus explains the differing critical attention to these two exhibitions. The exhibition's preface, written by Wang Zhiping, made the focus of *Nature, Society and Man* explicit:

> News photos cannot replace the art of photography. Content cannot be equaled with form. Photography as an art should have its own language. It is now time to explore art with the language of art, just as economic matters should be dealt with by using the methods of economics. The beauty of photography lies not necessarily in "important subject matter" or in official ideology, but should be found in nature's rhythms, in social reality, and in emotions and ideas.[10]

Works in the exhibition reflected two main interests in representing nature and society. Many of the images guided the audience to meditate on the beauty and serenity of landscape; other images offered glimpses into people's emotional states and daily lives (FIG. 6.5). None of the works broke new ground in artistic representation, but their mild humanism and aestheticism were extremely fresh and had a tremendous appeal to the public. Only by juxtaposing these works with the Cultural Revolution can one understand their significance and effect: in a country where art had been reduced to political propaganda for an entire decade, any representation of private love, abstract beauty, or social satire was considered revolutionary (FIG. 6.6). When some official critics disparaged this exhibition for its "bourgeois tendency" and lack of "Communist spirit," it attracted even more people from all levels of society, who saw it as "an unmistakable sign of the beginning of a cultural Renaissance."[11]

THE NEW WAVE MOVEMENT (1980-1989)

The April Photo Society organized two more *Nature, Society and Man* exhibitions in 1980 and 1981 (FIG. 6.7). On the surface, both exhibitions continued the success of unofficial photography in China: the number of participating artists doubled, each show attracted thousands of visitors, and the 1981 exhibition was even admitted into the National Art Gallery. On a deeper level, however, the two shows no longer retained the provocative edge of the 1979 exhibition. As the Cultural Revolution was gradually becoming a past memory, amateur photography could no longer create a big stir by simply filling up a cultural void. In addition, the April Photo Society's advocacy of "art photography" led to

FIG. 6.6: WANG MIAO, *Inside and Outside the Monkey Cage*, BLACK-AND-WHITE PHOTOGRAPH, A WORK IN THE FIRST NATURE, SOCIETY AND MAN EXHIBITION, 1979.

formalism and, in the worst cases, to a pretentious, stylized Salon style. Although some works in these two exhibitions dealt with serious social problems and reached a new level of artistic sophistication (FIG. 6.8), many images were overtly sentimental or packed with vague philosophical concepts. The photographers' attempts at abstract patterns and painterly effects often vitiated their spontaneous feelings for their subjects. Looking back, the critics Li Mei and Yang Xiaoyan attributed this to, among other factors, the artists' insufficient knowledge of the history of photography and their confusion between art and commercial photography.[12] Additionally, the changing locations of the three *Nature, Society and Man* exhibitions indicate that, by 1981, this series had been accepted by the authorities and that the April Photo Society had largely merged with the mainstream.

The second and third *Nature, Society and Man* exhibitions, however, had a specific significance in triggering the nationwide movement known as the Photographic New Wave. While the first show was held only in Beijing, these two later exhibitions traveled to cities around the country and inspired photographers in these places to carry out similar projects. Numerous local photography clubs and exhibitions emerged from the early 1980s onward. In Xi'an, for example, a group of young amateur photographers founded the Four Directions Photo Club (*Sifang yinghui*), and in Guangzhou, *Everyone's Photography Exhibition (Renren yingzhan)* attracted a huge crowd. Additional influential local photography clubs appeared around the mid-80s, including the Shaanxi Group based in Xi'an (*Shaanxi qunti*) and Shanghai's North River League (*Beihemeng*). But, Beijing remained the center of this movement. According to a report, more than a hundred photo clubs were founded there in the early and mid-80s and many unofficial exhibitions were organized on different levels during this period.[13] The two most important Beijing groups were the Rupture Group (*Liebian qunti*) and the Modern Photo Salon (*Xiandai sheying shalong*). By organizing three influential exhibitions from 1985 to 1988, the latter became the flagship of the New Wave movement during this period.

Compared with the April Photo Society artists, members of these later groups demonstrated much greater familiarity with Western photography. Their exhibitions were populated with images modeled upon almost all major styles of Western photography invented since the turn of the twentieth century. While the pursuit of qualities associated with fine art—pictorialism, abstraction, and technical perfection—continued to motivate many photographers, others, especially those of Beijing's Rupture Group and Shanghai's North River League, embraced symbolism and psychoanalysis. Their bizarre and absurd images, conceived as direct outcomes of intuition and irrationality, betray a sense of alienation

FIG. 6.7: SOME PUBLICATIONS OF THE SECOND *Nature, Society and Man* EXHIBITION, 1980, BEIJING.

from society (FIG. 6.9). Photographers concerned with so-cial issues found their models in the tradition of Western documentary photography. Inspired by works of Walker Evans, Dorothea Lange, Margaret Bourke-White, and Robert Frank—to name just a few—they began docu-menting neglected aspects of Chinese society and started a documentary turn that would dominate the New Wave movement from the mid-80s to the early '90s.

Such pluralism—one of the most important features of the Chinese cultural world of the '80s—was closely related to an information explosion during the early to mid-80s, when all sorts of so-called decadent Western art forbidden during the Cultural Revolution was introduced to China through reproductions and exhibitions. Hundreds of theoretical works by authors, from Heinrich Wölfflin to Jacques Derrida, were trans-lated and published in a short period. Images by Western photographers from Alfred Stieglitz to Cindy Sherman were reproduced in books and magazines, often accom-panied by historical or theoretical discussions. These texts and images aroused enormous interest among younger artists and greatly inspired their work. It was as if a cen-tury of Western art had been re-staged in China. The chronology and internal logic of this Western tradition was less important than its diverse content as visual and intellectual stimuli for hungry artists and their audience.

FIG. 6.8: LI JINGSONG, *Don't Forget Children*, BLACK-AND-WHITE PHOTOGRAPH, A WORK IN THE SECOND *Nature, Society and Man* EXHIBITION, 1980.

Thus, styles and theories that had long become history to Western art critics were regarded as con-temporary by Chinese artists and used as models. In other words, the meaning of these Westernized Chinese works was located not in the original significance of their styles, but in the transference of these styles to a different time and place.

Major vehicles for such reproductions and translations were popular photo journals and mag-azines, which increased rapidly in number and kinds throughout the '80s. Among these, *In Photogra-*

phy (Xiandai sheying) started in 1984 and soon became the most popular reading material of younger photographers. Published not in a political center like Beijing but in the new economic zone of Shenzhen, *In Photography* was under less scrutiny from official censorship, and its editors enjoyed greater freedom to determine its content. Indeed, the journal's two major goals, announced in the "Words From the Editors" in the first issue, were "to introduce exemplary works of foreign photographers" and "to promote experimentation and invention in domestic photography." This dual direction set a model for similar publications, which mushroomed in the following years. When another new journal, *Chinese Photographers (Zhongguo sheyingjia)*, was founded in 1988, its foreword included this humorous survey of the field:

> Speaking about today's photography, it is really as hot as this month's (July) weather. Its speedy expansion, enforced by a growing crowd of "feverish friends," has led to an increasing number of publications on photography. In addition to the two leading photo weeklies in Shanxi and Beijing (*People's Photography* and *Photo Newspaper*), there are journals and magazines of every orientation and style. For the popular audience, there is *Mass (Mass Photography)*; for the elite, *China (China Photography)*. For the avant-garde, Modern (*Modern Photography, or In Photography*) is the pioneer; for the experimental type, *Youth (Youth Photography)* leads the pack. On the conservative, leftist side you have *International (International Photography)*; on the more liberal, rightist side there is *World* (The World of Photography). Looking at this extensive list, one would be crazy to add another new title to it.[15]

FIG. 6.9: YOU ZEHONG, *Untitled*, BLACK-AND-WHITE PHOTOGRAPH, 1986.

Nevertheless, the writer of this foreword tried to justify the launching of *Chinese Photographers*. According to him, there was still much room for new publications, especially if they offered more concentrated studies of individual photographers. This agenda, adopted as the mandate of this new journal, indicated a shift of interest from acquiring general knowledge in world photography to developing close analyses of individual styles. Other Chinese photography journals published in 1988 reveal similar tendencies. The straightforwardly titled *Photography (Sheying)*, published in Shenzhen that year, organized its first issue around six foreign photographers and seven experimental Chinese photographers. Even the veteran *In Photography* subtly changed direction. No longer offering short introductory essays on such general topics as abstract photography or surrealist photography, its 1988 issues focused on cutting-edge photographers and their works.

This shift, in turn, indicated that by the late '80s, photography in China had basically "caught up" with the rest of the world. A considerable number of photographers, having practiced for a decade, had established track records that showed continuous artistic development. The intensive introduction to the history of photography, conducted by a host of popular journals and magazines over several years, much improved the

public understanding of this art. Several large-scale conferences on photography, taking place in Wuhu, Xi'an, Hangzhou, and other cities from 1986 to 1988, further helped bring the study of photography and photographic theory to a new level. These meetings included discussions of such issues as the subjectivity of photography, the return to realism, and the relationship between photographic theory and general aesthetics. While most papers presented in these conferences dealt with theoretical matters, some scholars and critics began to summarize recent experiences of Chinese photography in the form of historical surveys.[16]

<div align="center">A DOCUMENTARY TURN</div>

Documentary photography came to dominate the New Wave movement in the second half of the '80s.[17] Like those of the documentary movement in the '30s in the United States, Chinese documentary works were closely related to the social and political contexts of their time; their content, form, and tropes served the social programs that the photographers aspired to undertake. Generally speaking, these works followed two main directions, both reacting against the Party's propaganda art during and after the Cultural Revolution. The first developed as a branch of native soil art (*xiangtu meishu*), an important artistic genre in the '80s that advocated representations of ordinary people and what the photographers saw as the timeless spirit of Chinese civilization. The second direction echoed scar art (*shanghen meishu*) and scar literature (*shanghen wenxue*), focusing on human tragedies in Chinese society.

Both trends started in the late '70s. One of the earliest native soil photographic projects was conducted by Zhu Xianmin, who made eight trips to his hometown on the Yellow River (commonly considered the cradle of Chinese civilization) from 1979 to 1984 to photograph local people and their lives. When photo clubs emerged in the provinces in the early and mid-80s, many of them took as their mission "the search for the roots of our national culture." Among these clubs, the earliest and most famous was the Shaanxi Group (also known as Xibeifeng or the Northwest Wind), whose motto "back to the real" (*fugui xianshi*) provided an explicit counter to Mao's futuristic revolutionary realism (FIG. 6.10). This approach was also accepted by photographers in major cities. Wang Zhiping and Wang Miao, veterans of unofficial photography in Beijing, joined this trend and conducted prolonged field survey in rural west China. When their photographs appeared in a 1985 issue of *In Photography*, the accompanying text was welcomed by fellow photographers as a manifesto for this type of documentary photography. They wrote: "We believe that genuine beauty, greatness, and eternity can only exist in the depth of ordinariness...We try to portray you (i. e. China) with our response to your real appearance, not to give you a smiling face found on every fashion magazine's cover."[19] At this point, however, what was imagined to be records of real people began to take on overarching symbolic significance, and the

FIG. 6.10: WU JUN, *Drunk*, BLACK-AND-WHITE PHOTOGRAPH, 1985.

photographers, driven by idealism, adapted a rhetoric that verged on nationalist propaganda.

Both kinds of documentary photography emphasized a plain, down-to-earth style and played down the photographer's mediation between reality and representation. The native soil type produced ahistorical, romantic images with a strong ethnographic interest, while the scar type was by nature historical and critical, visualizing recent Chinese history as a series of discrete images that spoke of human experience during social or natural disasters. In many cases, images of this second type recorded historical events that would otherwise have been lost. This is why some writers have traced this type to the April Fifth Movement in 1976.[20] Made by amateurs, these unpolished images nevertheless preserved traces of a distinct moment in modern Chinese history; the memory clinging to them gave them an almost talismanic quality (see FIGS. 6.1, 6.2). These April Fifth photographs also initiated another important tradition associated with this type of documentary photography: the rhetoric of an emotional language that has come to regulate the perception and evaluation of documentary images. According to this rhetoric, visual records of historical events or social phenomena are expected to be direct, powerful, and moving, evoking strong emotional responses from viewers.

FIG. 6.11: LI XIAOBIN, *Shangfangzhe—People Pleading for Justice from the Higher Authorities*, COLOR PHOTOGRAPH, 1977.

Sophisticated works from this historical, critical tradition of documentary photography began to emerge in the late '70s. Continuing the April Fifth legacy, some photographers developed projects to depict aspects of Chinese society that had eluded artistic and media representations. One such project was Li Xiaobin's *Shangfangzhe—People Pleading for Justice from the Higher Authorities*. It dealt with an important social phenomenon ignored by most artists and reporters: tens of thousands of such *shangfangzhe*, often victims of the Cultural Revolution in remote areas, flooded Beijing's streets from 1977 to 1980. Unable to find justice through the local judiciary systems, they went to the Chinese capital to

FIG. 6.12: WU JIALIN, *People of Baowei*, BLACK-AND-WHITE PHOTOGRAPH, 1991.

FIG. 6.13: YU DESHUI, *Native Land: A Wandering Spirit*, BLACK-AND-WHITE PHOTOGRAPH, 1987.

present their cases directly to the central government. Traumatized and exhausted, they waited for weeks and even months outside the Justice Department, Ministry of Internal Affairs, or Department of Public Security, hoping to receive a response to their appeals. Few of them succeeded in achieving even this most rudimentary goal, however, so they continued to wait, often until they were forced to return home. Li Xiaobin took about a thousand photographs of these homeless and hopeless people.[21] One of his pictures—arguably the most poignant work of Chinese documentary photography from this period—captures the image of a haggard *shangfangzhe* wandering next to Tiananmen Square (FIG. 6.11). Eyes unfocused, he seems disoriented and in a trance. Yet he still has several large Mao buttons—symbols of loyalty towards the Chairman during the Cultural Revolution—pinned on his tattered clothes. This image aroused strong reactions—both sympathy and reflection—after its publication. Many viewers sensed in it an implicit criticism of Communist rule, which had ruined millions of people's lives and abused their hopes for a better China. Once again, a documentary image became a visual symbol, with a meaning extending far beyond the photograph's specific content.[22]

FIG. 6.14: YUAN DONGPING, *Mental Hospital*, BLACK-AND-WHITE PHOTOGRAPH, 1989.

These two types of documentary photography developed in parallel and were featured abundantly in photography publications and exhibitions after 1985.[23] What followed was an intense search for new documentary subjects by individual artists. A specific subject often came to distinguish a particular photographer.[24] Wu Jialin became known for his ethnographic images of the Wa people in Yunnan (FIG. 6.12), Yu Deshui won several prizes for recording lives along the Yellow River (FIG. 6.13), and Lü Nan and Yuan Dongping spent years photographing mental patients in asylums around the country (FIG. 6.14). Later Lü discovered a new subject in underground, rural Catholic churches, while Yuan embarked on a large project entitled *People of Poverty (Qiongren)*. Works by the last two photographers synthesized scar and native soil traditions, and therefore also departed from both. Their subjects—mental patients, blind and retarded children, dysfunctional elderly people, and the homeless—are ordinary, but they are also wounded and ignored. Their problems are not caused by particular political or social events; in fact the reasons for their injuries are relatively unimportant in these works. One can no longer find in them the tension-ridden scenes of confrontation in Li Xiaobin's social images, while the romantic aestheticization of the ordinary in native soil art is also avoided. The artists have moved away from the earlier narrative or poetic modes and have relied instead on a less impassioned mode of presentation that allows the images to speak for themselves.

Related to the search for new documentary subjects but also to the rapid transformation of the Chinese city, an increasing number of photographers were attracted to urban scenes—the changing cityscape, the ruins of traditional buildings and lifestyle, the invasion of Western culture and the market economy, and the new urban population and occupations. Their initial works, however, immediately exposed the limitation of the conventional documentary style, which was supposed to be naturalistic and objective, and at odds with the transient nature of the contemporary city and the photographers' self-involvement in urban lives. Consequently, some photographers, such as Gu Zheng, Mo Yi, and Zhang Haier, began to develop new concepts and languages

FIG. 6.15: ZHANG HAIER, *Self-portrait*, BLACK-AND-WHITE PHOTOGRAPH, 1987.

FIG. 6.16: ZHANG HAIER, *Bad Girl*, BLACK-AND-WHITE PHOTOGRAPH, 1989.

103

that would allow them not only to represent an external reality but also to respond to this reality.[25] Among them, Zhang Haier most successfully made the transition from documentary photography to conceptual photography. Combining a flash with slow shutter speed, his images of Guangzhou's street scenes seem both real and artificial; from the dark background his distorted and blurry face emerges, screaming toward the camera (FIG. 6.15). Zhang's portraits of Guangzhou prostitutes were the earliest such images, which later became a sub-genre in urban representations (FIG. 6.16). Instead of detaching himself from his subjects as a typical documentary photographer would do, he made his communication with these young women the real point of representation. Looking at these images is to look into the prostitutes' eyes; and there we find the photographer's silent existence.[26]

At this point, toward the end of the '80s, the New Wave movement had largely accomplished its mission of restoring photography's status as an art in China. A new kind of photography was emerging that allied itself with the burgeoning avant-grade art.[27] Almost instantly, it caught the attention of the international art world, as Zhang Haier and four other young photographers were invited to participate in the 1988 Arles Photography Festival in France. Such interest from abroad encouraged other Chinese photographers to explore new territories beyond documentary photography and art photography. While Chinese photography seemed to be entering a new stage, this development was suddenly halted by a political event: the government's violent suppression of the June Fourth Movement (the pro-democracy student demonstration in Tiananmen Square that ended in bloodshed on June 4, 1989). Avant-garde art was banned afterwards. For the next two to three years, no ground-breaking photography exhibitions were organized, and existing photographic journals only featured works devoid of political and artistic controversy. In this atmosphere, art photography and documentary photography were both tamed to become part of the official establishment. This period of repression created a significant gap in contemporary Chinese photography. When a new generation of photographers reemerged in the early and mid-90s, their challenges were not only to create new images but also to reinvent their identity as independent artists.

EXPERIMENTAL PHOTOGRAPHY (EARLY '90S TO THE PRESENT)

Like experimental art, experimental photography in China is a specific historical phenomenon defined by a set of factors, among which the artist's social and professional identity is a major one.[28] Chronologically, this photography first emerged in the late '80s, but only became a trend as of the early to mid-90s.[29] Before this, photography had basically developed within the self-contained field of Chinese photography (*Zhongguo sheying*), constituted by various art institutions including schools

FIG. 6.17: *The First Document Exhibition*, 1991, Beijing.

FIG. 6.18: RONG RONG, *East Village*, BLACK-AND-WHITE PHOTOGRAPH, 1994.

and research institutes, publishers and galleries, and various Associations of Chinese Photographers within the state's administrative system.[30] Even though amateur and unofficial photographers played a leading role in the New Wave movement, in their effort to reinvent these institutions they eventually had to join them.

This situation underwent a fundamental change in the '90s, when a group of young photographers organized communities and activities outside the institutions of Chinese photography. They owed their independent status, to a large extent, to their educational and professional backgrounds. Some of them were self-taught photographers who collaborated with experimental artists, others began their careers as avant-garde painters and graphic artists, but later abandoned brushes and pens for cameras. In either case they had few ties with mainstream photography, but constituted a sub-group within the camp of experimental artists. As concrete proof of this identity, these photographers often lived and worked together with experimental artists, and showed their works almost exclusively in unofficial experimental art exhibitions.[31] Unlike the amateur photographers of the '70s and '80s whose career paths often ended with appointments in professional institutions, the experimental photographers of the '90s insisted on their outsiders' positions even after they became well-known. This was possible because Chinese experimental art was rapidly globalizing during this period, appearing frequently in international exhibitions and also becoming a commodity in the global art market.[32] In this new environment, experimental photographers could claim an independent or alternative status domestically, while collaborating with international museums, curators, and dealers abroad.

Three events in the first half of the '90s played pivotal roles in the formation of this new unofficial photography. The first was the organization of a series of *Document Exhibitions (Wenxian zhan)* that helped sustain artistic experimentation during a difficult period: responding to the official prohibition of avant-garde art instituted immediately after the June Fourth Movement, a group of art critics designed this exhibition format in 1991 (FIG. 6.17) (the second and third shows were held in 1992 and 1994, respectively). Consisting of photographic records and reproductions of recent works by unofficial artists, it traveled to different cities and provided an important channel of communication between these artists throughout the country. Although the organizers of this series defined the exhibited images as documents, not real art objects, to the participating artists the photographs, especially those recording performances and temporary installations, *were* their works. The situation became more complex when a performance was photographed not by the artist but by a collaborating photographer. Questions about such an image included whether it was an unmediated record of the original art project,

or should it also be considered a creative work of the photographer. This and other questions led to discussions and debates about the nature of art mediums and about photographic representations of other art forms specifically. Not coincidentally, the third *Document Exhibition* had the subtitle *Revolution and Transformation of the Art Medium (Meiti de biange)*. The debate about the authorship of performance photography finally subsided in the late '90s. Many performance artists began to document their own works, assuming the function of a photographer, while an increasing number of experimental photographers designed and conducted performances for photographing. Both approaches reflect a further internalization of interactions between different art forms and mediums.

FIG. 6.19: ZHANG PEILI, *Continuous Reproduction*, BLACK-AND-WHITE PHOTO-GRAPH, 1993.

The second landmark event in the development of experimental photography was the establishment of the East Village—a community of experimental painters, performance and installation artists, and photographers on the eastern fringe of Beijing (FIG. 6.18).[33] Most of these artists were immigrants from the provinces, who moved into this tumbledown village from 1993 to 1994 for its cheap housing, and soon discovered their common interests and began to conduct collaborative art projects.[34] They also developed a close relationship to their environment—a polluted place filled with garbage and industrial waste—as they considered moving there an act of self-exile. The most crucial significance of the East Village community, however, lies in its formation as a close alliance of performing artists and photographers who inspired each other's work by serving as each other's models and audience. Many memorable photographs from this period, such as Xing Danwen's and Rong Rong's records of avant-garde performances by Zhang Huan, Ma Liuming, and Zhu Ming, directly resulted from this alliance. Viewed in the context of experimental Chinese art, however, this alliance also initiated one of the most important developments in this art from the mid-90s, when experimental artists working in different mediums increasingly envisioned and designed their works as performances, and when many of these artists were also increasingly attracted to photography, not only deriving inspiration from it but also making photographs themselves.

The third event was the appearance of new types of experimental art publications. After the June Fourth Movement, the two most influential journals of avant-garde art in the '80s—*Chinese Fine Arts Weekly (Zhongguo meishu bao)* and *Trends in Art Theory (Meishu sichao)*—were banned by the government; the existing art journals largely avoided controversial issues for political security. In response, some unofficial artists and art critics launched their own publications to facilitate the development of experimental art.[35] Among these publications, the most daring one was an untitled volume known as *The Book With a Black Cover (Heipi shu)*. Privately published by Ai Weiwei, Zeng Xiaojun, Zhuang Hui, and Xu Bei in 1994, it introduced a new generation of experimental Chinese artists to the world. Significantly, the volume featured photography as the most important medium of experimental art: readers found in it the earliest reproductions of East Village performance photographs, as well as conceptual photographic works by Zhang Peili, Geng Jianyi, Ai Weiwei, Lu Qing, Zhu Fadong, and Zhao Bandi (FIGS. 6.19, 6.20). Avant-garde serials dedicated exclusively to photography only appeared in 1996 as represented by *New Photo (Xin sheying)* (FIG. 6.21). Lacking both the money for printing and

a license for public distribution, its two editors, Liu Zheng and Rong Rong, resorted to high quality photocopying and produced only twenty to thirty copies for each issue.[36] The first issue bore a preface entitled "About 'New Photography,'" which defined this art in terms not of content or style but of the artist's individuality and alternative identity. This definition changed a year later, however, as the two-sentence introduction to the third issue declared:

> When **concept** enters Chinese photography, it is as if a window suddenly opens in a room that has been sealed for years. We can now breathe comfortably, and we now reach a **new** meaning of "**new** photography." (original boldface)

This statement reflected an important change in 1997, when experimental Chinese photography came to be equated with conceptual photography. Until then, experimental photographers had identified their art mainly through negation—they established their alternative position by divorcing themselves from mainstream photography.[37] But now they also hoped to define experimental photography as an art with its own intrinsic logic, which they found in the theories of conceptual art. This theoretical interest prompted them to form a new discussion group—the Every Saturday Photo Salon (Xingqiliu sheying shalong)—in September 1997. The exhibition they organized in conjunction with the Salon's first meeting, entitled *New Photographic Image (Xin yingxiang)* and held in a theater near the Pan-Asian Sports Village in north Beijing, was the first comprehensive display of Chinese Conceptual Photography.[38] Dao Zi, the project's academic advisor, wrote a highly theoretical treatise for this exhibition, interpreting "new image" photography as a conceptual art advanced by avant-garde Chinese artists under China's postcolonial, postmodern, and postautocratic conditions.[39]

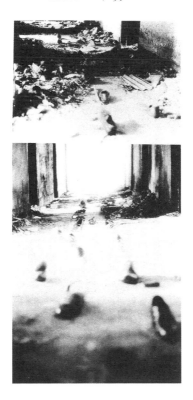

FIG. 6.20: GENG JIANYI, *Building No. 5*, BLACK-AND-WHITE PHOTOGRAPH, 1992.

It would be wrong, however, to conceive of experimental photography in the '90s as comprised of two discrete stages separated by this theorization process. In fact, although lacking a clearly articulated self-awareness, the rise of experimental photography in the early and mid-90s already implied a movement toward conceptual art, which gave priority to ideas over representation. Throughout the '90s and early '00s, experimental photographers also continuously found guidance in postmodern theories, and conducted experiments to deconstruct reality. No longer interested in capturing meaningful moments in life, they instead focused on the manner or vocabulary of artistic expression, and fought hard to control the situation within which their works were viewed. This emphasis on concept and display has led to a wide range of constructed images; the situation can be compared with American conceptual photography in the '70s, described by the poet and art historian Corinne Robins in these words:

Photographers concentrated on making up or creating scenes for the camera in terms of their own inner vision. To them... realism belonged to the earlier history of photography and, as seventies artists, they were embarked on a different kind of aesthetic quest. It was not, however, the romantic symbolism of photography of the 1920s and 1930s, with its emphasis on the abstract beauty of the object, that had caught their atten-

tion, but rather a new kind of concentration on narrative drama, on the depiction of time changes in the camera's fictional moment. The photograph, instead of being presented as a depiction of reality, was now something created to show us things that were felt rather than necessarily seen.[40]

Taking place twenty years later, however, a "replay" of this history in China during the '90s has produced very different results. Backed by postmodern theories and utilizing state-of-the-art technology, experimental Chinese photography more actively interacted with other art forms including performance, installation, sculpture, site-specific art, advertisement, and photography itself, transforming pre-existing images into photographic "re-representations."[41] Again, this tendency first surfaced in the early and mid-90s; although some emerging experimental photographers at the time (such as Rong Rong and Wang Jinsong) seemed to continue the straight, documentary tradition, their works actually reconfigured fragmentary, accidental images and inscriptions into new compositions and narratives (FIG. 6.22). Liu

FIG. 6.21: *New Photo* magazine, THE FIRST ISSUE, 1996.

Zheng, on the other hand, photographed manufactured figures including mannequins, statues, wax figures, and live tableaux, and mixed such photographs with images in the conventional documentary style. The layering of representations in this assemblage effectively erased any sense of real existence and experience.[42] While these three artists approached reality as a deposit of readymade photographic materials, towards the late '90s and early 2000s (and hence encouraged by the definition of experimental photography as conceptual art), more and more artists created objects or scenes as the subjects of photographs. Such projects, ranging from Wu Xiaojun's sculpted puppet show to Wang Qingsong's computer-generated monuments, and from Hong Lei's painted-over images to Zhao Shaoruo's reconstructed historical photographs, have constituted the majority of experimental photography since 1997.

FIG. 6.22: WANG JINSONG, *A Hundred "Chai" – "To Be Demolished,"* COLOR PHOTO-GRAPH, DETAIL, 1999.

This type of constructed photography could be seen as performance, not only because it involves actual performances and displays elaborate technical showmanship, but also because it takes theatricality as a major point of departure. Artists' interest in visual effect became increasingly stronger after 1997. If earlier conceptual photographers, such as Geng Jianyi and Zhang Peili, enhanced the conceptual quality of their works by repressing visual attractiveness (see FIG. 6.19), visitors to today's exhibitions of Chinese photography are often overpowered by the works' startling size and bold images, which not only rely on new imaging technologies but, more importantly, reveal the photographers' penchant for such technologies (FIG. 6.23).[43] To students of experimental Chi-

FIG. 6.23: FENG FENG, *Shin Brace*, COLOR PHOTOGRAPH, 1999-2000, SHOWN IN THE FIRST GUANGZHOU TRIENNIAL, GUANG-ZHOU, 2002.

nese photography (and experimental Chinese art in general), this two-fold interest in performance and technology is extremely important, because it reveals an obsessive pursuit of *dangdaixing* or contemporaneity.

Here, contemporaneity does not simply pertain to what is here and now, but is an intentional artistic construct that asserts a particular historicity for itself. It may be said that this construct is the ultimate goal of experimental Chinese art.[44] To make their works contemporary, experimental artists have most critically reflected upon the conditions and limitations of the present, and have conducted numerous experiments to transform the present into individualized references, languages, and points of view. Their pursuit of contemporaneity continuously underlies their fascination with postmodern theories, startling visual effects, and state-of-the-art technology. The same pursuit also explains the content of their works, which deliver unambiguous social and political messages and express strong assertions of individuality and self-identity. In fact, these works can be properly understood only when we associate them with China's current transformation, the ongoing process of globalization, and the artists' visions for themselves in a changing world. The four sections of *Between Past and Future: New Photography and Video from China*, focusing on history and memory, self, the body, and people and place, encapsulate some of the major themes of these works.

HISTORY AND MEMORY

Works in the first section of this exhibition refer to China's history and represent collective and individual memories, reflecting the artists' particular historical visions and artistic aspirations. Some of these images feature famous historical sites, particularly the Great Wall and the Forbidden City, important symbols of Chinese civilization and the nation. Both Hong Lei and Liu Wei take the Forbidden City as their subject. Hong's carefully crafted scenes of a mutilated bird lying in the former imperial palace fuse traditional melancholy with the contemporary fascination with violence. Liu's computer-generated images derive inspiration from traditional puppet theater to allude to a court intrigue. Miao Xiaochun and Ma Liuming have both photographed themselves in conjunction with the Great Wall. Miao envisions himself as a gentleman from the past who reencounters the Wall as a historical ruin in the contemporary world. Ma Liuming's photograph records one of his performances, in which he walked stark naked along the Wall till his feet bled. Entitled *Fen. Ma Liuming Walks on the*

Great Wall, the performance was conceived as an interaction between the artist's androgynous alter-ego (Fen. Ma Liuming) and the national monument. With long hair, an expressionless face made up with cosmetics, and supple limbs exposed in abandon, this constructed self-image heightens his sexuality and independence.

In contrast to such works that contemplate China's nationhood and cultural origins, some images in the exhibition resurrect dark, painful memories from the country's past. Wang Youshen's *Washing: The Mass Grave at Datong in 1941* is one of the most poignant examples in this group. This installation consists of newspaper pages on the wall and photographic images in two large basins under circulating water. The newspaper reports the discovery of the remains of thousands of Chinese who were buried alive by Japanese soldiers during World War II. The images in the basins represent these remains. "The water washes the image away," the artist explained, "just as time has washed people's memories clear of this atrocity that occurred fifty years ago."[45] Like Wang Youshen, Sheng Qi's interest lies in the historicity and vulnerability of printed images—and hence the existence and impermanence of the history and memory that they preserve. A series of photographs by Sheng represents his mutilated hand holding tiny photographs of Mao, his mother, and himself as a young boy. While his damaged body (he cut off one of his fingers in 1989) commemorates the June Fourth Movement, the black-and-white photos are remains of a more distant past associated with his childhood.

Many experimental art projects from the '90s were related to the artist's memories of the June Fourth Movement. Song Dong's *Breathing* offers an exceptionally powerful example of this type. The two images in this mini-sequence record a bipartite performance, with the first designed as a tribute to the ill-fated June Fourth Movement.[46] The picture was taken on New Year's Eve, 1996. Holiday lights outlined Tiananmen in the distance. Song Dong lay prone and motionless in the deserted Tiananmen Square, breathing onto the cement pavement for forty minutes. On the ground before his mouth a thin layer of ice gradually formed, leaving no visible trace. I offered this interpretation of the performance photograph when it was first shown at the Smart Museum of Art in Chicago:

> [Unlike some early works in experimental Chinese art] Song Dong is no longer staging a real or pretend suicide in *Breathing*. Instead he tries to inject life into the deserted square, thereby bringing us to those brief moments in history when the square was transformed into a "living place." It reminds us that in 1996 the square still remained an unfeeling monolith. *Breathing* not only represents a continuing effort to challenge this monolithic power but also demonstrates the extreme difficulty of making any change: all Song Dong's effort produced was a tiny pool of ice, which disappeared before the next morning.[47]

Both Sheng Qi and Song Dong connect the present to the past by evoking personal memories. Hai Bo's series of portraits more specifically forge memory links in the national psyche. Each series juxtaposes two photographs taken several decades apart. The first, an old group photo, was taken during the Cultural Revolution and shows men or women in Maoist or army uniforms; their young faces glow with their unyielding beliefs in Communism. The second picture, taken by Hao Bo himself, shows the same group of people—or in some cases, the surviving members—twenty to thirty years later. The contrast between the images often startles viewers. In an almost graphic manner, the two images register the passage of time and stir up viewers' personal memories.

Historical memory is also the subject of Xing Danwen's *Born with the Cultural Revolution* and the photo installation *Women.Here* by Sui Jianguo, Zhan Wang, and Yu Fan, but these two works give fuller accounts of the lives of specific persons and can therefore be considered biographical representations.[48] The creation of the second work responded to the Fourth International Women's Congress held in Beijing in 1995. Many leaders of women's movements around the world participated in the event,

but they were kept separate from ordinary Chinese people. Reacting to such separation, the three artists created *Women.Here* in the form of an experimental art exhibition—an alternative space where, in their words, "an ordinary Chinese woman could become part of the international event and the contemporary movement of women's liberation."[49] The installation/exhibition featured their mothers' and spouses' collections of personal photographs and memorabilia (FIG. 6.24). Compiled into chronological sequences and displayed in a public space, these fragmentary images told the lives of several ordinary Chinese women, unknown to most people beyond their families and work units.

PERFORMING THE SELF AND REIMAGINING THE BODY

Experimental photographers tend to be intensely concerned with their identity. The result is a large group of self-representations, including both self-portraits and images of the body. Consisting of forty-nine works by thirty-two artists, the second and third sections of this exhibition reflect the artists' urgent quest for individuality in a rapidly changing society.

As demonstrated by examples in the

FIG. 6.24: SUI JIANGUO, ZHAN WANG, AND YU FAN, *Women.Here*, PHOTO INSTALLATION, BEIJING, CONTEMPORARY ART GALLERY, 1995.

preceding section, experimental representations of history and memory are inseparable from artists' self-representations and reveal a close relationship between history and self that sets experimental art apart from other branches of contemporary Chinese art. Although academic painters also depict his-

FIG. 6.25: ZHUANG HUI, *Shooting a Group Portrait*, 1997.

torical events—often episodes in the founding of the People's Republic—they approach such subjects as belonging to an external, canonical history. Experimental artists, on the other hand, find meaning in the past only from their interactions with it. When they represent such interactions they customarily make themselves the center of the representation, as in Song Dong's *Breathing* or Ma Liuming's *Fen. Ma Liuming Walks on the Great Wall*. Mo Yi's *Made by the Police Department* is also inspired by the artist's experience during the June Fourth Movement: he was thrown in jail after participating in a demonstration in Tianjin. Unlike Song Dong's and Ma Liuming's performance photographs, Mo's work deconstructs the language of self-portraiture: to express his traumatic experience he repeatedly obscures his face with a white metal column inscribed with the words "Made by the Police Department."[50]

These and others images allow us to generalize four basic representational modes or types. The first is interactive in nature: the artist discovers or expresses him or herself through interacting either with historical sites (the Great Wall and the Forbidden City) or political institutions (Tiananmen Square and the police department). Other works in this group represent the artists' interactions with people in the present, as seen in Zhuang Hui's *Group Portraits*. To Zhuang, taking a picture of an entire crew of four hundred ninety-five construction workers, or of the six hundred-plus employees of a department store requires patient negotiation as well as skilled orchestration (FIG. 6.25). Such interaction with his subjects is the real purpose of his art experiment, whereas the photographs, in which he always appears way over to the side, certifies the project's completion.

The second type of image explicitly displays the body, which experimental artists employ as an unambiguous vehicle for self-expression. This body art was given the strongest expressions in Beijing's East Village, where artists like Zhang Huan, Ma Liuming, Zhu Ming, and Cang Xin developed two kinds of performances characterized by masochism and gender reversal. Ma Liuming's androgynous alter-ego, Fen. Ma Liuming, exemplifies this type. Masochism is a trademark of Zhang Huan—almost every performance he undertook involved self-mutilation and simulated self-sacrifice. In some cases he offered his flesh and blood; in other cases he tried to experience death, either locking himself inside a coffin-like metal case or placing earthworms in his mouth. By subjecting himself to an unbearably filthy public toilet for a whole hour, he not only identified himself with the place but also embraced it. With the same spirit, Zhu Ming designed a performance in 1997 during which he nearly suffocated inside a huge balloon;[51] Yan Lei photographed his beat-up body and face in 1995. Masochistic body representation manifested in more extreme forms in the late '90s, as represented by several works in *Infatuated with Injury*, a private experimental art exhibition held in 1999 in Beijing.[52]

The third type of self-representation also features performances, but the central figure, whether the photographer or a fellow artist, disguises him or herself as a fictional character or transforms him or herself into a symbolic image. A number of works in this exhibition fall into this category, including Hong's *Untitled*, Wang Jin's *A Chinese Dream*, Sun Yuan's *Shepherd*, Hong Lei's *After Liang Kai's Masterpiece "Sakyamuni Coming Out of Retirement"* and *I Dreamt of Being Killed by My Father When I Was Flying Over an Immortal Land*, and Hong Hao's *Mr. Hong Please Come In*, and *Mr. Hong Usually Waits Under the Arched Roof For Sunshine*.

In these last two works, Hong Hao disguises himself as an idealized "global citizen" in popular imagination—a young entrepreneur in an opulent environment served by a white-gloved servant. Examples of Cynical Realism, these images employ an iconography of self-mockery to express a dilemma between globalization and individuality that many experimental Chinese artists face.

Rong Rong's photograph of Cang Xin's performance *Trampling on the Face* represents a complex performative/photographic project that works within several modes of self and body.[53] For the performance, Cang Xin made a mold from his own face, and used it to cast fifteen hundred plaster masks in a month. Each mask bore a white paper strip on the forehead, on which he wrote the time of the

cast's manufacture. He then laid the masks on the ground to fill the entire courtyard of his house, and also hung some masks on the walls as witnesses of the performance. During the performance, guests were invited to walk on the masks to destroy them, until all these artificial faces (of Cang Xin himself) had shattered into shards. Finally he stripped and jumped on the broken masks, using his naked body to fragment them further.

Rong Rong's photograph vividly records this destructive/evocative process. Numerous masks, many of them destroyed, lie behind the figure in the foreground, who holds up a mask to cover his face. The date written on the mask's forehead is "2: 21-26 pm, November 26, 1994." The mask is damaged, with the left eye and a portion of the forehead missing. The figure behind the mask is not Cang Xin, but Ma Liuming, recognizable from his shoulder-length hair and delicate hand. Here Cang Xin and Ma Liuming have interchanged their roles: wearing Cang's face, Ma makes himself a surrogate of the performer and the subject of a simulated destruction. But it was the photographer who designed this performance within a performance as a subject to be photographed.

A fourth mode of self-imaging is that of self-portraiture, which constitutes an important genre in contemporary Chinese experimental art.[54] A common tendency among experimental artists, however, is a deliberate ambiguity in portraying their likeness, as if they felt that the best way to realize their individuality was through self-distortion and self-denial. These ambiguous images are still about the authenticity of the self. But they inspire the question "Is it me?" rather than the affirmation, "It is me!" More than one third of the self-portraits by experimental artists in the 2001 publication *Faces of 100 Artists* use this formula.[55] Many such images, such as Lin Tianmiao's and Jin Feng's self-portraits, make the subject's image blurry, fragmentary, or in the process of vanishing. Lin's digitally generated portrait, four meters high and two and a half meters wide, is out of focus and devoid of hair; the image thus represses the artist's female identity but enhances its own monumentality. Entitled *The Process in Which My Image Disappears*, Jin Feng's self-portrait shows the artist writing *en face* on a glass panel. As his handwriting gradually covers the panel, the letters also blur and finally erase his image.

Other artists employ different methods to deconstruct their conventional images. Yin Xiuzhen's *Yin Xiuzhen*, for example, is a concise biography of the artist, consisting of a series of her ID photographs arranged in a chronological sequence. The portraits have been cut into insoles and installed into women's shoes that Yin Xiuzhen made together with her mother. In so doing, the artist imbued the fragmented images with a sense of vulnerability and intimacy, transforming the standard ID photos into genuine self-expressions. Qiu Zhijie's photos, *Tattoo 1 and 2*, result from his persistent experiments to make his own image transparent.[56] The man standing straight in a frontal pose in both pictures is the artist himself. In one photo, a large character *bu*—meaning "no"—is written in bright red across his body and the wall behind him. Different parts of the character are painted on his body and on the wall. When these parts connect to form the character, they create the strange illusion that the figure's body has disappeared, and that the character has become independent, detached from the body and the wall. In other words, this character rejects the ground and makes the person invisible. The other picture employs a similar technique, with metal dots attached to both the body and the background. While the body again seems to vanish, the repetitive dots form an ever expanding visual field, with neither set boundaries nor clear signification.

Like Yin Xiuzhen's photo installation, these two photos by Qiu Zhijie reflect upon contemporary visual identifications of individuals. The figure's unnatural pose and expressionless face make the photos look like ID pictures. As an artist well-versed in postmodern theories, Qiu Zhijie believes that in this world "individuals have been completely transformed into an information process. Signs and codes have overpowered actual human beings, and our bodies have become merely their vehicles."[57] These two photos illustrate an answer to the artist's question of how to

make such signs and codes—passport photos, archives, etc.—disappear for a second time in an artistic representation.

Works in the last section of this exhibition respond to drastic changes in China's contemporary environment—the vanishing of traditional landscapes and lifestyles, the rise of postmodern cities, new urban cultures, and the large scale migration of populations. Underlying these interests is a generational shift in experimental art: a majority of the artists featured in this section started their careers in the '90s, and have been finally able to bid farewell to the Cultural Revolution and its visual and mental baggage. They can now comment on the Cultural Revolution and the June Fourth Movement as events firmly in the past. At the same time, they directly and rigorously interact with China's current transformation. An important aspect of this transformation, one that attracted many artists' attention, was the rapid development of the city. A striking aspect of a major Chinese metropolis like Beijing or Shanghai in the '90s and early 2000s has been its never-ending destruction and construction. Old houses came down everyday to make room for new hotels and shopping malls. Thousands of people were relocated from the inner city to the outskirts. In theory, demolition and relocation were conditions for the capital's modernization. In actuality, these conditions brought about a growing alienation between the city and its residents: they no longer belonged to one another.

This situation is the context and the content of many works in experimental photography of the '90s. In 1997 and 1998, Yin Xiuzhen was busily collecting what she referred to as "traces of a vanishing present" along the construction site of the Grand Avenue of Peace and Well-Being (*Ping'an Dadao*), an enormous project funded collectively by the Chinese government and individual investors with a total budget of three hundred and fifty million dollars. Envisioned as the second largest east-west road across central Beijing, the avenue took up a broad strip of land, some thirty meters wide and seven thousand meters long, in the most populated section of an overcrowded city. Yin Xiuzhen collected two kinds of materials: images of the houses (and their residents) before they were demolished and roof tiles of the houses after they were demolished. She then used these materials for various installations (FIG. 6.26). Bearing black-and-white photos of the demolished houses, the rows of tiles in this installation have an uncanny resemblance to a graveyard. In fact, we may think of this installation in terms of a mass grave, only the "dead" here are places, not people.

But people have indeed "disappeared" during such demolition and dislocation; and this is exactly the subject of Rong Rong's photographs of Beijing's demolition sites. Devoid of human figures, the half-destroyed houses are occupied by images left on walls, which originally decorated an interior but which has now become the exterior. A pair of dragons probably indicates a former restaurant; a Chinese New Year painting suggests a similarly traditional style. The majority of such "leftover" images are various pin-ups from Marilyn Moroe to Hong Kong fashion models. Torn and even missing a large portion of the composition, these images still exert an alluring power over the spectator—not only with their seductive figures but also with their seductive spatial illusionism. With an enhanced three-dimensionality and abundant mirrors and paintings-within-paintings, they transform a plain wall into a space of fantasy.

These works can be viewed together with photographs by Zhang Dali, the most famous graffiti artist in China, who developed a personal dialogue with Beijing through his art (FIG. 6.27). From 1995 to 1998, Zhang Dali sprayed more than two thousand images of himself—the profile of a shaven head—all over the city, often in half-destroyed, empty houses. He thus transformed these urban ruins into sites of public art, however temporarily. The locations he chose for his performance-photography

FIG. 6.26: YIN XIUZHEN, *Beijing*, PHOTO
INSTALLATION, QUEENSLAND ART
GALLERY, BRISBANE, AUSTRALIA, 1999.

projects often highlight three kinds of comparisons. The first contrasts a demolition site with an official monument. The second contrasts abandoned residential houses with preserved imperial palaces. The third contrasts destruction with construction: rising from the debris of ruined houses are glimmering high-rises of a monotonous, international style.

Zhang Dali's interest, therefore, lies not simply in representing demolition, but in revealing the different fate of demolished residential houses from buildings that are revered, preserved, and constructed. His photographs thus serve as a bridge from Rong Rong's urban ruin pictures to another popular subject of experimental Chinese photography in the '90s—representations of the emerging new cityscape, as seen in Yang Yong's representations of southern Chinese cities such as Shenzhen. Li Tianyuan's striking triptych *Tianyuan Space Station* further demonstrates how the new cityscape can reorient an artist's point of view and stimulate his imagination. The middle panel of the triptych represents Li standing in front of a modern glass building in central Beijing. His blurry image conceals his identity and the building's international style omits any local reference—he could be anyone in any city around the world. The right panel is a microscopic detail from the inside of the human body,

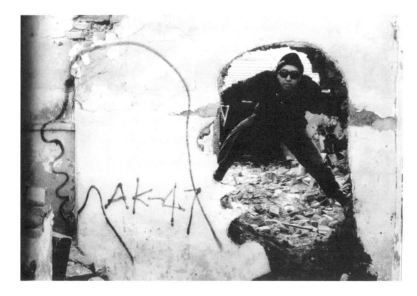

FIG. 6.27: ZHANG DALI AND HIS GRAFFITI
IMAGES IN BEIJING, 1998.

infinitely enlarged to resemble a cosmic abyss amidst a galactic nebula. The opposite left panel presents the view of a returning gaze from the space—an aerophotograph of Beijing. The white circle on this aerial map indicates where the artist stands in the city, and leads the viewer back to the central panel. Once viewed on earth, however, modern Beijing is again stripped of local features and can be imagined as a space station for its inhabitants. In a very different style, Luo Yongjin's *New Residential Buildings* offers a realistic, cynical view of the new city. Gloomy and depressing, his newly constructed residential buildings appear as abandoned ruins. Significantly, his rejection of the new city as a promised land has guided him back to the tradition of documentary photography, in which the power of an image must lie in its exploration of truth.

The emerging city attracts experimental photographers not only with its buildings but also with its increasingly heterogeneous population. Hu Jieming's *Legends of 1999–2000*, for example, registers the artist's fascination with the randomness of urban life. Made of photo transparencies with fragmentary scenes of people and their activities, this installation leads the audience to explore a city by throwing them into a maze. The new Chinese city it represents deliberately rebels against its predecessor. Whereas a traditional Chinese city has the typical, orderly image of a chessboard-like space concealed inside a walled enclosure, the new city is sprawling yet three-dimensional, fast and noisy, chaotic and aggressive. It refuses to stay quiet as a passive object of aesthetic appreciation, but demands our participation to appreciate its vitality.

To Chen Shaoxiong, a member of the avant-garde Big-Tailed Elephant Group in Guangzhou, a heterogeneous city resembles the stage of a plotless tableau; what unites its characters is the place they share. This notion underlies his series of photographs in this exhibition, which are conceived and constructed like a series of puppet theaters within the real cityscape. Images in each photograph belong to two detached layers: in front of a large panoramic scene are cut-out miniatures—passersby, shoppers, and policemen amidst telephone booths, traffic lights, different kinds of vehicles, trees, and anything found along Guangzhou's streets. These images are crowded into a tight space but do not interact. The mass they form is nevertheless fragmentary, without order, narrative, or a visual focus. In Chen's photo installation in this exhibition, two constructed tableaux of such cityscapes in glass boxes are suspended diagonally inside a larger container. A small TV screen, showing images referring to the 9/11 tragedy, further increases the feeling of dislocation and destabilization.

Representing urban spaces and population, Chen's photos are linked with another popular subject in contemporary Chinese photography—images of a new urban generation, or *dushi yidai* in Chinese. Works belonging to this category include Zheng Guogu's *The Life and Dream of Young People in Yangjiang*, Yang Fudong's *Don't Worry I Will Be Better*, Zhou Hongxiang's *Want Him/Her*, and Yang Yong's *Twilight of the Gods*. Instead of portraying the lives of urban youths realistically, these images deliver constructed visual fictions. Each work consists of multiple frames that invite us to read them as a narrative unfolding in time. Indeed, such interest in seriality and storytelling may be linked to contemporary Chinese experimental cinema, especially the "urban generation" films of the late '90s and early 2000s. But the stories in the photographs remain nonspecific or allegorical. What the artists hope to capture is a certain taste, style, and mood associated with this generation of people, and for this purpose they have created images that are often deliberately trivial and ambiguous. Yang Fudong's *Don't Worry I Will Be Better*, for example, represents a group of fashionable Shanghai yuppies, including a girl and several young men. The pictures resemble film stills, but the plot that connects them remains beyond the viewer's comprehension.

These images of the urban generation contrast sharply with other photographs in this exhibition, which represent deeper and less glamorous strata of Chinese society. Among these works, Yin Xiuzhen's *Tea Stand* creates a trompe l'oeil space of an ordinary teahouse found in any traditional quarter of

a Chinese city. Liu Zheng's *My Countrymen* portray aged entertainers, female impersonators, traveling troupes in the countryside, and obnoxious entrepreneurs in a dance bar. Wang Jinsong's *Standard Families* is an enormous composition consisting of hundreds of pictures, each in a standard portrait format representing a standard family: a couple with their only child. The word *standard* in the title thus refers to both the content and image of a Chinese family.

Experimental photography owes a great deal to the transformation of the city and the emergence of new urban spaces and lifestyles. But the city also realizes its impact on artists in a reverse way: sometimes, the chaos and high pressure associated with urban life drove artists to rediscover and communicate with nature through their art. Thus Song Dong designed and photographed a performance to affix a seal on the surface of a river, and Xiong Wenyun took a long journey to Tibet and photographed what she found en route. Still, as experimental artists become self-conscious about their postmodern identity, they can never take such a return to nature at its face value. Song Dong's obsessive seal-stamping left no impression on the water; and Xiong Wenyun installed a colorful curtain on the door of each Tibetan houses she photographed, to register an intrusion from an outside gaze.

§

When *Nature, Society, and Man* was held twenty-five years ago in Beijing, the organizers conceived of this exhibition as a new beginning to an unofficial history of Chinese photography that they had embarked on three years earlier. The opening sentences of the introduction to the exhibition express this historical vision:

> In April 1976, on the *bingchen* day of the Qingming Festival, a group of young men and women took up their simple cameras and joined the masses in Tiananmen Square. A sense of mission motivated them to record the scenes they saw; the photographs they took there have become an invaluable testimony to a life-and-death struggle that the Chinese people waged against the evil Gang of Four. In April 1979, the same group of young men and women is again playing a central role in organizing this exhibition, advancing their exploration into a new territory.

This new territory was simply photography freed from politics, allowing the camera to pursue a visual language for individual expression. As commonplace as it is in art history, this idea was revolutionary in China at that moment. It laid a foundation for the New Wave movement from the '80s to the early '90s, and has guided the development of experimental photography throughout the past decade. The result, as seen in *Between Past and Future: New Photography and Video from China*, both confirms and challenges the original intentions of the *Nature, Society and Man* exhibition. On the one hand, the current exhibition demonstrates that the development of photography in today's China is still driven by the desire for new visual forms as vehicles of individual expression. On the other hand, these forms and expressions have never succeeded in escaping their political and social context. To the contrary, this exhibition shows how political and social issues have reentered contemporary Chinese photography and stimulated artists' experimentations with visual forms.

Many works in the exhibition address problems concerning society and the artist's identity. But even a work that does not directly deal with such problems still internalizes China's social transformation and economic development in its representation and production. Most works in this exhibition do not reflect prolonged, inward contemplation or systematic articulation of a personal style. Instead, they index explosive moments of creative impulse and energy. The lack of technical finesse in some of these images is compensated for by their unusually rich visual stimuli and bold imagination. The key

to understanding these works, therefore, is not a gradual transformation of forms and perception, but the artists' sensitivity to new technology and popular culture, their fast-track experimentation with new forms and techniques, and their ease in selecting and changing visual modes. All these factors are inherent aspects of China's explosive economic development and rapid globalization. But this also implies that it is difficult, if not impossible, to predict the future development of this art: because the primary goal of experimental Chinese photography is to capture the excitement of its own time, it is a self-conscious contemporary art concerned with its own contemporaneity, and belongs to a suspended moment between past and future.

Originally published in Wu Hung and Christopher Philips, eds., *Between Past and Future: New Chinese Photography and Video* (New York and Chicago: International Center of Photography and Smart Museum of Art, 2004), 11-36.

THE "OLD PHOTO CRAZE" AND CONTEMPORARY CHINESE ART

In visual culture, a "craze," or *re* in Chinese, is a state of heightened excitement and activity that develops around certain "fetish images"—be they commercial icons of Pop stars or private possessions of nostalgic value.[1] A cultural craze differs from general fetishism, however, in the emotional energy generated among a sizable populace during a particular period. In this sense a craze is close to a "movement." But unlike a mass movement (*yundong*), it is typically unsystematic and unorganized. Instead of articulating any political ideology, it derives its substance from shared experience and longing.

The "old photo craze" (*lao zhaopian re*) in China during the '90s had all these symptoms of a cultural craze. Evidence for its wide reach was everywhere, from snapshots of old Beijing or Shanghai on the walls of trendy restaurants to family pictures recently transferred from private albums to the antique market. But it was the omnipresence of "old photo" books, serials, and postcards in bookstores that most convincingly clinched the existence of a cultural fever. Among these publications, the sweeping success of a tiny serial called *Old Photos (Lao zhaopian)* astonished everyone in 1997, and in effect announced the arrival of the "old photo craze."[2]

Launched in late 1996 by a newly established provincial publishing house (Shandong Pictorial Press, founded in 1994), the first three issues of this serial became instant blockbusters in the mass book market (FIG. 7.1). Each issue was subsequently reprinted six or seven times, from the initial ten thousand copies to a total of three hundred thousand. For the fourth issue, therefore, the publisher decided to produce an astounding initial print run of two hundred and forty thousand. The serial's founder and chief editor Feng Keli told me that these four issues, published within a single year, from December 1996 to October 1997, eventually sold more than 1.2 million copies altogether, making the serial one of the most popular publications in post-Cultural Revolution China.[3]

In terms of physical form, an issue of *Old Photos* is a thin volume of about five and a half by eight inches in a vertical layout, containing seventy to eighty small, low-quality photographic images scattered through 126 to 158 pages. The lack of technical refinement in these photo reproductions can

certainly be attributed to the publication's low budget and retail price. The first ten issues of the serial only cost 6.50 RMB each, less than a U.S. dollar. (From NO. 11, the price for an issue increased to 8.50 RMB, about one U.S. dollar.) But an equally, if not more, important reason has to do with the editors' approach to these images, which are meaningful only as integral components of short entries. The general tendency of the serial is to contextualize images with historical narratives, not to elevate them to the rank of independent works of art. (This is especially clear in the first ten issues of the serial. From NO. 11, a centerfold was added to display selected images of higher artistic quality.) In a sense, though reproduced *en masse* and sold throughout the country, these images retain their grassroots identity. Instead of inspiring awe, their ordinariness evokes familiarity in the millions of "ordinary" readers of the serial.[4]

FIG. 7.1: *Old Photos*, NO. 1, 1996.

A less obvious but probably more important achievement of the serial is the number and variety of publications it inspired, which began to emerge in profusion from late 1997 onward.[5] The two earliest "copycats" were *Old Photo Album (Lao Xiangce)* published by the Inner Mongolia People's Press and *A Century of Old Photos (Bainian lao zhaopian)* by the Economy Daily Press. Both launched in November 1997 (i.e., a month after the fourth issue of *Old Photos* came out), even their cover designs closely imitated their shared prototype (compare FIGS. 7.1, 7.2 and FIG. 7.3).[6] For *Old Photos*, Feng Keli had selected a kind of yellowish paper for its invocation of the "mutability of time" (*cangsang*);[7] now this feature was also imitated by the newcomers.

FIG. 7.2: *Old Photo Album*, NO. 1, 1997.

It is perhaps no coincidence that these early "old photo" serials, including the original *Old Photos*, were all published by relatively obscure, provincial publishing houses, who were eager to break into the mass book market. Their success then inspired many other "old photo" books and serials over the next three years from 1998 to 2000. But the later publications increasingly specialized in particular types of historical photographs; the usual subjects included architecture and the city,[8] lifestyle and costume,[9] important figures and landmark events,[10] famous universities and institutions,[11] works by early photographers, and groups or generations of people. *Old Photos of Students Sent to the Countryside during the Cultural Revolution (Zhiqing lao zhaopian)* put out by Tianjin's Hundred Flowers Press falls into this last category (FIG. 7.4). The first issue of the serial, published in February 1998, had an initial print run of three hundred thousand copies, which sold out almost immediately.

The trend toward specialization was also reflected in the products of the Shandong Pictorial Press, the publisher of the *Old Photos* serial. One of its 1998 publications is *His-*

百年
老照片
（第一册）

海南书出画社

torical Photos You Have Never Seen (Ni meiyou jianguo de lishi zhaopian); its new booklist for 2001 included *Mutability of Time as Seen in the Changes of Things and Scenery (Fengwu liubian jian cangsang)*. Both publications focused on images of important historical figures and events, leaving photographs of a more private nature to the original *Old Photos* serial.[12] The momentum of "old photo" publications declined in the early 2000s. The first issue of *Old Photos* in the new millennium (NO. 13, published in March 2000), for example, included a postscript written by Wang Jiaming, the chief editor of the Shandong Pictorial Press, in which he acknowledged that "the nostalgia trend that has prevailed for a time is weakening day by day" *(cheng yishi zhi sheng de huijiu zhi feng, erjian shiwei)*. He nevertheless reconfirmed his devotion to the *Old Photos* serial, although its sales had dropped to one-tenth of the first four issues.[13] After 2001, the serial and other "old photo" publications continued to be produced and could be easily found in bookstores, but no longer generated the kind of excitement they did in the late '90s; and their market was shrinking. By 2003, the craze for "old photo" reproductions and publications was clearly over.

THE INVENTION OF "PHOTO/TEXT"

As a broad cultural and social phenomenon, the "old photo craze" can be analyzed from multiple angles. For example, the compilation and popularity of "old photo" books and serials were clearly related to changes in China's publishing industry and commercial book market. Scholars have also linked these publications to *huai jiu* or "nostalgia," which surfaced as a major theme and stimulus in Chinese literature and film in the '80s and '90s.[14] (But as this paper will suggest, most "old photo" publications are dominated by a desire to forge "microhistories," not by the sentimentality of "longing for the past" or "reminiscing about the old." We thus need to reexamine the connections made previously between these publications and nostalgia.) A third perspective is the history of collecting: from the '80s, all sorts of Cultural Revolution memorabilia and other relics from China's recent past acquired commercial value; historical photographs joined such "collectibles" slightly later, around the mid to late '90s. In this context, "old photo" publications were both the consequences of and stimuli to the cultural activity of collecting. This observation further leads us to notice a persistent relationship between collecting and publishing in China during the '90s: as soon as certain printed images—old posters, advertisements, postcards, cigarette cards, and matchboxes—became subjects of collecting, they also became subjects of reproductions, which in turn encouraged general appreciation of these popular or commercial images. Viewed from this angle, the "old photo" books and serials of the late '90s followed the pattern set by previous publications of other types of old prints, which had appeared before the mid-90s.[15] Last but not least, the abundant reproductions of old photographs of traditional architecture—an important component of "old photo" publications—clearly responded to the rapid transformation of the Chinese city in the '90s: as thousands and thousands of old houses were demolished to make room for new residential and commercial buildings, only their images alone could be preserved.

Whereas all perspectives are important for a fuller understanding of the "old photo craze," the main purpose of this essay is to discuss this phenomenon from an art historical and visual cultural

perspective, focusing on two issues that are directly related to the re-presentation and permutation of photographic images at a particular historical moment. The first issue concerns the invention of a type of integrated visual-textual representation that I call a "photo/text." The second issue is the role of "old photo" images in contemporary Chinese art. Discussions of these two issues reveal different intentions and techniques of using old photographs in current cultural production, leading us to consider the relationship between an elite art tradition and a popular visual culture.

On the cover of the first issue of *Old Photos* is the image of two girls dressed in high-collared jackets and wearing western-style necklaces (see FIG. 7.1). Two maple leaves overlap with the photo's thick frame and allude to the passage of time: like the photograph of the anonymous girls, they are also fragments left from a vanished past. This group of images, however, is not a self-contained representation, because the portrait is actually cropped from a larger photograph that accompanies an entry in the issue (FIG. 7.5); its role is to entice readers to read the text, which identifies the girls as fashionable young ladies in the early Republican period, as demonstrated by their short hair and unbound feet, and by their clothes and ornaments.[16]

FIG. 7.4: *Old Photos of Students Sent to the Countryside during the Cultural Revolution*, NO. 1, 1998.

As this example shows, many "old photo" books and serials published from 1997 to 2000 did not simply reproduce historical photographs, but contained photo/texts—short, informal literary compositions centered on one or more photographic images. Often writing in the first person, their authors assume the role of storytellers or eyewitnesses, even when their subjects have nothing to do with personal experience. Photographic images in such compositions never simply "illustrate" the accompanying texts; nor do the texts merely "explain" the photographs. Rather, images provide stimuli, clues, and sites for reconstructing history and offering recollections. The wide varieties of images imply different

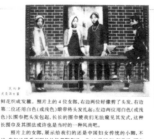

FIG. 7.5: TAO YE, "NEW DRESSES OF WOMEN IN THE EARLY REPUBLICAN PERIOD," *Old Photos*, NO. 1, 1996.

possibilities for historical reconstruction. In fact, the true originality of the *Old Photos* serial—as well as the paramount reason for its commercial success—lies precisely in its openness to such possibilities: instead of devoting the serial to a particular kind of biography or history (as many earlier and later "old photo" publications did), its editors envisioned it as an open space for professional and amateur writers to compose photo/texts of any kind, as long as they found resonance with a broad readership. Feng Keli's 1996 proposal for the serial makes this idea transparent:

> As to the basic requirements for contributions to the serial, both photographs and texts should sustain prolonged interest. But let legendary ones be legendary, entertaining ones be entertaining, educational ones be serious, and conceptual ones be conceptually sharp. In any case, a contribution should always dwell on facts. "Representing facts" is the soul of the serial. Guided by the content of photographs, the genres and format of texts may shift from biography (*zhuanji*) to essay (*sanwen*) and jottings (*suibi*), to investigation (*kaoju*) and exposition (*shuoming*). The longer pieces can run several thousand characters, the shorter ones, several hundred to several dozen characters. Form should always suit content, and there should be no fixed standards. Each issue should contain forty to fifty contributions.[17]

FIG. 7.6: TWO PUBLICATIONS FROM THE SHANDONG PICTORIAL PRESS: *A Century of Chinese History in Photographs* and *Old Photos*.

A possible prototype for such versatile photos and texts was a group of illustrated essays that the writer Liu Xinwu wrote from 1986 to 1987 for the influential literary journal *Harvest (Shouhuo)*. Published in a special feature titled "Private Photo Albums" (*Siren zhaoxiang bu*), these essays responded to a well-known proposal by the veteran writer Ba Jin, then the journal's chief editor. In his 1979 *Random Reflections (Suixiang lu)*, Ba Jin called for "a museum of the Cultural Revolution" to preserve memories of the political calamity and to prevent similar tragedies in the future.[18] Liu Xinwu opened his first essay in "Private Photo Albums" by meditating on the "information value" (*xinxi jiazhe*) and "historicity" (*lishigang*) of photographs. The specific historicity of private photos in the post-Cultural Revolution era prompted him to write this series of "private histories." As he explains:

> I think that although the fatal destruction of the Cultural Revolution must have greatly reduced the number of old photos in China, a considerable amount of photos must have fortunately survived. I believe that many individuals must still possess albums or boxes that contain innumerable precious "original images" from twenty, thirty, forty, or fifty years ago and even from more remote eras. Of course, many people may not want to publicize these images, and their rights should be honored by society and protected by law. Still, many other people may want to share the "original images" in their private photo albums with society at large, or may accept this idea after persuasion. Their private images can therefore contribute to today's "information explosion," enriching people's emotional world and encouraging rational thinking.[19]

Liu Xinwu's essays cannot be taken as the direct source of the *Old Photos* serial, however, not only because the two were separated by a whole decade, but also because they are different in several major ways.[20] First, Liu wrote his essays as serious literary works of lasting value.[21] But as Feng Keli proposed, the texts in the *Old Photos* serial should respond to images and be affiliated to images. In other words, the photo/texts in this publication are self-consciously "image-centric" and "image-driven." Instead of associating themselves with literature, they constitute a special genre of composite visual/textual representation. This identity of the photo/texts in *Old Photos* is clearly stated in the editors' announcement to solicit contributions, a feature of each issue:

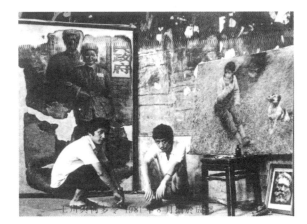

FIG. 7.7: WANG CHUAN AND HE DUOLING IN FRONT OF THEIR WORKS, 1981.

> The [submitted] photographs should be at least twenty years old and sufficiently legible. A photograph (or several photographs) should elucidate an event, a person, a scenic spot, or a type of fashion. An entry should be composed around such images. The style of writing can be of any kind, ranging from biography, prose or notes to research or explanation. A photograph can be accompanied by an essay or by brief comments. It is also possible to submit writing alone, but in such a case the author should provide suggestions for finding relevant photographs.[22]

FIG. 7.8: WANG CHUAN, SURVIVORS, OIL ON CANVAS, 1981.

Moreover, unlike Liu's essays that are creations of a well-known author, an issue of the *Old Photos* serial normally has forty or more contributors, many of whom have received only average education; their writings are straightforward accounts of someone or something they know. Such authorship is implied in the announcement cited above: the standards it sets up clearly aim to encourage amateur writers. The serial is therefore a "mass publication" in the sense of both readership and authorship.

Finally, although *Old Photos* contains a considerable number of entries that allude to personal tragedies in the '60s and '70s, its goal was not to establish a "museum of the Cultural Revolution" in printed form. In a departure from Ba Jin's vision, the editors of this serial (as well as those of other "old photo" publications in the '90s) reject an explicit political or ideological agenda. Alternatively, the serial's agenda in representing historical "facts" lends itself to various interests and pursuits, from personal reminiscence to political rhetoric, and from anecdotes to entertainment. It may be said that the attraction of this publication ultimately lay in its providing an

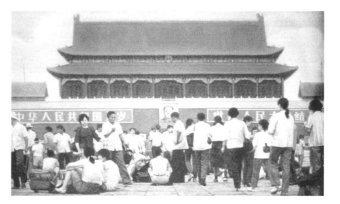

FIG. 7.9: YANG YIPING, *The Square*, OIL ON CAN-
VAS, 1987-1988.

open space for people of diverse backgrounds to write on different kinds of old images. In his original proposal, Feng Keli envisioned some "features" or "columns" for the serial, including "Mingren yishun" (Moments in the lives of the famous and renowned); "Jiushi chongwen" (Reminders of bygone things); "Gushi fengwu" (Things and scenes of the old days); "Xiri mingxing" (Stars of long ago); "Siren xiangbu" (Private photo albums); "Shijian xiezhen" (Reports of real events); "Miwen pianying" (Unknown histories and fleeting images); "Ningwang ji" (Gazing and meditating on images); "Yi Qin e" (Reminiscing about old friends), and a few others. These subtitles did appear in the various issues of the serial, but never evolved into conventional "features" and "columns." Rather, the editors developed an unusual strategy to mix entries under these themes, while constantly introducing new themes in each issue.[23] The result is a spontaneous collection of images and texts, which favors randomness and chance effect, and refuses stability and standardization. Looking through each volume, readers constantly feel that they are stumbling upon forgotten people and events, unexpectedly resurrected from their unconscious memory.

Upon reflection, we realize that Liu Xinwu's "Private Albums" only changed the subject of a preexisting type of photo history in China, which had been devoted to Communist leaders and heroes

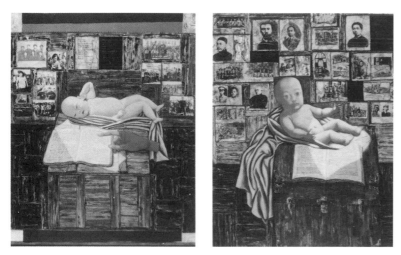

FIG. 7.10: ZHANG XIAOGANG, *Genesis*, OIL ON CANVAS, 1992.

such as Mao Zedong and Lei Feng. This series of photo essays did not alter the basic format and logic of such history, which focuses on a single subject and has a self-confessed political purpose. By mixing this biographical mode with many other focuses and subjects, however, "old photo" publications made themselves vehicles for constructing a different type of history—history as collage and chance result, and as the synthetic voice of a multitude of amateur authors. We can call such personalized, unsystematic historical accounts "microhistories."

This type of historical reconstruction naturally destabilizes the established visual and textual representations of official history. Again using *Old Photos* as an example, a mass-produced "old photo" serial is typically low budget and humble-looking; its small and sometimes blurry black-and-white pictures hardly inspire serious artistic appreciation; and its fragmentary entries betray few formal or structural concerns. For these reasons, these publications easily escape the attention of academic historians, whose interests are commonly guided by individual authors/artists or definitive "works" of art and literature. I would suggest, however, that the lack of structural coherence and aesthetic appeal should be considered an intentional feature of these publications, which defines a particular kind of materiality and makes "chance" an important factor in visual and literary production.

FIG. 7.12: FENG MENGMO, *A Private Photo Album*, INTERACTIVE COMPUTER INSTALLATION, 1996.

Interestingly, the unsystematic, fragmentary quality of *Old Photos* is rooted in its history. The idea of publishing this serial arose from considerations regarding how to utilize materials "leftover" from an official-style photo-history called *A Century of Chinese History in Photographs (Tupian Zhongguo bainian shi)* (FIG. 7.6). This expensive (1,500 yuan), multivolume compilation was the single most important project of the Shandong Pictorial Press from 1993 to 1995, and absorbed nearly the entire budget of this newly established publishing house. More than five thousand historical photographs were collected for the purpose, but only two thousand seven hundred were actually printed. The remaining two thousand three hundred pictures, not "significant" enough to enter the monumental history book, then became the basic materials for the initial issues of *Old Photos*. It is thus fair to say that this serial was founded on fragments (more precisely, on fragments of fragments, because the five thousand photographs gathered by the Press were already historical fragments). This legacy was continued and strengthened throughout the later issues of the serial, which incorporate contributions randomly submitted to the publisher.

Five features separate "old photo" images in contemporary Chinese art from the "old photo" publications discussed above. First, instead of mechanically reproducing extant photographs, these images result from artistic imagination and representation. Second, as artistic representations, these images are singular works of art created for an elite audience, not part of a mass publication for the reading public. Third, these artistic representations supposedly demonstrate the originality of individual "experimental" artists,[24] rather than foregrounding fragmentary memories of common people. Fourth, as paintings, installations, and photographs, these artistic representations are "visual" in intent, rather than part of a sustained image/text dialogue. Finally, designed and created initially for art exhibitions, these artistic representations lose their "aura" when they are turned into print forms for wider circulation.

FIG. 7.13: YIN XIUZHEN, *Yin Xiuzhen*, PHOTO INSTALLATION, 1999.

Despite these differences, however, both products employ the same stable of visual materials—old photographs—and developed in tandem. Artistic representations of old photos started in the '80s and became a vogue mainly in the second half of the '90s. My discussion has shown that the same period witnessed the emergence of post-Cultural Revolution "photo/texts" (as exemplified by Liu Xinwu's illustrated essays in the '80s) and the popular "old photo craze." The simultaneity of these trends leads us to explore their historical connections. Methodologically, this exploration focuses our attention on the relationship between art and visual culture—two fields of visual production that, in this case, used the same visual materials for divergent purposes. The differences between artistic representations of old photos and mass-produced "old photo" publications, however, demand different strategies in analysis. If my discussion of the *Old Photos* serial has focused on its general characteristics and tendencies, the following discussion of "old photo" images in contemporary art necessarily focuses on individual works as artists' responses to common social issues.

FIG. 7.14: ZHENG LIANJIE, FAMILY HISTORY, PERFORMANCE, TIANANMEN SQUARE, BEIJING, 2000.

FIG. 7.15: HAI BO, *They No. 6,* TWO PHOTOGRAPHS TAKEN IN 1973 AND 1999.

A survey of such images reveals three different approaches in using old photos to construct visual narratives in contemporary art. In the first approach, works respond to major events in modern Chinese history and express collective experiences of generations of people. The second approach adapts a biographical mode, using old photos to construct personal histories for ordinary Chinese. The third approach represents faded or damaged photographic images as "ruins," alluding to the instability of historical memory. On a deeper level, all three approaches reflect the artists' keen interests in China's historical temporality, and "old photo" images provide the artists with an effective means to re-imagine the country's past, present, and future.

Starting from the early '80s, some young artists already used images of stressed and damaged photos to allude to the bygone Cultural Revolution. The earliest such example I have found is a remarkable oil painting created by the Sichuan artist Wang Chuan in 1981 (FIG. 7.7). Titled *Survivors (Xingcun zhe)* and measuring over six feet tall, it monumentalizes an old photograph that is burnt at the edges and torn into pieces (FIG. 7.8). The couple in the photograph are the artists' parents, who took the picture when they were young and idealistic, serving the revolutionary cause in the Red Army. The specific story of the photograph (and its destruction) is nevertheless absent in the painting. Instead it tells the tragedy of a whole generation: numerous such intellectuals were purged during the Cultural Revolution for their "bourgeois educational background," bad class origins, or both. Many of them were thrown into prison or detention centers; their belongings were confiscated and their photographs destroyed. Wang Chuan depicted one such destroyed photograph, whose fragments had fortunately survived the holocaust. But he deliberately gave the painting an ambiguous title: the spectator wonders whether *Survivors* only refers to the fragments (which have been pieced together) or also to the couple in the photograph.

FIG. 7.16: RONG RONG, *1996 No. 3.2,* BLACK-AND-WHITE PHOTOGRAPH, 1996.

Yang Yiping's *The Square (Guangchang*, 1987-88) and Zhang Xiaogang's *Genesis (Chuangshiji*, 1992) also employed images of old photographs to reflect on the Communist revolution, but from different angles. A veteran avant-garde artist, Yang was a member of the Stars Art Society—the first unofficial art group to emerge in post-Cultural Revolution China—and he participated in the society's two early exhibitions in 1979 and 1980. *The Square* marked a new departure in his art, as it initiated a series of works that infused suprarealism (a style he previously favored) with the imagery of old photos (FIG. 7.9). In this sense, calling this painting a "realistic" representation, as some art critics have done, is misleading. Rather, Yang's subject is his personalized vision of Tiananmen Square that both unites and contrasts the past and the present. This reading explains many puzzling and seemingly contradictory features of the painting: the brownish, nearly monochromic coloration alludes to an aged photograph; but the figures' clothes and hairstyles are all contemporary. These figures are portrayed naturalistically as seen in a snapshot; but the depiction of the place is deliberately unrealistic: Tiananmen's base is artificially shortened and the stone sculptures in front of the monument are eliminated. A major goal of the painter must have been to create a spatial and temporal disjunction and to contrast Tiananmen with the surrounding people, who seem to be accidentally appearing there. While Tiananmen's physical prowess is emphasized—its heavy superstructure dominates the upper half of the painting, the masses in the lower half are scattered in a startling state of disunity; none of them pays the slightest attention to the Communist monument or Mao's portrait on it.

FIG. 7.17: RONG RONG, *1996 No. 2.2*, BLACK-AND-WHITE PHOTO-GRAPH, 1996.

An even stronger symbolic overtone characterizes Zhang Xiaogang's *Genesis* (FIG. 7.10). The two paintings in this mini-series depict two newborn babies in the center, each lying above a desk and placed next to an open book. One baby is reddish and raises his head to stare into the onlooker's eyes. The other baby is yellowish and turns his head toward the book, reading the text under the guidance of a disembodied red hand. Old photos painted in the background offer clues for understanding the meaning of each composition. The photos on the top row behind the first baby represent Communist pioneers, including the founders of the Chinese Communist Party. The baby may thus symbolize the original inspiration of the revolution and the awakening of the Chinese people—a significance reinforced by the baby's alertness and "revolutionary" color. The photos in the other painting all show "revolutionary students" during the Cultural Revolution, either marching in mass rallies or being reeducated through labor in the countryside. The passive and obedient baby in front of these pictures seems to typify the experience of this generation, who received Communist ideology as unfeeling dogma dictated by an impersonal, faceless power.

These paintings remind us of Ba Jin's call for a "memory museum" of the Cultural Revolution. Indeed, although each work uses images of old photos in a different way, these images all signify memories—China's historical memories in general and memories of the Cultural Revolution specifically. The artists shared Ba Jin's and Liu Xinwu's belief that only by preserving such memories could the Chinese people prevent another calamity in the future. This retrospective, politically charged perspective, how-

FIG. 7.18: WANG YOUSHEN, *News Paper*, PHOTO INSTALLATION, 2001.

ever, lost its appeal to a new generation of experimental artists, who entered the field of contemporary art in the early and mid-90s. To them, the '60s and '70s had become history, and they were finally able to bid farewell to the Cultural Revolution and its visual and mental baggage. Their work increasingly responded to China's current transformation, not to history and collective memory. Although "old photo" images continued to signify the past in their works, these images were used to confirm the artists' attachments to the present.

I have termed this trend in the Chinese art of the '90s a "domestic turn,"[25] which coincided with the introduction of new art forms, mainly installation, performance, and multimedia art, from western contemporary art. As these art forms gained wider currency among this group of artists, their works no longer converted old photos into paintings, but featured real or digitized old photographs—images that brought about a heightened sense of immediacy and the real, and which also encouraged the artists to develop a "biographical" mode in representing their subjects, often their relatives and themselves.

The unofficial installation and exhibition *Women.Here (Nüren.Xianchang)* occupies a special position in this development, as it was the first project in contemporary Chinese art that used family photos to forge private histories and to comment on current political affairs. Three young faculty members in the Central Academy of Fine Arts—Sui Jianguo, Zhan Wang, and Yu Fan—staged this installation and exhibition as a "counter-event" during the Fourth International Women's Congress held in Beijing in 1995 (FIG. 7.11). Using old photographs and memorabilia found among their mothers' and wives' private possessions, they hoped to present these "real Chinese women" to contrast with the official representation of a staged "global womanhood."[26] Following a different vein, the Beijing artist Feng Mengbo created an interactive computer installation in 1996 (FIG. 7.12). Entitled *A Private Photo Album (Siren zhaoxiang bo)*, it consists of several series of old photos that restage the lives and social environments of his grandparents, parents, and himself. Pursuing a visual autobiography in a more succinct manner, Yin Xiuzhen made a photo installation in 1999, in which her own photos from different periods were cut into inner soles and inserted in old-fashioned women's shoes (which she had made with her mother)(FIG. 7.13). Yin thinks that the interior of a woman's shoe is the most intimate space of her body. Making personal photos into public art while heightening their intimacy, this work heightens the tension between private memory and public display.

Differing from these biographical representations, some works created in 1999 and 2000

"frame" a historical duration by juxtaposing images of past and present, leaving the subjects' experiences during these years to the viewer's imagination. One of such works is the performance *Family History (Jiazu suiyue)*, conducted by Zheng Lianjie in 2000 in Tiananmen Square (FIG. 7.14). Displaying an enlarged black-and-white photo that his family had taken in 1957, Zheng and his son took another photo in the Square forty-three years later. Framed within the present image of the same place, the historical photo acquires an acute past temporality. Similarly, Hai Bo has routinely juxtaposed two photographs taken several decades apart in a photo installation (FIG. 7.15). The first, an old group photo, shows young men or women in Maoist or army uniforms; their young faces aglow with their unyielding belief in the Communist faith. The second picture, taken by Hao Bo himself, shows the same group of people—or in some cases, the surviving members—twenty or thirty years later. In an almost graphic manner, the two images register the passage of time and stir up viewers' recollections of certain moments in their own lives.

The interest in representing the passage of time is given a sharper focus in a third kind of image, in which dilapidated photographs acquire the meaning of contemporary "ruins." The representative artist in this group is Rong Rong, who moved to Beijing from rural Fujian in 1993. Among the many contemporary Chinese artists fascinated by the transformation of the city, Rong Rong's photographs of demolished traditional houses best capture the anxiety and silence adrift in these urban "black holes." These photographs typically focus on torn posters of movie stars and fashion models—commercial prints that people had abandoned with their fomer homes (FIG. 7.16). These pin-up images, which are too superficial to supply any individuality, highlight the absence of human subjects in the representations. As a consequence, Rong Rong's photographs do not register a specific past or present. What they represent, instead, is a transient time and space as a general condition of the transformation of Chinese cities in the '90s.

Going one step further, Rong Rong has made the vulnerability of photographic images a central theme of his work. A series of his photographs study the mortality of photographs by documenting photos displayed in public spaces (FIG. 7.17). Faded and discolored, each such photo-within-a-photo is a ruin of its former self, and registers most acutely traces left by time itself. But to Wang Youshen and Miao Xiaochun, the passage of time is not an abstract concept. The vulnerability of photographic images signifies above all the impermanence of historical memory. Wang has worked as an editor for the official newspaper *Beijing Youth Daily* since 1988. His 2001 installation *News Paper (Xinwen zhi)* displayed eroded historical photographs that he had discovered in the newspaper's archives (FIG. 7.18). In an earlier installation called *Washing: The Mass Grave at Datong in 1941 (Qingxi: 1941 Datong wan-*

FIG. 7.19: WANG YOUSHEN, *Washing: The Mass Grave at Datong in 1941*, PHOTO INSTALLATION, 1995, DETAIL.

renkeng, 1995), the newspaper pages on the wall report the discovery of a pit containing the remains of thousands of Chinese who were buried alive during World War II. Below the wall, photographic images of the unearthed human remains were placed in two large basins under circulating water (FIG. 7.19). "The water washes the image away," Wang commented, "just as time has washed people's memories clear of this atrocity that occurred fifty years ago."[27] His view is echoed by Miao Xiaochun, who has projected a historical photo onto a white curtain in an installation (FIG. 7.20). The photo is familiar: taken by the wartime journalist Wang Xiaoting in 1937, it shows a crying child at the Shanghai Railway Station after a Japanese bombing. Barely visible on the curtain, however, the "fading" of the image alludes to the disappearance of people's memory of the event.

CONCLUSION

In addition to investigating two recent historical situations in which old photos were reproduced and represented for contemporary needs, this essay provides concrete examples for thinking about the relationship between art and visual culture. I have summarized five differences between artistic "old photo" images and mass-produced "old photo" publications; here I will pinpoint some of their connections, thereby defining them as linked cultural practices in a shared historical context.

As mentioned earlier, on the most basic level, the two types of visual production shared a stable of materials: the same kinds of family and historical photos inspired amateur writers and avant-garde artists to create their photos, texts, and experimental works. Additional evidence suggests that some artists may have been influenced by popular photos/texts. I have introduced Hai Bo's "double portraiture," which juxtaposes an old group portrait with a recent one (shown in the 49th Venice Biennale in 2001) (see FIG. 7.15). This format is also seen in popular "old photo" serials. For example, an entry called "Eight Sisters" (Ba jiemei) in NO. 13 of the *Old Photos* serial (published in March 2000) includes two photographs of eight women (FIG. 7.21). The first was taken in 1969 at the peak of the Cultural Revolution; the second, showing the same women in 1986, records their first reunion seventeen years later. It is possible that Hai Bo derived inspirations from this or similar photos/texts. Even if he did not, the striking similarity between his work and such "non-artistic" images reveals a common mentality at work.

FIG. 7.20: MIAO XIAOCHUN, *Screen*,
SLIDE INSTALLATION, 2001.

FIG. 7.21.: FOUR PAGES FROM "EIGHT SISTERS," *Old Photos No.13*, MARCH 2000.

Also as mentioned earlier, artistic representations of old photos and mass-produced photos and texts developed side by side through the '80s and '90s. Both forms first emerged in the '80s to respond to the Cultural Revolution; the value of old photos as sites of personal and collective memories underlay Liu Xinwu's writing as well as paintings by Wang Chuan, Yang Yiping, and Zhang Xiaogang. The '90s again witnessed parallel changes in artistic and popular representations of old photos. Most importantly, both types of representation turned away from grand history and ideology, and took as their mission forging "microhistories" and recounting the fragmentary personal experiences of ordinary people. "Representing facts" became the guiding principle for both forms; the general tendency was therefore that of a "return to the real." The sense of realness was also manifested in the materiality of both forms, albeit in different ways. Whereas popular "old photo" publications filled a huge public space with mass-produced, low-budget reading and viewing materials, artistic representations employed old photos as "readymade" materials for installations and performances.

This "return to the real" also explains the popularity of documentary photography in China during the '80s and '90s. I have written elsewhere about the development of this photographic genre after the Cultural Revolution. Initiated by a collective effort to preserve memories of the April Fifth demonstrations at the end of the Cultural Revolution,[28] documentary photography evolved into a broad art movement in the '80s and '90s, producing a huge corpus of images that record, among other subjects, people's daily lives, social injustice, and urban development.[29] Many documentary photographs, especially images of traditional architecture and lifestyle made in the late '90s, show uncanny similarities to old photos.[30] Some photographers self-consciously derived styles and compositions from historical photographs.[31] Their works, which internalized the temporality and even the materiality of old photos, were typically reproduced in volumes and sold in bookstores. In all these aspects, documentary photography allied itself with the popular "old photo craze." On the other hand, documentary photography also had a strong relationship with experimental art. Installation and performance artists used both old and new documentary photos in their projects.[32] Moreover, there was no rigid line separating a documentary photographer from an experimental artist; the former became the latter as soon as he made photography itself the subject of representation and interpretation. Documentary photography thus mediated popular and artistic representations of old photos, and became part of the negotiation between art and visual culture.

As the internet has grown into a unifying field of visual presentation since the early '00s, it has provided a new mechanism for connecting popular and artistic representations of old photos. A Google

search for "老照片" (*laozhaoping*) at the end of 2004 instantly conjured up five hundred thirty-seven thousand entries, including many large websites on the subject. Some of these websites, such as *Old Photos of Students Sent to the Countryside during the Cultural Revolution (Zhiqing lao zhaopian),*[33] originated from the "old photo" serials in the late '90s. At the same time, the internet has also become a window for showcasing artistic representations of old photos, as experimental artists like Rong Rong and Feng Mengbo have all established their own websites, and as museums and art galleries also routinely circulate electronic images of works by these and other artists. It is interesting to note, however, that while such promotions have helped expand the market of contemporary art, the computer technology has undercut publications of old photos in printed forms. To this end, the astonishing number of websites and web pages dedicated to preserving, collecting, and disseminating historical photographs may suggest that the "old photo craze" never really dissipated, but has instead migrated from a print culture to a virtual world of image making and presentation.

Originally presented at the symposium *From Print to Photography*, organized by the Center for the Art of East Asia, University of Chicago, in May, 2004.

Intersections: AN EXHIBITION OF CONTEMPORARY
CHINESE PHOTOGRAPHY AND OIL PAINTING

This exhibition deals with a fundamental issue in contemporary Chinese art: the interrelationship between photography and painting. It is fundamental because few oil painters and photographers in post-Cultural Revolution China can escape this interrelationship, which has influenced and even controlled their art in different ways and on multiple levels. From the '60s through the '80s, photography provided painting with a sanctioned reality to depict (although the content of this reality changed greatly over time), while most "experimental photographers" (*shiyan sheyingjia*) of the '90s and early 2000s were first trained as painters or graphic artists. How do painting and photography interact with each other in today's Chinese art? To Chen Danqing, one of the artists featured in this exhibition, "copying [photographs in oil] is not to imitate other people's language. Like playing musical compositions, copying is itself a language."[1] The other five artists each answer the question differently; but all have problematized the relationship between painting and photography in their works. In this way, these artists—three photographers and three oil painters—demonstrate how this relationship has become a shared focus of their artistic experimentation. To understand the experimental nature of their works, however, we need to briefly reflect upon the connections between painting and photography in Chinese art since the '60s.

Painting from photos became a legitimate artistic practice during the Cultural Revolution (1966-1976), when numerous paintings—portraits of Mao Zedong and his wife Jiang Qing, heroic images of the revolutionary masses, and narrative pictures of the Party's glorious history—were copied or recreated from photographs (FIG. 8.1). This was not because there was a shortage of live models, but because officially sanctioned photography provided an "authentic reality" for artists to re-present. Paintings based on such photographs took on the authority of their models; and painters who adopted such models could worry less about possible political criticism. Although it was no secret that official photographs were already heavily edited and idealized (by choosing special angles and lighting, and by using the editing technique known as *xiuban,* "repairing a negative"), painting could transform propaganda materials into art by further appropriating them (through adding color, enlarging the dimensions, and combining multiple photographic images in a single pictorial composition). During this crucial period in modern Chinese history, therefore, photography and painting together constituted the basic technology of a symbolic art; their difference depended on varying degrees of idealization. Consequently painters began to collect photographic reproductions—mostly newspaper clippings and plates removed from magazines—as sources for paintings.

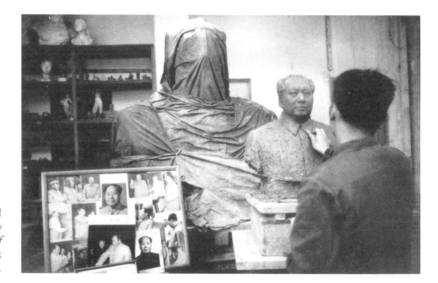

FIG. 8.1: MARC RIBOUD, *A Student in the Central Academy of Fine Arts Making an Image of Mao Zedong,* BLACK-AND-WHITE PHOTOGRAPH, 1957.

This situation underwent a significant change in the late '70s and early '80s, when a new generation of oil painters rejected the symbolic art of the Cultural Revolution and tried to resurrect a "genuine realism" freed from official ideology. Chinese art critics commonly consider Chen Danqing's *Tibetan Series (Xizang zuhua)*—his graduation work from the Central Academy of Fine Arts in 1981—representative of this new art. Significantly, the contrast they make between Chen's painting series and propaganda art is also the contrast they find between two different kinds of photographs: if a propaganda painting idealized an already idealized official photo, the *Tibetan Series* is akin to a collection of anonymous, informal snapshots (and indeed Chen used such photos in painting the series)(FIG. 8.2). It was also around this time—from the '70s to '80s—that a large number of painters began to take photos for both personal and professional purposes. The pictures they took differed markedly from official

photographs in both style and content. Used as sources for painting, however, these images continued to be treated as reality itself.[2]

Many well-known examples of so-called "native soil art" (*xiangtu meishu*) of the '80s, such as Luo Zhongli's *Father* (FIG. 8.3), can be reinterpreted in this light as resulting from a "switch" in the painter's photographic model. The next such "switch" occurred a decade later, in the early '90s, when an upcoming "new generation" of artists (*xinshengdai*) further rejected romanticizing ordinary people (such as Chen Danqing's earthy Tibetans and Luo Zhongli's larger-than-life peasants), but developed a penchant for representing fragmentary and trivial urban life. Attracted by meaningless scenes surrounding them, they portrayed beauticians with exaggerated fake smiles, lonely men and women in a sleeping car on a train, or yuppies jumping mindlessly on a trampoline (FIG. 8.4). These skilled realist painters, the brightest products of China's art academies at the time, continued to derive inspiration and images from photographs.[3]

FIG. 8.2. CHEN DANQING, *Tibetan Series, Mother and Son*, OIL ON CANVAS, 1980.

§

In all these cases, photography's participation in a painting's creation was never openly acknowledged. Rather, photography inserted an invisible layer between a realistic painting and reality, secretly replacing the latter. To unambiguously acknowledge photography's role as the direct source of pictorial representation, as Chen Danqing did in the early '90s through a new series of oil paintings, thus represented an important breakthrough in conceptualizing realistic painting. Each composition in this series consists of two or three panels with radically different themes; what connect them into a single work are the artist's intuitive reactions to their divergent source materials, mostly printed images he found randomly in magazines and newspapers. In the case of his painting *Expressions* he wrote: "In the autumn of 1990 I happened to cast my eye on a photograph of a flamenco dance in an old magazine when I was in a French bookstore on Fifth Avenue. The urgent and desperate expressions on the dancers' faces startled me. In a flash, I recalled a photograph published in *Life* magazine a year ago, which showed Beijing students carrying a dying demonstrator hit by gunfire [in the June Fourth Movement]. I made an instantaneous decision to copy both pictures and put them together. This set of copies became my first diptych called *Expressions*."[4] Commenting on this and other images in the series, I wrote these words in 1995:

Tiananmen [sic] must have re-connected Danqing to the Chinese scenes. But he was mature enough to know that this connection was established by media. Media *is* reality; images constitute a visual world. Images make him laugh and cry, love and hate. Images connect with images, logically or arbitrarily, on the street and in his mind. Images produce images, through copying and appropriation. If fifteen years ago Danqing once believed that his Tibetan paintings represented real people, now he is depicting neither heroic Chinese students nor ecstatic Spanish dancers, but images that have made him laugh and cry, love and hate, images that are connected to one another only in his mind. There are deliberate fragmentation and unexpected linkages. These piecemeal yet interconnected images have become *his* reality.[5]

§

FIG. 8.3: LUO ZHONGLI, *Father*, OIL ON CANVAS, 1981.

Chen Danqing's new approach toward popular photography matches Hong Lei's attitude toward classical painting. After graduating from the Nanjing Art Academy, Hong Lei entered Beijing's Central Academy of Fine Art in 1993. Although he later abandoned the brush for the camera, his academic training prepared him to develop a persistent engagement with traditional art. Most of his works since 1996 have been based on Song court paintings—the most exquisite ever produced in Chinese history. More specifically, he has "translated" these images into contemporary artistic expressions through two kinds of appropriation: while the original masterpieces on silk are transformed into mechanically produced photographic prints, the delicately painted images are replaced by real figures, animals and objects. But both kinds of appropriation serve to intensify his *feeling* about the original work—often a melancholy mood with a tragic underpinning.

Two of his photographs dating from 1997, for example, derive inspiration from Song bird-and-flower painting. To escalate the "morbid beauty" he found in the original, however, he staged dead birds lying in verandas in the Forbidden City, entangled with blood-stained jade and turquoise necklaces (FIG. 8.5). A year later he created *After "Sakyamuni Coming Out of the Mountains" by Liang Kai of the Song Dynasty*, a work with an even closer relationship to a particular classical painting (FIG. 8.6A,B). Turning the painted landscape into a stage set and substituting a real figure for the image of Sakyamuni, the photograph both acknowledges and reinter-

FIG. 8.4: YU HONG, *Flying*, OIL ON CANVAS, 1997.

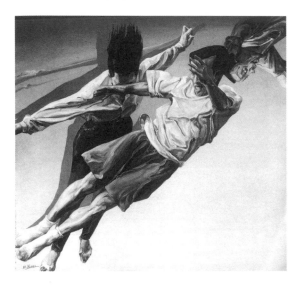

prets its model. Using Chen Danqing's metaphor, here Hong Lei works like a musician in interpreting a piece of classical music. As Chen writes: "A player cannot change the notes, beat and rhythm of the original music at will. 'Follow the score obediently' Beethoven demands on his manuscript. Yet we are presented with a large selection of performance versions of his music to choose from."[6]

This logic is reversed in Liu Zheng's *Four Great Beauties*, included in this exhibition. Instead of imitating well-known paintings, Liu has created these large, dramatic photographs as grand oil paintings in a classical tradition. The different orientations of the two photographers may be partially due to their different educational backgrounds: unlike Hong Lei, Liu Zheng never studied in a privileged art school but was trained as an engineer in a college of science and technology, majoring in optics. After graduation, he worked for a newspaper as a photojournalist, before becoming a freelance experimental artist. To him, classical art remains remote and mysterious, and the dialogue he has developed with bygone masters (both master photographers and painters) is more about negotiation than deconstruction.

Regardless of such differences, however, the issue that Liu Zheng deals with in his art is close to those of Chen Danqing's and Hong Lei's. A persistent theme in his work is again the erasure of distinction between images and reality; and photography allows him to articulate such erasure into an individual art style.[7] His monumental series *My Countrymen* (*Guoren*, conventionally known as *The Chinese*[8]), for example, consists of one hundred photographs and links real people to dying, death, and posthumous mutilation on the one hand and to fantastic or macabre figurations of the body on the other. In Liu Zheng's own words, these images are installed in the series because they are "simultaneously real and surreal, both here and not here."[9]

My Countrymen is one part of a tripartite visual epic, which Liu Zheng has been working on for several years. The other two parts are *Three Realms (Sanjie)* and *Revolution (Geming)*. *Three Realms*, in turn, consists of "Myth," "People," and "History," each forming a semi-independent series on its own. The *Four Great Beauties* belongs to the last series and is centered on Yang Yuhuan, Xi Shi, Wang Zhaojun, and Diao Chan—four famous *femmes fatales* in Chinese history. Pictorially, the four compositions resemble other photographs he has made for the *Three Realms*, such as two 1997 pictures in the "Myth" section that restage two Peking opera plays, *The Legend of the White Snake (Baishe zhuan*, FIG. 8.7) and

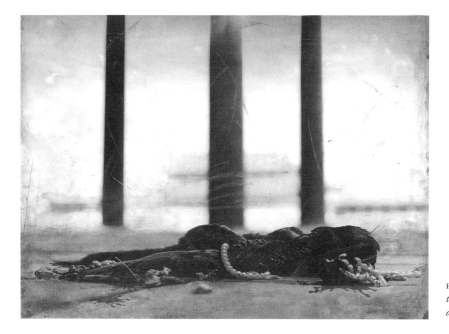

FIG. 8.5: HONG LEI, *Autumn in the Forbidden City (East Veranda)*, COLOR PHOTOGRAPH, 1997.

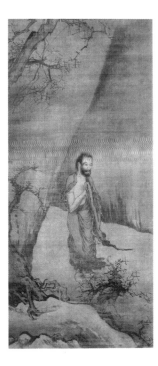

FIG. 8.6A: LIANG KAI (SONG DYNASTY), *Sakyamuni Coming Out of Mountains,* INK AND COLOR ON SILK.

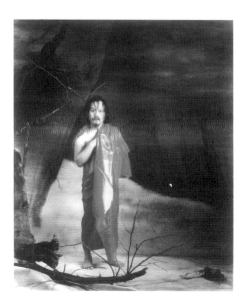

FIG. 8.6B: HONG LEI, *After "Sakyamuni Coming Out of Mountains" by Liang Kai of the Song Dynasty,* COLOR PHOTOGRAPH, 1998.

The Monkey King Defeats the White-Boned Demon Three Times (Sun Wukong sanda Baigujing, FIG. 8.8). Like these earlier works, the *Four Great Beauties* derive their subject from timeless fables in traditional Chinese literature, and use live models to construct large, complex tableaux. Thematically, however, they shift from mythology to human drama, in which love turns into despair and lust prompts court intrigue and murder. Ambitious in conception and rich in tonal variation, these painterly photographs do not reconstruct history, but retell familiar stories through images.

§

In creating the *Four Great Beauties,* Liu Zheng took on multiple roles, first staging four tableaux of a historical drama and then transforming them into photographic images. The oil painter Shi Chong has developed a similar tactic, but has theorized it as forging a "second reality," or art itself[10]:

> In the process of employing figurative forms to represent a "second reality," I try to incorporate the creative process and concepts of installation and performance, creating what I call "artificial artistic copies." The incorporation of these concepts and techniques, as well as the employment of a suprarealistic pictorial style, not only increases the amount of visual information in a two-dimensional painting, but also injects the spirit of the avant-garde into easel painting.[11]

Putting this idea into practice, Shi Chong has produced each of his supra-realistic paintings at the concluding point of a lengthy process that integrated five different forms of visual art—sculpture, installation, performance, photography, and painting—into a single artistic production. To take his

1996 project *The Stage* as an example (FIG. 8.9), he first collected small objects and cast a mask from the female model's face. This was followed by the second stage of the project, a "performance" during which the objects were attached to the model and the model was transformed into a still-life image. This performance thus produced an "installation"—a static scene conceived as the third stage of the project. This scene was then photographed, and the photographs were synthesized and transformed into a painting. In this project, various kinds of "artistic copies" were created in a continuous process of image making, gradually distancing art from reality. Moving from three-dimensional to two-dimensional representations, layers of manufactured forms became increasingly abstract and illusionistic. As the final product of the project, the painting responded to and reproduced previously manufactured forms. Instead of mimicking nature, it was itself a "second reality."[12]

§

The last two artists in this exhibition—the painter Li Songsong and the photographer Han Lei—have each developed a dialogue with the "old photo craze" (*lao zhaopian re*) in contemporary China. The strength of this cultural trend has best been testified to by the sweeping success of a tiny serial called *Old Photos (Lao zhaopian)*. Launched by a provincial publishing house (Shandong Pictorial Press, founded in 1994), the first three issues of the serial became instant blockbusters in the mass book market. Each issue was reprinted six or seven times, from the initial ten thousand copies to a total of three hundred thousand. For the fourth issue, the publisher decided to produce an astounding initial print run of two hundred forty thousand copies. These four issues, published within a single year from December 1996 to October 1997, eventually sold more than 1.2

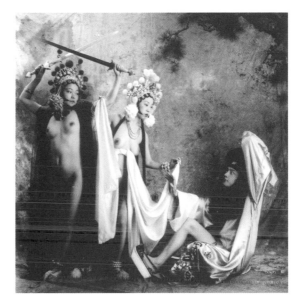

FIG. 8.7: LIU ZHENG, *The Legend of the White Snake*, BLACK-AND-WHITE PHOTOGRAPH, 1997.

million copies altogether, making the serial one of the most popular publications in post-Cultural Revolution China.[13]

What caused the success of *Old Photos* was a prevailing sentiment of nostalgia in society and people's desire to forge private histories—two factors which to a large extent shaped Chinese popular culture in the '90s.[14] Manifestations of this popular culture included numerous reproductions of old photos, postcards, posters, matchboxes, and stamps—ephemeral materials from a recent past that suddenly acquired historical and commercial value. Among such reproductions, old photos were the most personal and emotional. The impact of such images on contemporary Chinese art is significant, although to my knowledge no art critic has discussed this impact in any depth. Generally speaking, post-Cultural Revolution experimental artists developed an intense interest in representing history and memory, and this interest has connected their art with the "old photo craze." I have discussed representations of history and memory in experimental Chinese art elsewhere.[15] Here, I want to suggest that old photos have not only supplied such representations with images and styles, but have also helped negoti-

ate the relationship between an elite "avant-garde" art movement and a popular cultural trend. This is a long story. Here, I can only give some examples to demonstrate a wide range of roles that old photos have played in contemporary Chinese art.

Starting from the early '80s, some young artists began to use images of stressed and damaged photos to allude to the bygone era of the Communist Revolution. *Survivors (Xingcun zhe),* a remarkable painting created by the Sichuan artist Wang Chuan in 1981, is the earliest such example I have been able to find (FIG. 8.10). Ten years later, in 1992, another Sichuan artist Zhang Xiaogang made two symbolic paintings. Called *Genesis (Chuang shiji),* each composition depicts a newborn baby lying in front of old photos (those in one painting are portraits of Communist pioneers; those in the other painting represent "revolutionary students" during the Cultural Revolution).

In more recent years, some artists have used photographic images to evoke memories of the Sino-Japanese War. Zhao Liang's 1999 *Untitled,* for example, transforms a still photo into animated images. In 2000, Miao Xiaochun projected a famous historical photo onto a white curtain. The image is familiar: taken by the wartime journalist Wang Xiaoting, it shows a crying child at the Shanghai Railway Station after a Japanese bombing. The faint, barely visible projection in the installation, however, alludes to the disappearing historical memory of the event. To me, Wang Youshen's 1995 *Washing: The Mass Grave at Datong in 1941* remains the most poignant example in this genre. In this installation, the newspaper pages on the wall report the discovery of the pit, which contained the remains of hundreds of thousands of Chinese who were buried alive during World War II. Below the wall, photographic images of the unearthed human remains were placed in two large basins under circulating water. "The water washes the image away,"

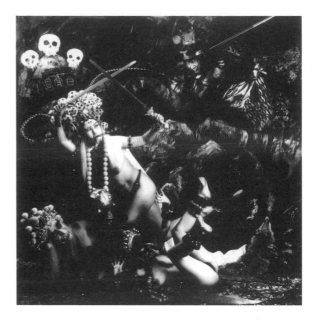

FIG. 8.8: LIU ZHENG, *The Monkey King Defeats the White-Boned Demon Three Times,* BLACK-AND-WHITE PHOTOGRAPH, 1997.

FIG. 8.9: SHI CHONG, *The Stage,* OIL ON CANVAS, 1996.

142

Wang commented, "just as time has washed people's memories clear of this atrocity that occurred fifty years ago."[16]

From the mid-90s, an increasing number of experimental artists used family photos to forge "private histories," and in so doing they also embraced contemporary art forms such as installation, video, and multi-media art. For example, Sui Jianguo, Zhan Wang, and Yu Fan staged their unofficial installation and exhibition *Women.Here (Nüren.Xianchang)* during the Fourth International Women's Congress held in Beijing in 1995. Using photographs and memorabilia found in their mothers' and wives' private possessions, they hoped to present these "real Chinese women" to contrast with the official representation of a staged "global womanhood." Following a different vein, the Beijing artist Feng Mengbo created an interactive installation in 1996. Entitled *Private Photo Album (Siren zhaoxiang bo)*, it consists of several series of old photos that restage the lives of his grandparents, parents, and himself. The fourth and last series in the installation reconstructs the visual environment of the Cultural Revolution based on the artist's memory. Pursuing a visual autobiography in a more symbolic language, Yin Xiuzhen made a photo installation in 1999, displaying her own photos from different periods in old-fashioned women's shoes (which she made together with her mother). Making these

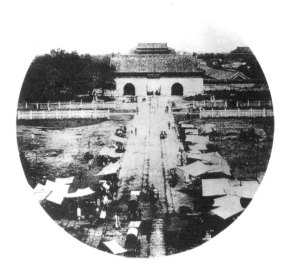

FIG. 8.10: ANONYMOUS, *The Gate of the Great Qing*, CA. 1900.

photos into public art while heightening their intimate relationship with the artist herself, this work problematizes the nature of private memory in a public representation. Meanwhile, artists like Zhang Xiaogang continued to blur the boundary between political iconography and avant-garde art; paintings in his *Big Family (Da jiating)* series derive their format and style from Cultural Revolution studio photos, exploring the hidden human relationship in these anonymous images.

Other works created since the late '90s have demonstrated a conscious effort to explore photography's role in forging "memory links" between past and present. In his 2000 *Family History (Jiazu suiyue)*, for example, Zheng Lianjie and his son displayed an enlarged black-and-white photo that his family took in Tiananmen Square forty-three years later. Framed within the "present" image of the same place, the historical photo acquires an

FIG. 8.11: HAN LEI, *Hunchback Bridge*, HAND PAINTED PHOTOGRAPH, 1998-2003.

acute "past" temporality. Similarly, Hai Bo has juxtaposed two photographs taken several decades apart. The first, an old group photo, shows young men or women in Maoist or army uniforms; their young faces glow with their unyielding belief in the Communist faith. The second picture, taken by Hao Bo himself, shows the same group of people—or in some cases, the surviving members—twenty or thirty years later. In an almost graphic manner, the two images register the passage of time and stir up viewers' recollections of certain moments in their own lives.

Going one step further, some experimental photographers take the vulnerability of photographic images—and hence the impermanence of the history and memory that they represent and preserve—as their central theme. A series of photos by Rong Rong, for example, studies the "mortality" of photographs by documenting the "lives" of various kinds of photos displayed in public places. Faded and discolored, many such photos have become "ruins" of their former selves. Wang Youshen, on the other hand, has made installations to display eroded and scratched archival photographs. Significantly, he discovered these photos in the archives of the official newspaper *Beijing Youth Daily*, where he has worked as an editor since 1988. Similar to his *Newspaper Great Wall* series, these installations aimed to destroy a media-constructed reality or mythology.

The relationship between experimental art and the popular "old photo craze" is a complex issue, which I hope to discuss more fully in a future study.[17] For now, the examples given above provide a context for understanding works by Han Lei and Li Songsong in this exhibition. Han Lei's photographs are intertextual in nature because they gain meaning from referring to historical photos. A comparison between his *Hunchback Bridge (Luoguo qiao)* (FIG. 8.11) and the old photo in FIG. 8.10 (which captures a glimpse of old Beijing around 1900) demonstrates how he derives format, style, taste, and mood from historical photography. The bridge—a famous Qing dynasty architectural structure in the Summer Palace—appears as an image resurrected from the past, gloomy and desolate. The circular frame, seldom used by contemporary photographers, heightens the image's identity as a self-conscious "art photo" of a retro type; and the tonal effect gives the picture an aged feel. It would be a mistake, however, to appreciate this work in a purely stylistic sense, because Han Lei's purpose is not simply to make an "old looking" photograph. Rather, he conceived the photograph as a memory-image. He has been quoted as saying: "Memory is itself a kind of image. What I have attempted is to turn such images in my mind into pictures in reality."[18] The "aged look" of his photographs thus signifies the artist's personal connection with the past. They external-

ize his internalized historical sensibility and visual experience, transforming conventional old photos into contemporary, individual expressions.

This general significance of Han Lei's photographs explains a particular feature of his works in this exhibition. Whether representing figures or landscape, the images are deliberately ambiguous and incomplete: the mountains seem to be vanishing from view, and a portrait refuses to stay within the picture frame. Frequently the prints seem overexposed or discolored; their awkwardness distances the images not only from reality but also from "real" old photographs. We can relate these images to Li Songsong's paintings, which likewise depict the artist's recollections of historical photos. For example, the painting in FIG. 8.13 is clearly inspired by photographs of Chairman Mao's funeral in Tiananmen Square in 1976 (FIG. 8.12). All three paintings in this exhibition are also based on documentary photographs of the history of the Chinese Communist Party: Mao's wife Jiang Qing waving the "little red book" during the Cultural Revolution, a gathering of Chinese leaders and their foreign visitors, and a performance of *A Brother and a Sister Exploring Virgin Land (Xiongmei kaihuang)* in the Communist base Yan'an. The paintings' summary, untrammeled appearance makes them simultaneously copies and abstractions of the photographs. The fast movement of the brush both delivers images and erases details, so that we can imagine the scenes as either emerging or disappearing in front of our eyes. Because the original photos are familiar to millions of Chinese people, the paintings' succinct brushwork has an indexical function to trigger the viewer's memories of their photographic models, while demonstrating the painter's admirable skill in translating conventional documentary photographs into artistic, painterly images.

§

The photographs in this exhibition are examples of Chinese conceptual photography, which became a major trend in contemporary Chinese art around the mid-90s.[19] Until then, experimental photographers had mainly established their alternative position negatively by divorcing themselves from mainstream photography.[20] But from the mid-90s, they also hoped to define experimental photography as an art with its own intrinsic logic, which they found in theories of conceptual art. Since then, their emphasis on idea and display has led to a wide range of constructed images. Their goals can be compared with those of American conceptual photographers of the '70s, who, as described by Corinne Robins were "making up or creating scenes for the camera in terms of their [i.e., the artists'] own inner vision."[21] Taking place twenty years later, however, a Chinese "replay" of this history has also incorpo-

FIG. 8.13: LI SONGSONG, *The Square*, OIL ON CANVAS, 2001.

rated a strong sense of contemporaneity. Backed by postmodern theories and utilizing state-of-the-art technology, experimental Chinese photography has actively interacted with other art forms including painting, sculpture, performance, installation, site-specific art, advertisement, and photography itself, transforming pre-existing images into photographic re-representations.[22] Similarly, the seemingly realistic paintings in this exhibition actually subvert the notion of a realistic representation being a direct pictorial transference of reality. To this end, all artists in the show have carried out experiments to interact with pre-existing images. No longer interested in capturing meaningful moments or images in life, they have instead focused on the manner or vocabulary of artistic expression. It is such experiments, plus their superb technique and their sensibility to visual form, that make their works exciting and absorbing.

Originally published in Wu Hung, ed., *Intersection: Contemporary Oil Painting and Photography* (New York: Chambers Fine Art, 2004), 6-17.

Variations of Ink: A DIALOGUE WITH ZHANG YANYUAN

This exhibition takes its title from a principle in traditional Chinese painting criticism and connoisseurship, namely that *mo fen wu se* (ink encompasses all the five colors).[1] The inventor of this principle was the great Tang dynasty art critic and historian Zhang Yanyuan, whose *Lidai minghua ji* (Record of the Famous Painters of All the Dynasties), compiled in 847, constitutes, in Michael Sullivan's words, "the earliest known history of painting in the world."[2] The significance of this treatise, however, goes far beyond its early date of composition. Zhang's ideas continue to inspire contemporary artists and art critics in their creation and appreciation of visual forms. Not only the title of this exhibition, but the whole idea of assembling a group of works to reflect on the role of ink in contemporary Chinese art, comes from Zhang's writings and, more specifically, from the section in his treatise entitled "On Painting Materials, Tracing and Copying."

This section, the eighth one in the treatise, has received less attention from scholars, partly because the heading gives the impression that here Zhang (I have omitted "Yanyuan" from this point on since the reader is aware of the referent) deals exclusively with technical matters of painting. This is certainly not true. For one thing, in this section one finds the most sophisticated—and at times the most philosophical—discourse on the art medium of ink ever attempted by a Chinese writer. Because

of its profundity, as well as abstractness, this discourse has transcended its particular historical time to become a "primary text" in Chinese art criticism. I read this text once again last year and was surprised by its relevance to recent works by some contemporary Chinese artists who are experimenting with the value of ink in abstract visual expression. Since I have also been absorbed by the idea of organizing what I call "experimental exhibitions" to test the role of public art display, I have a two-fold purpose in organizing this small show.

First and more practically, *Variations of Ink* is an exhibition that presents to the public a group of ink paintings and installations that exemplify an important branch of contemporary Chinese experimental art. These works, which largely affiliate themselves with abstract and conceptual art, demonstrate a shared tendency to separate "ink" from "brush." Hence, they also divorce themselves from traditional Chinese painting, which consistently emphasizes the joint importance of *bi* (brushwork) and *mo* (ink).[3] In other words, one finds in these works the deliberate dominance of ink over other visual elements. By pushing the role of this traditional medium to such an extreme, the artists both substantiate an ancient art tradition and subvert it.

Gone with the brushwork are identifiable shapes and other mimetic qualities of a painting. *Variations of Ink* offers abstract "ink" images that reject direct literary translation and social interpretation. Western viewers who have been following recent exhibitions of Chinese "avant-garde" art outside China may find these "formalist" works both refreshing and puzzling. The previous exhibitions, including some I have curated, have often interpreted contemporary Chinese art in a sociopolitical framework; such a framework has often guided the curator's selection of artists and works, either consciously or unconsciously. One purpose of this exhibition is, therefore, to balance this familiar picture with images that reveal other kinds of experimentation in contemporary Chinese art. These experiments, which typically focus on the formal qualities of a painting in terms of materiality, abstract shape, and tonal variation, have frequently been overlooked in large "sociological" exhibitions of contemporary Chinese art.

Second and more fundamentally, although in most exhibitions texts elucidate images, I see this exhibition as serving the reverse role and providing synchronized "postmodern" visual commentaries on Zhang's writings on ink. The idea is that by looking at these contemporary images, the public may reach a better understanding of the ancient text. Zhang's discussion of ink forms is an independent entry, separated from his discussion on "brushwork" in the same treatise. It is almost as if he foresaw the divorce of ink from brush as they are manifested in these images created more than a thousand years after his time.

Variation of Ink hopes to provide a site for dialogue between contemporary Chinese art and its remote origins. This is a "dialogue" because each work on view testifies to a deliberate negotiation between an artist and his artistic origin. While these artists acknowledge their roots in premodern Chinese art, they are also trying to renew this art form by making it contemporary and global. These two seemingly opposite paths have led them to rediscover the "essence" of ink—a concept at the heart of Zhang's discourse.

§

Zhang Yanyuan begins his discourse on ink with the creation of the universe:[4]

> Now the fashioning forces yin and yang have intermingled; the myriad images emerge in complex patterns. No human words are needed for the mysterious transformation of things— the divine work of Nature operates alone to generate this process.

For Zhang, *yan* (words) refer to all verbal and visual signs. Invented by human beings long after the creation of the universe, these signs serve to identify and describe natural phenomena but remain ultimately external to them. One category of such signs is color, which can be used to mimic the concrete appearances of things and living creatures, but can never reveal their essence. Hence in his words:

> Grasses and trees spread forth their glory without depending on cinnabar and jasper; floating clouds and swirling snow are naturally white without waiting for ceruse to make them so; the turquoise mountains do not need mineral "sky blue" powder; and the phoenix is iridescent without the application of multiple colors.

This series of analogues leads Zhang to define the unique role of ink. To him, this black substance alone allows artists to achieve what cannot be achieved by using radiant "mimetic" colors. The "colorlessness" of ink turns out to be its most precious strength. When used well it can produce endless layers of subtle shades that *imply* a multitude of colors without *representing* them. What the artist can capture in an ink painting, therefore, is not the outward appearance of things, but the *yi* or "mind" and his own comprehension of the phenomenal world. Zhang summarizes this view: "If by using ink a painter can allude to the five colors, we say that he has grasped the mind. But if an artist's mind is fixed on true colors, the essence of things will escape him."

Once this principle is established, Zhang proceeds to give painters specific advice by developing the concept of *liao* or the "completeness" of a painting. He writes:

> Now in painting things, what an artist should especially avoid includes meticulous delineation and coloration of forms, excessive carefulness to details, and explicit display of skills and finish. From here it follows that one should not deplore lack of completeness but rather that completeness is deplorable. For once one knows that an image has reached its completeness, where is the need of completing it further? It is not that there is really any incompleteness here: it is not recognizing when an image has reached its completeness that is the real incompleteness.

Here, Zhang is speaking about two different kinds of "completeness": one is understood as a thorough rendering of external appearances and the other refers to the complete grasp of the mind. He seems to be speaking not only to painters but also to viewers of ink paintings. What one should look for in such a painting, he advises, is whether the painter has deliberately rejected a naturalistic representation and reached this second kind of completeness. A good painter is someone who can translate the mind into the "five colors" of ink; a good viewer is someone who can see such a mind in the lack of colorful, mimetic images.

§

The contemporary Chinese curator and art critic Pi Daojian writes in the opening of his introduction to an exhibition called *China: 20 Years of Ink Experiment*: "At a time when globalization is becoming so pervasive and prevalent, it is almost impossible to find an artistic issue as 'Chinese' as 'ink.'"[5] Contrary to what one would expect, however, Pi finds the reason for the "Chineseness" of this so-called *shuimo wenti* (ink problem) not in ink's origin as a traditional medium, but in a debate among modern Chinese artists and art critics that has continued for over a century. The focus of this debate is whether *shuimo hua* (ink painting), though of traditional origin, can also be modern and contemporary.

It is impossible to even briefly review this debate in this short essay. As Pi has observed, the various participants in the debate remained nationalistic and solipsistic until the '80s, since they had rarely thought of the problem in international terms and since their solutions to "revolutionize" ink painting had heavily relied on renewing the subject matter of representation. An important change in ink painting took place in the '80s that fundamentally altered the orientation of this debate. Instead of approaching ink simply as a medium for painting, an increasing number of younger artists began to treat ink itself as the subject of artistic experimentation. While some of these artists had received formal training in traditional Chinese painting and calligraphy, many had not. Although they developed intense interest in ink and were fascinated with the potential of this material in contemporary art, they stayed firmly outside the camp of *guohua* (national painting).[6] Indeed, a movement promoting a new "ink art" gradually emerged in the '80s and '90s. The most important contribution of this movement was to redefine this art as a branch of *shiyan yishu* (experimental art), which allies itself with international, multimedia contemporary art, not with the orthodox school of "national painting."

The works in this exhibition are the fruit of this movement. The five participating artists include Chen Xinmao, Chen Guanwu, Wang Tiande, Zhang Jianjun, and Yang Jiechang. They are all in their thirties and forties and belong to the post-Cultural Revolution generation of experimental artists. Most of them have engaged in avant-garde experimentation since the '80s, and all of them have been experimenting with ink-related images for fifteen to twenty years. What this exhibition can offer is only a narrow glimpse of their wide-ranging experiments.

Although some images in this exhibition, such as those by Chen Xinmao and Chen Guangwu, employ calligraphy and printing, the general strategy is to subvert and "deconstruct" calligraphy and printing as *accepted* art traditions and technologies.

Chen Xinmao's multimedia paintings frequently feature distorted historical texts—incomplete and partially smeared wood-block prints as a result of misprinting (FIG. 9.1). The blurred characters appear dilapidated, as "ruins" or "traces" of some canonical books that have gained a new identity as images of purely visual significance. The ambiguity between textual and visual expression is heightened by the varied use of the ink, which assumes contradictory roles from reproducing texts to making texts illegible, sometimes burying characters under richly-textured, spreading blots.

FIG. 9.1: CHEN XINMAO, *History Book Series—Blurred Printing*, INK AND COLOR ON PAPER, 2002.

Chen Guanwu's attitude towards calligraphy—an art form that he has been practicing since the age of sixteen—is similarly iconoclastic. His works in the exhibition interpret calligraphy as a laborious writing practice, which dismisses any literary implication of writing through sheer repetition (FIG. 9.2). With diluted ink, Chen writes characters over and over on the same spot; the result is a layered presence of gray tones. To stress the subtlety of this ink "color" he frames it with harsh, black dots derived from the heterogeneous tradition of geometric abstraction.

FIG. 9.2: A VIEW OF THE EXHIBI-
TION *Variation of Ink*, SHOWING
CHEN GUANGWU'S *Untitled*
(1997) IN THE FOREGROUND
AND WANG TIANDE'S CHINESE
FAN (1996) AND CHINESE GAR-
MENT (2002) IN THE BACK-
GROUND.

In both Chen Xinmao's and Chen Guanwu's works, traditional Chinese ink and contemporary visual techniques, such as collage, installation, and performance, form "a stirring coalition."[7] This particular form of multi-media art also typifies works by the other three artists in this exhibition. Among them, Wang Tiande has arguably made the most serious effort to integrate two-dimensional ink painting with three-dimensional installations. His well-known piece, *Ink Manu* (1996), consists of a round dining table surrounded by six Ming-style chairs (FIG. 9.3). These pieces of furniture, as well as bowls, dishes, and wine bottles on the table are covered with rice paper and, in turn, painted with broad ink strokes. Instead of chopsticks, a pair of Chinese writing brushes is left in front of each empty chair, alluding to six "ghost painters" who have just completed their creations.

Wang Tiande's individual ink paintings often have round frames—a shape in his view that embodies a more organic, wholesome understanding of the cosmos typically found in Eastern philosophy (FIG. 9.4). This view may also underlie Zhang Jianjun's installation, *Fog Inside*, which he created in 1992 in Warsaw (FIG. 9.5). The work is minimalist in spirit —a large, flat, round cylinder filled with

FIG. 9.3: WANG TIANDE, *Ink Manu*,
INSTALLATION, 1996.

FIG. 9.5: ZHANG JIANJUN, *Fog Inside*, installation, WARSAW, 1992.

FIG. 9.4: WANG TIANDE, *Chinese Garment*, INK ON PAPER, 2001.

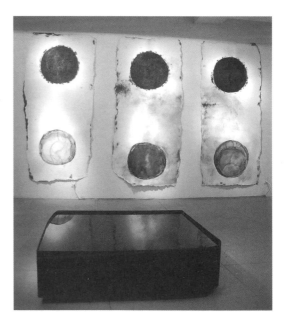

FIG. 9.6: ZHANG JIANJUN, *Inkwell and Water & Fire*, INSTALLATION, PAINTING, 2002, 2006.

FIG. 9.7: YANG JIECHANG, *Square—100 Layers of Ink*, INK ON XUANZHI PAPER, METAL BOX, 1994-1995.

ink-infused water. Although the cylindrical shape recalls a steel sculpture, the water inside it generates a sense of impermanence—a feeling reinforced by the steam that slowly rises from the liquid surface and disappears in the air. For the current exhibition, Zhang Jianjun has replaced the round cylinder with a square cube as the centerpiece of the larger installation and performance project. Surrounding this square cube are paintings that show large, burnt circles. The juxtaposition of the two primordial shapes—square and circle—as well as their respective connections with fire and water, implies the opposition between yang and yin (FIG. 9.6). It is the audience who brings these two cosmological forces into play, as they move between the painting and the installation while sprinkling pieces of a dry ink into the square "inkwell."

Our last artist, Yang Jiechang, began to create abstract ink paintings in the late '80s. To him, such artistic experiments are intimately connected to his study of Zen Buddhism and Taoism. In the series *100 Layers of Ink*, he obsessively applied layers on layers of ink, creating abstract "black holes" with shining surfaces (FIG. 9.7). A new style he has developed since the late '90s is characterized by bold, explosive ink drawings (FIG. 9.8). The titles of these works, such as *Crossss, Knots, and @*, supply a certain sense of lived experience to otherwise abstract forms. These works belong to the series *Double View*, a title that, in Martina Koeppel-Yang's view, hints at "the technique of multiple layers of ink" and the "ambivalence of the outer appearance of the things."[8] Even deeper in Yang Jiechang's experiment is his ambivalent relationship with traditional Chinese art and culture. On the one hand, to quote Koeppel-Yang again, his art "shows an anti-traditional, anti-cultural attitude." On the other hand, "the elimination of skill, imagery and personality is nothing less than the sublimation of the self, the ultimate aim of the cultivation of personality the Chinese literati practiced through painting and calligraphy."[9]

We may apply these words to the other four artists as well.

Originally published in Wu Hung, ed., *Variations of Ink: A Dialogue with Zhang Yanyuan* (New York: Chambers Fine Art, 2002).

FIG. 9.8: YANG JIECHANG, *Cardiogramme*, INK AND ACRYLIC ON XUAN PAPER, 1999-2000.

EXHIBITION

The "issue" of exhibition attracted many Chinese experimental artists, art critics, and independent curators in the '90s, and subsequently brought them into linked activities and discussions. One question was at the center of this issue: *How do we exhibit experimental art publicly?* Throughout the decade, it was evident that an increasing number of curators and artists had chosen "to go public." This phenomenon became especially obvious after the mid-90s. The advocates of this approach hoped that by finding new channels of bringing experimental art into the public sphere, they could realize the social potential of this art and undermine the prohibitions traditionally imposed upon it. They also hoped that these new channels would eventually constitute a social basis for the "normal workings" of experimental art, thus enabling it to contribute to China's ongoing social and economic transformation. These agendas were not simply concerned with the exhibition *per se,* but rather intimately related to large questions about the role of experimental art in China as well as the relationship between experimental artists and society at large.

HISTORICAL BACKGROUND

To understand the "experimental" nature of many exhibitions organized in the '90s, we need to briefly review the history of experimental art exhibitions in China since the late '70s. We can divide the thirty years between 1979 and 2000 into three periods. The first period, represented by the exhibitions of the Stars group in 1979 and 1980, marked the beginning of public exhibitions of experimental art in post-Cultural Revolution China. Most members of the group never received formal art training and were not affiliated with any official art institution. The group's early activities included private discussion sessions and informal art shows. Its members made a breakthrough by exhibiting their works in a small public park next to Beijing's National Art Gallery in September 1979 (FIG. 10.1). A big crowd gathered. The local authorities interfered and cancelled the exhibition two days later. The Stars responded by holding a public demonstration on October 1st, the 30th anniversary of the People's Republic of China.

Going one step further, the group hoped to take over an official exhibition space. A year later, this hope was partially realized: supported by some open-minded art critics in the semi-official Chinese Artists' Association, the *Third Stars Art Exhibition* was held on an upper floor in the National Art Gallery. More than 80,000 people went to the show in a period of sixteen days. From the very beginning, therefore, Chinese experimental art had a strong tendency to expand into the public sphere and to par-

ticipate in social movements. But in the case of the Stars, a public sphere was narrowly defined as a "political space"— the National Art Gallery. Members of the group followed a mass movement action called *duoquan*—"taking over an official institution"—derived from the Cultural Revolution itself. Although the *Third Stars Art Exhibition* was the first experimental art exhibition held in the National Art Gallery, its impact on the official system of art exhibition was as brief as the show itself. This triumphant moment of the Stars was followed by a ten-year long absence of experimental art in the National Art Gallery, till the enormous *China/Avant-garde* exhibition took over this official space again in 1989.

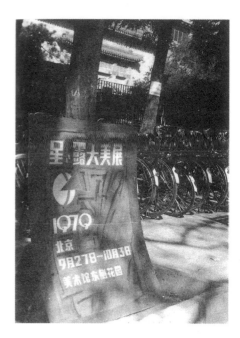

FIG. 10.1: "*Stars*" EXHIBITION, 1979, BEIJING.

This 1989 exhibition concluded the second period in the history of experimental art exhibitions. During this period, the Stars' precedence was followed by a nationwide movement of experimental art that emerged around the mid-80s. Known as the '85 Art New Wave, this movement involved a large number of individual artists in different cities and provinces. These artists formed many "avant-garde" art groups and societies, experimenting with art forms and concepts that they had just learned from the West. In terms of exhibitions, what distinguished this period from the previous one was mainly the large number and variety of shows and public performances. Experimental art exhibitions were organized in all sorts of places, from a classroom in an art school to an open ground in a park (FIG. 10.2). However, the organizers made little effort to develop these spaces into regular channels of exhibiting experimental art. Rather, many of them were still preoccupied with the idea of taking over an official art gallery through an organized movement.

FIG. 10.2: AN AVANT-GARDE PERFORMANCE TAKING PLACE AT PEKING UNIVERSITY DURING THE '85 ART NEW AVE MOVEMENT.

This approach was especially favored by the leaders of the '85 Art New Wave. In an effort to bring scattered groups into a nationwide movement, they proposed as early as 1986 to hold a national exhibition of experimental art in Beijing.[1] They finally realized this plan three years later in the *China/Avant-garde* exhibition. Without compromising the seminal importance of this exhibition in the history of contemporary Chinese art, it is also necessary to recognize its limitations. First, although it included many works that were radical and even shocking, the no-

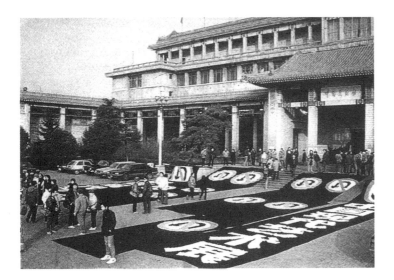

FIG. 10.3: *China/Avant-garde* EXHIBITION, 1989, NATIONAL ART GALLERY, BEIJING.

tion of a comprehensive, "national" exhibition was traditional and, ironically, found its immediate origin in the official National Art Exhibitions. Second, although its organizers gave much thought to the location of this exhibition, there was little discussion about how to change the system of art exhibition in China. The 1989 exhibition was envisioned as a grand but temporary event—another triumphant moment of "taking over" a primary official art institution. The National Art Gallery was transformed upon the opening of the exhibition: long black carpets, extending from the street to the entrance of the exhibition hall, bore the emblem of the exhibition: a "No U-turn" traffic sign signaling "There is no turning back" (FIG. 10.3). Many "accidents" during the exhibition, including a premeditated shooting performance, made a big stir in the capital (FIG. 10.4). There was a strong sense of happening associated with this exhibition, which was closely related to the social situation of the time.

The third period in the history of experimental art exhibition started in the early '90s. As I have discussed elsewhere, a fundamental development of Chinese experimental art since the early '90s up till now has been a shift from a collective movement to individualized experiments.[2] These experiments are not limited to art mediums and styles, but are also concerned with the forms and roles of exhibitions.

FIG. 10.4: TANG SONG AND XIAO LU, PERFORMANCE DURING THE *China/Avant-garde* EXHIBITION, NATIONAL ART GALLERY, 1989.

These concerns reflect a new direction of Chinese experimental art toward normalization and systematization. Instead of pursuing a social revolution, curators and artists have become more interested in building up a social basis, which would guarantee regular exhibitions of experimental art and reduce interference from the political authorities. A number of new factors in Chinese art have encouraged this interest and include: 1. the deepening globalization of Chinese experimental art, 2. a crisis in the existing public exhibition system, 3. the appearance of new types of exhibition spaces as a consequence of China's socioeconomic transformation, and 4. the emergence of independent curators and their growing influence on the development of experimental art. These factors all interact, contributing to new kinds of exhibitions that have been planned to expand existing exhibition spaces and to forge new exhibition channels. Because these exhibitions are, to a large degree, social experiments, and because their results are still to be seen, I call them "experimental exhibitions."

STIMULI OF "EXPERIMENTAL EXHIBITIONS"

Chinese experimental art was "discovered" by Hong Kong, Taiwan, and western curators and dealers in the early '90s. A series of events, including the world tour of the *Post 89: China's New Art* exhibition organized by Hong Kong's Hanart Gallery, the appearance of young Chinese experimental artists in the 1993 Venice Biennale, and cover articles in *Flash Art* and *The New York Times Magazine*, introduced this art to a global audience.[3] Since then, Chinese experimental art has attracted growing attention abroad. To list just a few facts in 1999, the last year of the decade: at least two large exhibitions of this art took place in the United States; the Beijing-born artist Xu Bing was awarded a MacArthur Fellowship in the same year; another New York-based Chinese artist, Gu Wenda, was featured on the cover of *American Art*; twenty Chinese artists were selected to present their work in that year's Venice Biennale, more than the number of either the American or Italian participants; Cai Guo-Qiang won one of the three International Awards granted at this Biennale. While Xu Bing, Gu Wenda, and Cai Guo-Qiang were among those Chinese artists who have immigrated to the West and established their reputations there, artists who decided to remain home found no shortage of invitations to international exhibitions and art fairs. Their works were covered by foreign media and appeared regularly in books and magazines.

Many artists in this second group were "independent" in status, meaning that they were not associated with any official art institution and often had no steady job. This lifestyle had become prevalent among experimental artists since the early '90s, and had allowed them to go back and forth between China and other countries.[4] A parallel phenomenon in the '90s was the appearance of "independent curators" (*duli cezhanren*). Usually not employed by official or commercial galleries, these individuals organized exhibitions of experimental art primarily out of personal interest. They normally had other things to do as well—some of them were art critics and editors while others were artists themselves. In either case, they kept close relationships with experimental artists, and introduced them to a larger audience through their exhibitions and writings. Experimental artists and independent curators played an increasing role in the art of the '90s because of their familiarity with the international art scene—not just with a few fashionable names and styles but, more importantly, with standardized art practices including various types of exhibitions and exhibition spaces. They had become, in fact, members of a global art community; but they identified themselves with "Chinese art" and decided to act locally.

A key to understanding these independent artists and curators—many of them seem to have been thoroughly westernized—is their deep bond with China. They believed that their work was part of contemporary Chinese culture and had been inspired by Chinese reality. Ironically, this self-realization was encouraged by their frequent participation in international exhibitions. If before the mid-90s an

invitation to a major international exhibition was a big deal, such invitations were no longer rarities in the late '90s. While still traveling abroad, some artists began to question whether such exposure had any real significance. Many experimental artists also became increasingly critical toward foreign curators, accusing them of coming to China to "pick" works to support their own views of China and Chinese art, which the artists saw as a typical orientalist or post-colonial practice. This criticism was shared by many independent curators.[5] It then became natural for these curators and artists to launch projects to hold indigenous exhibitions facilitated by their familiarity with western exhibitions. But here they ran into another problem.

In sharp contrast to its popularity among foreign curators and collectors, Chinese experimental art in the '90s was still struggling, to say the least, for basic acceptance at home. Although books and magazines about avant-garde art were easily found in bookstores since the mid-90s, actual exhibitions of this art, especially those of installation, video art, computer art, and performance, were still generally discouraged by state-run art museums and galleries. Moreover, to organize any public art exhibition, one had to closely follow a set of rules. According to a government regulation, all public art exhibitions must be organized (*zhuban*) by institutions entitled to or-ganize such exhibitions, and all public art exhibitions must be held in registered exhibition spaces and be approved by responsible authorities. This regulation gave the gov-ernment and its agencies almost unlimited power to turn down any proposed exhibition or to close any exhibition that had already been installed or even opened.

Any independent curator who planned to orga-nize an exhibition of experimental art in the '90s had to face this reality. On the other hand, the fact that so many exhibitions of experimental art, including some extreme ones, did take place in those ten years proves that the afore-mentioned regulation only represents part of reality; there was much room for artists and curators to explore. Starting from 1994 and especially after 1997, many exhibitions or-ganized by these curators indicated a new direction: these curators were no longer satisfied with just finding any avail-able space—even a primary space such as the National Art Gallery—to put on an exhibition. Rather, many of them organized exhibitions for a larger purpose: to create regular exhibition channels and to "legalize" experimental art. To these curators, it had become possible to pursue these goals because of the new conditions of Chinese society. They be-lieved that China's socioeconomic transformation had cre-ated and continued to create new social sectors and spaces that could be exploited for developing experimental art.

FIG. 10.5: A BILLBOARD ERECTED IN 1999 NEXT TO TIANANMEN SQUARE, SHOWING A COLLAGE OF MANY RECENTLY CONSTRUCTED BUILDINGS IN BEIJING.

NEW CONDITIONS FOR EXHIBITING EXPERIMENTAL ART

This socioeconomic transformation started in the '70s and '80s: a new generation of Chinese leaders made a dramatic turn to develop a free-market economy soon after the Cultural Revolution was over. The consequence of this transformation, however, was not fully felt until the mid-90s when nu-

merous private and joint-venture businesses began to overwhelm state enterprises. Major cities such as Beijing and Shanghai were completely reshaped, showing off their newly gained global confidence with glimmering shopping complexes and five-star hotels (FIG. 10.5). Changes also took place in people's lifestyles. While private real estate was abolished during the Cultural Revolution, the hottest commercial items in the '90s were houses and apartments. Hollywood films conquered Chinese movie theaters; fashion shows and beauty pageants were ranked among the most popular TV programs. Of course there were also serious things to worry about: millions of laid-off (*xiagang*) workers were struggling to support their families; a widening gap between the rich and the poor constantly threatened social stability. Generally speaking, China in the '90s was a huge mixture of old and new, feudal and postmodern, excitement and anxiety. The country's future seemed to depend on the outcome of the negotiation between conflicting traditions, desires, and social forces.

These words also describe the situation of art exhibitions in the '90s: important progress was definitely taking place, but a new system of public exhibitions remained the goal for a future development. In China, any art exhibition is defined first of all by its physical location. My survey of the exhibition spaces of experimental art in 1999 and 2000 yielded the following varieties:[6]

1) Spaces for public exhibitions (or "open" exhibitions) of experimental art:
 A) Licensed exhibition spaces
 i. Major national and municipal galleries (e.g., National Art Gallery in Beijing, Shanghai Art Museum, He Xiangning Art Gallery in Shenzhen)
 ii. Smaller galleries affiliated with universities and art schools (e.g., Capital Normal University Art Gallery and Contemporary Art Gallery in Beijing)
 iii. Semi-official art galleries (e.g., Yanhuang Art Gallery in Beijing, Art Gallery of Beijing International Art Palace, and Chengdu Contemporary Art Gallery)
 iv. Versatile exhibition halls in public spaces (e.g., Main Hall of the former Imperial Ancestral Temple in Beijing)
 B) Privately-owned galleries and exhibition halls
 i. Commercial galleries (e.g., Courtyard Gallery, Red Gate Gallery, and Wan Fung Art Gallery in Beijing)[7]
 ii. Non-commercial galleries and exhibition halls (e.g., Design Museum in Beijing, Upriver Art Gallery in Chengdu, and Taida Art Gallery in Tianjin)
 C) Public, non-exhibition spaces[8]
 i. Open spaces (e.g., streets, subway stations, parks, etc.)
 ii. Commercial spaces (e.g., shopping malls, bars, supermarkets, etc.)
 iii. Mass media and virtual space (e.g., TV, newspapers, and Web sites)
2) Spaces for private exhibitions (or "closed" exhibitions) of experimental art:
 A) Private homes
 B) Basements of large residential or commercial buildings
 C) "Open studios" and "workshops" sponsored by individuals or institutions
 D) Embassies and foreign institutions

The main exhibition channels of experimental art in the early '90s were private or closed shows, whose audiences were mainly artists themselves, their friends, and interested foreigners. Terms such as "apartment art" and "embassy art" were invented to characterize these shows (FIG. 10.6). Starting from 1993, however, exhibitions began to be held in various public spaces. Commercial galleries started to appear; some of them supported experimental art projects that were not aimed at financial return (FIG.

10.7).[10] Some university galleries, such as the Capital Normal University Art Gallery and the Contemporary Art Gallery of the Central Art School (known in Chinese as Zhongyang Meishu Xueyuan Fuzhong or Highschool Affiliated to the Central Academy of Fine Arts), became major sites of experimental art in Beijing, mainly because their directors—in these two cases Yuan Guang and Li Jianli, respectively—took on the role of supporting this art (FIGS. 10.8, 10.9). Sympathizers of experimental art also emerged in state-run exhibition companies. For example, one such individual, Guo Shirui, then the director of the Contemporary Art Center under the National News and Publication Bureau, began in 1994 to organize and sponsor a series of influential experimental art exhibitions.[11]

"Experimental exhibitions" of the late '90s continued this tendency. Their organizers focused on the three types of public spaces listed above, and tried to develop them into regular meeting places of experimental art with a broader audience, thereby cultivating public interest in this art. Their basic means to realize this goal were to develop exhibitions of experimental art in these spaces. Following this general direction, independent curators could still work with large or small licensed "official" or "semi-official" exhibition spaces, but tried to convert their directors into supporters of experimental art. Alternatively, they could devote their energy to helping privately-owned exhibition spaces to develop interesting programs. A third strategy was to use "non-exhibition" spaces to bring experimental art to the public in a more flexible manner.

EXPANDING EXISTING SPACES:
EXHIBITING EXPERIMENTAL ART IN PUBLIC GALLERIES

Let's take a closer look at these efforts and their conditions. First, important changes had taken place in many licensed public galleries, thus creating the possibility to bring experimental art into these places. Traditionally, all these galleries were sponsored by the state, and their exhibitions served strong educational purposes. Although this was still true in theory in the late '90s, in actuality most of these public galleries had to finance their own operations, and for this and other purposes had to modify their image to appeal to a wider audience. As a result, their programs became increasingly multifunctional. Even the National Art Gallery in Beijing routinely held three different kinds of exhibitions, which were more than often ideologically self-contradictory. These included: 1. mainstream exhibitions organized by the gallery to support the government's political agendas and to showcase "progressive" traditions in Chinese art,

FIG. 10.7: A POSTER FOR AN EXHI-BITION HELD AT BEIJING'S COURT-YARD GALLERY IN 1999.

FIG. 10.8: POSTER OF THE EXHIBITION *Women. Here* AT THE CONTEMPORARY ART GALLERY OF THE CENTRAL ACADEMY OF FINE ARTS HIGH SCHOOL, BEIJING, 1995.

2. imported exhibitions of foreign art, including avant-garde western art, as part of China's cultural exchanges with other countries, and 3. short-term and often mediocre "rental" exhibitions as the main source of the gallery's income (the gallery collects a handsome fee for renting out its exhibition space and facilities). It became easily questionable why the gallery could show western avant-garde art but not Chinese avant-garde art, and why it willingly provided space to an exhibition of obviously poor quality but not to an exhibition of genuine artistic experiment.

Unable to respond to these questions but still insisting on its opportunistic practices, the National Art Gallery—and indeed the whole existing art exhibition system—was rapidly losing its credit. It is therefore not surprising to find that the position of the National Art Gallery was not always shared by other official art galleries. Some of these galleries, especially newly established and "semi-official" ones, were more interested in developing new programs to make themselves more cosmopolitan and "up-to-date." The He Xiangning Art Gallery in Shenzhen, for example, advertised itself as "a national modern art museum only second to the National Art Gallery in Beijing."[12] Instead of taking the latter as its model, however, it organized a series of exhibitions to explore "the complex relationship between experimentation and public function, academic values and visual attractiveness" in contemporary art (FIG. 10.10).[13] A similar example was the Shanghai Art Museum,

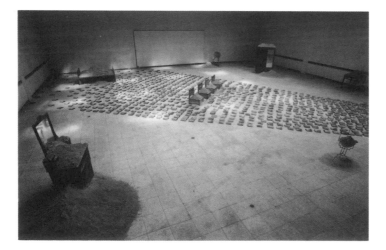

FIG. 10.9: YIN XIUZHEN'S EXHIBITION, *Ruined City*, CAPITAL NORMAL UNIVERSITY ART GALLERY, BEIJING, 1996.

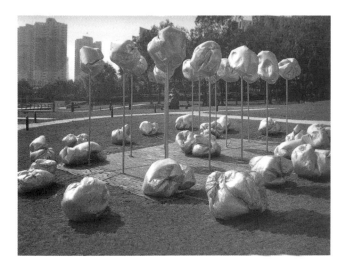

FIG. 10.10: CHE KE, *Environment,* a work shown in the *Second Yearlong Contemporary Sculpture Exhibition* AT HE XIANGNING ART GALLERY IN SHENZHEN, 1999.

which assembled a collection of contemporary oil paintings and sculptures in less then five years, and organized *Shanghai Spirit: Shanghai Biennale 2000* to feature "works by outstanding contemporary artists from any country, including Chinese experimental artists."[14] The organizers of this exhibition placed a strong emphasis on the relationship between the show and its site in Shanghai, a city that "represents a specific and innovative model of modernization, a regionally defined but globally meaningful form of modernity that can only be summed up as the 'Shanghai Spirit.'"[15] Some independent curators were attracted by the opportunities to help organize these new programs, because they saw potential in them to transform the official system of art exhibition from within. In their view, when they brought experimental art into official and semi-official exhibition spaces, this art changed the nature of the space. For this reason, these curators tried hard to work with large public galleries to develop exhibitions, although such projects often required delicate negotiation and frequent compromises.

Generally speaking, however, national and municipal galleries were still not ready to openly support experimental projects by young Chinese artists. Even when they held an exhibition of a more adventurous nature, they often still had to emphasize its "academic merit" to avoid possible criticism. Compared with these large galleries, smaller galleries affiliated with universities, art

FIG. 10.11: *2000 China. Internet Video and Photo Art* EXHIBITION, HELD AT THE ART GALLERY OF THE JILIN PROVINCIAL ART ACADEMY, 2000.

schools, and other institutions enjoyed more freedom to develop a more versatile program, including featuring radical experimental works in their galleries for either artistic or economic reasons. If a director was actively involved in promoting experimental art, his gallery, though small and relatively unknown to the outside world, could play an important role in developing this art. Examples of such cases include the Capital Normal University Art Gallery and the Contemporary Gallery of the Central Art School, which held many original exhibitions from 1994 to 1996. On the part of an independent curator, if he proposed to stage an exhibition for a short period and to keep it low profile, he was more likely to use such exhibition spaces.

Exhibitions housed in universities and art schools became prevalent around the mid-90s, although some curators and artists made a greater effort toward the end of the decade to attract official sponsorship and to make an exhibition known to a larger audience. One such example was the recent *2000 China. Internet Video and Photo Art*, held at the Art Gallery of the Jilin Provincial Art Academy (FIG. 10.11). As many as fifty-two artists throughout the country participated in this exhibition; their works were grouped into sections such as "conceptual photography," "multi-media images," and "interactive internet art." The sponsors of the exhibition included the Jilin Provincial Artists' Association and Jilin Provincial Art Academy, which provided the exhibition not only with an exhibition space, but also computer equipment, supporting facilities for internet art, and a fund of 50,000 yuan (about $3,900). An additional fund of 50,000 yuan was raised from private businesses in Changchun. The exhibition attracted a local crowd, and also linked itself with artists and viewers far away through the internet.

FORGING NEW CHANNELS:
EXHIBITING EXPERIMENTAL ART IN SEMI-PUBLIC AND PRIVATE GALLERIES

From the early '90s, some advocates of experimental art launched a campaign to develop a domestic market for experimental art. The first major initiative in this regard was the *First Guangzhou Biennale* in October 1992, which showed more than four hundred works by three hundred and fifty artists and was supervised by an advisory committee formed by fourteen art critics. Unlike any previous large-scale art shows, this exhibition was sponsored by private entrepreneurs and had a self-professed goal to establish a market system for contemporary Chinese art. Its location in an "international exhibition hall" inside a five-star hotel was symbolic. The amount set aside for awards was 450,000 *yuan* (about $120,000 at the time), an unheard of amount of money for any of the show's participants. Suffering from the inexperience of the organizers as well as antagonism from the more idealistic artists, however, this grand undertaking ended with a feud between the three major parties involved in the exhibition: the organizers, the sponsor, and the artists.[16]

Two exhibitions held in 1996 and 1997 were motivated by the same intent to develop a market system for experimental art, but had a more specific purpose in facilitating the earliest domestic auctions of experimental art. Called *Reality: Present and Future* and *A Chinese Dream*, both events were curated by Leng Lin and sponsored by the Sungari International Auction Co. Ltd., and both took place in semi-public art galleries. The location of the 1996 exhibition was the Art Gallery of Beijing International Art Palace located inside the Holiday Inn Crowne Plaza Hotel in central Beijing. Established in 1991, this gallery was funded by a private foundation, but obtained the legal status of a "public exhibition space" from Beijing's municipal government largely because of the political connections of the gallery's founder Liu Xun, who was the head of the semi-official Artists' Association before he created the Beijing International Art Palace and became its director. The Yanhuang Art Gallery, location of the 1997 exhibition and auction *A Chinese Dream*, was the most active semi-official exhibition space in China in the early '90s. Founded by the famous artist Huang Zhou in 1991 and supported by two

foundations, it was a private institution affiliated with an official institution, first with Beijing's Municipal Bureau of Cultural Relics and then with the Chinese People's Political Consultative Conference.[17]

The semi-public status of these galleries gave them greater flexibility to determine their programs. This is why each of them could have held an exhibition and auction as a joint venture between three parties: an independent curator, a semi-public gallery, and an auction house. The position of the auction house in this collaboration was made clear by its vice chairperson Liu Ting, a daughter of the late Chinese President Liu Shaoqi: "At present, as a commodity economy continues to expand in China, how to build up an art market for high-level works has become one of the most pressing issues in cultural and artistic circles. The current exhibition, *Reality: Present and Future* sponsored by the Sungari International Auction Co. Ltd., represents one step toward this goal."[18]

Another noticeable example of a semi-public gallery is the Chengdu Contemporary Art Museum founded in September 1999. Large enough to contain several football fields, this enormous gallery is part of an even larger architectural complex including two luxury hotels (one five-star and one four-star). The whole project is financed by Chengdu's municipal government and a Chinese-American joint venture company called the California Group (*Jiazhou Jituan*). Deng Hong, the museum's director and the Chairman of the Group's Board of Trustees, states the purpose of the museum:

> Twenty years after China opened its doors and began to undertake a series of reforms, the achievement of our country in the economic domain is now recognized by the whole world. But we must also agree that progress in the cultural sphere, especially in the area of cultural infrastructure, falls far behind our economic growth. Since the mid-90s or even earlier I have been thinking that we should not only build a large scale modern art gallery with first-rate equipment, but, more importantly, need to introduce more advanced operating mechanisms and new modes in curating exhibitions, in order to facilitate and promote the development of Chinese art... This is the fundamental and long-term goal of the Chengdu Contemporary Art Gallery.[19]

The museum's inauguration coincided with an enormous exhibition. Called *Gate of the New Century*, this exhibition included a considerable number of installations and some performance pieces—content which would normally be omitted in a mainstream state-run gallery. But the exhibition as a whole still followed the mode of a synthetic, anonymous National Art Exhibition. Partly because of such criticism, the museum decided to sponsor versatile exhibitions of more experimental types.

Unlike the Chengdu Contemporary Art Museum, which is partially funded by the local government and is thus defined here as "semi-public," some art galleries are entirely privately owned. A major change in China's art world in the '90s was in fact the establishment of these private galleries, which far out-numbered semi-public galleries and provided more opportunities to exhibit experimental art outside the official system of art exhibition. Commercial galleries appeared first in the early '90s, and by the end of the '90s had constituted the majority of private galleries. Strictly speaking, a commercial gallery is not a licensed "exhibition space." But because it is a licensed "art business" (*yishu qiye*), its space can be used to show art works without additional official permission. In the middle and late '90s, quite a few owners or managers of these commercial galleries took a personal interest in experimental art, and supported "non-profit" exhibitions of installations, video art, and performances in their galleries. Maryse Parant, who interviewed a number of such owners or managers in Beijing, noted that "these galleries are also precursors. They not only sell, they also serve an educational purpose, digging a new path for art in China, shaping a market so that artists can continue their work and be seen."[20] While mainly offering "milder" types of experimental art to western collectors, these galleries occasionally held bolder shows organized by guest curators. One such show was the *Factory No. 2* exhibition held in

Beijing's Wan Fung Gallery in early 2000. Curated by three young students in the Department of Art History at the Central Academy of Fine Arts, this impressive exhibition featured installations and works with explicit sexual implications seldom seen in a commercial gallery (FIG. 10.12).

FIG. 10.12: *Factory No. 2* EXHIBITION HELD AT BEIJING'S WAN FUNG GALLERY IN EARLY 2000.

Non-commercial, privately funded art galleries were an even later phenomenon in China. These were galleries defined by their owners as "non-profit" (*fei yingli*), meaning that they supported these galleries and their operations with their own money, and that the art works exhibited there were not for sale. Although most of these owners did collect, the main program of these galleries was not to exhibit private art collections, but to hold a series of temporal shows organized by guest curators. These galleries thus differed from both commercial galleries and private museums, and had a greater capacity to exhibit more radical types of experimental art. For this advantage, some independent curators devoted much time and energy to help establish non-commercial galleries.

There had been no precedent for this type of exhibition space in Chinese history. Nor was it based on any specific western model, although its basic concept was certainly derived from western art museums and galleries funded by private foundations and donations. Because China did not have a philanthropic tradition of funding public art, and because no tax law was developed to help attract private donations to support art, founding a non-commercial gallery required originality and dedication. It was a tremendous amount of work for curators and artists to persuade a company or a businessman to establish such an institution to promote experimental art. But because a gallery like this did not belong to a government institution and was not controlled by any official department, some curators and artists saw a new system of exhibition spaces based primarily on this kind of private institution. Their hope seemed to be shared by the owners of some of these galleries. Chen Jiagang, the owner and director of Upriver Art Gallery in Chengdu, Sichuan province, made this statement:

> The rise of great art at a given time originates not only from the talented imagination and activities of a few geniuses, but also from the impulse and creativity of a system. To a certain extent, an artistic work completed by an individual needs to be granted its social and historical value by a system. After the sustained efforts and striving of several generations, contemporary Chinese art has made a remarkable progress. But the system of contemporary Chinese art still remains mired in its old ways. Art galleries, agents, privately-owned art museums as well as a foundation system have not yet been established, which, as a result, has obstructed the participation of contemporary Chinese art in contemporary Chinese life and establishment of its universality to a certain extent. As an important part in the contemporary art system, the function and development of art galleries is urgent.

The Upriver Art Gallery has been established to provide the finest Chinese artists, critics and exhibition planners with a platform in order to support experiments in and academic research on contemporary Chinese art. In this way, it hopes to stimulate the achievement of first class art and its dissemination in society at large and the selection of works on academic merit.[21]

It is unclear how many galleries of this kind were established in the '90s; the three best known were respectively located in Chengdu, Tianjin, and Shenyang.[22] Each of them had a group of independent curators and experimental artists as advisors. Some of the most original exhibitions of experimental art in 1998 and 1999 took place in these and other private galleries. Because the owners of these galleries were either large companies or rich businessmen, their influence and relationship with local officials helped protect the exhibitions held in their galleries. In addition, their connections with local newspapers and TV stations helped turn these exhibitions into public events. Several shows held in the Upriver Art Gallery, for example, supplied the media with sensational materials and attracted people of different professions and classes to the exhibitions. Encouraged by such attention, some curators took public interaction as their goal, developing exhibitions around themes that would arouse public discussion and debate. However, there was a serious drawback to this type of gallery and exhibition spaces: its operation and existence relied on the financial situation of its owner. It was not uncommon that when a company began to lose money, it immediately stopped supporting art exhibitions and even closed down its exhibition hall.

CREATING VERSATILE EXHIBITION SPACES:
BRINGING EXPERIMENTAL ART TO THE PUBLIC

A significant effort made by independent curators and artists was to hold experimental art exhibitions in versatile, non-exhibition spaces. Instead of creating either official or private regular exhibition channels, these were "site-specific" exhibitions that served two interrelated purposes: they brought experimental art to the public in a dynamic, guerilla-like fashion, and in so doing transformed non-exhibition spaces into public exhibition spaces. The organizers of these exhibitions shared the belief that experimental art should be a part of people's lives and should play an active role in China's socioeconomic transformation. Because these curators often wanted to demonstrate an unambiguous relationship between an exhibition and its social environment, most of these projects were strongly thematic and centered on certain public spaces. It was also common for these curators to ask artists to submit site-specific works for their exhibitions, and in this way encourage these artists to contextualize their art within a public space.

This direction was exemplified by a number of original projects developed in 1999 and 2000. For example, the exhibition *Supermarket* was actually held in a supermarket in downtown Shanghai (FIG. 10.13); the fashionable bar Club Vogue in Beijing became the site of the exhibition *Art as Food*

FIG. 10.13: SONG DONG, *Here You Can Find Contemporary Art for Sale*, PERFORMANCE, A WORK IN THE SUPERMARKET EXHIBITION, HELD IN THE SHANGHAI SQUARE SHOPPING CENTER, 1999.

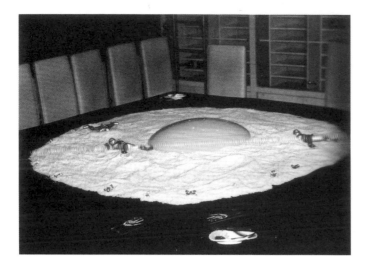

FIG. 10.14: ZHANG NIAN'S INSTALLATION AT THE EXHIBITION *Art as Food* HELD AT BEIJING'S CLUB VOGUE, 1999.

Related to such experiments in expanding public exhibition spaces was the effort to adapt popular forms of mass media to create new types of experimental art. The artist Zhao Bandi, for example, not only turned his conceptual photographs into "public welfare" posters in Beijing's subway stations (FIG. 10.16), but also convinced the directors of CCTV to broadcast these photographs for similar purposes. Other experimental artists created works resembling a newspaper. The most systematic undertaking along this line was a project organized by the art critic and independent curator Leng Lin. Here is how he described the experiment:

This project was put into practice in July 1999. Called *Talents*, it initially consisted of four artists: Wang Jin, Zhu Fadong, Zhang Dali, and Wu Xiaojun. Its purpose was to explore a new way of artistic expression by adapting the form of the newspaper. Derived from this popular social medium, this form combines experimental art with people's daily activities, and brings this art into constant interaction with society. This project produced a printed document resembling a common newspaper. Each of its four pages was used by one of the four artists to express himself directly to his audience. In this way, these artists' final products became inseparable from the notion of the newspaper, and the idea of artistic creativity became subordinate to the broader concept of mass communication... We put *Talents* in public spaces such as bookstores and fairs. People could take it free of charge (FIG. 10.17).[23]

But for some artists and curators, the newspaper was already too traditional a mass medium, so they began to explore newer information technologies such as the internet. It became a common practice in the '90s for Chinese experimental artists to have personal web pages to feature their art works. But independent curators also discovered this space to organize "virtual exhibitions." For example, supported by the website "Chinese-art.com" based in Beijing, these curators took turns to edit the *Chinese Type Contemporary Art Magazine*. Each issue of the magazine, primarily edited by

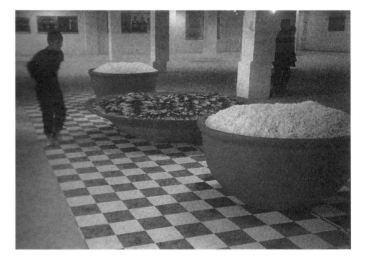

FIG. 10.15: THE EXHIBITION HOME?: *Contemporary Art Proposals* HELD AT THE STAR-MOON HOME FURNISHING CENTER IN SHANGHAI, 2000.

an active independent curator of experimental art, integrated short pieces of writings with many images; the form was more like an exhibition than a conventional art journal (FIG. 10.18). The significance of such "virtual exhibitions" could also be understood in a more specific context: when public display of experimental art became difficult in the early '90s, some art critics curated "document exhibitions" (*wenxian zhan*) to facilitate the communication between experimental artists. Consisting of reproductions of works and writings by artists scattered throughout the country, these traveling shows provided in-

FIG. 10.16: ZHAO BANDI'S PHOTO DISPLAYED IN BEIJING'S SUBWAY STATIONS, 1998.

formation about recent developments of Chinese experimental art. These "document exhibitions" were replaced in the late '90s by "virtual exhibitions" on the internet, which served similar purposes in a new period.

PUBLIC AND PRIVATE "EXPERIMENTAL EXHIBITIONS"

Generally speaking, an exhibition becomes "experimental" when the focus of experimentation has shifted from the content of the exhibition to the exhibition itself: its site, form, and function. Issues about these aspects of exhibitions loomed large in the '90s because of an increasing conflict between a rapidly developing experimental art and a backward system of art exhibition. Instead of seeking solutions in a radical social revolution, advocates of experimental art placed their hopes on China's socioeconomic transformation, and decided to speed up this transformation with their own

FIG. 10.17: PEOPLE READING *Talents* ON BEIJING'S STREETS, 1999.

efforts. Consequently, they planned many exhibitions to widen existing public spaces and to explore new public spaces for exhibiting experimental art, and to find new allies, patrons, and audiences for this art. In this sense, the experimental nature of these public exhibitions lay, first of all, in their professed goal of forging a "new system" of art exhibition in China. Under this general goal, each exhibition became a specific site for a curator to conduct a series of experiments. These experiments again stimulated the participating artists into experimenting with new concepts and forms in their art.

Although, in theory, an open exhibition is a public event and a closed exhibition is a private affair, the line between the two was not definite in the '90s. An open exhibition was probably not so open after all because of concern with its possible cancellation. According to the artist Song Dong, for example, careful planning and low profile are two key reasons that allowed the Capital Normal University Art Gallery to develop a consistent program of experimental art exhibitions for three years from 1994 to 1996.[24] Although the gallery is a licensed, public exhibition space, the exhibitions held there during these years were short and mainly organized over weekends. These exhibitions inside a walled campus were not widely advertised; their timing was also carefully determined. All these factors made these "public" exhibitions actually semi-public or half-closed events.

On the other hand, although a closed show could be an informal gathering held in someone's house or apartment,

FIG. 10.18: PART OF NINE CHINESE ARTISTS, A "VIRTUAL EXHIBITION" ORGANIZED BY LENG LIN FOR THE WEB SITE WWW.CHINESE-ART.COM IN 1998.

it could also be a serious undertaking with a grand goal, realized only after painstaking preparation. Its opening could attract hundreds of people, and its impact could be felt in the subsequent development of experimental art for a long period. One artist has summarized what he sees as the only thing separating a closed exhibition from an open one: you know it's happening not through a formal announcement or invitation, but from an e-mail or a telephone call. Closed exhibitions still remained an important channel for exhibiting experimental art throughout the '90s, but their significance changed in new social environments, and especially in relation to exhibitions of experimental art in various public spaces. In fact, the increased efforts to organize public exhibitions of experimental art altered the meaning and direction of closed exhibitions, and brought these private events into a broader movement of "experimental exhibitions."

For the most part, in the '90s, the reason for organizing a closed exhibition was mainly a matter of security and convenience: its organizer did not have to obtain permission and worried less about outside obstruction. But this was no longer sufficient for a closed show organized at the end of the '90s: when many curators and artists were urging that experimental art be brought to the public, and when there was a strong possibility of exhibiting experimental art publicly, a closed show had to justify itself by providing additional benefits. A main reason sought was protecting the "purity" of experimental art. Against the trend of exploring public channels for experimental art, some artists and curators insisted that any effort to publicize this art would inevitably compromise its experimental spirit. While this rhetoric was not new, its actual consequence was worth noting. Parallel to the ongoing effort of mak-

ing experimental art accessible to the public, there appeared a counter movement of making closed shows more extreme and "difficult" to attend. Experiments of using living animals and human corpses to make art can be viewed, in fact, as part of this counter movement: since these experiments would almost certainly be prohibited by the government and denounced by the public, they justified the necessity of the closed exhibitions planned exclusively for "insiders" within the experimental art circle.

Many closed exhibitions organized toward the end of the '90s were no longer informal and casual gatherings at someone's home, but had become serious undertakings and reflected a growing concern with the purpose and form of this type of exhibition. Much thought was given to their sites and ways of organization, making these shows a special brand of experimental exhibition. One of them, *Trace of Existence*, was a major exhibition of Chinese experimental art in 1998. The curator Feng Boyi explains the exhibition's site in an article he wrote for the exhibition catalogue:

> Because experimental art does not have a proper place within the framework of the official Chinese establishment of art exhibitions, it is difficult to exhibit this art openly and freely. We have therefore selected a disused private factory in the east suburbs of Beijing as our exhibition site, hoping to transform this informal and closed private space into an open space for creating and exhibiting experimental art. Held in this location, this exhibition allows us to make a transition from urban space to agricultural countryside in a geographical sense, and from Center to Border in a cultural sense. This location mirrors the peripheral position of experimental art in China, and this exhibition adapts the customary working method of contemporary Chinese experimental artists: they have to make use of any available place to create art.[25]

Each of the eleven participating artists selected a specific location within the exhibition space as the site of his or her work (FIG. 10.19). Song Dong, for example, used the factory's abandoned dining hall to stage his installation: twelve large vats containing 1,250 cabbages picked on the spot. Wang Gongxin projected his video *Tending Sheep* in a sheep pen with a real sheep in it (FIG. 10.20). The curator subtitled the exhibition "a private showing of contemporary Chinese art," but also supplied large buses to take several hundred people to view and participate in this one-day event.

Going one step further, some curators and artists made an attempt to create regular channels for private exhibitions. One of these channels was the "Open Studio" program sponsored by the Research Institute of Sculpture in Beijing. Initiated by Zhan Wang, the director of the institute and an active experimental artist himself, this program offered young artists spaces to exhibit controversial ar-

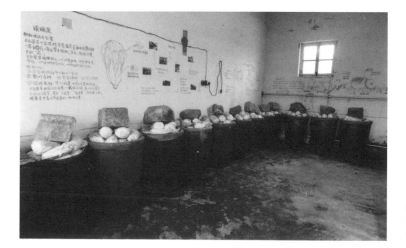

FIG. 10.19: SONG DONG'S WORK IN THE EXHIBITION *Trace of Existence* CURATED BY FENG BOYI IN BEIJING, 1998.

tistic experiments; the institute posed no limit on their experimentation. The second Open Studio, held on April 22, 2000, was actually a carefully prepared exhibition, called *Infatuated with Injury*, organized by independent curator Li Xianting.[26] Several works on display used living animals and human corpses. During this exhibition, the hallway and the five "open studios" were packed with people. An investigation was soon conducted by the leadership of the Central Academy of Fine Arts, the superior organization of the institute, to look into this "highly abnormal" event.[27] Here, the division between a public exhibition and a private one again became nearly indistinguishable.

Originally published in Wu Hung, ed., *Reinterpretation: A Decade of Experimental Chinese Art*, 1990-2000 (Guangzhou: Guangdong Museum of Art, 2002), 83-97.

FIG. 10.20: WANG GONGXIN'S WORK IN THE EXHIBITION *Trace of Existence*, BEIJING, 1998.

THE 2000 SHANGHAI BIENNALE:

THE MAKING OF A "HISTORICAL EVENT" IN CONTEMPORARY CHINESE ART

The Third Shanghai Biennale was held from November 6, 2000, to January 6, 2001, in the newly expanded Shanghai Art Museum (FIGS. 11.1-11.3). Soon after its opening—and long before it completed its full course—people were already envisioning it as history. Thus we heard much about its projected "historical significance" during the first few days of the show, albeit from divergent positions and conflicting points of view. An official opinion, put forward most forcefully by the Museum itself, was that the Biennale was deemed to become a landmark in the history of contemporary Chinese art. Fang Zengxian, the Museum's chief official and the director of the Biennale's Artistic Committee, hence made this grandiose statement: "The significance of its [i. e. the Biennale's] success will far transcend the exhibition itself. As an activity established on an international scale that seriously addresses the issues of globalization, post-colonialism and regionalism, etc., this Shanghai Biennale will set a good example for our Chinese colleagues and is bound to secure its due status among other world-famous biennial art exhibitions."[1] Independent art critics and artists also voiced their own opinions. Some of them confirmed the Biennale's landmark significance, but constructed such significance according to different historical frameworks. Others criticized the Biennale and organized counter-activities. But like any antagonism, the intensity of these criticisms and activities revealed the opponents' pressure and attraction to the opponent.

This essay reflects upon these different reactions to the *2000 Shanghai Biennale*, not only because these opinions contribute to the Biennale's complex meaning, but also because they testify to differing positions in the current construction of the history of contemporary Chinese art—a history being written in multiple versions and with multiple voices.

§

Why were opinions about the Biennale's "historical significance" spelled out in such a speedy and urgent manner? Why did the exhibition become "past" even before its completion? The reason seems simple: from the moment the news broke about the Shanghai Art Museum's plan to organize a "truly international" Biennale, this forthcoming exhibition was perceived, discussed, and debated in

China as an event. Practical matters directly related to its planning and execution—the selection of the curators and artists, the possible restrictions and compromises of the government, new ways of raising funds and their implications—dominated the discussion; the exhibition's content and its possible contribution to art itself attracted much less attention.[2]

As an anticipated event, the Biennale also stimulated other anticipated events, mainly a host of so-called "satellite" exhibitions organized by independent curators and non government galleries (FIGS. 11.4, 11.5).[3] As art events, these exhibitions—both the Biennale and the "satellite" shows—largely fulfilled their mission upon their opening, which all took place within two to three days around November 6th as a series of linked "happenings." The strong sense of happening was also generated by the sudden get-together of a large number of artists and critics, reinforced by all the bustle and movement. Not only did the Museum invite many guests (including some of

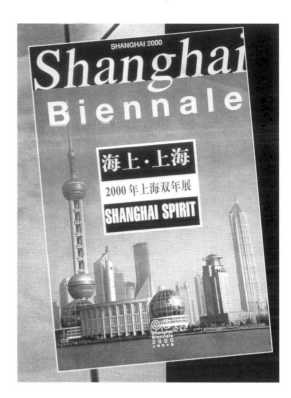

FIG. 11.1: POSTER OF THE THIRD SHANGHAI BIENNALE.

FIG. 11.2: SHANGHAI ART MUSEUM DURING THE THIRD SHANGHAI BIENNALE.

international renown), each of the "satellite" shows also formed its own "public." While the gap between the official and unofficial activities remained, participants at these activities often intermingled and roamed together from one show to another show, one party to another party. However, a few days later Shanghai was empty. Most of the artists and art critics had left and all the "satellite" shows were over. The Biennale alone persisted. It was no longer threatened by competition and possible disruption, but the excitement and exuberance once surrounding it was also gone.

This situation confirms an observation I have made elsewhere, that in the late '90s and in 2000, a dominant issue in Chinese art was the *exhibition*: its form, timing, location, and function.[4] Without much organized effort or conscious promotion, this issue attracted many curators and artists, and brought them into linked activities and interactions. These activities were not about *art* per se because they were not directly concerned with art medium, style, or subject. But they were closely related to the development of contemporary Chinese art

at the moment, because the divergent focus and purpose of an exhibition often predetermined the ideological orientations and stylistic choices of the works in it. Many "experimental exhibitions" were also organized to test the public roles of contemporary art and to "legalize" new and novel art forms.[5] An investigation of these exhibitions and their social context led me to write a book-length catalogue, entitled straightforwardly *Exhibiting Experimental Art in China.*[6] By sheer coincidence it came out just a few days after the Shanghai Biennale opened. The Biennale and the off-Biennale shows continued the phenomena described and analyzed in the book, which in turn provides a historical background for understanding the event-oriented "exhibition frenzy" surrounding the Biennale.

FIG. 11.3: THE OPENING CEREMONY OF THE THIRD SHANG-HAI BIENNALE.

FIG. 11.4: YIN XIUZHEN, *Playing Toy Bricks; Constructing Skyscrapers,* INSTALLATION, *Normal and Abnormal* EXHIBITION, SHANGHAI, 2000.

FIG. 11.5: XU ZHEN, *The Difficulty with Colors,* PHOTOGRAPH, *Useful Life* EXHIBITION, SHANGHAI, 2000.

But an event still differs from a "historical event." To qualify as the latter, the Biennale must signify a particular historical temporality and locality. It is here that we find conflicting notions and positions, and hence different constructions of contemporary Chinese art history. Returning to the Shanghai Art Museum's own rhetoric, the Biennale was identified as an instant historical milestone because it inaugurated a "global" era for the industry of contemporary Chinese art exhibitions. This view may puzzle some people because, as it is well known, contemporary Chinese art had been part of the global art scene since the early '90s, and many important international exhibitions now regularly feature works by contemporary Chinese artists. This view becomes understandable when we realize that it is limited to officially sponsored exhibitions in China, which had remained largely "local" before the *2000 Shanghai Biennale*. Recalling that Beijing's National Art Gallery still refuses to show installation, performance, and multimedia works, any sympathizer of the Shanghai Biennale would see its reformist, if even revolutionary, nature.

To the Museum itself the Biennale was also a huge breakthrough: it allowed this official art institution to proudly announce its entrance into the global era. True, from 1996 the Museum had adopted the fashionable term "Biennale" (*shuang nian zhan*) for a sequence of its exhibitions. But such adoption was superficial because the exhibitions remained largely domestic and traditional. This, of course, could still be a defendable choice if the Museum was prepared to modify the exhibition genre conventionally associated with the term Biennale. But instead, the two earlier Shanghai Biennales in 1996 and 1998 were viewed as preliminary stages in a long-term evolution toward an established international norm: the Museum would eventually shed its "local" image and identity, and its Biennales would be "true to their name" (*ming fu qi shi*) and join the ranks of other "true" Biennales and Triennials in Venice, Lyon, Kwang-ju, Sydney, and Yokohama—to name just a few.

This official, evolutionary approach to contemporary Chinese art had a definite locality in 2000: Shanghai. In fact, only by linking the Biennale to a herculean effort of the city to (re)assert its global, cosmopolitan identity can we understand the exhibition's true rationale and feasibility. Viewed in this context, this flashy and costly Biennale was not even the prime showcase in 2000's Shanghai. Housed in a refurbished colonial building, the visual display it offered to an international audience was nowhere close to the spectacular cityscape of Pudong (FIG. 11.6). An oversized architectural circus, this cityscape startles visitors with a naked desire to impress and with an exaggerated ambition to propel the whole city from the past to the future. Just a few days prior to the Biennale, Shanghai also expressed the same desire and ambition through "the largest staging of Verdi's *Aïda* ever attempted in the world." Performed by Chinese and foreign

FIG. 11.6: SKYLINE OF PUDONG DISTRICT, SHANGHAI.

musicians, it featured a grand march consisting of three thousand PLA soldiers disguised as Egyptian warriors and all the available elephants in Shanghai.

There is no question that the *2000 Shanghai Biennale* facilitated the same globalization program on a municipal level. The exhibition's thematic title was "Shanghai Spirit" in English but "Haishang, Shanghai" in Chinese. The latter title, which means literally "Shanghai Over the Sea," relates this coastal city to the ocean, marine culture, and the outside world. But having pushed the "Shanghai spirit" this far, the exhibition's organizers had to stop and reassert the national identity of their project. Thus in their rationalization of the Biennale, internationalization or globalization eventually retreated to the background, while the Biennale itself "endeavored to promote Chinese mainstream culture."[7] It was even said that this exhibition would serve a nationalistic cause to undermine the dominance of foreign curators in setting standards for contemporary Chinese art.[8] Such words become hollow and self-contradictory, however, given that the same Museum also invited two curators from outside China to help select artists and works, even though many independent curators in China had campaigned for years to organize domestic shows.

§

So let us listen to what these independent curators and art critics had to say about this Biennale. Here the voices become less distinct and certainly not uniform. Partly because the Shanghai Art Museum did invite Hou Hanru and Toshio Shimizu—two international curators of independent status—to join its curatorial team. To some independent Chinese curators, the gap conventionally separating a government-sponsored art exhibition from their own projects had significantly diminished. In other words, although none of these independent Chinese curators were directly involved in organizing the Biennale, this government-sponsored exhibition did reflect some radical changes. Significantly, among these changes, the two most crucial ones were also the two most sought-after goals of previous "experimental exhibitions" organized by independent curators. Their first goal, not surprisingly, was to take over the curatorship of major art exhibitions. According to them, individual curators, not government institutions and committees, should be directly responsible for an exhibition's content, form, and purpose, and should have the power and right to control these matters. Their second goal was to "normalize" or "legalize" (*he fa hua*) experimental art, meaning the creation of legitimate exhibition spaces for controversial art forms and styles as well as for works that challenge social and political norms.

FIG. 11.7: FIRST FLOOR OF THE SHANGHAI ART MUSEUM DURING THE THIRD SHANGHAI BIENNALE, SHOWING WORKS BY SUI JIANGUO AND FANG LIJUN.

It seems that these two goals were realized, at least partly, in the Shanghai Biennale, which not only invited two guest curators but also included video and installation works by some experimental Chinese artists (FIG. 11.7). To those independent curators who had been campaigning for these reforms, this was clearly a victory for their part. Thus, they constructed the Biennale's "historical significance" in quite a different way from the Museum: while the Museum interpreted the Biennale as representing a new stage in an officially-sponsored evolution from the local to the global, these independent curators and critics linked the Biennale to previous unofficial exhibitions. From their point

of view, the reforms in this Biennale resulted, to a large extent, from their persistent effort to challenge and reinvent the old exhibition system in China. Thus Zhu Qingsheng—a Peking University professor who is also an avant-garde artist and critic—claimed that the *2000 Shanghai Biennale* was the most important Chinese exhibition since the 1989 *China/Avant-Garde* exhibition. Gu Chenfeng—another veteran organizer and critic of experimental art—recalled the 1992 *Guangzhou Biennale* organized by independent curators, which according to him initiated many new curatorial practices that then influenced subsequent art exhibitions in China.[9] Many other statements reflect different experiences and judgments. Taken together, however, they reflect a collective attempt to forge an unofficial historiography, which attributes the main force behind the opening up of China's exhibition channels not to official reforms, but to initiations made in the unofficial sectors in Chinese art and to the general course of globalization.[10]

We can generally agree upon this view because we can map out an unambiguous historical process leading to the two aforementioned reforms in the *2000 Shanghai Biennale*. Avant-garde art exhibitions became prevalent in China in the '80s, but their organizers were mainly artists or committees formed by art critics. "Independent curators" (*duli cezhanren*) only appeared in the '90s; the reasons for their emergence include, among others, a growing knowledge of international art practices and the increasing presence of Hong Kong, Taiwan, and western curators in China. Usually not employed by official or commercial galleries, these individuals organized art exhibitions primarily out of personal interest; their projects thus reflected strong individual preferences, knowledge, and social aspirations.

Among the numerous exhibitions organized by these independent curators in the '90s, some were ambitious undertakings aimed at establishing a new exhibition system in China. The *Guangzhou Biennale* mentioned earlier, for example, included more than three hundred and fifty artists and had a self-professed goal of establishing a market system for contemporary Chinese art. Collaborative projects between independent curators and private, semi-public, and even official galleries increased after the mid-90s.[11] Some of these projects failed—one outstanding example being the *First Academic Exhibition of Chinese Contemporary Art* organized by Huang Zhuan. Installed in two primary sites in Beijing, it campaigned for a more active and independent role for individual curators in organizing large, public art exhibitions. The government cancelled the show right before its opening.[12] But there were plenty of successful cases; the same Huang Zhuan, for example, later worked with the He Xiangning Art Gallery in Shenzhen to organize the gallery's *Second Yearlong Contemporary Sculpture Exhibition*, an exhibition that aimed to explore "the complex relationship between experimentation and public function, academic values and visual attractiveness."[13] Under this direction, the show included works by established foreign sculptors as well as by young Chinese experimental artists. This type of curatorial practice clearly anticipated the 2000 Shanghai Biennale.[14]

§

It would be a mistake, however, to take Huang Zhuan and his comrades as representative of all independent curators and experimental artists. Their goals and agendas are by no means shared by everyone in this multifaceted, "unofficial" art community. In fact, some independent curators and artists openly oppose any collaboration with official art institutions, which they consider opportunistic and against the spirit of the avant-garde. In late 2000, this position was most self-consciously embodied by the off-Biennale exhibition entitled *Buhezuo fangshi*—literally, *Ways of Non-Cooperation* but rendered into English by the exhibition's organizers as *Fuck Off* (FIGS. 11.8-11.10). Ai Weiwei and Feng Boyi, co-curators of the show, explain this project: "*Fuck Off* is an event initiated by a group of curators and artists who share a common identity as 'alternative'. In today's art, the 'alternative' position entails chal-

FIG. 11.8: THE LOCATION OF
THE *Fuck Off* EXHIBITION.

FIG. 11.9: *Fuck Off*
EXHIBITION: INTERIOR.

FIG. 11.10: CHEN YUNQUAN, *United Broad-
casting*, INSTALLATION, *Fuck Off* EXHIBITION,
SHANGHAI, 2000.

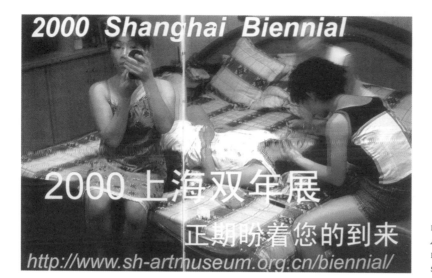

lenging and criticizing the power discourse and popular conventions. In an uncooperative and uncompromising way, it self-consciously resists the threat of assimilation and vulgarization."[15]

So they also conceived of their exhibition as an event, but an event designed to counter and subvert the "master event"—the Biennale. In their vision, this "alternative" exhibition, though much smaller and off-center, would challenge and debase the Biennale's centrality and dominance. In an interview, Ai Weiwei refused to call his show a "satellite" or "peripheral" activity.[16] The statement cited above makes it clear that to him and Feng Boyi, since their exhibition represented the "alternative" position in contemporary Chinese art, it played a critical role in challenging the dominant "power discourse" at this historical moment. From this position, they interpreted the Biennale as posing a "threat of assimilation and vulgarization": the inclusion of some experimental artists in this official showcase could only destroy their experimental spirit. Their refusal of this reformist official exhibition, therefore, also implied their rejection of a reformist historical narrative centered on the evolution or transformation of the official exhibition system, whether this narrative was formulated by the art establishment itself or by independent curators who hoped to change the system from within.

Some artists shared this anti-establishment position and designed individual "art events" to express their sentiment. One of these projects—a series of interactive "Web Advertisement"—was created by Xu Tan as the Biennale's "publicity materials." The poster-like advertisement bears words like "THE 2000 SHANGHAI BIENNALE AWAITS YOUR ARRIVAL" and the Museum's website (FIG. II.II). The image under the words, however, features young prostitutes putting make-up on their faces about to receive clients. A subtler project was carried out by Li Wei, who appeared in the Biennale on the exhibition's opening day with his head framed by a large, rectangular mirror (FIG. II.I2); (he did this by sticking his head out from a hole cut in the center of the mirror). This happened to be a continuation of many similar performances he had conducted since 1998: wearing a "mirror collar," he photographed himself in front of Tiananmen, on the Great Wall, before foreign tourists on the Altar to Heaven, and among dead pigs in a butcher's shop. In each case, the mirror transformed the building and people before him into elusive and reversed images. So when he stepped into the Shanghai Art Museum that day, the mirror again made its target—this time the Biennale—into unreality.[17]

But generally, projects showing direct critiques of the Biennale were few; most works in the off-Biennale exhibitions—even in *Fuck Off*—did not engage with the "master event."[18] Moreover, to my knowledge no Chinese artist invited to participate in the Biennale turned down the invitation. I was also not surprised to learn that the organizers of *Fuck Off* also practiced self-censorship to ensure the show's realization, eliminating and restricting some art projects that might provoke a cancellation by the authorities. These situations raised questions as in what sense an "alternative" exhibition such as *Fuck Off* challenged the official show, how effectively it shifted the power center, and to what extent it realized its uncooperative intentionality. The "historical significance" of *Fuck Off*, in my view, mainly lies in its assertion of an alternative position, thus keeping this position vital in contemporary Chinese art. But it was far from clear, either in this particular exhibition or in the general practice of 2000's Chinese art— what the "alternative" meant beyond self-positioning, attitude, and verbal expressions; and this is perhaps why no real confrontation between the Biennale and other shows was found in *art*. The Biennale's selection of artworks—ranging from Liang Shuo's realistic *Urban Peasants* (FIG. 11.13) to Matthew Barney's iconoclastic

FIG. 11.12: LI WEI, *Mirror: November 6, 2000*, PERFORMANCE, SHANGHAI, 2000.

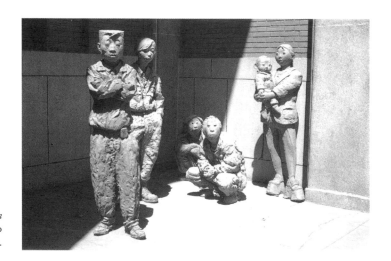

FIG. 11.13: LIANG SHUO, *Urban Peasants*, SCULPTURE, THIRD SHANGHAI BIENNALE, 2000.

Cremaster 4, was clearly a compromise of hugely different aesthetic positions and judgments. The off-Biennale exhibitions were much less serious and more dynamic, containing some works that were aggressive and even deliberately shocking. But stylistic and ideological solidarity was again not the goal of the works in these shows. To me, with their conflicting self-identities and complex self-contradictions, all these exhibitions—both the official and unofficial ones—contributed to something larger, and will be remembered as part of an exciting moment in contemporary Chinese art.

Originally published in *Art AsiaPacific* 2001(31), 42-49.

Tui-Transformation:
A SITE-SPECIFIC EXHIBITION AT BEIJING 798

Tui-Transfiguration is a site-specific exhibition I curated at Beijing's Factory 798 in September 2003.[1] It displayed twelve series of photographs that Rong Rong and inri had created over the past decade, and can be considered a mid-career retrospective for these two artists. But I also conceived and planned the show as an *experimental exhibition* that posed questions about the language, site, audience, and function of a contemporary art exhibition itself. These two purposes are not separate. In fact, a principal goal of this project was to create a symbiosis between the exhibition's content and location: whereas Rong Rong and inri's photographs largely represent their intimate interactions with urban and natural environments, the exhibition site—an abandoned factory shop—tells a story about Beijing and China. Combining these two stories in a coherent visual display, the exhibition reinforced their messages and created an artistic space with which the audience could interact.

A BRIEF HISTORY OF BEIJING 798

Factory 798 has come to signify an emerging art space at Dashanzi in east Beijing (FIG. 12.1). In actuality, it is the code name of one state-run factory among several in the area; the others include 718, 797, 751, 706, and 707. As I will explain later, these factories were subdivided in 1964 from an enormous industrial complex called Factory 718, whose planning started in 1951, two years after the founding of the People's Republic of China. In that year, Premier Zhou Enlai approved the proposal to add yet another manufacturing plant in Beijing's east suburbs. Before this moment, the construction of a large electric tube factory had begun in the same area (FIG. 12.2). Known as Factory 774, it was one of the 156 projects for which the Soviet Union provided assistance during China's first Five-Year Economic Plan.[2] The new factory would be supported by another socialist country—East Germany—to produce radio electric components. According to a 1953 agreement between China and East Germany, architects and engineers from the East German Telecommunication Industry Bureau would design the buildings of Factory 718 and provide all technical support. Between 1954 and 1957, three hundred German technicians worked on the construction site (while about three hundred Russian specialists served in the nearby Factory 774) (FIG. 12.3). When Factory 718 was finally completed in 1957, it had a floor space of approximately five hundred thousand square meters (including workers' dormitories).[3] The project was considered a shining example of the collaboration between China and her socialist "brother countries," as Luo Peilin, an American Ph.D. and the head of the factory's preparatory team from 1951 to 1953, recalled recently: "Germany... was wholeheartedly willing to help us; after all we were both socialist countries and they also wanted to do more business with us... Everything had to go by their specifications, and parts and often-used tools had to be transported from Germany." He then used several examples to demonstrate the high technological standards and professionalism of German engineers and architects.[4]

FIG. 12.1: FACTORY 798 AT DASHANZI IN EAST BEIJING.

FIG. 12.2: FACTORY 774.

The Germans designed the factory shops in a typical Bauhaus style, with large skylights illuminating interconnected interior spaces in simple geometric shapes (FIG. 12.4). It was something of a miracle that this architectural style, which was criticized at the time in the Soviet Union as "the matchbox-style of modernist construction," was adopted in China to build her largest munitions manufacturing operations. Although during that period China took the Soviet Union as its model in all aspects of social life and economic development, Factory 718's architecture violated the Russian ideal of "combining advanced technology with national character." Again, according to Luo Peilin, the reason had more to do with China's financial condition than aesthetics or politics: the Bauhaus design proved more practical and economical. The model favored by Russian architects, on the other hand, had a palatial style but would have been too costly to build (see FIG. 12.2, showing the façade of Factory 774 constructed with assistance from the Soviet Union).[5]

Due to its extraordinary scale and state-of-the-art technology, Factory 718 became a showcase of China's future as conceived by Mao Zedong in the early and mid-50s—an advanced socialist state based on heavy industry and communist ideology. It is reported that once Mao stood above Tiananmen and said that he hoped one day to see hundreds of chimneys (symbols of China's industrialization and modernization) from there. In a hurry, Beijing's urban designers filled large pieces of land inside and outside the city with various kinds of factories (FIG. 12.5). The city's Bureau of Urban Planning announced proudly in 1958:

> By the end of 1957, new industrial structures aggregated 2,200,000 square meters in area, while the net value of industrial production rose to twelve times the 1949 figure. Peking is becoming more and more a city of production.[6]

Among the new industrial facilities, Factory 718 became a source of national pride because its scale surpassed even its counterparts in other socialist countries. Li Rui, the factory's first director, recalls in a memoir: "Throughout this period (i. e. late '50s), when I held the post of Joint Factory 718 Director, I was exceptionally proud of the scale of Factory 718. It was undoubtedly the largest joint factory in the entire socialist unification plan. A similar factory existed in Moscow and was also built with the assistance of the East Germans; however it could never compete with the size of our factory in China. As for Germany, their comparable factories were all very small and the capacity of more than twenty factories had been employed for constructing our one factory."[7] As a result, Factory 718 was also the largest single architectural complex in the world built in the Bauhaus style after World War II.

The opening of the factory on October 5, 1957 was celebrated with great fanfare, with East Germany's Vice Premier Eric Honneker and China's Vice Premier Bo Yibo present at the ribbon-cutting ceremony. The factory was closely linked with the military industry from the beginning and exported its products to North Korea, Romania, and other socialist countries.[8] Top Chinese leaders, including Zhu De and Deng Xiaoping, frequented the place, often with foreign visitors (FIG. 12.6). The factory gradually grew into a self-sufficient "industrial town," with its own theaters and stadiums, elementary

and high schools, libraries and swimming pools, various sport, drama, and dance groups, and a contingent of workers' militia (FIG. 12.7A-D). The factory's growth finally reached a critical point in the early '60s, when it had to be broken up for better management. Consequently, Factory 718 was divided in 1964 into six independent factories with code names of 706, 707, 718, 751, 797, and 798 (FIG. 12.8). This structure continued till 2001, when five of the six factories (except for 751) were reunited under the Seven Stars Electronic Group. By that time, however, most of these factories had severely declined, and some had virtually ceased to operate as functional industrial manufacturers.

§

I first visited the place in January 2002, when Mr. Yukihito Tabata of the Tokyo Gallery invited me to see the future location of his new Beijing venue, called the Beijing-Tokyo Art Project. I was impressed by the gallery's open architecture, but was truly astonished by the whole area—a giant industrial plant from the Maoist era that had turned into gloomy ruins (FIG. 12.9). Huang Rui, who had moved into the area earlier and found the location for the Tokyo Gallery, guided us through seemingly endless empty factory shops. I was in awe: the spaces, huge as indoor football fields, were shadowy and echoing. Silent and lifeless, they nevertheless preserved rich memories. Here and there I saw traces of "big character" posters, painted revolutionary slogans on peeling walls, and dilapidated meeting halls for political gatherings. For people of my generation, these images and words pertaining to various moments in China's modern history brought back personal memories.

FIG. 12.3: GERMAN TECHNICIANS ON THE CONSTRUCTION SITE OF FACTORY 718.

A major change in the factory's identity occurred in the late '50s and early '60s, after China's relationship with the Soviet Union soured. The socialist brotherhood abruptly fell apart, and China suffered especially from the failure of the Great Leap Forward, devastating famines, and the withdrawal of all financial and technological support from her former allies. The international significance of Factory 718 and other industrial facilities at Dashanzi suddenly diminished; instead they began to play crucial roles in China's domestic politics and self-strengthening campaign. Slogans still visible in the factories, including "Regenerate the country's vitality with our own strength; work with all our determination to make the country strong" (*zili gengsheng, fafen tuqiang*), testify to the Party's efforts to mobilize the Chinese people to overcome a difficult period of isolation.

FIG. 12.4: Bauhaus-style shops of Factory 718.

As soon as the Chinese economy had recovered a little the Cultural Revolution broke out. The country went through an even worse period of political chaos; but 718 (and later the six factories that branched out from it) experienced an unexpected spiritual renaissance: when Mao told the country that "The proletarian class should occupy the superstructure," workers were

FIG. 12.5: DEVELOPMENT OF BEIJING
FROM 1949 TO 1957.

FIG. 12.7B: WORKERS' ACTIVITIES AT
FACTORY 718, LATE 1950S.

FIG. 12.6: DENG XIAOPING INSPECTING FAC-
TORY 718, LATE 1950S.

FIG. 12.7C: WORKERS' ACTIVITIES
AT FACTORY 718, LATE 1950S.

FIG 12.7A: WORKERS' ACTIVITIES
AT FACTORY 718, LATE 1950S.

FIG. 12.7D: WORKERS' ACTIVITIES
AT FACTORY 718, LATE 1950S.

dispatched to take over the leadership of all the universities and cultural institutions in China's capital (FIG. 12.10). That was indeed the third and last glorious period in the factory's history—a moment that is again attested to by writings on its ruined walls. Mostly Maoist quotations and slogans praising the god-like wisdom of the Great Helmsman, this revolutionary graffiti art is today treasured by interior decorators of the trendy galleries and cafés, which have populated the area in the past two years (FIG. 12.11).

FIG. 12.8: DIVISIONS OF STATE-OWNED
FACTORIES AT DASHANZI.

What I saw on my trip to Dashanzi in early 2002, then, was the beginning of a process that has transformed the place from a declining industrial base into a prosperous "art district" in China's capital. The ultimate reason for this transformation must be found in China's socioeconomic reforms since the Cultural Revolution. Starting in the late '70s, a new generation of Chinese leaders initiated a series of reforms to develop a market economy, a more resilient social system, and an "open door" diplomatic policy that opened China to foreign investment as well as cultural influence. The consequence of these changes is now most acutely felt in major urban centers such as Beijing and Shanghai: the layouts and skylines of these cities have been completely reshaped; numerous private and joint-venture businesses, including privately-owned art galleries, have sprouted like mushrooms after a storm. Educated young men and women move from job to job pursuing personal well-being, while a large "floating population" keeps entering metropolitan centers from the countryside to look for work.

FIG. 12.9: A RUINED SHOP IN FACTORY
798 WITH SURVIVING REVOLUTIONARY
SLOGANS.

Two direct consequences of these social changes in Beijing have been the drastic decline of state-owned heavy industry and the rapid rise of the commercial, tourist, and entertainment sectors. As a result, most factories at Dashanzi reduced their productivity drastically, and a large number of factory workers left their jobs. (It has been reported that since 2002, eleven thousand workers and more than three hundred administrators have "retired," while three thousand workers have "left their posts" (*xiagang*), a euphemism for layoff.[9]) Struggling to survive, the factories rented out or sold their buildings to generate income. A milestone in this development was the construction of a modern highrise (called Hongyuan Condo) on the original site of Factory 718's central administrative building, which had been torn down to make room for the commercial building. The other side of the coin was that the Chaoyang district, where the factories are located, has become the most cosmopolitan area in Beijing, largely due to its strategic position as the home of foreign embassies and many international companies (FIG. 12.12). From the early '90s, this district has also attracted an increasing number of "independent artists" (*duli yishujia*) with no direct

FIG. 12.10: WORKERS TAKING OVER
THE LEADERSHIP OF UNIVERSITIES,
CULTURAL REVOLUTION POSTER, LATE
1960S.

FIG. 12.11: A POPULAR CAFÉ AT
FACTORY 798 IN 2003.

FIG. 12.12: A SECTION OF CHANG'AN
AVENUE IN THE CHAOYANG DISTRICT.

institutional affiliation. Many of them come from the provinces. To this generation of experimental artists, the Cultural Revolution has become remote past, and their works often directly respond to China's current transformation. They find stimuli in a place like Chaoyang, which is sensitive to social changes and also presents economic opportunities. Thus, although Beijing's earliest "artist's village" (*huajia cun*) was established in Yuanmingyuan in the western suburbs, the gravity soon shifted to the east side of the city. The East Village community emerged in the early '90s; Rong Rong was one of its resident artists. Many Yuanmingyuan artists moved to Tongxian east of Chaoyang; and they were followed by other freelance artists looking for cheap studio space in an increasingly expensive city. The relocation of the Central Academy of Fine Arts from the center of the inner city to a factory near Dashanzi in 1995 helped attract more artists to the district.

The rebirth of the industrial complex at Dashanzi as an art space owes something to all these conditions—Beijing's general globalization and de-industrialization, the cosmopolitan culture of the Chaoyang district, and the concentration of experimental artists in the area. The joint force of these conditions also distinguishes this place from previous art spaces in Beijing. Although still in an early stage of development, it has demonstrated its potential to integrate previously separate spaces and institutions related to a burgeoning contemporary art scene—galleries, publishers, artists' studios, performance centers, design firms, showrooms, restaurants, and music bars (FIG. 12.13). As the base of a new community of independent artists, it is no longer situated in a rural or semi-rural area, but is geographically and culturally connected to Beijing's expanding downtown. Here are some important events since 2000, which chronicle the place's steady transformation into an art space.[10]

2000

After the Central Academy of Fine Arts moved its new campus to the Wangjing area, Sui Jianguo, the head of the school's Department of Sculpture and a well-known experimental artist, rented a shop in Factory 706 and made it his studio. Afterwards, the designer Lin Qing and the publisher Hong Huang created "lofts" here as their living and working places. The idea of turning the factories into a Chinese SoHo began to emerge.

2001

After returning from New York, the experimental writer

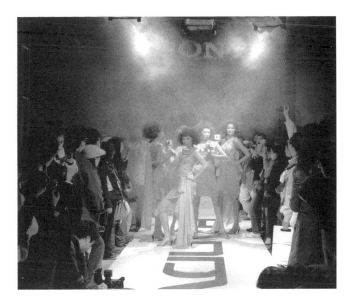

FIG. 12.13: PROMOTION OF SONY PROD-
UCTS IN A SHOWROOM AT DASHANZI.

and musician Liu Suola located her studio and home here. She was followed by Robert Ber-
nell, who turned Factory 798's original Muslim dining hall into his Timezone8 publishing
house. The place's reputation as a center of alternative art publishing grew further when *New
Wave (Xin chao)* magazine and the Chinese Interactive Media Group (Zhongguo hudong
chuanmei jituan) moved into the area. For the headquarters of *New Wave*—the factory's
original indoor stadium—the architect Zhang Yonghe added several multicolored cubicles
to neutralize the haunting atmosphere of the empty stadium. This avant-garde art journal
went out business after publishing twelve issues. Before it disappeared, however, three trendy
magazines—*Looking at Global Metropolis, Youth Clan of Seventeen,* and *Enjoyment: The World
of Brand Names*—had become its neighbors. Also around this time, from the end of 2001 to
early 2002, a number of experimental artists, including Huang Rui, Chen Lingyang, Cang
Xin, and Bai Yiluo, established their studios here and began to form a small but high-pow-
ered artists' community.

2002

As He Wenchao has noted, the most important event in this year was the founding of the
Beijing-Tokyo Project, a branch of the Tokyo Gallery, well-known for promoting Japanese
avant-garde art since the late 1940s. Largely due to Huang Rui's persuasion, the gallery
rented a 400-square-meter shop in Factory 798 and remodeled it into a contemporary art
gallery. For the first time, the factory's Bauhaus-style architecture was noticed and appreci-
ated by artists and gallery owners. The slogan left from the Cultural Revolution was also
carefully preserved. The gallery opened in October with the exhibition *Beijing Afloat (Bei-
jing Fushihui)* curated by Feng Boyi. Rong Rong and inri were among the eleven artists in
the show. The establishment of the Beijing-Tokyo Project was a landmark in the district's
history for two reasons: first, because of its location, this emerging art space became known
as 798, although it includes spaces in other factories. Second, following the example of
the Beijing-Tokyo Project, close to forty galleries, clubs, music bars, and other art-related
businesses and organizations established their operations here from late 2002 to 2003. The
number of artists' studios also increased to more than thirty.

FIG. 12.14: POSTER OF THE
PROJECT REMAKING 798.

FIG. 12.15A: AN INDEPENDENTLY
ORGANIZED EXHIBITION DURING
THE PERIOD OF THE 2003 BEIJING
BIENNALE.

FIG. 12.15B: SUI JIANGUO, A STUDY
OF CLOTHES WRINKLES—THE
RIGHT ARM, A WORK IN THE LEFT
HAND AND RIGHT HAND EXHIBI-
TION AT 798, 2003.

2003

This year witnessed the beginning of the project *Remaking 708 (Zaizao 798)* (FIG. 12.14). Initiated by Huang Rui and Xu Yong in April, its mission was to preserve the old factories in Dashanzi and transform them into a *Yishuqu* (art district) in contemporary Beijing. The two organizers made this statement in their manifesto: "[In this district], the ideal of the avant-garde will coexist with the flavor of the past, the notion of experimentation will be emphasized together with social responsibility, and spiritual and financial pursuits will prevail simultaneously."[11] As concrete results of this developmental plan, the Benevolent Club in 798 became Beijing's newest center of alternative music, fashion shows were sponsored by famous manufacturers (such as Sony and Toyota) to promote their products; fashionable restaurants and cafés mushroomed; and a series of high-quality experimental art exhibitions were organized in this year. The wave of art shows culminated in September, when twelve "satellite exhibitions" took place here during the official Beijing Biennale (FIG. 12.15A, B). Among these exhibitions was *Tui-Transfiguration*.

A SITE-SPECIFIC EXHIBITION AS A VISUAL NARRATIVE

Tui-Transfiguration took place in the Grand Kiln Factory Shop (Dayaolu Chejian) in 798, which is approximately 65 meters long, 32 meters wide, and 14 meters high (FIG. 12.18). Because this was the first art exhibition staged here, it in effect transformed the shop into a public "art space." To realize the shop's enormity one should not think of it as an individual building, but as a "container" of groups of architectural structures and machines. Originally, a 50-meter long kiln, like a giant serpent, lay in the middle of the space and was connected to a huge chimney at one end (FIG. 12.16). The kiln had been destroyed before the exhibition (FIG. 12.18), but the chimney still stood amidst rusty machines and industrial waste. Other remains from the past included Mao's words painted on the walls, broken windows hanging on the ceiling, and some free-standing buildings with boarded-up windows. A row of two-level houses stood opposite the chimney. Most of its rooms were filled with junk; the factory's security guards used the two small rooms near the shop's gate as a hangout.

It is difficult to imagine a place more unsuitable for displaying two-dimensional works of art. But since my purpose was to create an interactive, "site specific" exhibition, not a standard photography show, the challenge became how to merge the photographs and the architecture into a flow of images and spaces around a central concept.

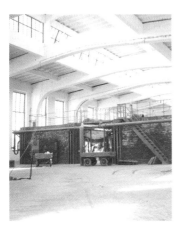

FIG. 12.16: THE GRAND KILN
FACTORY SHOP IN THE 1950S.

This concept—a temporal progression from death to rebirth—underlay both the photographic works and the transformation of 798, and united the exhibition's content and site. In preparing the show I interviewed the artists and analyzed their art—its stylistic and thematic development, and its relationship with the artists' lives. This study provided a narrative structure (FIG. 12.19 A.B), which was then internalized and enhanced by the exhibition. The transition from a textual analysis to a spatial presentation was realized through restructuring the existing architectural space and constructing various architectonic frames with different materials. The result was a series of spaces with shifting images and materials (FIG. 12.20).

SPACE ONE: RUINS

Positioned next to the entrance at one end of the factory shop, this section naturally introduced the whole exhibition. The existing ruins in this space—mainly a two-story building with its dilapidated walls and dusty interior—provided a powerful setting for this part of the show, whose theme was also "ruins." Works displayed here were selected from four groups of Rong Rong's photographs: *Untitled, Wedding Gown, Ghost Village,* and *Ruin Pictures*—all centered on the notions of ruination and death.

We made no effort to tidy up the space. The photographs, either hanging down from the ceiling or installed next to boarded-up windows, became part of the environment. Their dull metal frames further helped merge the images with the site (FIG. 12.21). Some of the pictures represented half-demolished houses in Beijing: the residents are long gone, but torn posters and postcards on the walls allude to their former existence. Installed here, these images changed their identity from self-contained pictorial representations to a series of "visual commentaries" on the exhibition's environment. A particular group of photographs showed portions of naked male and female bodies. These were made from destroyed film negatives that Rong Rong had found in a half-demolished house. I decided to hang these pictures in the disused rooms on the second floor of the two-story building (FIG. 12.22). Without any explicit indication of their existence, the audience accidentally "discovered" them when they were exploring the site.

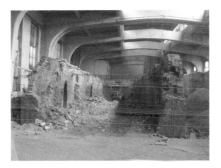

FIG. 12.17: DEMOLITION OF THE "GRAND
KILN" IN THE GRAND KILN FACTORY
SHOP, 2003.

FIG. 12.18: THE SITE OF THE
EXHIBITION: THE GRAND
KILN FACTORY SHOP.

FIG. 12.19A: INITIAL IN-
STALLATION PLAN FOR
TUI-TRANSFIGURATION BY
WU HUNG.

FIG. 12.19B: INITIAL IN-
STALLATION PLAN FOR
TUI-TRANSFIGURATION BY
WU HUNG.

Figurative representations took over in the second section of the exhibition, which included three photo-series by inri (*1999. Tokyo*, *Grey Zone*, and *Maximax*) and one by Rong Rong (*East Village*). All the figures in these photographs respond to their immediate urban environments, whether a nightly Tokyo street, a public toilet in Beijing's suburbs, or a sealed room in a nondescript apartment building. None of their actions can be translated literally into words, however. Rather, these are spontaneous expressions of confusion, alienation, and exhilaration. inri's grotesque *1999. Tokyo*, in her words, represents "illusions born from the radiation of darkness—a symphony of the changing light and shadow." What these and other images convey is a vague sense of happening—something begins to emerge from the ruins. Then there is a constant feeling of struggle. Rong Rong's *East Village* records memorable performances by the village's struggling artists—performances that move the viewer with the performers' pain and desire. inri's explanation of her *Grey Zone* concludes with this sentence: "To struggle free from hopelessness, to stay alive in a desert-like world: this is the meaning of the *Grey Zone*."

These images thus promise a transformation but do not demonstrate a rebirth. Because "transformation" was the central concept of the exhibition, these works were installed in the central section of the factory shop, on the empty ground left by the bygone kiln (FIG. 12.23). The photographs were displayed on both sides of large panels, planted in the ground as freestanding screens (FIG. 12.24). Unlike the previous section of the exhibition, a new architectural material—frosted glass—was used to make the panels. Shimmering in the decaying factory shop with a faint greenish tint, these panels symbolized a new life growing out of the baked soil. The panels formed broad arches one leading to another, guiding the audience forward along a spiral path. The first three series of photographs on the panels were all black-and-white, but the fourth one, inri's *Maximax*, was brightly colored. This series concluded the section also because it most acutely represents the subject's emotional awakening—a transformation that finally leads to rebirth accompanied by uncontrollable joy and pain.

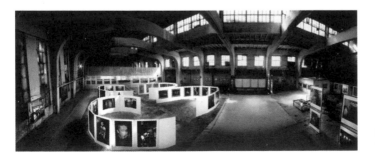

FIG. 12.20: A GENERAL VIEW OF
TUI-TRANSFIGURATION.

Beauty and youth becomes the dominant theme of the third section of the exhibition, which features two groups of collaborative works that Rong Rong and inri created after they had found each other and fallen in love. As if reborn from ruins, nature, still unspoiled, comes back to life. The two photographers embrace this amazing world. Harmony has triumphed; struggle has subsided. Sensual pleasure has returned to supply the main purpose for artistic creation; even the frozen, frightening winter landscape of Mt. Fuji can only inspire joy.

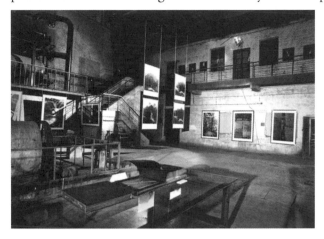

FIG. 12.21: SPACE ONE: "RUINS."

These two groups of photographs, one shot in various scenic spots around the world and the other on the frozen lake under Mt. Fuji, were organized into two architectural spaces in the exhibition. The doubling of the space aimed to create subtle layers and to reinforce the sense of transition. The first space centered on a large gauze curtain, hung across the entire width of the factory shop and behind the glass panels in Space Two. White and see-through, this curtain served multiple structural and expressive purposes (FIG. 12.25). First, gently dividing the factory shop into two halves, it alluded to a subtle conceptual shift in the exhibition's narrative from transformation to rebirth. Second, in contrast with the hard, industrial glass panels in the previous section, the soft, domestic material of the curtain evoked a sense of intimacy and attachment to life. Third, while providing a surface on which a group of pictures were hung in this section, the curtain also delayed access to the exhibition's climax—the *Mt. Fuji* series comprised of thirteen large light boxes (FIG. 12.26). Immaterial and seemingly created by light itself, this last group of images concluded the exhibition, which had gradually evolved from death to rebirth and from destruction to reconstruction.

In addition to these three parts, a fourth group of photographs—many self-portraits that Rong Rong and inri had created over the years—were displayed on the two side walls of the factory shop. In this position, they constituted an independent sequence of self-representation while relating the three "spaces" in the middle into a dynamic whole.

AN EXPERIMENTAL EXHIBITION AS AN INTELLECTUAL/ARTISTIC PROJECT

One of my earlier "experimental exhibitions" was called *Canceled: Exhibiting Experimental Art in China*. Shown in 2000 in Chicago, it re-

FIG. 12.22: RONG RONG'S PHOTOGRAPHS DISPLAYED IN A STORAGE ROOM OF ABANDONED FURNITURE, PART OF SPACE ONE: "RUINS."

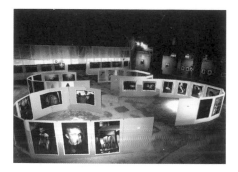

FIG. 12.23: SPACE TWO: "TRANSFORMATION."

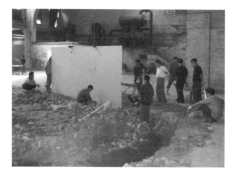

FIG. 12.24: WORKER ERECTING FROST GLASS PANELS FOR SPACE TWO: "TRANSFORMATION."

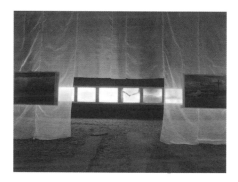

FIG. 12.25: CURTAIN SEPARATING SPACE TWO: "TRANSFORMATION" AND SPACE THREE: "REBIRTH."

presented and interpreted a previous exhibition—*It's Me (Shi wo)* curated by Leng Lin in Beijing in late 1998. The accompanying catalogue discusses the changing art scene in China and documents important "experimental exhibitions" organized over the past five years. In a review of this exhibition and the catalogue, James Elkins calls the whole project, quite pointedly, "a new kind of hybrid between art practice, museum installation, historiography, and social history." In such an exhibition, according to him, the curator positions himself between creative art, art history, art criticism, and curatorial and museum practices. For the same reason, he thinks that I should have defined my roles in the project more explicitly, because in his view, such interventions on the part of the curator indicate new directions for both museum exhibitions and art historical writing.

I am in complete agreement with his analysis and criticism, and have tried to articulate such interventions in *Tui-Transfiguration* more forcefully. It should have become clear by now that to me, an "experimental exhibition" like this one should have a clear social message; its structure should reflect a serious study of both the content and site of the exhibition; and its installation should be an artistic/intellectual project in its own right, internalizing and reinforcing the exhibition's central concept.

Perhaps most important, as a site-specific project, *Tui-Transfiguration* interacted with an actual place by transforming a former factory shop into a space for art exhibition and performance. This new space is temporary and unstable, however. In fact, the owner of the factory—the Seven Stars Electronic Group—has refused to rent the shop again for art-related events, including a large art festival held at Dashanzi from April to May in 2004. In this sense, *Tui-Transfiguration* also encapsulates the transient nature of Factory 798 and the uncertainty of its future.

On the surface, Factory 798 now already looks like a mirror image of New York's SoHo or Chelsea. But the place is not yet assimilated into Beijing's established cultural and economic scenes. Its attraction still lies in its reputation as the city's newest cultural frontier. And as any frontier, it generates anxiety as well as excitement. The anxiety comes from two unanswered questions: Will the factories eventually be destroyed to make room for lucrative apartment buildings and shopping malls? Or will the district be able to stabilize its emerging identity as a lively

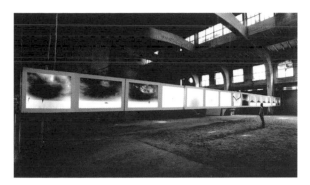

FIG. 12.26: RONG RONG AND INRI: MT.
FUJI IN SPACE THREE: "REBIRTH."

"contemporary art district"—a space Beijing still lacks and desperately needs? At this point a group of activists—artists, curators, publishers, and gallery owners—are working hard to save the factories for the sake of contemporary art. Any creative art project taking place there, including *Tui-Transfiguration*, is part of this collective effort.

It is in this spirit that I want to conclude this essay with an historical reflection on this collective undertaking known as *Reconstructing 798*. The primary goal of the project, as mentioned earlier, is to transform an industrial complex from China's Communist era into a contemporary art and cultural space. The purpose of the project is therefore not to create a "living historical museum," but to incorporate traces and memories of the past into the present and future. Similar architectural/cultural projects have been pursued in different parts of the world, one example being a huge factory complex in Duisburg, Germany, which has been turned into a great urban park while leaving the blight and ruins intact (FIG. 12.27). Because of China's unique cultural tradition and historical experience, however, promoting such projects in Beijing or Shanghai has a specific significance.

Until very recently, China had espoused a revolutionary philosophy of "no construction without destruction." "Revolution" in this sense is not just the province of modern-Leninism, but comes from China's ancient conception of *tian ming* or the "mandate of heaven" (The Chinese word for revolution, *ge ming*, comprises the character for "eliminate" or "abolish" followed by that for "mandate" or "fate.") Each time a new dynasty came to power, there was quite literally a "change of mandate," as the most pressing task facing a new sovereign was to remove all traces of the previous mandate. Put into practice by visual means, this violent political philosophy encouraged systematic destruction of visual signs left behind by a previous social order, whether architecture, engraving, or painting. Looking back over China's history, this phenomenon was a common occurrence. At times when it was unfeasible to completely destroy an entire architectural complex (as in the case of the Forbidden City), it was repainted and renamed in line with the new order and its "change of mandate." It is true that modern Chinese museums hold rich collections of archaeological artifacts, but they have nearly all been dug up from below ground; the number of extant above-ground ancient buildings is negligible given China's extremely long history. I suspect that this situation has resulted from a series of "cultural revolutions" that have been conducted by successive regimes, as well as from the deep influence of "no construction without destruction" on the cultural psychology of China's populace.

The fate of Beijing in the twentieth century is the best proof of both forces. Not only were historical structures such as the city walls eliminated long ago in an organized campaign; but even today, Beijing's preservation of historical architecture is limited to the special areas of historical and tourist sites. These include mainly palaces and temples with brightly decorated facades, buildings that never had much relevance to the lives of local residents. Vernacular and industrial architecture has been destroyed

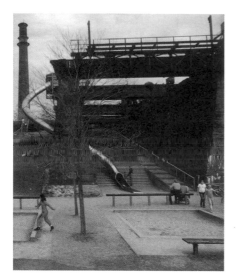

FIG. 12.27: PUBLIC PARK
BUILT AT THE RUINS A FAC-
TORY COMPLEX IN DUISBURG,
GERMANY

en masse, replaced by crude storefronts and offices. "When will the people of our country truly come to cherish their history?"—Intellectuals and architects have been asking this question since the 1950s. But reality shows this sort of innocent appeal to be of little use. More feasible, perhaps, is to make a few places into examples, to preserve old, "useless" architecture for contemporary uses beyond tourism and political propaganda, and through such experiments to gradually inject a permanent awareness for the value of conservation into Chinese culture and thought. This may be the ultimate meaning of *Tui-Transfiguration*, described at the beginning of the exhibition's preface:

In classical Chinese, *tui* refers to the biological process in which certain arthropods and reptiles shed their skins while growing and transforming. From this root meaning the character has gained two general significances. First, it denotes a profound change in one's life that amounts to rebirth. In particular, *chan tui*—the sloughing of the cicada's skin—has become synonymous with the achievement of immortality through discarding the impermanent human body. Second, *tui* also signifies the physical remains left after such transformation. A host of compound words related to this usage, including *tui qiao* (a sloughed-off shell), *tui yi* (sloughed-off clothes), and *tui zhi* (sloughed-off material), all pertain to death but also convey the hope for a transcendent, albeit elusive, afterlife.

"Exuviation"—the technical English term for this biological phenomenon— does not have these metaphorical connotations. Another word that does possess such connotations, however, is transfiguration, defined in dictionaries as "a marked change in form or appearance that glorifies or exalts." It also has a religious significance and refers to, in the Bible, the sudden emanation of radiance from Jesus's body after his resurrection.

Defined as such, *Tui-Transfiguration* offers a metaphorical predication of the future of Factory 798—that this place, in its development into a vital space of contemporary Chinese art, will not simply be destroyed and replaced, but will transform itself to acquire a new life. This significance of the exhibition is embodied by Rong Rong's and inri's photographs. Structured in the exhibition's four sections, these images constitute a visual narrative from death and ruins to rebirth and transcendence.

Parts of this essays were originally published in "*Tui-Transfiguration*: An Experimental Exhibition at Factory 798," in Huang Rui ed., *Beijing 798: Reflections on Art, Architecture and Society in China* (Beijing: Timezone 8, 2004), 58-69, and Wu Hung, *Rong Rong and inri: Tui-Transfiguration* (Beijing and Hong Kong: Timezone 8, 2004).

SPATIAL NARRATIVES:
CURATING THREE "TEMPORAL" EXHIBITIONS

The purpose of this essay is not to discuss contemporary art and art exhibition on a theoretical level or from a macrohistorical perspective. Rather, my aim here is to introduce three exhibitions I have curated in response to a compelling question posed by Kao Ch'ien-hui in the last issue of *Journal of Taipei MOCA*. Namely, how does a curator of contemporary art interact with artists and art critics, even combining the latter's role, in organizing exhibitions?[1] The three exhibitions I want to discuss generally fall into the category of "experimental exhibitions," in which the main subject of experimentation shifts from the content of a display to the location, form, and audience of the display.[2] More specifically, the experiments conducted in the three exhibitions are all related to narrative, but each project is motivated by the desire to develop a different narrative structure in telling a particular story about China and Chinese art. There is *Tobacco Project: Shanghai*: through extending a previous exhibition in America to the other side of the Pacific, it both represents and reflects upon China's globalization and modernization process. With a radically different scope, *Canceled* meditates on the conditions and social roles of a contemporary art exhibition in China through re-presenting an aborted experimental exhibition called *It's Me*. The First Guangzhou Triennial, entitled *Reinterpretation: A Decade of Experimental Chinese Art*, embodies a third historical logic. As its title implies, it looks back at the recent history of contemporary Chinese art from a present vantage point; developing a "flashback" perspective thus becomes an integral element of the exhibition's conceptualization and design.

DISLOCATION AS GLOBALIZATION

Xu Bing's *Tobacco Project* consisted of two "site-specific" exhibitions. The first, *Tobacco Project: Durham*, took place in November 2000 in Durham, North Carolina. It was sponsored by Duke University and organized by Professor Stanley Abe (FIG. 13.1). The second exhibition, sponsored by the Shanghai Gallery of Art which I curated, continued the project in a new location (FIG. 13.2).[3] Entitled *Tobacco Project: Shanghai*, it took place on the other side of the Pacific. The move to China and the inclusion of new works that Xu Bing created specifically for the new location enriches the project's content and changes its meaning.

Xu Bing once told me how he conceived the *Tobacco Project*. When he visited Durham in early 2000 after Duke University had invited him to develop an art project there, his first impression of the

FIG. 13.1: POSTER OF *Tobacco Project: Durham*, DUKE UNIVERSITY, 2000.

place was the omnipresent smell of tobacco in the air. The guide told him that Durham had been a center of the American cigarette industry since the late nineteenth century. James B. Duke (1865-1925), the founder of the American Tobacco Company in Durham, also founded Duke University (FIG. 13.3). Now Durham is well-known not only for its cigarette factories but also for its cancer research institutes; the funds for medical research come mainly from local cigarette manufacturers. These seemingly absurd connections between the tobacco industry and a famous university and between promoting smoking and supporting medical science immediately caught Xu Bing's attention. An additional connection soon emerged once he began to work on the project: James Duke had a very close relationship with China. It is said that upon learning of the invention of the cigarette machine in 1881, his first words were: "Bring me the atlas!" As he leafed through the maps of various countries, he checked their population, not their location and boundaries. Coming to the figure 430,000,000 he exclaimed: "That is where we are going to sell cigarettes." That country was China.

Because of its location, *Tobacco Project: Durham* naturally focused on the relationship between Duke as a tobacco tycoon and the local economy, politics, and education. This relationship constituted the first historical context of the project and underlay Xu Bing's selections of the exhibition sites, including the farmhouse where James Duke grew up, the Durham Tobacco Museum located in Duke's expanded estate, the central library of Duke University, and an abandoned cigarette factory shop in Durham. (This last plan was later shelved for safety reasons.) The second historical context of the *Tobacco Project* —the expansion of the American tobacco industry in China and its consequences—was only implied in some individual objects in the exhibition, which employed images of cigarette posters and cigarette cards that Duke's company produced in Shanghai, designs of Chinese cigarette boxes, as well as Tang dynasty poems and quotations from Chairman Mao. A main characteristic of this exhibition was its polycentricism: Xu Bing neither planned it as a coherent visual display nor emphasized the thematic continuity between individual works. Instead, tobacco inspired him

FIG. 13.2: POSTER OF *Tobacco Project: Shanghai*, SHANGHAI ART GALLERY, 2004.

to create a series of disparate objects and installations, each pointing to a specific memory or meditating on general implications of the cigarette to human life. Some of the objects and installations were unusually personal and intimate, such as the projecting his father's medical records (who died from lung cancer) onto a building in the Duke Homestead. Others were more detached and philosophical. One installation in this second category had an extremely long cigarette burning slowly on a copy of *Spring Festival Along the River*, a famous handscroll painting created by Zhang Zeduan in the eleventh century. The charcoal scar left on the painting's surface not only alludes to the damage caused by smoking but also registers the passage of time—a shared element in both smoking a cigarette and viewing a traditional handscroll.

Tobacco Project: Shanghai retained this emphasis on chance memories and associations, but the change in location brings out the hidden potential of the project. In fact, because of its relocation to Shanghai, the central concept of the project shifted to signifying the Sino-American relationship and China's globalization process. To be sure,

FIG. 13.3: JAMES B. DUKE (1865-1975).

the movement of *Tobacco Project* from Durham to Shanghai self-consciously mirrors the global expansion of the American tobacco industry in general and its rapid development in China specifically. Checking historical records, we find that after its establishment in 1902, the British American Tobacco Company under Duke's control made a great effort to explore the Chinese market. The secret of its success in China lay in its integrating local production and distribution into a single system. During this process, Duke transferred capital and introduced new technology and administrative skills to China, making China not only a hugely profitable cigarette market but also an immense tobacco plantation and cigarette production base. (It is noteworthy, however, that although Duke was famous in America for promoting technological innovation, his company in China employed a large unskilled and cheap labor force. In 1915, for example, the company used 13,000 such workers for simple tasks such as sorting tobacco and packing cigarettes.) Some simple numbers demonstrate the rapid development of the British American Tobacco Company. In a mere ten years from 1905 to 1915, the company's investments in China increased more than six-fold from $2,500,000 to $16,600,000, and its sales skyrocketed from 1.25 billion cigarettes in 1902 to 80 billion cigarettes in 1928. From 1915 through the 1920s, the United States sold more cigarettes per year (with one exception) in China than to the rest of the world combined. The British American Tobacco Company, the largest American cigarette company in China, amassed a total profit of over $380 million between 1902 and 1948.

Shanghai was the headquarters of the company: its office building at the corner of Suzhou Road and Museum Road and its factories at Lujiazui in Pudong set a model for any foreign manufacturer's successful operation in China. One mark of its success was, first of all, its commercial domination: each month in 1915 in Shanghai alone, the British American Tobacco Company sold as many as one hundred million cigarettes, more than fifty times the combined number of cigarettes sold by

FIG. 13.4: INTERIOR OF THE SHANGHAI
ART GALLERY, NO. 3 ON THE BUND.
THE PRINCIPAL SITE OF *Tobacco Project:
Shanghai.*

its competitors. Such startling commercial success owed much to the company's advertisement campaign, which in turn helped reshape Shanghai's local visual culture. Advertisements of its products appeared in newspapers, posters, murals, scroll paintings, pamphlets, and calendars; horse-drawn carriages and rickshaws carried the company's trademarks through Shanghai's streets. The company carefully designed its products to appeal to local interest, and cultivated loyal customers by encouraging them to collect the "cigarette cards" found in every pack. Each year the company put out a richly illustrated calendar, which became so popular that supposedly it could be found "in every corner of the country," and whose publication at the end of every year was always "a sensational event." The company even set up an art program to train artists and designers. It is no exaggeration to say that in twentieth-century art history, the British American Tobacco Company greatly contributed to the emergence and development of a new, commercial visual culture in China through its art products.

Xu Bing is neither a sociologist nor an economic historian, and his works in this exhibition do not directly represent or analyze these historical events. By bringing these works into a dynamic dialogue with the city at large, however, we were able to create constant interactions between images and spaces and between past and present. First, the exhibition took place in two separate sites: the opulent, state-of-the-art Shanghai Gallery on the Bund (FIG. 13.4) and a dark, dilapidated tobacco warehouse left from the old days (FIG. 13.5). The gallery is situated in a famous colonial building known as "3 on the Bund" (FIG. 13.6). Renovated by the popular American architect Michael Graves, it housed, among others, top fashion stores and restaurants like Giorgio Armani and Jean-Georges in 2004. To Xu Bing, the building's uninhibited pursuit of luxury simultaneously evokes the sense of nostalgia and danger: it seems to reinvent Shanghai's bygone colonial glamorous image as Paris of the East, yet it is also a catalyst of the combined power of money and politics in globalized China today. This double feeling of nostalgia and danger is wonderfully captured by the centerpiece of the exhibition—an enormous "tiger-skin carpet" made of 660,000 cigarettes (FIG. 13.7). On the one hand, a "tiger-skin carpet" always reminds Xu Bing of the homes of the nouveau-riche; on the other hand, he derives the image of the carpet from an old photo, in which two European hunters pose in front of a freshly skinned tiger to show off their invincibility (FIG. 13.8). As a site-specific installation, this "carpet" turned the main hall of the Shanghai Gallery into a simulated living room—a transformation reinforced by secondary

FIG. 13.5: OLD TOBACCO WAREHOUSE IN
SHANGHAI. THE SECOND SITE OF *Tobacco Project:
Shanghai.*

installations, such as a bouquet made of red-tipped, poisonous matches (FIG. 13.9).

In sharp contrast, the feeling of the other exhibition venue—the old tobacco warehouse—was desolate and ghostly. For this space Xu Bing designed a light installation showing a passage from an old cigarette advertisement (FIG. 13.10). The passage reads: "As a new invention, making cigarettes utilizes the most efficient, satisfactory method. This is because cigarettes are machine manufactured, pure in essence and standard in appearance, and most suitable for human health." While these words remind the audience of those glorious days of the tobacco industry when smoking cigarettes was considered fashionably modern, the installation, made of cold, white neon light simmering in artificial clouds, reinforced the ghostly atmosphere of the warehouse.

FIG. 13.6: NO. 3 ON THE BUND.

Another kind of image-space dynamic characterized the design of a different section of the Shanghai Gallery. Overlooking the Bund, the gallery also faces the Huangpu River that divides Shanghai into Pudong and Puxi (East and West of the Huangpu River) districts. While today's Pudong displays a multitude of high-rises and has become a symbol of China's modernization (FIG. 13.11, in the early twentieth century it was the site of foreign-owned factories and warehouses. Amazingly, a major factory complex of the British American Tobacco Company originally stood almost directly across the river from No. 3 on the Bund (FIG. 13.12). Such a collapse of memory and reality inspired Xu Bing to create a work called *Windows Facing Pudong* for the exhibition: with the help of some art students he copied old photographs of Pudong and the Bund on the gallery's windows and adjacent walls (FIGS. 13.13-13.14). The result was a composite image of Shanghai's modern history: when one looked at the black-and-white drawing, one also saw today's Pudong in the distance. To this image-space interaction we added a third element: near the window—but not too close—we installed Xu Bing's work *Along the River during the Qingming Festival* (FIG. 13.15). Some historians have used the original painting by Zhang

FIG. 13.7: XU BING, *Inventing Cigarette,* INSTALLATION, 2004, SHANGHAI ART GALLERY.

Zeduan to demonstrate the highly advanced commercial economy during the Northern Song; others even consider it proof of "early capitalism" in a major Chinese urban center. In Xu Bing's installation, a specially made cigarette lay on the long scroll from the beginning to the end. It burned slowly across the painting, and left a charcoaled scar on the surface (FIG. 13.16). The message is twofold: first, parallel to the Huangpu River flowing outside the gallery and painted on the windows and walls, here is another river that has also been connected to China's urbanization and commercialization; the installation thus added a historical layer to the narrative pur-

FIG. 13.8: AN OLD PHOTOGRAPH
SHOWING A EUROPEAN HUNTER AND
HIS WIFE POSING IN FRONT OF A TIGER
SKIN. THE SOURCE OF THE DESIGN OF
XU BING'S *Inventing Cigarette.*

FIG. 13.9: XU BING, *A Bouquet of Match
Flowers,* INSTALLATION, 2004, SHANGHAI
ART GALLERY.

FIG. 13.10: XU BING, *Tobacco Language,*
LIGHT INSTALLATION, 2004, OLD TOBACCO
WAREHOUSE, SHANGHAI.

FIG. 13.11: A VIEW OF PUDONG IN 2004.

FIG. 13.12: A FACTORY COMPLEX OF THE
BRITISH AMERICAN TOBACCO COMPANY
AT PUDONG, CA. 1920S.

FIG. 13.13: XU BING CREATES *Windows Facing
Pudong,* SHANGHAI ART GALLERY, 2004.

FIG. 13.14: XU BING, *Windows Facing
Pudong,* SHANGHAI ART GALLERY, 2004.

FIG. 13.15: XU BING, *Along the River
during the Qingming Festival,* SHANGHAI
ART GALLERY, 2004.

FIG. 13.16: XU BING, DETAIL OF *Along the River during the Qingming Festival,* SHANGHAI ART GALLERY, 2004.

sued in the exhibition. Second, while the burning of the cigarette generated a strong impression of the passage of time, the scar it left evoked the feeling of destruction and provoked the audience to reflect upon the dark side of any historical progression.

These examples illustrate the central curatorial strategy of the *Tobacco Project: Shanghai* to create various kinds of interactions between spaces, images, and objects. Some images and objects bring back memories of the past; others interact with the present. Mixing and overlapping, they generated confusion in our historical perception, as if past and present were staged simultaneously by means of the cigarette, a commercial product that has been transformed into a visual medium. Just as foreign economic invasion helped turn China into a semi-colonial society a century ago, so too the current Chinese "economic miracle" heavily relies on foreign investment and is a by-product of her globalization. In this exhibition we seem to hear constant echoes between the past and the present: once again there is the transmission of foreign money, technology, and management, and once again China provides the world with cheap labor as well as an oversized market. The meaning of such echoing, however, must be discovered by viewers themselves.

RECONSTRUCTING EXPERIENCE

To Michel Foucault, a painting can be a representation of a previous representation. W. T. J. Mitchell calls such as a painting a metapicture, a painting which explains what pictures are: "to stage, as it were, the 'self-knowledge' of pictures."[5] The exhibition *Canceled: Exhibiting Experimental Art in China* that I organized at the Smart Museum of Art at the University of Chicago in 2000 followed a similar logic. In its basic conception, this exhibition re-presented—not restaged—a previous exhibition, and in so doing brought out what I found essential in the earlier event. This previous exhibition was called *It's Me: An Aspect of Chinese Contemporary Art in the '90s* and was curated by the independent Chinese curator Leng Lin. It would have been held November 21-24, 1998, in the former Imperial Ancestral Temple in Beijing, had it not been cancelled by the local authorities right before the opening reception.

There was a blizzard in Beijing on November 21. But many artists, art critics, and journalists still made their way to attend the show's opening in the early morning. When they arrived at the Imperial Ancestral Temple, however, they found the exhibition hall tightly shut. So they stayed outside and talked about the event. They complained about the frequent cancellations that experiment art suffered from, and raised questions about the social role of artists. A cancelled exhibition thus turned into a public forum.

206

Among the visitors was the filmmaker Wu Wenguang. Starting from the late '80s when he made his first documentary film *Bumming in Beijing: The Last Dreamers,* he had developed a close relationship with experimental artists and frequented avant-garde exhibitions. Unlike other people, he looked at such events through a digital camcorder that never left his hand. That morning, attracted by the snow-covered cityscape, Wu Wenguang turned on his camcorder from the moment he left home. On the way to the Imperial Ancestral Temple he and his friends chatted and made jokes about those fashionable "groupies" in the contemporary art circle. The light, playful atmosphere, however, suddenly evaporated when they arrived at the Imperial Ancestral Temple and saw a freshly written official notice at the entrance, announcing the "postponement" of the exhibition, a euphemism for cancellation. He continued shooting: his camcorder circled around the Main Ritual Hall that housed the exhibition. The doors and windows were tightly shut. His view then turned to the huge courtyard below. Against the snow-covered ground was the dark silhouette of a cluster of some thirty artists, art critics, and a small audience who had come to the reception. About a year later, Wu Wenguang edited the footage into a short video documentary entitled *Diary: November 12th, 1998, Snow.* To my knowledge, this is the only such documentary in China, and perhaps even in the whole world, that records the instantaneous responses of the curators and artists to the government cancellation of their art exhibition.

In preparing the exhibition *Canceled*, I conducted detailed research into *It's Me*, including its theme, content, selection of the site, and sponsorship. Among the people I interviewed, the curator Leng Lin, the sponsor Guo Shirui, and the artist Song Dong (who designed the only site-specific work for the show) provided me with first-hand information about the project and with their different accounts of the exhibition's cancellation. This research allowed me to define three interrelated aspects of *It's Me* as the guiding concepts of *Canceled*.

First, *It's Me* was installed but aborted. The exhibition never opened, and the exhibition items—paintings, photographs, and installations—remained unseen in the exhibition hall. The subject of *Canceled* was therefore an exhibition that was never realized, not a group of art works or artists as one normally finds in an art exhibition. Second, when one thinks of *It's Me* as "an exhibition that was never realized," one approaches it retrospectively and focuses on the event of cancellation. I thus defined the focus of *Canceled* more specifically as this event—the cancellation of *It's Me*. Third, this event transformed the Main Ritual Hall in the Imperial Ancestral Temple—the site of *It's Me*—from an exhibition space into a place of public resentment and protest. Wu Wenguang summarized the situation in the voiceover of his documentary: "The works of art are all inside; the people are all outside." This observation provided a key image for my design of *Canceled*.

Alluding to the free-standing screen that blocks the entrance to the Main Ritual Hall, a partition wall (a "screen") shielded the entrance to *Canceled* to heighten the feeling of enclosure and separation (FIG. 13.17). This "screen" also served a practical role: it provided an ideal space to pose the introductory text for the exhibition and also to display two images, one of the interior and one of the exterior of the Main Ritual Hall (FIG. 13.18). Illuminated from behind, the images indexed the two spatial and thematic components of the exhibition (the inside and outside of the exhibition hall; an aborted exhibition and a denied viewership), and enabled the audience to grasp the basic concept of the exhibition before they entered the galleries.

A second partition wall divided the exhibition space into two galleries side by side, representing the interior and the exterior of the Main Ritual Hall in the Ancestral Temple (FIG. 13.19). The first gallery—the courtyard surrounding the Hall—was empty and painted light gray. The second room—the Hall—was deep crimson and crowded with three large columns connected by painted beams on the ceiling. The two galleries were linked by a passageway, whose narrowness again stressed the separation of the inner and outer spaces as well as the inaccessibility of the inner space.

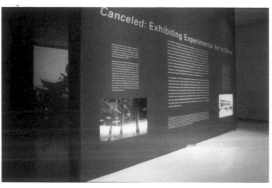

The symbolism of each gallery was clinched by the images shown in it. In the first gallery, Wu Wenguang's video documentary was projected on an entire wall. The audience who came to *Canceled* assumed Wu's position to approach *It's Me* from the outside—traveling through Beijing's streets, arriving at the Ancestral Temple, reaching the Main Ritual Hall, and remaining outside the hall in the courtyard (FIG. 13.20). In the second gallery, Song Dong's video installation, *Father and Son in the Ancestral Temple*, was projected onto three columns constructed for the occasion (FIG. 13.21). As mentioned earlier, this video installation was the only site-specific work designed for *It's Me* (see FIG. 13.18). Its original significance lay in the interrelationship between the three portraits and between the portraits and their architectural framing. The two images to either side represented Song Dong and his father, each telling his life story. The third "portrait" in the middle was a composite image formed by both his and his father's faces. The composite figure also recounted some biographical facts, but the oral narrative was no longer intelligible because the blurred voices mingled the lives of the two men. Unlike the *portraits* on the two side columns, the subject of this third image was the *negotiation* between the father and son: all key elements of a negotiation—contest, conference, and transference—were made literal by fusing their images together.

The meaning of this video installation was further enriched by the architectural setting. It is commonly known that all crucial components of traditional Chinese culture—politics, religion, and ethics—have their principles modeled upon the father-son relationship. The Imperial Ancestral Temple encapsulates the traditional Chinese virtue of filial piety. Although the imperial system was abolished and China changed enormously in the twentieth century, the father-son relationship still dominates Chinese society, which is still essentially patriarchal. To Song Dong, therefore, meditating on his relationship with his father in the former Imperial Ancestral Temple would have a two-fold significance. On the one hand, this work would signify China's progress, because in traditional China no one but the emperor could use this place to honor his father. On the other hand, this work would indicate the persistence of Chinese traditions, because the installation still shares the central theme of the old Ancestral Temple, the father-son relationship. This two-fold significance would make this site-specific project both "contemporary" and "Chinese," a goal Song Dong had been pursuing for years in his art.

FIG. 13.18: INTERIOR AND EXTERIOR OF THE MAIN RITUAL HALL IN THE FORMER IMPERIAL ANCESTRAL TEMPLE.

This meaning of the video installation changed in *Canceled*. Most important, it was no longer a site-specific project, but became a means of recreating the original exhibition site in an art museum in

FIG. 13.19: AN INSTALLATION
PLAN OF *Canceled,* DRAWING BY
SONG DONG, 2000.

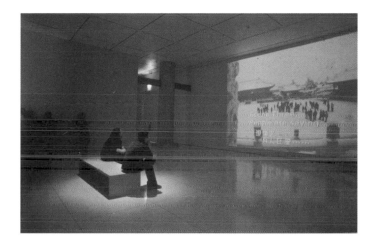

FIG. 13.20: OUTER GALLERY, *Canceled,*
SMART MUSEUM OF ART, UNIVERSITY
OF CHICAGO, 2000.

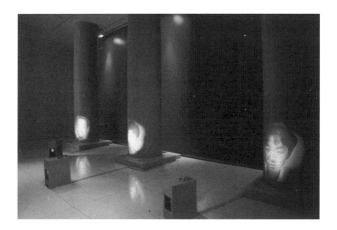

FIG. 13.21: INNER GALLERY, *Cancelled,*
SMART MUSEUM OF ART, UNIVERSITY OF
CHICAGO, 2000.

Chicago. In other words, the installation now alluded to the space inside the Main Ritual Hall, which was closed to visitors who went to see the exhibition *It's Me* on November 21, 1998. In fact, some visitors to *Canceled* were puzzled by the "emptiness" of the show and asked where the artworks were when they walked into the galleries. Their confusion actually fulfilled the intention of the exhibition because the two video works, instead of being individual art objects or images, had succeeded in transforming the galleries into a spatial representation of *It's Me*.

Perhaps most important, through juxtaposing these spaces and images, *Canceled* was able to integrate the perspectives and experiences of three types of people involved in an experimental art exhibition: the organizers of *It's Me*, the artists in *It's Me*, and the audience who went to see the exhibition without knowing that it had been cancelled. These three positions are embodied in the design of *Canceled*. Whereas Song Dong's video installation in the inner gallery stood for the original exhibition, Wu Wenguang's documentary shown in the outer gallery provided a vivid account of the exhibition's cancellation from a visitor's point of view. These two spaces and images implied the double positioning of the curator Leng Lin, who created the show and also bore the consequences of the cancellation. He was thus both "inside" and "outside" the Main Ritual Hall during the cancellation.

SPATIALIZING A RETROSPECTIVE

Although billed as a "triennial," the First Guangzhou Triennial in the Guangdong Museum Art, for which I served as the chief curator, did not follow the norm of international biennales and triennials to invite international artists from different countries. Neither did it have a catchy "central concept" as most biennales and triennials do. A number of reasons had led me to mount a retrospective of experimental Chinese art on this occasion. The most crucial reason was that in my view, despite the rapid progress and globalization of contemporary Chinese art in recent years, this art, generally speaking had still not acquired a serious critical attitude toward itself. Yet without such an attitude, there would be no basis for in-depth art criticism and art historical scholarship, and artistic experimentation would mainly be stimulated by random instinct, not substantiated by deepening knowledge and experience. Therefore, when I was invited to curate the First Guangzhou Triennial, I proposed to title it *Reinterpretation: A Decade of Experimental Art in China* (1990-2000). The main goal of the exhibition was to collaborate with curators, art critics, scholars, and artists from China and abroad to develop a historical narrative for contemporary Chinese art (FIG. 13.22).

This project also attracted me for a more specific reason: the prospect of realizing the concept of "retrospective" through the manipulation of an exhibition's structure and design. A retrospective exhibition by definition presents and examines "past events" from a present vantage point, and is thus characterized by a distinctive "historical" perceptual and conceptual mode. While this is commonplace knowledge, a retrospective of contemporary art demands us to reflect critically upon this type of art exhibition. Briefly, a conventional retrospective (still being held in numerous museums today) habitually follows a "chronicle" mode, exhibiting and interpreting representative works of an artist in a linear, chronological sequence. This exhibition mode is closely related to the purpose and method of traditional art historical scholarship, which takes reconstructing "historical evolution" as its main goal. As such, a traditional retrospective exhibition rarely foregrounds its agendas and criteria. It is dominated by objects; the curator remains largely invisible.

This "objective" approach becomes incompatible with a contemporary art exhibition because the concept of the contemporary requires the active participation and subjective intervention on the part of artists, art critics, and curators. Instead of viewing themselves as dispassionate observers of art objects, contemporary art curators consider their own experiences, identity, and points of view crucial

FIG. 13.22: THE
FIRST GUANGZHOU
TRIENNIAL IN THE
GUANGDONG MU-
SEUM OF ART, 2002.

elements in articulating exhibition projects. It is from this standpoint that I attempted three types of experiments in planning the First Guangzhou Triennial, making the subjectivity of a retrospective a central point of representation.

First, instead of following a conventional chronological order, I devised a "flashback" structure for the entire show. The exhibition consisted of three main thematic sections: "Memory and Reality," "Self and Environment," and "Global and Local." The forth and last section, called "Experimentation Continues," featured new works made for the Triennial by a group of invited artists. In terms of the time of creation, the works in "Memory and Realty" are the earliest, as many of them date back to the early '90s. Their content is also related to China's historical experience during the Cultural Revolution, the Sino-Japanese War, and even earlier periods. Those in the "Self and Environment" section are later in date, and are mainly associated with a "domestic turn" in contemporary Chinese art around the mid-90s. Many works in "Local and Global" are even newer, responding to the heightening process of globalization in the second half of the decade. The chronological sequence of the sections, however, was reversed in the exhibition hall: the last section ("Local and Global") was shown on the first floor while the first section ("Memory and Reality") was on the third floor (FIG. 13.23). We also purposefully staged most works in "Experimentation Continues" outside, so the audience could encounter them even before entering the gallery (FIG. 13.24. also see FIG. 13.22). While this sequence seems "illogical" from an evolutionary approach, it internalized a perception intrinsic to a retrospective: the audience proceeded from the present to the past, gradually rediscovering memories and constructing a "flashback" history of contemporary Chinese art.

"Framing" was the second method I used to bestow the Triennial with a "retrospective" temporality. The galleries in the Guangdong Museum of Art are located to the right of the museum building, connected with the main lobby by a passageway. Because it is relatively low and has hard marble walls, this passageway is usually left empty during an exhibition. But in my view, its position as a "threshold" to the galleries had much potential for a better use. More specifically, it could be turned into a "liminal space"—a transitional sphere in anthropological theory which has the ability to change people's concept of time and space during a ritual procession.

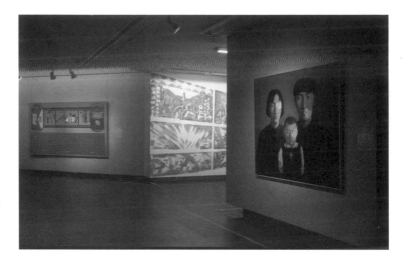

FIG. 13.23: A VIEW OF THE DISPLAY OF THE FIRST GUANGZHOU TRIENNIAL ON THE THIRD FLOOR OF THE GUANG-DONG MUSEUM OF ART, 2002.

FIG. 13.24: HUANG YONG PING, *Bat Project II,* INSTALLATION, FIRST GUANG-ZHOU TRIENNIAL, 2002. THIS WORK WAS CENSORED RIGHT BEFORE THE OPENING OF THE EXHIBITION, BUT MANY PEOPLE HAD SEEN ITS CREATION.

Among the artists whom we invited to create new works for the Triennial, Cai Guo-Qiang was especially sensitive to this kind of transformation. During my discussion with him about his installation project called *Kaleidoscope*, we gradually formed a plan of using this work to transform the passageway into a "time tunnel." The installation consisted of slowly rotating kaleidoscopes, each containing images of the works that Cai created in a given year during the '90s. Driven by electric motors and illuminated from the rear, the kaleidoscopes slowly rotated, projecting changing images on the two walls of the

FIG. 13.25: CAI GUO-QIANG, *Time Tunnel,*
FIRST GUANGZHOU TRIENNIAL, 2002.

passageway (FIG. 13.25). It can be said that this installation was itself a miniature retrospective of Cai's art in the '90s. Displayed at the entrance to the Biennale, however, it also framed the entire exhibition. As the visitors passed through this "time tunnel," they became part of a sphere of transformation. The rotating images on the walls conveyed the passage of time, leading spectators to explore the depth of the exhibition.

The third way of making the concept of retrospective concrete was to transform an old work into a new, contemporary piece. Some artists in the Triennial were not satisfied with simply restaging their previous projects. They argued—and I totally agreed with them—that certain contemporary art forms such as installation and performance are intrinsically site- and time-specific; to restage them in a museum would cancel their original significance. How to include such works in a retrospective thus became a theoretical problem.

This problem was the central topic of my discussion with the artist Zhan Wang. The curatorial committee selected Zhan Wang's installation *Temptation* to be included in the Triennial. First shown

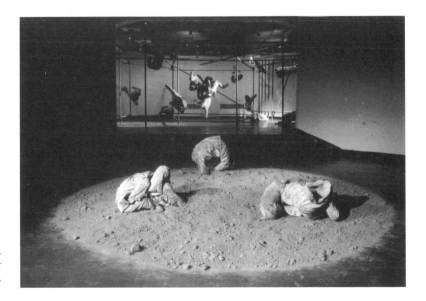

FIG. 13.26: ZHAN WANG, *Temptation,*
INSTALLATION, CONTEMPORARY ART
MUSEUM, BEIJING, 1994.

in Beijing's Contemporary Art Gallery in 1994, the installation originally consisted of a group of bodiless figures frozen in dramatic poses (FIG. 13.26). Made of clothes and glue, these were "human shells" dressed in a Mao suit, a symbol of the Cultural Revolution. Their extremely contorted gestures gave the impression of passion, pain, torture, and a life-and-death struggle. But there was neither a subject nor an object to struggle against. Empty and suspended, these human forms were created not as self-contained sculptures, but as "signs" of desire and loss that had the infinite potential to be installed in different combinations and in various environments; and indeed Zhan Wang experimented with various installation methods after the initial exhibition of the work. I described these experiments in 1999:

> Suspended on a scaffolding these forms gain a heightened instability and anxiety. Placed on brown dirt they seem to form an immediate relationship with the dirt, a relationship that reminds Zhan Wang that a person's body is returned to the earth after death. But the most dramatic installation is placing these human shells among a half-destroyed building in central Beijing. Suddenly the ruin and the shells become one and together emphasize a profound absence of the human subject. They also testify to fascination with torn and broken forms and a shared attraction to destruction and injury, although it is by no means clear what is actually wounded other than the building and the empty shells themselves.[6]

With this background, it becomes understandable why Zhan Wang was opposed to the idea of restaging the original 1994 installation in the Triennial. His objection triggered off a prolonged email-conversation between us, in which we contemplated various possibilities to refashion the work in the retrospective. I will not copy those emails here, which have been published in Chinese to document the Triennial's curatorial process.[7] It suffices here just to state the final outcome of this communication: Zhan Wang staged a funeral in the Triennial to "bury" the bodiless figures, thereby terminating the metamorphosis of the work. His new installation inside the Guangdong Art Museum consisted of rows of wooden boxes lined up in front of a back-illuminated photograph (FIG. 13.27). Two-dimensional and weightless, the photograph documented the original installation of *Temptation* in 1994—a past moment of the work was thus reframed within the "present" installation in 2002. The figures were now put in the coffin-like boxes. Without the lid, they were exposed to the audience like corpses in an open-casket funeral. To complete the project, the museum gave Zhan Wang a plot of land as the final burial site for the figures.

§

I proposed at the beginning of this essay to use three cases to illustrate the manner in which a curator can assume the role of an art critic and even an artist through reinventing the form of an exhibition. There are of course many other ways to develop interactions between curating, art criticism, and art creation. For example, explanatory captions, catalogues, lectures, workshops, and symposiums can all serve as direct channels for a curator to participate in art criticism. But whereas a catalogue or symposium creates an "interpretative context" for an exhibition, this essay focuses on the exhibition itself and suggests that an exhibition's spatial structure can become a vehicle in developing critical concepts and theoretical discourses. The three cases discussed here demonstrate that when curating in an existing museum or gallery, the key to engaging in art criticism and theoretical thinking is to articulate an "exhibition space."

Here, the concept of an "exhibition space" does not simply mean the architectural space of a museum or gallery. Rather, it denotes a dynamic spatial and perceptual network constituted by architecture, art projects, and the audience. Each exhibition must thus demand—and generate—a different

FIG. 13.27: ZHAN WANG, *Temptation II*, INSTALLATION, FIRST
GUANGZHOU TRIENNIAL, 2002.

exhibition space even if it uses the same building. My three examples further demonstrate that not only does architecture physically contain an exhibition, but an exhibition also necessarily redefines architecture, endowing an existing architectural space with new, specific meaning.

This further implies that the relationship between architecture, art projects, and the audience in a contemporary art exhibition is not a natural given, but must be self-consciously constructed by the curator based on a well-articulated plan. In other words, a particular exhibition space is always connected to a particular critical discourse; we can even consider an exhibition space as the "spatialization" of a discourse. Through creating such space and discourse the curator automatically engages in a negotiation with the art system and, in fact, often challenges and reinvents the existing institutional framework. For instance, by displaying the newest experimental works (some of which were exceptionally daring and challenging) outdoors, the First Guangzhou Triennial not only expanded the physical dimensions of the museum, but also facilitated the transformation of the museum from a tightly-guarded official space to a more open, flexible contemporary art space. Likewise, *Tobacco Project: Shanghai* not only used a posh commercial gallery as its venue, but also critiqued the globalization process which had created the gallery.

In contrast to compiling a catalogue and writing captions for exhibition items, to envision and design an exhibition space requires visual imagination and requires close collaboration between the curator, the artist, and the architect. It, of course, takes much more time to develop a complex exhibition space than simply filling a gallery space with individual works. But, to my mind, because such projects initiate debate and engage in art-making and architectural design, they constitute the most dynamic and exciting aspects of curating a contemporary art exhibition.

Parts of this essay were originally published in Wu Hung, *Xu Bing: Yancao jihua* (Xu Bing: Tobacco Project), (Beijing: Renmin daxue chubanshe, 2006) and in *Dangdai yishujia zhiyan* (Words of Contemporary Artists), December 2004, Museum of Contemporary Art, Taipei, 47-69.

INTERNATIONALIZATION

NEGOTIATING BEAUTY IN CONTEMPORARY ART: AN EXHIBITION

When J. Claretie wrote after viewing the First Impressionist Exhibition in 1874: "M. Monet... Pissarro, Mlle, Morisot, etc., appear to have declared war on beauty,"[1] this Parisian critic could not have expected that this comment would predict a fundamental impulse in twentieth-century art, confirmed over and over by avant-garde painters and sculptors both through words and images. Among some well-known examples, Pablo Picasso's 1909 *Les Demoiselles d'Avignon* enraged his contemporaries with its "grotesque," "ugly" figures; Marcel Duchamp added a moustache and goatee to Mona Lisa's face in 1919; Salvador Dali said in 1933 that "Beauty shall be edible or nothing;" and Bennett Newman declared in 1948 that "The impulse of modern art is the desire to destroy beauty." These and other instances constitute a general historical context for conceiving the renewed discussion of beauty in current aesthetics and art criticism as a "return of beauty."

Far from simply resurrecting a once-negated historical concept, this "return of beauty" is a complex contemporary phenomenon associated with different ideologies, social groups, intellectual aspirations, and artistic innovations. The word "beauty" has been infiltrating the art world from various directions—from a commercial visual culture that has never been so prevalent and powerful, from the intensified interpenetration of popular and elite art on a global scale, from technological inventions that create new kinds of images at a breakneck speed, and from political movements such as the Black Power Movement in America during the '60s and the Urban Beautification campaign in China today.

Those who have contributed to beauty's return include both "progressives" and "conservatives"—not only critics of the art establishment and advocates of feminism and multiculturalism, but also defenders of the pure aesthetic experience in art appreciation and urban planners working for municipal architecture bureaus. Indeed, there is no unified front or fronts behind the "return of beauty." When I attended the panel discussion "What Is Beauty?" during the 2002 Chicago Humanities Festival (titled *Brains and Beauty*, this festival was yet another manifestation of the trend), each of the ten panellists (including the European historian Simon Schama, the American cultural

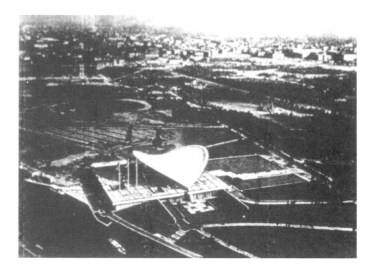

FIG. 14.1a: Congress Hall and the site, Berlin, 1956.

critic Wendy Steiner, the Western art historian Robert Rosenblum, the African American sculptor Richard Hunt, and the connoisseur of South Asian Buddhist art Pratapaditya Pal) spoke about their own understandings of beauty in near monologues that had little to do with each others' ideas. We know the popular adage "Beauty is in the eye of the beholder." That discussion seemed to prove "Beauty is in the mind of the speaker."

But to believe this would be the end of any communication about different perceptions and ideas of beauty. My experience in that panel discussion, in fact, strengthened my decision to organize the current exhibition as a series of interactions between different traditions and positions in contemporary art, rather than a collection of artistic "monologues" assembled under a single roof. This introduction explains why such a plan is necessary and how it is realized in the exhibition.

<center>DIVERSITY OF BEAUTY</center>

Some time ago I read this passage in Hans-Georg Gadamer's essay "The Relevance of the Beautiful," and was troubled by it:

> When I find something beautiful, I do not simply mean that it pleases me in the same sense that I find a meal to my taste. When I find something beautiful, I think that it "is" beautiful. Or, to adapt a Kantian expression, I "demand everyone's agreement."[2]

The passage troubled me because of the author's conviction of the Kantian "demand" even in the late twentieth century, and because of its automatic negation of any possible "disagreement" outside this conviction. One such disagreement would have been the first written definition of "beauty" in East Asia, found in the earliest Chinese dictionary compiled by the second-century philologist Xu Shen. Like Gadamer, Xu also associates beauty with food, but from an entirely different angle. The definition reads:

> Beauty means "delicious." The character for beauty (*mei*) consists of the graphs for "sheep" (*yang*) and "big" (*da*). Among the six domestic animals [i.e., horse, ox, sheep, pig, dog, and chicken], the sheep is the first of those which provide meals (*shan*). Beauty is [therefore] synonymous with "goodness" (*shan*) [because "goodness" and "meals" are homonyms in Chinese].[3]

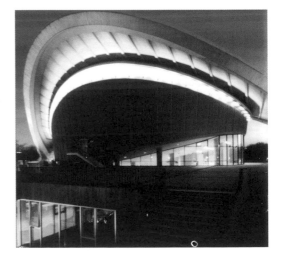

I begin this section with these two passages because they immediately put my discussion of beauty within the framework of *diversity*. Diversity does not mean complete alienation and segregation, but denotes differences as well as connections. Xu Shen's and Gadamer's ideas of beauty certainly depart greatly from each other, but both explain the concept in terms of food. The question then becomes why and how Xu Shen uses fine food as a positive proof in associating beauty with goodness, while Gadamer contrasts beauty with a good meal to demonstrate beauty's inherent autonomy and universality. To answer this question we need to situate the two authors in their cultural, intellectual, and aesthetic contexts. But such an inquiry itself would

FIG. 14.1b: TODAY'S HOUSE OF WORLD CULTURES (FORMER CONGRESS HALL), 2004.

contradict the "Kantian demand": there would indeed be no need to consider diversity if one person's perception of beauty can be taken as a token of *sensus communis* (common sense). When Gadamer—as well as Burke and Kant before him—talked about beauty, there was no place for "others" in their thinking. To them, individual perceptions of beauty only signal greater or lesser degrees in discriminating between the *sensus communis* of the beautiful.

This seemingly dated universalistic approach has resurfaced since the '90s as a target to be challenged. These challenges have, in turn, contributed significantly to the "return of beauty." Attacks on the Burke-Kantian notion of beauty are, of course, not new. Leaving

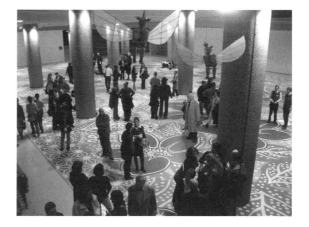

FIG. 14.2: MICHAEL LIN, *Palais des Beaux Arts,* FLOOR MURAL, HOUSE OF WORLD CULTURES, 2003-2004/2005.

aside the anti-beauty campaign of the historical avant-garde, we find throughout the twentieth century that critics with different backgrounds have questioned the legitimacy of this notion formulated at a particular moment in the West. The French painter and sculptor Jean Dubuffet, for example, rejected the western concept of beauty altogether because of its implicit imperialistic, discriminatory nature. As he stated in a 1950 lecture: "Beauty does not enter into the picture for me. I consider the western notion of beauty completely erroneous. I absolutely refuse to accept the idea that there are ugly people and ugly objects. Such an idea strikes me as stifling and revolting."[4] Without articulating an alternative notion of beauty, however, Dubuffet's rejection of beauty became yet another gesture of his well-known iconoclastic attitude toward cultural and artistic canons; the elusive "savages," mentioned now and then in the lecture, merely projected his anti-establishment identity onto an imaginary time and space.

By contrast, recent critics of the classical notion of beauty (and its consequences in art and art criticism) self-consciously historicize the Burke-Kantian model and pursue new theoretical formulations for beauty to empower their own alternative identities. Dubuffet's tactic is reversed, as these critics tend to embrace beauty instead of abandoning it. But like Dubuffet, they commit themselves to certain social or political agendas, which legitimate their effort to free beauty from its traditional conceptual

FIG. 14.3: SAMTA BENYAHIA, SITE-SPECIFIC WINDOW INSTALLATION, HOUSE OF WORLD CULTURES, 2005.

and institutional framework.

Often combining social critiques with a sociological interpretation of art, their writings on beauty differ from the scholarship of some philosophers, who have contributed to the "return of beauty" by reexamining the *nature* of beauty as an aesthetic category. Is beauty a specific property or quality, signified by a person or a thing? Is beauty fundamentally a kind of sensory experience? Does beauty result from communication or from self-discovery? How have the notions of beauty and the sublime changed since the times of Burke and Kant? What is the relationship between aesthetics and ethics? These questions are not irrelevant

to the social criticism of beauty, but they generally remain within the discipline of aesthetics as an abstract intellectual exercise.

The current exhibition is related to both types of inquiry, but has a more intimate relationship with the first type for two reasons. First, as mentioned earlier, the social critique of beauty is associated with social identities, especially those of under-privileged social groups in western civilization, including women, gays, minorities, and people of color. To Wendy Steiner, for example, the history of twentieth-century art is in many respects a history of resistance to the female subject, and a "return to beauty is possible only because of the cultural work on gender that has gone on throughout the century."[5] One component of such cultural work, in her argument, is to reinterpret the relationship between beauty and the sublime—the cornerstone of the Burke-Kantian aesthetic theory and modern art criticism—as a gender-biased theoretical formulation. In this reinterpretation, as the feminist critic Barbara Claire Freeman writes, the sublime appears as "an allegory of the construction of the patriarchal subject, a self that maintains its borders by subordinating difference and by appropriating rather than identifying with that which presents itself as other."[6] Whereas Freeman advocates a "feminine sublime" to reverse the conventional gender dynamism, Steiner envisions the emergence of a new kind of beauty in art. Defying sexual stereotyping, it will become a site for expressing pleasure, empathy, interestedness, and other aesthetic experiences which, in her view, have been repressed in modern art under the sublime's shuddering power.

Second, the social critique of beauty re-addresses the relationship between art and the viewing subject. Dave Hickey, for examples, links beauty with the beholder's visual response to sensual images and illusionistic space in post-Renaissance western art. To him, the modernist struggle with and ultimate triumph over the effeminacy of such images and space not only rejected "beautiful" figures, forms, and taste in artistic representation, but also severed a direct relationship between art and the beholder. The consequence, as he writes in his influential essay "Entering the Dragon," is that "The bond of commonality between artist and beholder is dissolved by the artist's prophetic singularity. In this restructured dynamic, the function of the beholder is to be dominated and awestruck by the work of art."[7] Be-

FIG. 14.6: QIN YUFEN, *Yu Tang Chun,*
SITE-SPECIFIC INSTALLATION, HOUSE
OF WORLD CULTURES, 2005.

cause this domination has been facilitated by a confederation of the art establishment—museums, universities, planning bureaus, foundations, publications, and endowments, a return to beauty can "steal the institution's power" by restoring a direct and spontaneous connection between visual forms and the secular beholder.

In summarizing these arguments, I am not suggesting that this exhibition is directly indebted to these specific theories or interpretations. Rather, they demonstrate a strong desire to free beauty from traditional aesthetic discourses, to reframe beauty within heterogeneous social, intellectual, and political spaces, and to reconnect art with the public. This exhibition is motivated by the same desire and aims to strengthen contemporary art's increasingly diverse social and cultural bases.

NECESSITY FOR NEGOTIATION

I started the preceding section with two passages on beauty by Xu Shen and Gadamer. This section begins with a third passage from a more recent book by Elaine Scarry, titled *On Beauty and Being Just:*

> Many human desires are conterminous with objects. A person desires a good meal and—as though by magic—the person's desire for a good meal seems to end at just about the time the good meal ends. But our desire for beauty is likely to outlast its object because, as Kant once observed, unlike all other pleasures, the pleasure we take in beauty is inexhaustible.[8]

I do not think that in writing these sentences the author deliberately alludes to Gadamer's passage cited earlier, but this makes their similarities even more striking. Like Gadamer, Scarry bases her argument on Kant and considers beauty a spiritual delight that transcends the material world. To prove

FIG. 14.7: ZHU JINSHI, *Approaching Shangri La,*
SITE-SPECIFIC INSTALLATION, HOUSE OF WORLD
CULTURES, 2005.

223

FIG. 14.8: JENS HAANING, *Arabic Jokes,*
SITE-SPECIFIC INSTALLATION, 1996
(COPENHAGEN), 2005 (BERLIN).

this, she also contrasts beauty with the mundane plea-
sure of enjoying a good meal. What we find here is the
self-referentiality of a disciplinary discourse. Scarry, how-
ever, departs from the earlier assertion that the individual
perception of beauty merely manifests common sense.
Not only does she devote a section of her book to discuss
beauty's "decentering" effect (quoting Simone Weil, she
says that beauty requires us "to give up our imaginary
position as the center"),[9] but in one place, she also lists
"cultural difference" as a condition in perceiving beauty.[10]
All of these indicate a shift from a universalistic position
to a particularistic position in thinking and talking about
beauty.[11] But this transition is not completed in the book
because the discourse as a whole is not decentered. Al-
though Scarry's references and examples include many
philosophers, poets, painters, and works of art, none of
these come from spaces outside a rarefied western civi-
lization. Consequently, although "cultural difference" is
acknowledged, it is not given a voice or point of view.

Such voices and points of view are abundant, of
course. We find them not only in pre-modern art tradi-
tions (which are displayed prominently but in isolation in
"world art museums" such as the British Museum and the
Metropolitan Museum), but also in modern and contem-
porary art

and aesthetics, which have increasingly become diversified
fields of artistic and intellectual interactions. What are
missing in Scarry's discussion of beauty, I would suggest,
are not just examples from traditional Islamic, Chinese,
or Indian art and philosophy, but, more importantly, are
modern and contemporary ideas about beauty from these
and other places, which respond to western aesthetics in
different ways.

FIG. 14.9: *Hans-Peter Feldmann, in
collaboration with Babel,* PRINTED
VOLUME, 2005.

An example of such a response is Junichiro Ta-
nizaki's life-long search for beauty. As it is commonly
known, this famous Japanese novelist was influenced at
the beginning of his career by western writers such as Ed-
gar Allan Poe, Oscar Wilde, and the French Decadents.
In particular, Wilde's *Portrait of Dorian Gray* (which
Tanizaki translated into Japanese) inspired him to write
The Tattooer, a short story about beauty and the power
of artistic creation.[12] After moving from "metropolitan"
Tokyo (which was destroyed by the great earthquake in
1923) to "old fashioned" Osaka, however, Tanizaki took
strong interest in traditional Japanese literature and cul-
ture. Although beauty remained central to his writings, it

was now perceived via indigenous sensibilities to native material, form, color, and sound. To rediscover such sensibilities is the subject of his essay "In Praise of Shadows," an extraordinarily delicate piece of writing that contrasts, in one place, the "muddy" Japanese complexion with the harsh electrical light of the modern world: "I would call back at least for literature this world of shadows we are losing. In the mansion called literature I would have the eaves deep and the walls dark, I would push back into the shadows the things that come forward too clearly, I would strip away the useless decoration."[13]

It is important to realize that Tanizaki's distaste for modern western technology and aesthetics is itself a modern aesthetic experience, enlivened not only by his nostalgic love for traditional beauty but also by his complex responses to western literature and philosophy. Without exploring such complexity we cannot truly appreciate his work, nor be able to understand the broadening significance of western art, literature and philosophy in the twentieth century, which had come to provide both models and targets for a world engaged in the process of modernization. This role of western art, literature and philosophy in global cultural production has been intensified since Tanizaki's day. The very concepts of "indigenous beauty" and "traditional aesthetics" were rediscovered or reinvented as reactions to western prototypes.

Li Zehou's popular book, *The Path of Beauty—A Study of Chinese Aesthetics*, is one such case. *Mei*, the Chinese character for *beauty*, is often used in traditional writings to describe female (and occasionally male) attractiveness, delicious food and drink, fine materials and craftsmanship, moral and intellectual excellence, and even good politics.[14] It rarely referred to fine arts, especially literati painting that is supposed to transcend "superficial prettiness" and technical ingenuity. Nor did beauty ever become a key concept in philosophy, as important Confucian and Taoist thinkers through the ages showed little interest in connecting *mei* to metaphysical contemplation. But the character has gained a new and elevated meaning in modern Chinese to signify both fine arts and the discipline of aesthetics. The invention of two terms—*mei shu* (literally, "the technique of beauty") for fine arts and *mei xue* (literally, "the study of beauty") for aesthetics—coincided with East Asia's coming into the modern era. Instead of simply copying western models, however, the development of art and aesthetics in twentieth-century China incorporated many conflicting elements from native traditions and foreign influences to produce indigenous artistic styles and aesthetic discourses.

This short reflection on the changing meaning of "beauty" in the Chinese language provides a back-

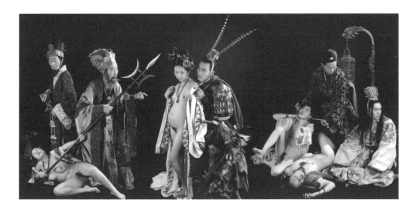

225

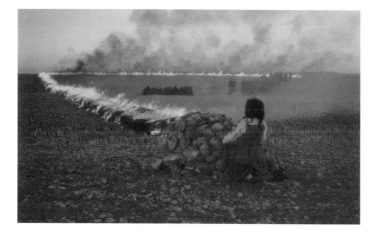

FIG. 14.12: SHIRIN NESHAT, *Passage,* VIDEO AND SOUND INSTALLATION, 2001.

ground for us to read Li Zehou's *The Path of Beauty.* One of the most important contemporary Chinese philosophers, Li was trained first as a Kantian scholar and established his reputation by elucidating Kant's writings for a Chinese intelligentsia. *The Path of Beauty* was written for a more general audience. Its purpose, as Li states, is to search for "laws" in traditional Chinese art.[15] While this goal reflects the unmistakable influence of classical German philosophy, it has also led him to find new ways to connect beauty with the Chinese art tradition. He does this by simultaneously adopting and revising Kant's aesthetic theory. Most importantly, while promoting beauty to a central position in appreciating and analyzing Chinese art, he demotes the importance of the "sublime" and in effect abandons the bipartite structure essential to the Kantian theory. He historicizes different kinds of beauty, including the "ferocious beauty" of the Shang and Zhou dynasties, the "tranquil beauty" of the Wei and Jin dynasties, and so on. It is as if Li has returned to a pre-Kantian aesthetic realm inclusively called beauty, before it was subdivided into the sublime and the beautiful.

These examples imply the widespread assimilation of and reaction to European ideas of beauty in different parts of the modern world. Through this interaction, local sensibilities of beauty have been discovered and indigenous theories of beauty have been developed. To include these sensibilities and theories in an inquiry of beauty would fundamentally change the content and logic of the field of aesthetics. A similar challenge exists in the study of modern and contemporary art. Although modern art became a global phenomenon from the late nineteenth century on, and although the many current Biennales and Triennials around the world customarily feature confederations of international artists, recent art historical scholarship on beauty often focuses exclusively on western examples. In this respect, it may not be a complete coincidence that *Regarding Beauty*, a very large and expensive exhibition celebrating the fiftieth anniversary of the Hirshhorn Museum in Washington, D.C., was organized the same year Scarry published her book. In addition

FIG. 14.13: KATARZYNA KOZYRA, THE RITE OF SPRING, VIDEO INSTALLATION, 1999-2002/2006.

to their shared significance as important signposts of the "return of beauty," the exhibition, like Scarry's discussion, framed itself within the boundaries of western art history. To be sure, the question here is not whether the exhibition should have included a broader range of international artists, but whether its coverage could realize its self-professed goal as an inquiry into "the changing nature and perception of beauty over the last four decades of the twentieth century."[17]

My discussion in this section has made it clear that such an inquiry can be realized only on a global scale (just think how closely integrated the world has become since the '60s). This exhibition will not conduct a survey of "regional" ideas and perceptions of beauty, but will explore how beauty functions as an important site for artists around the world to re-imagine and reinvent contemporary art. The principal mechanism at work is negotiation, understood as an ongoing process of "conferring with" one another.[18] It is an ongoing process because there is no longer any aim to reach a universal definition of beauty. Instead the goal is to express oneself while listening to others—to continually position and re-position ourselves.

FIG. 14.14: SHI CHONG, A PORTRAIT AT *X Day X Month X Year*, OIL ON CANVAS, 1998-1999.

CONTEXTUALIZING THE EXHIBITION

This exhibition has a number of contexts—architectural, social, and discursive—that have provided basic references for thinking through beauty's content and form. The so-called "return of beauty" is one of these contexts. While recognizing the impact of this intellectual and artistic trend in opening up new spaces in contemporary art and art criticism, I have also suggested that scholarly writings and art exhibitions in this trend have mainly been motivated by self-reflections within western aesthetics and art history. By shifting the current project from this reflective mode—from the interiority of western art and aesthetics—to a "negotiation" between different perceptions and representations of beauty, we can bring the discussion to a new level.

FIG. 14.15: CINDY SHERMAN, *Untitled #156*, PHOTOGRAPH, 1985.

This idea has prompted us to envision the exhibition as a site for artistic and intellectual exchange. The eighteen artists in the show are from fourteen countries and regions, and work in different art forms, including not only painting and sculpture but also photography, installation, multimedia art, and film. The exhibition can thus reflect on beauty's multifaceted role in today's art on a global scale. It is important to emphasize that these artists and works are not selected to typify large cultural and artistic traditions. Instead, the dialogue between them is about how individual artists from different cultural and artistic backgrounds re-imagine and re-represent beauty. Unfolding around

concepts such as the body, mythology, technology, trauma and death, transcendence, and the public space, this dialogue confronts the established notion of beauty and inspires the audience to reflect upon the relationship between beauty and artistic creation today.

Another context for the exhibition is its urban and architectural environment, which has also played an indispensable role in the conceptualization and planning of the project. Because of its location and architecture, the House of World Cultures has rich and complex meanings connected to local memories and world history. Briefly, the place

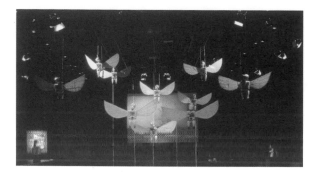

FIG. 14.17: HERI DONO, *Angels Caught in a Trap* INSTALLATION, 1996/2005.

where the House now stands was the old Unter den Zelten Square in the Tiergarten. In the seventeenth century, the square belonged to the Brandenburg Electors and was famous for its game preserves and pleasure grounds. During the March Revolution of 1848, Unter den Zelten became synonymous with the heated political debates held there. The place was decimated during World War II. Situated in the heart of Berlin's historic center, near the Platz der Republik, the Reichstag, and the Brandenburg Gate, it experienced the worst of the bomb damage of 1945, partially because Hitler's bunker lay nearby.

After Berlin was divided, the place stood in close proximity to the sector border. Partly because of this it was chosen as the location of the Congress Hall—the original name of the building that now houses the House of World Cultures. Constructed by the American government in the mid-50s at the height of the Cold War, the Hall was given strong political significance as a symbol and beacon of western democracy and freedom. Its purpose, as President Eisenhower stated in the cornerstone ceremony in 1956, was "to serve the cause of liberty and those basic human values which we are committed to preserve."[19] To ensure that this message could be delivered to the Communist world, the Hall was erected on an artificial mound so its contours could be seen clearly from the other side of the border.

FIG. 14.16: DAVID MEDALLA, *Bubble Machine*, MOVING SCULPTURE, 1963-2003.

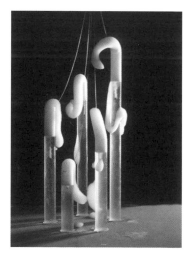

Entrusted with such propaganda functions in the Cold War environment, the Hall was also built to embody a particular notion of beauty. It was an "expression of today"[20] in both a political and aesthetic sense. Its designer, the American architect Hugh Stubbins, combined modern form, innovative structure, and state-of-the-art technology into an architectural manifesto for the freedom of thought and expression. Completed in 1957 as the U.S. contribution to the International Building Exhibition (INTERBAU), the structure had a highly unusual roof built like a dome turned inside out. Rising up dramatically to the north and south, the roof resembles a great bird with outstretched wings about to take flight. Inside the building, the roof turned into a tent of suspended cables and rods, hovering over a curved auditorium and glass-enclosed staircases. Stubbins' emphasis on "movement" was evident everywhere. As Barbara M. Lane has observed, although the building contained many functional spaces, a large amount of space was taken up by circulation areas, mainly the enormous foyer and the many ramps and stairs that connected the five levels of the build-

ing. "These interior arrangements," she wrote, "like those of the exterior plaza and its approaches, gave a visual impression of people always in motion."[21]

Nearly half a century has passed since this building was constructed. Little wreckage of wartime destruction remains in the neighborhood, and there is no longer a policed border dividing the east and west of Berlin. The Congress Hall itself has also become history, replaced by the House of World Cultures as "a leading centre for the contemporary arts and a venue for projects breaking through artistic boundaries" (FIG. 14.1).[22] The current exhibition is one such project. But in order to break new boundaries it must also respond to history and memory. It does so in two ways. The first is to engage the building in the exhibition's dialogue on beauty. The second is to extend the notion of "movement" in the building's architectural program, connecting the exhibition with public spaces beyond the architectural complex.

As introduced earlier, this building is itself an example of modernist visionary architecture and manifests a particular ideal of beauty. As such, by housing the show, it inevitably participates in the exhibition's "negotiation" with beauty. Making this potential interaction a central concept in designing the exhibition, we have commissioned large-scale public artworks for key spaces to bring the architectural context into visual interlay. One such space is the foyer. This enormous and empty space generates little visual interest in itself, partly because of its ambiguous role as a transit space *and* as a "great hall" for holding large gatherings. For the exhibition, the Taiwan-born artist Michael Ming Hong Lin covered the foyer's floor

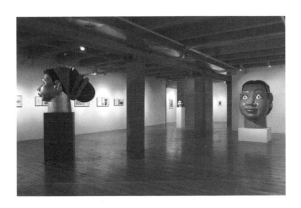

FIG. 14.18: RAVINDER REDDY, *Tera,* SCULPTURE, 2004.

with a giant mural, showing bold floral patterns in bright, vibrant colors (FIG. 14.2). The source of these patterns—Taiwanese everyday fabrics used in bedrooms—has largely gone out of fashion and is disappearing from people's lives. As these patterns are magnified here to embrace people and architecture with their innocent splendor, the mural reveals the artist's attempt to preserve a local, vernacular tradition of beauty, and to transform a contemporary art institution through the intimate yet fabulous "premodern" images in this tradition.

Lin's exuberant, organic flowers contrast with Samta Benyahia's elusive window installation comprised of numerous transparent, intensely blue rosettes (FIG. 14.3). The rosette motif, known as *fatima*, is commonly seen on Andalusian-Arabic pottery and architecture. But to Benyahia, an Algerian-French artist from Constantine, the meaning of this image far exceeds an ornamental or stylistic device. Embodying wisdom and beauty in Islamic visual culture, it also has two additional significances to the artist; a multicultural symbol of cosmic order and universal harmony, and an allusion to ideal femininity—a meaning implied in the name *fatima*. With a multitude of such rosettes, Benyahia transforms the soaring glass wall of the foyer into a patterned screen, which simultaneously partitions and links the interior and exterior spaces. In seeing the rosettes people also see through them. Gentle and tranquil, the screen incorporates dichotomies and oppositions—inside and outside, masculine and feminine, light and shadow—into its own existence.

Entering the foyer, therefore, a visitor to the exhibition immediately finds himself or herself *within* a dialogue between different forms and ideals of beauty. Whereas the Chinese and Islamic floral

motifs contrast with and complement each other, they also "ne-
gotiate" with the foyer's concrete walls and columns, bestowing
visual interest on the place. Walking through the foyer above
Lin's floor-mural and below Benyahia's window-screen, the
visitor continues to explore other expressions of contemporary
beauty in various circulating spaces, in the passageway behind
the foyer (which is transformed by Rong Rong and Inri's *Mt.
Fuji* into a picture gallery, FIG. 14.4) and in the communal area
next to the cafeteria (where Lin Tianmiao's and Wang Gongxin's
fashion mannequins stand amidst images of urban ruins, FIG.
14.5). Displayed in these spaces, these expressions, in the form
of installations, videos, and photographs, guide the visitor's
movements while enriching the architectural environment.

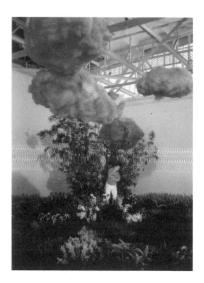

FIG. 14.19: ZHUANG HUI,
Chashan County, INSTALLATION,
2001-2002/2006.

Because we believe that a dialogue on beauty must en-
gage public spaces and the public itself, we have made a series
of decisions to extend this dialogue beyond the exhibition hall.
From this perspective, the foyer plays a unique role in connect-
ing spaces inside and outside the hall. Two groups of works have
been commissioned to further strengthen this connection. The
first group, consisting of two outdoor installations by Qin Yufen
and Zhu Jinshi, still "negotiates" with the building but from
its exterior (FIGS. 14.6, 14.7). Originally from China, these two artists are now Berlin residents. Their
installations use everyday materials to express their transnational experience, defying any categorical
notion of beauty. Qin Yufen, for example, stages her work in the right-side reflecting pool in front of
the House, forming a dialogue with Henry Moore's modernist sculpture to the left. On piled-up metal
stands are attached colorful plastic sheets "like clothes drying in open air." The sheets are printed with
e-mails that she has received through the internet responding to her public solicitation for comments
on beauty. The installation is accompanied by a sound piece, synthesizing music of different countries
and conversations in different languages.

Works in the second group penetrate more deeply into Berlin's urban spaces. Jens Haaning
has created artistic "trash cans" similar to those he has made for Copenhagen. Placed on the streets in
Vesterbro, Copenhagen's red light district and ethnically mixed area, the trash cans were festooned with
posters that juxtaposed a blonde pin-up girl with Arabic writing (FIG. 14.8). While no one would have
missed the sexual implications of the image, the text remained impenetrable to outsiders. Entitled *Ara-
bic Jokes*, the "jokes" he played did not just mean the content of the written passage, but also referred
to the paradoxical mixing of such "global" and "local" signs in today's world. In this exhibition, similar
"trashcans" are placed inside the House and on the street, attesting to Haaning's notion that art institu-
tions are part of a greater public space:

> The way I understand and deal with art institutions are as public spaces very much connected
> to, and part of, other aspects of culture and society. I often reflect on the art institution as a
> player in a bigger game by posing questions like: What is the political function of the art in-
> stitution in Great Britain [or we should add "Germany" or "Berlin"–Wu Hung], and to what
> extent does it function as a reflection room for different issues, for example, post colonial
> questions?[23]

230

Finally, Hans-Peter Feldmann has made a booklet for the exhibition. His first such work dated back to 1968—a tiny publication with a print run of one thousand copies. Cheaply printed with cardboard covers, the booklets were meant to be consumed, not to be cherished as individual works of art. His contribution to this exhibition is similarly unpretentious (FIG. 14.9). The images in the booklet come from his well-known "picture archive" of found images—mass-produced postcards, magazine photos, and posters—in which "beauty" is a predominant subject. The audience is free to take copies of the booklet away. In so doing, they bring the images back in the public sphere of a print culture in which the omnipresence of beauty means precisely the omnipresence of these images.

CODA: PROBLEMATIZING BEAUTY

Dave Hickey has observed the rise and fall of beauty from a broad art historical perspective. Locating beauty in the beholder's visual response to images, he argues that "the dazzling rhetorical innovations of Renaissance picture-making enabled artists to make speculative images of such authority that power might be successfully bestowed upon them, by their beholders, rather than (or at least prior to) its being assigned by the institutions of church and state."[24] Accordingly, the demotion of beauty in modern times has occurred as the power of interpreting art is transferred from beholders to institutions.

Hickey's historical vision is impressive. But in my view he has probably exaggerated the divorce between image-making and image-viewing today. The problem is that as an art historian writing in the early '90s, he still confined his observations to the domain of High Art (and responded mainly to abstract art and conceptual art), rather than venturing into the disorienting field of everyday visual culture.[25] If he had immersed himself in this area, he would have found without difficulty that representations of beauty had not been weakened in modern times, but had been much enhanced by new visual forms and technologies. Discussing beauty today, we can see more clearly how these forms and technologies—not only photography, movies, TV, and video, but also digital imaging—have strengthened the viewer's control over "images of beauty" by making these images infinitely consumable, reproducible, and disposable, and how they have taken over painting's role to become new and much more powerful vehicles of pictorial illusionism.

What all this means is that contemporary art no longer takes the direct representation of beauty as its purpose. It does not mean, however, that this art has disengaged itself from representations of beauty. In fact, to be contemporary, contemporary art must define itself through a constant communication and negotiation with various popular representations of beauty, from industrial designs to commercial advertisements, and from political propaganda to pornography. There are plenty such examples; (the names Andy Warhol, Gerhard Richter, and Robert Mapplethorpe instantly jump to mind). Instead of offering unproblematized "beautiful images," contemporary artists turn such images into critiques of beauty. Haaning's and Feldmann's works in this exhibition support this observation. Their citations of popular images of beauty create ruptures in the reproduction and circulation of these images, thereby reinvesting them with new, rhetorical meaning.

FIG. 14.20: NAM JUNE PAIK, *Moon Is the Oldest Television*, VIDEO INSTALLATION, 1965-1967.

Generally, all the artists in the exhibition problematize beauty in their works from different angles. Thus, these works naturally transgress the conventional boundaries of beauty, and completely ignore the Kantian dichotomy between beauty and the sublime. Some of the artists, such as Matthew Barney and Liu Zheng, make art history a subject for deconstruction and reconstruction (FIGS. 14.10, 14.11). Others, including Shirin Neshat, Katarzyna Kozyra, Shi Chong, and Cindy Sherman, redefine the body—*the* traditional site of beauty in western art—through individualized languages, references, and points of view (FIGS. 14.12-14.15). The domination of technology becomes another focus for reflecting on beauty. David Medalla's *Bubble Machine* betrays the allure of fashion and high-tech, but also demonstrates the alienation of the self brought about by technological advances (FIG. 14.16). Heri Dono animates his *Angels Caught in Trap* with techniques from a "pre-computer" era (FIG. 14.17). Different views toward feminine beauty are found in works by Ravinder Reddy and Zhuang Hui: while Reddy's larger-than-life sculptures turns an ordinary woman into a goddess (FIG. 14.18), Zhuang's narrative installation shows the fragility of beauty in contemporary life (FIG. 14.19).

Contestation and negotiation can also be initiated by the artist toward himself or herself, as exemplified by Nam June Paik's 1996 *Moon is the Oldest Television*, a work consisting of two sections that the artist created thirty years apart (FIG. 14.20). Significantly, Paik makes no effort to harmonize the two parts. Instead, he contrasts the earlier section—a series of still, tranquil images of the moon reflected on television screens—with a new perception of beauty. In the added section, two video projections conjure up a slow-moving Moon goddess next to a female Korean dancer performing an exuberant drum dance. Here, Paik seems to have rediscovered or have reinvented anthropomorphic images of beauty in Korean culture and mythology. Putting the two parts together, however, he rejects the technique of displacement by bringing them into a dialogue that problematizes both.

This exhibition, therefore, no longer defines beauty as a property or quality of works of art, or as the spectator's sensory responses to "beautiful images," but conceives beauty as a problematic in today's artistic creation and appreciation. Instead of offering a group of images that is readily understood as beautiful, it confronts the audience with complex artistic expressions that challenge conventional notions and representations of beauty. It is hoped that such a challenge, which may be initially puzzling and confusing, will eventually lead to communication—that the audience will be propelled to discover the role that beauty plays in the conceptualization of these works, and to think about the artists' different ideas of beauty in relation to their different backgrounds and aspirations. Probably only such an interaction between the artists and spectators can finally justify organizing such an exhibition at the beginning of the twenty-first century, for if beauty is still a viable concept in contemporary art, as this curator believes, it must prove this by posing questions and demanding answers.

Originally published in *Uber Schoneheit* (About Beauty), (Berlin: Haus der Kulturen der Welt, 2005), 18-39.

NEITHER HEAVEN NOR HOME:
REPRESENTING LANDSCAPE AND INTERIOR SPACE
IN CONTEMPORARY EAST ASIAN ART

Not long ago, when I was preparing an exhibition on the problematic of "beauty" in contemporary art, I reread Kenneth Clark's *Landscape into Art*, which traces representations of nature in European art. The narrative ends abruptly after the triumph of landscape painting in the nineteenth century, and the book's epilogue mainly reflects on the absence of nature in today's art and art criticism. In a melancholy tone, Clark writes:

> Although this faith [in landscape] is no longer accepted so readily by critical minds, it still contributes a large part to that complex of memories and instincts which are awakened in the average man by the word "beauty." Almost every Englishman, if asked what he meant by "beauty," would begin to describe a landscape—perhaps a lake and mountain, perhaps a cottage garden, perhaps a wood with bluebells and silver birches, perhaps a little harbor with red sails and white-washed cottages; but at all events, a landscape. Even those of us for whom these popular images of beauty have been cheapened by insensitive repetition, still look to nature as an unequalled source of consolation and joy. Now if this appetite is still so widespread and so powerful, have we grounds for thinking that landscape painting will continue to be a dominant form of art?[1]

Why has nature disappeared from contemporary art? Can it regain a central position in artistic representations as Clark hopes? What would such new representations look like? There are some of the issues I want to discuss in this essay.

Clark's passage surprised and inspired me both at once. I was surprised because he made such a strong claim for landscape's connection with the concept of beauty. Before reading the book, I had been under the impression that for most of western art history, the human body, especially the nude, was the unraveled site for imagining and representing beauty. I certainly did not invent this idea, which is repeated and elaborated in many learned books. Umberto Eco's popular *History of Beauty*, for example, focuses on figurative representations and only mentions nature in passing.[2]

FIG. 15.1: KANG UN, *Pure Form: Resonance*, OIL ON CANVAS, 2004.

But Clark must be correct: plenty of evidence indicates a strong relationship between nature and beauty in European art, especially after Edmund Burke (1729-1797) and Immanuel Kant (1724-1804) subdivided the aesthetic realm (which had previously been inclusively called beauty) into the sublime and the beautiful. All sorts of landscape styles were invented from the late eighteenth to nineteenth centuries to attract the eye and to stir up the mind. Simply by recalling the following names can one recognize the overwhelming importance of landscape in the formation of modern art: John Constable (1776-1837), Jean-Baptiste-Camille Corot (1796-1875), John Mallord William Turner (1775-1851), Gustave Courbet (1819-1877), Camille Pissarro (1830-1903), Claude Monet (1840-1926), van Gogh (1853-1890), Georges Seurat (1859-1891), Paul Cézanne (1839-1906), and Paul Gauguin (1848-1903). Influential art critics such as John Ruskin (1819-1900) further provided landscape images with aesthetic justification and fused them with poetic imagination. Using nature to demonstrate his concept of Typical Beauty, for example, Ruskin described a powerful storm in 1842. The account ends with this acclamation: "This and this only is in the pure and right sense of the word BEAUTIFUL."[3]

FIG. 15.2: SUDA YOSHIHIRO, *Weed*, PAINTED WOOD SCULPTURE, 2000.

I was inspired by Clark's passage because his claim for the connection between landscape and beauty potentially solves one of the questions posed earlier: Why did representations of nature decline sharply after Monet and Cézanne? Here "decline" does not mean that we are surrounded by fewer landscape images. In fact, the burgeoning tourist industry is perhaps producing more such images than any other time in human history. Rather, landscape representations have largely disappeared from "canonical" works of contemporary art and ceased to generate artistic innovation and theoretical discussion. For instance, the newest edition of *Movements in Art since 1945* contains

288 illustrations, not one of which is a landscape painting. Likewise, not even a paragraph on landscape or nature is provided in the *Theory in Contemporary Art Since 1985,* an anthology scheduled to come out in 2005.[4] Although some important contemporary artists, Gerhard Richter and Anselm Kiefer among them, have produced interesting landscape images, their effort has done little to break the silence around landscape representation in the discourse on contemporary art.

Some authors have tried to explain this silence. Clark, for one, has argued that the invention of photography must have undermined landscape painting, not only because it makes it possible for anyone to capture nature's appearance instantaneously and in minute detail, but also because it has infinitely expanded human vision beyond the world seen through the unaided eye.[5] Without ruling out this technical factor, I would also suggest that the art of landscape declined in tandem with the concept of beauty. Many scholars have noted that after the nineteenth century, aesthetics moved beyond "the science of beauty." From the early twentieth century on, incessant technical innovations came to control people's lives and their perception of the world, ushering in an age of the "technological sublime," which privileges vitality and reasoning over decorum and sentimentality. Artistic creativity is linked to energy and theory. In terms of art style, since cubism, artists have devoted themselves to all manner of aesthetic contemplation, exclusive of beauty. Some of them, like Barnett Newman, have declared that "The impulse of modern art is the desire to destroy beauty."[6]

Such iconoclastic statements have carried great weight in redefining aesthetic standards. When masterpieces of abstract expressionism, minimalism, and conceptualism fill an important exhibition of contemporary art (for example, in one critic's words, Newman's *zip* paintings guarded MOMA's 1999 *Modern Starts* "like a ghostly colossus"[7]), they vindicate the victory of abstraction over "beautiful" images of human figures and landscape.

When we turn to contemporary East Asian art, we find a situation that both conforms to and diverges from the fate of landscape representation described above. On the one hand, like their counterparts in the West, contemporary artists in East Asia have a strong avant-garde drive to subvert established norms. They are no longer interested in providing images of natural beauty in unproblematized ways, or in producing visual pleasure through the contemplation of harmonious, readily acceptable forms. In terms of medium, they have tended to reject traditional ink painting in favor of modern or contemporary forms, beginning with oil painting and moving on to installation, multimedia art, and site-

235

specific art. All these tendencies have contributed to a similar demotion of landscape painting in contemporary East Asian art.

On the other hand, this art does not exist in vacuum, but has a complex relationship linked with other art traditions in East Asia. While this relationship is often antagonistic because avant-garde artists acquire their identities from rejecting tradition art forms and from allying themselves with an international contemporary art,[8] they do not reject deep rooted local cultures and aesthetics. In fact, a common tendency among contemporary artists in China, Korea, Japan, and Taiwan has been to rediscover local cultures and aesthetics and to fuse them with contemporary visual expressions. Thus, although most of these artists consider themselves global citizens and have developed a penchant for novel, challenging art forms, they share a national cultural heritage with artists working in traditional genres. Nor should we overlook the common educational background of these two groups of artists. Many avant-garde or experimental artists were educated in art academies and started their career as ink or oil painters; only later did they abandon the brush for contemporary art forms. Conversely, painters working in traditional mediums can reinvent themselves as contemporary artists by making their works conceptual and self-reflective. There is indeed no fixed boundary separating contemporary art from traditional art genres and forms, which are still thriving in East Asia. We can thus understand why the general attitude of a contemporary East Asian artist toward traditional landscape representations is often that of a negotiation, not a negation.

Looking for new directions, an increasing number of art critics and theorists have begun to think about modern and contemporary art beyond western practices and discourses.[9] Some of them argue that the "return" of certain aesthetic concepts can potentially expand the discourse on contemporary art on a global scale.[10] Two such movements, "the return of beauty" and "the return to the real," have generated considerable debate. Although less discussed, there have also been signs for a "return of nature." For example, Richter's postcard-like landscape paintings are arousing increased attention from art historians. Earth Art and site-specific art have often been affiliated with conceptual art, but now there is a growing awareness of their relationship with landscape art.[11] A number of large exhibitions of photography and video art have focused on landscape.[12] I would propose, however, that if nature indeed returns to artistic representation and discourse, its first destination will be contemporary East Asian art. This is because East Asia has the longest and richest history of landscape art and theory, because this tradition is still very much alive, and because contemporary East Asia art is in constant interaction with this tradition.

In this light, the current exhibition can be considered a major effort in promoting this "return of nature." While its full impact is yet to be seen, the exhibition's impressive cover-

FIG. 15.4B: FAN KUAN (FL. 990 – 1030), *Travelers Among Mountains and Streams*, INK ON SILK, EARLY 11TH CENTURY.

FIG. 15.5A: JEONG SEON (1676-1759), *Mt. Diamond*, INK AND COLOR ON PAPER, DATED 1734

236

age demonstrates a strong desire to vindicate the importance of landscape not only to contemporary East Asian art but also to contemporary art in general. The rest of this essay aims to justify this effort. I want to emphasize, however, that I provide neither a comprehensive introduction to landscape representations in contemporary East Asian art nor a thorough discussion of this exhibition. A comprehensive introduction would have to cover other artists and examine the history of landscape art in the modern era. A full discussion of the exhibition must wait until the exhibition opens and many of the proposed projects are realized. Instead, I intend to use works by the artists selected for this exhibition to elucidate some major directions in landscape representations in contemporary East Asian art, as well as the relationship between such representations and those of interior space.

RESURRECTING BEAUTY IN LANDSCAPE

I began this essay by contemplating the strong bond between nature and beauty in nineteenth-century European art, and its subsequent decline in twentieth-century avant garde art and art theory. It should thus come as no surprise that a "return of nature" would be coupled with a "return of beauty." Here, beauty is defined as a sensory experience that a spectator derives from his or her communication with an image, not as an objective property or quality of works of art. The best description of this experience, I believe, is Roland Barthes' notion of *punctum*: "a kind of subtle beyond" that "stings" or "pricks" the viewer.[13] In contrast, stadium is inevitably about the rationale of an image, such as the artist's intention or a critic's contextualization.

Dave Hickey also defines beauty in terms of visual experience but from a different angle. Based on an art historical analysis, he argues that beautiful images "enfranchise the audience and acknowledge its power—to designate a territory of shared values between the image and its beholder."[14] Consequently, the avant-garde rejection of "beautiful" figures, forms, and tastes has severed a direct relationship between art and the audience: "The bond of commonality between artist and beholder is dissolved by the artist's prophetic singularity. In this restructured dynamic, the function of the beholder is to be dominated and awestruck by the work of art."[15]

To locate beauty in contemporary landscape art is therefore to find those occasions in which the beholder and an image are reconnected in a direct, spontaneous relationship. Without the mediation of art historical analyses and theoretical framing, the spectator feels instantaneously "touched" by the image and claims that it is "beautiful." In Hickey's view, this kind of response "steal[s] the in-

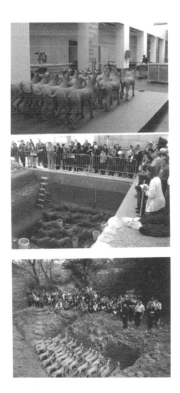

stitution's power" and reestablishes the visual images as the central factor in art appreciation. For an art critic, it means that he should put his analytical tools aside, even momentarily, and detect the power of images with the naked eye. This kind of exercise reveals the strength of some contemporary naturalistic images, including Kang Un's "sky" images (FIG. 15.1). These paintings are not large, usually about 1.6 x 1.1 meters, but they lift the viewer's spirit with an impression of infinite vastness. Their resemblance to nineteenth-century Romantic landscape is not accidental, as the artist states that what he pursues is also sublimity—to connect "plane, space, and spirituality" through the images of the sky.[16]

This statement also describes Kobayashi Toshiya's abstract photographs and Mukaiyama Kisho's minimalist paintings. Although the two artists have developed their styles along different lines, their works inspire a similar sense of quietude and introspection. Seemingly formless, these works have a delicate and even ephemeral quality, generated by shimmering light that seems to emit from within the picture plane. Critics have linked these abstract expressions with nature, and have used words like "sublimity," "purity," and "beauty" to describe them. Such comments are supported by the artists. Mukaiyama says that he feels a sense of awe before nature. Being a member of the Shingon sect of Kukai Buddhism, he characterizes the goal of his art as maintaining a spiritual peace in a humble lifestyle.

FIG. 15.6: YAMAGUCHI AKIRA, *A Journey through the Womb*, OIL AND WATERCOLOR ON PAPER, 2004.

FIG. 15.8: ZHAN WANG, *Ornamental Rock*, STAINLESS STEEL SCULPTURE, 1998.

Other contemporary East Asian artists, more inclined to problematize beauty in landscape, keep their distance from such an unironical effort to fuse nature with faith. Their question is no longer how to internalize nature spiritually, but how to reflect on the appropriation of beauty and nature in today's postmodern and materialistic soceity. Suda Yoshihiro's ironical imitations of natural forms—diminutive sculptures that transform flowers and plants into lifeless representations—show how meticulous an artist can become in this regard (FIG. 15.2). In Shon Jeung-Eun's case, an increasingly sarcastic perception of beauty characterizes the development from her 2000 *Moon Garden* at the Pusan Biennale to her 2002 *Please Don't Leave Me* at the Gamo Gallery in Seoul. In the second installation, a manufactured tropical forest resonates through a surround sound system amid islands of plastic palm trees, artificial sunflowers and lilacs, and stuffed birds—intentionally tacky plastic imitations (FIG. 15.3). But

all of these may just reflect the artist's inner dilemma, as she has confessed: "I thought of this as a kind of modern paradise. When I say *Please Don't Leave Me*, it means real beauty, not a fake one. Even though I made a sarcastic garden and river, I still want to find the real beauty in people's mind."[17]

NEGOTIATION WITH THE PAST

Fully recognizing the long tradition of landscape art in their cultural heritage, many contemporary East Asian artists have created landscape images to respond to this tradition—a past which simultaneously inspires pride and imposes a burden. In other

FIG. 15.9: MARUYAMA NAOFUMI, *east and west 2*, ACRYLIC ON COTTON, 2004.

words, in making these images their goals are not to represent an unmediated nature, but rather to reinterpret old masterpieces, to celebrate a return to archaic models as contemporary forms, and to guide people to revisit their past through new avenues.

A premise of this type of landscape representation is therefore to create a critical distance from the past, which enables artists to engage with tradition while transforming it into contemporary visual forms. Artists have been experimenting with many different methods to do so. Yoo Seung-Ho, for example, has redrawn great masterpieces in Chinese and Korean landscape art with tiny dots and letters. According to him, painting landscape in this manner "produces an echoing effect."[18] The word "echoing" seems to capture the essence of his work, in which some canonical images reemerge as faint, ghostly "echoes." Place his *Echowords* next to the original *Travelers Among Mountains and Streams by Fan Kuan* (early 11th century), for example: The solid mountain peaks in the Northern Song masterpiece have dissolved into a distant, hazy view (FIGS. 15.4A, B). Describing Fan Kuan's painting, Michael Sullivan writes: "This is not a picture to stand back from, grand as it is, but to lose oneself in. Fan Kuan's aim is to make us feel that we are not looking at a picture at all but actually standing on those rocks beneath that great cliff, until, as we gaze on it, the sounds of the world about us fade away, and we hear the wind in the trees, the thunder of the waterfall, the clatter of hooves on the stony path."[19] Yoo Seung-Ho's reworking, however, serves the opposite purpose in disengaging the spectator from such involvement. Whereas the minute letters he uses to "draw" the landscape reposition a familiar painting at the border of image and text, the titles to his works are humorous and imply the sense of play: *Yong Yong*, for example, means "you

FIG. 15.10: WU CHI-TSUNG, *Rain*, VIDEO, 2002.

would die (of teasing or embarrassment)," and *Chun, Chun* means "slow, slow" but also mimics the sound of laughing.

Song Dong and Whang Inkie are also prompted by the desire to negotiate with traditional landscape painting, but their works reveal a greater degree of tension between the past and the present. Both artists achieve this through employing contemporary visual technology. The work Song Dong proposes for this exhibition, for example, consists of videos projected on three special "screens" that resemble traditional painting scrolls. Each video restages the creation of a landscape painting in a traditional manner, but at the same time destabilizes the traditional scroll format. This double impulse to re-present and deconstruct traditional landscape art also underlies an earlier project by Song Dong. Called *Edible Landscape*, it was an elegant *bonsai* made out of "vulgar" materials from Chinese cuisine, including chicken feet and pig's feet. Mimicking a rarified landscape form in traditional art, it was eventually consumed by the audience simply as food.

FIG. 15.11: SUH DO-HO, *Gate Small*, SOFT SCULPTURE, 2003.

Like Song Dong, Whang Inkie was also trained as a painter, and his "digital *sansuhua*" (digital landscape) likewise reinterprets traditional literati paintings through modern means. Typically, he first scans a well-known landscape painting and then reformulates the computer image into an accumulation of thousands of acrylic and silicon pieces. The resulting mosaic-like composition preserves the general appearance of the original landscape, but also resonates with viewers from our digital era. His

FIG. 15.12: SUH DO-HO, *348 West 22nd Street, Apt. A, New York, NY 10011* (corridor), SOFT SCULPTURE, 2000/2001.

After "Mount Diamond," for example, appropriates the Korean National Treasure *Mt. Diamond* by Jeong Seon (1676-1759) (FIG. 15.5A). The grayscale in the original painting has been eliminated during the computer rendering process, and the new painting shows only the extreme tonalities in yellow and black (FIG. 15.5B). Whereas we have seen a similar strategy in Yoo Seung-Ho's *Echowords* (see FIG. 15.4A), Whang's "Lego landscape" has a more explicit symbolic significance, as it seems to typify the process in which a hybrid and technology-driven contemporary culture assimilates and transforms a traditional "naturalistic" art.

Hybridity and technology are again brought into conflict with traditional visual forms in Yamaguchi Akira's multipanel oil paintings. Subdivided into sections by clouds and architecture, each panel resembles a narrative *e-maki* scroll, in which actions seem to take place in a fictional machine-age Edo (FIG. 15.6). At first glance these works offer a (deliberately) misleading impression of being nostalgic, as if the painter's goal is to resurrect a bygone art genre. Looking at them closely, however, the viewer discovers endless "insertions" of contemporary images. As a re-

FIG. 15.13A: XU BING, *Background Story*,
INSTALLATION, MUSEUM FÜR OSTASIATISCHE
KUNST, BERLIN, 2004, BACK VIEW.

sult, the paintings, like pop-cultural fictions, take on complicated issues in today's Japanese society—the fascination with violence, the promises and failures of technology, and the burden of the past.

<div align="center">LANDSCAPE AS MEMORY</div>

In a general sense, each of these re-presentations of traditional landscape images dwells on collective memories—some distant images from East Asian art history resurface in the mind of a contemporary artist. Sometimes, however, an artist shuns such "ready-made" images and the issue of representation, and puts the nature of collective memory to test through the invention of a cultural mythology. Cho Duck-Hyun's mock archaeological excavation, a project he conducted in San Francisco's Asian Art Museum in 2003, is one such work. He began the project by burying a pack of life-size resin dogs in a pit behind the museum. Several months later he carried out an excavation and "discovered" the dogs (FIG. 15.7). The archaeological work was scientifically documented. The findings were then displayed in the museum, surrounded by galleries that contained genuine artifacts from Korea's past. A document accompanying the exhibition informed the audience how the dogs had traveled to America from Korea in the remote past. Integrating historical facts, local Californian lore, and pure fantasy, the story raised

FIG. 15.13B: XU BING, *Background Story*, INSTALLA-
TION, MUSEUM FÜR OSTASIATISCHE KUNST, BERLIN,
2004, FRONT VIEW.

questions about the authenticity of history and memory in the process of globalization.

If in this project Cho Duck-Hyun invented a fictional past, the Chinese sculptor Zhan Wang created a fictional future with a series of stainless ornamental rocks (FIG. 15.8). By applying a pliable sheet of steel over an ornamental rock found in a traditional garden and hammering it thoroughly, he achieves a hollowed form which reproduces every minute undulation on the surface of the original stone. The purpose, as he described when he first started the project, is to reinvent a form of traditional landscape sculpture by bestowing it with new materiality:

> Placed in a traditional courtyard, rockery satisfied people's desire to return to Nature by offering them stone fragments from Nature. But huge changes in the world have made this traditional ideal increasingly out of date. I have thus used stainless steel to duplicate and transform natural rockery into manufactured forms. The material's glittering surface, ostentatious glamour, and illusory appearance make it an ideal medium to convey new dreams [in the contemporary world].[20]

FIG. 15.14: SHU-MIN LIN, *Hypnosis No. 1*, INSTALLATION AND VIDEO, SHANGHAI BIENNALE, 2004.

We must realize that to Zhan Wang, "glittering surface, ostentatious glamour, and illusory appearance" are not negative qualities, and the manufactured rocks are not meant to be satire or mockery. Rather, both the original rockeries and his copies serve people's visual or intellectual needs. While their different materials reflect spirits of different times, their formal resemblance defines them as "sites of memory," where culture evolves through remembrance and renewal. Believing that his stainless steel rockeries most accurately represent "authentic" Chinese culture in the postmodern condition, Zhan Wang has developed a plan to replace the natural rocks in front of some important buildings in Beijing with steel copies made from them.

In striking contrast with these conceptual projects, other landscape images in contemporary East Asian art are imbued with the artists' personal memories and childhood dreams. Deeply autobiographical, these images express intimacy and innocence, and defy rational thinking and a macrohistorical narrative. One such artist is Maruyama Naofumi. Since his inclusion in the *Modest Radicalism* exhibition at Museum of Contemporary Art Tokyo in 1999, Naofumi has impressed art critics with his dreamy, mysterious paintings. Possibly owing to the long period he spent in Germany, his gentle, atmospheric landscape images betray influences of Romanticism. But the figures in the

FIG. 15.15: CHANG EUNG-BOGG, *Silence*, INSTALLATION, 2003.

FIG. 15.16: LIU JIANHUA, *Ordinary and Fragile: Map of Venice*, CERAMIC SCULPTURE, 2003.

landscape—often children drawn in a graphic style as cut-out images—are offset by pop art and comic book drawings (FIG. 15.9). In interviews he identifies these children as characters in his dreams, and hence metaphors for innocence and the self.[21] Naofumi's interests in fairytale, dream, and children are shared by Kwon Ki-Soo, whose paintings mix traditional landscape imagery with cartoon-like figures. Unlike Yamaguchi Akira's dark vision of a world full of violence and anxiety (see FIG. 15.6), however, Kwon's hybrid style and images are delightful and humorous.

INSIDE OUT, OUTSIDE IN

The modern and postmodern conditions, it is said, have caused a separation between man and nature. Nature is internalized as memories or as visual images. Consequently, the clear distinction between inside and outside, or interior and exterior space, has become increasingly vague. This section discusses three major manifestations of this phenomenon in contemporary East Asian art, all of which blur the boundaries between landscape images and representations of interior space and objects used in daily life.

1. TRANSPARENCY/TRANSLUCENCY

In Wu Chi-Tsung's *Rain* (2002), an ordinary cityscape is transformed into a work of conceptual art by an invisible object—a transparent glass window whose existence is revealed by drops of rain on its surface (FIG. 15.10). The video therefore does not

FIG. 15.17: IBA YASUKO, *Untitled*, OIL ON CANVAS, 2003.

FIG. 15.18: MICHAEL LIN, FLOOR
MURAL, TAIPEI BIENNALE.

just show an exterior space—a river, a bridge, and the city beyond—but also implies an interior space where the artist stands. It is the (invisible) glass window that brings these two architectural spaces into a single pictorial or cinematic space.

Translucency differs from transparency in its partial "see-throughness." Unlike a transparent window which can be totally or nearly invisible, a translucent wall both arrests and evades gaze. While seen, it never volunteers to leave the spectator's view, but at the same time it pretends to guide the spectator toward something else behind it. (I say "pretends" because it does not really allow the spectator to see the space behind it.) Translucency, therefore, means a double hesitation, a reluctance to make the object the viewing focus or to yield. The result is the object's partial disappearance and the viewer's lack of commitment. A translucent object or structure can thus be a perfect metaphor for memory, which bridges the past and the present with its ambiguous existence.

Such ambiguity characterizes a series of "soft structures" that Suh Do-Ho has made to replicate his living spaces, including his childhood home in Seoul and his apartment in New York (FIG. 15.11). The fabric he uses is semi-transparent, and he can literally pack an entire soft structure in a suitcase. Seoul Home is sewn in diaphanous, celadon-green silk organza. Installed in different spaces, it can drape in puddles on the floor or float like a ghost in the air. Another "soft structure," 348 West 22nd St., Apt A, New York, NY 10011, is fabricated out of grey nylon. Viewers can enter and walk through the immaterial, weightless apartment, feeling as if they are trespassing on someone else's dream (FIG. 15.12).

To Xu Bing, a translucent surface provides a means of turning a real landscape into a visual illusion. His recent installation in Berlin's Museum of East Asian Art, entitled Background Story, consisted of two spaces separated by a frosted glass screen. On one side of the screen one sees a "landscape installation": branches of pine trees, dry twigs, and piles of cotton wool are held together to form a confusing assemblage of natural materials (FIG. 15.13A). On the other side, the silhouette of the installation is discerned through the frosted glass as a two-dimensional landscape image reminiscent of an East Asian painting (FIG. 15.13B). The text on the explanation panel explains that the image re-represents a Ming Dynasty painting, Birthday Celebration in the Pin Pavilion by Dai Jin (1388-1462). Owned by the museum until 1945, this painting, together with 5,400 other works (over ninety percent of the museum's collection at the time), were taken to the Soviet Union at the end of World War II. Far from being a mere visual game, the illusory image on Xu Bing's translucent screen alludes to nature and to a missing landscape representation.

A large group of works in contemporary East Asian art employ a strategy that I call "spatial reversal." By installing a bedroom onto the ceiling, for example, Shu-min Lin instantly reverses people's perceptions and turns reality into a daydream (FIG. 15.14). Many of his holographic works—a specialty of Lin's—have the same quality. One of them, *Reincarnation*, layers as many as forty-nine images onto one hologram, generating a complex illusion in which three-dimensional images of bodies and faces disappear and reappear as the spectator changes the direction of his gaze. His 1997 *Sun Gazing* is based on a famous Chinese story about Kua Fu, a legendary figure who spent his entire life chasing the sun. The thirty-eight feet-long hologram installation guides the viewer to follow a light beam (which imitates the movement of the sun) in a sealed space, mimicking Kua Fu's heroic but uneventful journey.

Spatial reversal is also the key concept of a 2003 group project that Mukaiyama Kisho participated in. Earlier, I discussed the visual beauty of his minimalist paintings, especially the effect of "light" generated by the colored surfaces. But in this project, he and ten other artists installed their works inside a windowless container, 12 meters long, 2.4 meters wide, and 2.6 meters high.[22] No light illuminated the interior of the container; visitors were given flashlights when they entered it. The result was an "absolute interiority"—an exhibition space completely insulated from the outside.

A reversal can also be made between the public and private domains in a more abstract way. In contrast with Chang Eung-Bogg and Nara Yoshitomo, whose intimate representations of private spaces are included in this exhibition (FIG. 15.15), Lee Mingwei has designed various projects to problematize the private versus public dichotomy in spatial conception. This has been a central concept of his many experiments since the 1990s. His *Dining Project* (1997), for example, transformed a gallery in the Whitney Museum of American Art into the home of an Asian emigrant: having selected sixty guests by lottery, he invited them to the museum one at a time, where he cooked Asian food and dined with them. In his *Reflections* (1999) in Wellesley College's Davis Museum and Cultural Center, he used a mirror wall to divide a small wooden chamber into two sections. As images of the visitors in the two sections merged into a single illusory space, the installation challenged the conventional separation between private and public space.

FIG. 15.19: HAM JIN, *Untitled*, MINIATURE SCULPTURE, 2005.

These two visual strategies also destabilize conventional visual experience, but achieve this goal through the manipulation of size relationship and materiality. Artists frequently employ two methods of transforming an ordinary structure or object into a "monument," either by replacing an ephemeral material with an everlasting one, or by magnifying its proportions to overpower the human onlooker. The first approach is adopted by the Chinese artist Liu Jianhua, who has for years "eternalized" figures and everyday objects in porcelain (FIG. 15.16). Immune to time and natural elements, his cold, pristine sculptures are also exempt of human feeling. Interpreting these works in relation to China's drastic social transformation in recent years, the art critic Chang Tsong-Zung views them as "memorials" or "monuments" of a lost past:

> The loss of physical artifacts and ways of life is universal in an age as prodigiously productive as ours, but what is alarming in China's case is the rate and extent of change, and also the general belief that eradication of a legacy so carefully preserved by our ancestors is now inevitable if not the right thing to do. Many artists have commented on this phenomenon, and artworks about identity, memory, and social cohesion are now numerous in Chinese contemporary art. In the case of Liu Jianhua, his emotional tie to special memories of the past is related to his chosen material, porcelain. Through this pristine, calming material Liu connects with the history of its elegant past, while expressing his sense of hollowness and despair in face of the loss of familiar surroundings.[23]

Paintings by Iba Yasuko and Song Hyun-Sook in this exhibition exemplify the alternative method to monumentalize everyday objects through magnifying them (FIG. 15.17). But it is Michael Lin's giant floor mural that most dramatically demonstrates the effect of this visual strategy. In recent years, Lin has created many such murals, covering a space as large as nine hundred square meters with bold floral patterns in bright, vibrant colors (FIG. 15.18). The source of these patterns—Taiwanese

FIG. 15.20: MORI MARIKO, *Kumano,* GLASSPRINT PHOTOGRAPH, 1998, FULL COMPOSITION.

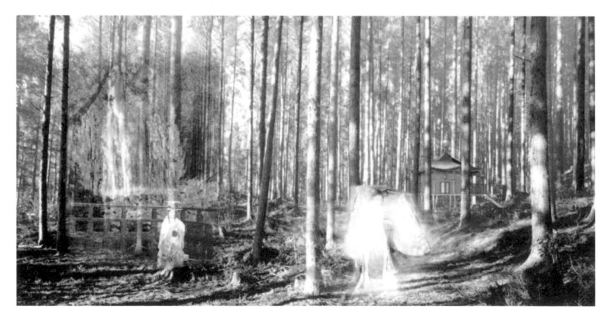

everyday fabrics used in bedrooms—has largely gone out of fashion and is disappearing from people's lives. As these patterns are magnified to embrace people and architecture with their innocent splendor, the mural reveals the artist's attempt to preserve a local, vernacular tradition of beauty, and to utilize it to create contemporary art forms in gigantic dimensions. His works are "gigantic" in two senses. The first is comparative: the word refers to the mural's extraordinary size compared to a patterned quilt. The second is perceptual: it refers to the scale of the mural from the point of an onlooker, who finds himself enveloped by the floral images, surrounded by them, and astonished by their magnificence. He thus conceives of the images as a "landscape."

Opposite to Lin's monumental painting is Ham Jin's miniature sculptures of human and animal figures (FIG. 15.19). Made of bizzare materials ranging from toothpaste, popcorn, chewed gum, dried anchovies, and cigarette butts to a kind of plastic clay called Sculpey, many figures are no larger than the tip of his thumb. They are installed in unusual places to construct social scenes and to tell stories. In his exhibition, *Aewan*, at the PKM Gallery in Seoul, for example, in one place, he arranged his tiny figures inside a gap one centimeter high, which runs between the walls and ground of the gallery's second floor. There, the figures play, are arrested, and get out of jail, narrating a series of events in a biographical manner.

Significantly, *everything* in this installation is a miniature version of a real thing—not only figures and animals, but also buildings, vehicles, and objects. We wonder why he has so painstakingly made these figures according to a uniform scale of reduction. The answer must be found in the specific artistic goals of the *miniature*. Susan Stewart has suggested that miniature images most consciously create an interior space and time in a fictional world.[24] Unlike life-size figures that attempt to map art onto life, the metaphoric world of the miniature skews the temporal and spatial relations of the everyday world. Concealed in narrow crevices, Ham Jin's miniatures constitute a world free from the natural laws of the human realm, a world of their own.

CODA: NEITHER HEAVEN NOR HOME

In conclusion, the above examples demonstrate that if there is indeed a "return of nature" in contemporary East Asian art, what is returning is not nature as an objective reality, but a nature that is internalized as memories, experiences, discourses, and fantasies. I will therefore end this essay with Mori Mariko's *Kumano*, arguably the most complex work among her impressive repertoire. The title refers to two works she created from 1997 to 1998, a video installation (*Alaya*) and a six-meter long glassprint photograph (FIGS. 15.20). The project was completed in 1999 with two architectural works, *Garden of Purification* and *Dream Temple*.

The central theme of *Kumano* is the process leading to purification. In both the video and photograph, Mori appears as a geisha or a Shinto priestess in a glowing *kimono*, inviting the spectator to follow her into a primordial forest. Huge pine trees surround a secret space and make it a magical site for transformation. There, she turns herself into an enchanted princess or a bodhisattva wearing a jeweled crown. She glides through the misty forest, making dance gestures in slow, hypnotic motion, and prays under a luminous waterfall suspended in midair. Deep inside the forest, the mysterious Dream Temple shimmers like turquoise, and promises enlightenment as the destination of the spiritual journey. A year later, Mori constructed this temple as a three-dimensional, architectural form (at the Fondazione Prada in Milan). She transformed an ancient wooden structure, the Temple of Dreams in Horyuji built in 739 A.D., into a glass building. A visitor enters the building and finds himself in a meditation chamber amidst abstract images of light. All the while the Temple changes from opaque to transparent and back again in response to his movement.

We can use many ideas articulated in this essay to explain this work. *Kumano* results from an ambitious pursuit of beauty, attained by mixing traditional art forms with hitech illusions. It resurrects memories of the past, most clearly by the artist's self-transformation into multiple images from Japanese history and religion. This is a work of contemporary art that mystifies landscape and sacralizes architecture, and that integrates ideas from East and West. Mingling kitsch and fetish, it is transparent in both concept and form. In terms of this last feature, all images—figures, waterfall, stone paths, and a row of crimson railings—appear weightless and insubstantial, like echoes lingering in the magical forest. To indicate that the photography is no more than a visual representation, the artist superimposes a long inscription written in a made-up, archaic calligraphy over the images, making the landscape an illusion conjured up behind a transparent, invisible screen.

Originally published in Kim Sunhee, ed., *The Elegance of Silence: Contemporary Art from East Asia* (Tokyo, Mori Art Museum, 2005), 150-173.

CONTEMPORARY ASIAN ART AS GLOBAL ART:
A "DIACHRONIC APPROACH"

When the Gwangju Biennale began in 1995, there were only a handful of biennales or triennials in the world, and no comparable international art events existed in other East and Southeast Asian countries. Today, however, numerous exhibitions worldwide have adopted the fashionable name "biennale." Some insist on showing contemporary art on a global scale, but many have developed more specific regional and thematic approaches, or have focused on particular art forms. The rapid proliferation of biennales and triennials is arguably most pronounced in Asia. Three other Korean biennales, for instance, are scheduled to open in September and October this year: the Busan Biennale (September 16 to November 25), the Daegu Photography Biennale (October 17-29) and the Seoul International Media Art Biennale (October 18 to December 10). China has also seen a dozen or so biennales and triennials spring up within its borders—all but one created in the last five years. The consequences of this phenomenon are two-fold. On the one hand, the term "biennale" has generally lost its original meaning as a large international exhibition held every other year to showcase the most up-to-date development in contemporary art, differing little, in the worse cases, from a commercial art fair or a government-sponsored "national exhibition." On the other hand, this situation has

prompted more adventurous curators to recapture the "experimental" spirit of a biennale by conceptualizing each event as a distinct curatorial project with specific goals, characteristics, and structures. Two common features of such "experimental" biennales are their emphasis on the symbiotic relationship with their locations, and their self-professed role in reorienting the theoretical and historical discourse on contemporary art.

FIG. 16.1: THE 6th GWANGJU BIENNALE, SEPTEMBER 2006.

FIG. 16.1: THE 6th GWANGJU BIENNALE, SEPTEMBER 2006.

These features underlie the Sixth Gwangju Biennale, whose central theme is "Asia" (FIG. 16.1). By making Asia the focus of representation and interpretation, the exhibition poses two large questions to artists, art critics, and general audiences: What is Asia at this moment of human history as seen in contemporary art? How is contemporary Asian art related to contemporary Asia?

Every educated person would agree that Asia has never been a static entity, but has constantly acquired new identities and significance throughout history. Its transformation has reached a new level in recent years: with sixty percent of the earth's population living in Asia, this largest continent currently generates the strongest economic development as well as the most dangerous religious and political tension in the world. Indeed, "What is Asia?" may well be an unanswerable question, because Asia itself defies simple perception and definition. Not only do various Asian countries have divergent cultural traditions and historical experiences, but their present and future also differ. While enthusiastic economists predict that the twenty-first century will be an "Asian century," Asia is also the site of ongoing, brutal wars that kill people and destroy homes on a daily basis.

FIG. 16.2: Michael Joe, *Bodhi Obfuscatus (Gwangju)*, interactive installation, 2006, 6th Gwangju Biennale.

Just as contemporary Asia is inseparable from international politics and the global economy, its art constitutes a crucial part of international contemporary art. But what is contemporary Asian

FIG. 16.3: ENTRANCE TO THE SECTION SHOWING WORKS BY FLUXUS ARTISTS IN THE 6TH GWANGJU BIENNALE.

art? Is "contemporary Asian art" a meaningful concept in art history and criticism? If so, then in what way or ways is this art both regional and contemporary? How is it related to global art? What is its relationship with various Asian art traditions? Once again, these are questions that do not have simple and straightforward answers. But I believe that every historian, critic and curator of contemporary art—not just Asian art specialists—should seriously consider these issues as they relate to our general understanding of global contemporary art in two ways.

First, contemporary Asian art is no longer confined to a single geographical sphere, nor is it defined by the artist's ethnicity. Not only do many "Asian artists" now live and work around the world, but non-Asian artists, including some prominent figures, have derived ideas and visual vocabulary from Asian art, religion and philosophy (FIGS. 16.2, 16.3). To artists of both kinds, Asia and its traditions do not have a given, objective existence, but must be rediscovered and individualized. Such rediscovery and individualization means active engagement: through constantly redefining Asia and its cultural heritage, these artists also constantly discover themselves and enrich contemporary art in general. Second, people are accustomed to thinking of European art as a "global" art tradition because its styles and techniques have been used by artists from different places to

FIG. 16.4: A VIEW OF THE LAST CHAPTER, 6th GWANGJU BIENNALE.

express their feelings and experience. However, a similar international dimension in Asian art and culture has been ignored, even though it has been penetrating both contemporary art and popular visual culture on a global scale. As globalization continues to intensify, such cultural crossings—not just from West to East but also from East to West—will undoubtedly play a greater role in the general development of contemporary art.

§

These basic characteristics of contemporary Asian art formed the basis for the bifurcated structure for the Sixth Gwangju Biennale. Entitled *Fever Variations*, the Biennale consists of two "Chapters" presenting and interpreting contemporary art from complementary perspectives, one synchronic and the other diachronic. Taking a synchronic approach, "The Last Chapter" ("Trace Route: Remapping Global Cities") examines the notion and reality of the city, tracking changes and mapping global simultaneity not only on routes across Asia, Middle East, North America, Europe and Latin America, but also inter-continentally (FIG. 16.4). "The First Chapter" ("Trace Root: Unfolding Asian Stories"), for which I served as Chief Curator, takes the diachronic approach to showcase new developments in contemporary art from an Asian perspective. It should be empha-

FIG. 16.5: DINH Q. LÊ, *The Headless Buddha*, INSTALLATION CONSISTING OF A SCULPTURE AND A LIGHBOX, 1998.

sized that this "diachronic approach" differs fundamentally from the "evolutionary approach" of art forms and styles, which characterizes the conventional master narrative of contemporary art based on a Western model. This part of the 2006 Gwangju Biennale self-consciously questions the legitimacy of this narrative in describing and interpreting non-Western contemporary art. Rather than producing another regional variation (even a "counter version") of the Eurocentric narrative of contemporary art, the curatorial team has deliberately abandoned the "standard" structure and elements of this narrative, such as chronology, stylistic evolution, and the genealogy of artists and schools. Instead, we have tried to define the concepts and paradigms which have been most essential to contemporary artists' perceptions and imaginings of Asia. Based on a survey of works (by both Asian and non-Asian artists) that embody this approach, we identified four major topics which enabled us to organize our selections within a thematic network.

Displays in the first section, entitled "Myth and Fantasy," reflect the artists' individual rediscovery and re-fashioning of ancient myths, religious themes and sha-manistic rituals. Fascinated by a mythical time and space before history, these artists have conducted these projects as a means of developing a dynamic dialogue with Asian cultural roots. Although several works in the section employ images of the Buddha, each reflects upon a different aspect of the Asian experience. Dinh Q. Lê, for example, was born in Vietnam in 1968 and immigrated with his family to the United States at the age of ten. As a child in Vietnam, he had watched his aunt weave traditional grass mats. Employing this traditional technique, many of his early works done in California were "photo-weavings" resembling mosaics. Underlying these images was a desire to invent individualized cultural myths, as he explains: "By interweaving self-portraits and historical and mythological images from both cultures, I dissect existing histories to create new mythologies."[1] *Headless Buddha*, his work in the Biennale, is more specifically a commentary on the destruction and survival of traditional Asian culture, and on the conflict between local religious practice and global art collecting (FIG. 16.5). In an interview, Lê recalled how he had been struck by the "rows and rows of headless Buddha statues" at Angkor Wat, whose heads had been chopped off by looters and had ended up in famous museums in the West. Yet the local people have continued to worship a severed Buddha, honoring the image with fresh lotus flowers. "In my instal-

FIG. 16.6: WHANG INKIE, *An Old Breeze-Southern Province*, MAGNET ON HOLOGRAM FILM, 2006, 6TH GWANGJU BIENNALE, 2006.

FIG. 16.7A: XU BING, *Background Story II*, MIXED MEDIA INSTALLATION, 6TH GWANGJU BIENNALE, FRONT VIEW, 2006. THIS INSTALLATION IS INSPIRED BY THE GWANGJU MASTER HUH BAEK-RYUN'S 1947 RENDITION ENTITLED *Landscape after Rainfall.*

FIG. 16.7B: XU BING, *Background Story II*, MIXED MEDIA INSTALLATION, 6TH GWANGJU BIENNALE, BACK VIEW, 2006. THIS INSTALLATION IS INSPIRED BY THE GWANGJU MASTER HUH BAEK-RYUN'S 1947 RENDITION ENTITLED *Landscape after Rainfall.*

lation", Lê says, "I have a lightbox with a photograph of one of the headless statues. Facing it, on a museum-style pedestal, is a concrete replica of the missing head. There seems to be a dialogue between them. The piece is ... about displacement, becoming like a self-portrait of me going back to Vietnam, looking for my former self."

The second section of "The First Chapter" focuses on the twin concepts of "Nature and Body." Here, various works in divergent media attest to multiple directions in artistic experimentation, through which their creators imbue images of nature with a strong sense of contemporaneity. Significantly, contemporary East Asian artists demonstrate an especially acute awareness of the long history of landscape art in their cultural heritage,

FIG. 16.8: KIM JONG-KU, *Mobile Landscape,* VIDEO INSTALLATION, 6TH GWANGJU BIENNALE, 2006.

and have reinvented images to respond to this tradition—a past which simultaneously inspires pride and imposes burden. However, their goals in making these images are not to represent an unmediated nature, but rather to reinterpret old masterpieces and to guide people to revisit a familiar past through new paths. The Korean artist Whang Inkie, for example, was initially trained as a traditional painter, but his "digital *sansuhwa*" (digital landscape) reinterprets literati paintings through modern means. Typically, he first scans a well-known landscape painting and then reformulates the computer image into an accumulation of thousands of

FIG. 16.9: JEAN-MARC PELLETIER, *Kemuri-mai,* INTERACTIVE SOUND/IMAGE INSTALLATION, ARS ELECTRONICA FESTIVAL, LINZ, AUSTRIA, 2004.

acrylic and silicon pieces. The resulting mosaic-like composition preserves the general appearance of the original landscape, but also resonates with viewers in our digital era. His piece, *An Old Breeze-Southern Province* in this Biennale, employs similar strategies: it transforms a traditional Korean painting into a picture made of black magnet on an enormous screen covered with a hologram film (FIG. 16.6) Compared with other landscape-inspired works in the exhibition, such as those by Xu Bing (FIG. 16.7) and Kim Jong-ku (FIG. 16.8), *An Old Breeze-Southern Province* has an explicit symbolic significance, as it typifies the process in which a hybrid and technology-driven contemporary culture assimilates and transforms a traditional "naturalistic" art.

FIG. 16.10: AKIO KAMISATO, TAKEHISA MASHIMO, AND SATOSHI SHIBATA, *Moony,* INTERACTIVE INSTALLATION, 2003/2006.

Works in the third section, "Trace of Mind," reveal the strong impact of Asian philosophy and

religion on contemporary art. In particular, Zen Buddhism and the Daoist philosophy of nature have inspired many contemporary artists to create works as spontaneous expressions of the mind. Such cultural interaction has already characterized earlier avant-garde movements such as Fluxus, but it has gained additional strength from new technological inventions. Three new-media works in this section are good examples of this ongoing trend. In an extremely austere manner, Jean-Marc Pelletier from Canada centers his sound installation *Kemuri-mai* on the image of burning incense. Responding to the movement (and even breathing) of the audience, the smoke rising from the incense sways, scatters, and twists, becoming a "smoke dance" that further produces

FIG. 16.11: SHU-MIN LIN, *Inner Force*, INTERAC-TIVE INSTALLATION, 2005.

a sonic landscape (FIG. 16.9). Whereas this work embodies Zen aesthetics, the digital installation *Moony* by Japanese artists Akio Kamisato, Takehisa Mashimo, and Satoshi Shibata is inspired by the famous fable about "dreaming of being a butterfly" by the Daoist master Zhuangzi (CA. 370-CA. 280 BCE). They project images of butterflies onto water vapor (FIG. 16.10). These images interact with the audience, blurring the boundary between illusion and reality. A third work, *Inner Force* by the Taiwan artist Shu-min Lin, further erases the physical mediation between images and the mind (FIG. 16.11). He attaches sensors to the participants' heads which measure the alpha wave activity of the brain. In response to the brainwaves, images emerge on the glass screen, transform, and finally disappear.

The last section, "Past in Present," reflects upon the complex relationship between tradition and reality. Instead of representing history and memory as given facts, the artists actively examine the intricate mixture of past and present. As a result, their representations of Asia are complex and energizing—images that challenge conventional views of this vast space. The Chinese artist Song Dong's enormous installation, *Waste Not*, aims not only to activate memories, but also to transform them into contemporary experience (FIG. 16.12 A, B). The numerous pieces of "waste" here—used bottles, shoes, plastic bags, boxes, toys, utensils, furniture, and even the timber frame of a demolished traditional house—are from

FIG. 16.12A: SONG DONG, *Waste Not*, INSTALLATION, BEIJING-TOKYO ART PROJECTS, 2006.

the possessions of his mother Zhao Xiangyuan, who has over several decades collected such junk for its potential usefulness. Viewers who have lived through difficult times easily hear echoes of history in these mundane objects, but a nostalgic response is not the artist's purpose. Instead, he created this installation to facilitate three kinds of transformation. First, the project redefines "waste" as "art." Second, it transforms an ordinary woman into an artist. Finally, it changes Song Dong's relationship with his mother, as they now form a partnership in creating contemporary art. In so doing, *Waste Not* finds meaning in bridging memories of the past with artistic experience of the present.

This "First Chapter," therefore, does not

FIG. 16.12B: SONG DONG, *Waste Not*, INSTALLATION, 6TH GWANGJU BIENNALE, DETAIL, 2005/2006.

formulate hard-and-fast answers to the question: "What is contemporary Asian art?" Rather, works respond to this question in various ways from the artists' points of view. As a whole, therefore, the chapter explores the artists' active dialogue with history and memory, and highlights their reactions to social and political issues related to contemporary Asia. Instead of producing a "counter narrative" of the prevailing chronicle of modern and contemporary art, we hope that this part of the Biennale will open up new spaces for historical imagination. Through intersecting with a synchronic section that focuses on global networking and information technology, such a diachronic dimension adds three-dimensionality to a presentation of today's art.

Originally published in *Gwangju Biennale 2006: Fever Variations I* (Gwangju: Gwangju Biennale, 2006), 21-30, and *Orientations* 37.6 (September 2006), 79-84, with revisions.

CODA

DE-FLATTENING "REGIONAL" CONTEMPORARY ART

Twelve years ago, fourteen "avant-garde" Chinese artists marched into the 45ᵗʰ Venice Biennale. Prompted by a fanfare of news reports in popular art magazines, that moment announced the official entrance of contemporary Chinese art into the global space, and also introduced a paradox that has been associated with this type of Chinese art to this day. This paradox, if I can summarize it in a single sentence, is that although in general perception contemporary Chinese art must be in some essential way connected to China (so it can be recognized as "Chinese"), it must also acquire independent agency in order to enter the Global Salon. The impact of this paradox is complex and transcends simple value judgment. In the rest of this talk, I will reflect upon some aspects of this paradox for two purposes: first, it may help clarify the murky entanglement between so-called "international" contemporary art and various brands of "regional" contemporary art—not only contemporary Chinese art, but also contemporary Indian art, contemporary Iranian art, contemporary Korean art, and so on. Second and more practically, this reflection responds to a repeated challenge in curating multi-national exhibitions, namely, that of retaining the authenticity of non-western contemporary art, instead of "flattening" it to suit a preexisting art historical narrative and exhibition mode.

Here "flattening" means simultaneous conflation and growth: depth is turned into horizontality; events and representations are reconfigured into lateral networks and synchronic relationships. Such transformation has its liberating effects, to be sure. One startling example is the rapid multiplication itself of biennales and triennials—even China has seen a dozen or so such exhibitions within its borders, all created in the past five years except for one. Organized and sponsored by provincial and municipal governments, official art institutions, private companies, philanthropists, and independent curators and artists, these events have only one thing in common: their emphasis on global connections and their penchant for being contemporary. As such, they merge into an international system of art and commerce, to which they contribute heightened excitement and anxiety, generated not so much by the art itself but by the unprecedented transformation of an enormous country and its 1.3 billion people.

Regardless of where a multi-national exhibition is held, in Venice or Shanghai, it easily "flattens" the historical dimensions of a regional contemporary art through a simultaneous process of decontextualization and recontextualization—a process that resembles the act of collecting. The contemporaneity of a regional art is redefined as a suspended moment outside any historical narrative. In the case of contemporary Chinese art in such settings, while it is reframed within a global context, it nevertheless cannot be "inserted" into the existing history of modern and contemporary art because of its specific timing, inspirations, criteria, and contexts. This dilemma has further led to a particular perception of individual artists: because most non-western artists are automatically associated with their countries or regions, they too have become suspended. This is why those truly original artists actually suffer most from this perception: even though their works appear in numerous international exhibitions, they disappear in standard histories of contemporary art or are grouped into a separate, minor chapter.

Multi-national exhibitions also easily "flatten" the political dimensions of regional contemporary art. Although in the West, the avant-garde as a historical movement belonged to the past, in the domestic sphere of many Third World countries, the concept of "contemporary art" still often signifies social experiments that aspire to challenge established art institutions and systems. In China during the '90s, for example, new art forms such as installation, performance, and site-specific projects conveyed a strong social message to subvert established norms. This significance largely disappears when experimental Chinese works are displayed in international exhibitions that feature endless installations and multi-media works. The new exhibition venues thus should be thought of as a means of *translation*—something that reconstructs old definitions and regenerates new meanings—and should also be identified as new sites of art production and circulation. As such sites, biennials and triennials not only commission works for an international audience, but also channel "regional artists" into a global socioeconomic network. It was precisely in the early '90s, around the 45th Venice Biennale, that contemporary Chinese artists first became a global commodity, promoted by transnational commercial galleries and auction houses, and collected by foreign collectors and museums.[2] Today, when contemporary Chinese artists travel to almost every important international exhibition, the commercialization of their works has also reached a critical point.

These reflections lead to a practical, curatorial issue: How to "de-flatten" regional contemporary art in a multi-national exhibition? As the curators of such exhibitions, it is natural for us to search for the best artists and the newest works to realize a given curatorial project. My earlier reflections, however, raise questions about the implications of this practice in displacing, decontextualizing, and appropriating "regional" artists and their works. These questions cannot be answered by means of cultural preservation—the interaction of contemporary art in a global space is an irreversible trend and must constantly produce new meaning. To respond to these questions productively, we need to reflect upon the existing models of multi-national art exhibitions; the goal is to bring artists from different parts of the world into a genuine artistic and intellectual exchange.

This goal is idealistic but not utopian. Many efforts can be made; a primary one would be to reintroduce the notion of "depth" into a multi-national exhibition. This is the principal intention of the 2006 Gwangju Biennale in Korea, for which I am serving as a curator (see "Contemporary Asian Art as Global Art" in this volume). To realize this goal, this exhibition situates artists at the juncture of synchronic and diachronic dimensions of contemporary art. The "diachronic dimension" is defined as artists' dialogues with histories and memories, and as their responses to previous aesthetic and visual languages. Since such dialogues and responses constitute important aspects of contemporary art in general and transcend regional boundaries, what unites or separates artists will be their artistic aspirations and strategies, not their birthplaces, residency, or ethnicity. The show will

not produce a "counter narrative" of the prevailing chronicle of modern and contemporary art, but will hopefully open up new spaces for historical imagination.[3] Intersecting with a "synchronic" section that focuses on global networking and information technology, this diachronic dimension will add three-dimensionality to a presentation of today's art.

Originally presented at the conference "Where Art Worlds Meet: Multiple Modernities and the Global Salon," held in Venice in December 2005.

NOTES

1

RUINS, FRAGMENTS, AND THE CHINESE MODERN AND POSTMODERN

1. Michel Baridon, "Ruins as a Mental Construct," *Journal of Garden History*, VOL. 5, NO. 1 1985: 84-96; quote from 84.

2. Alois Riegl, "The Modern Cult of Monuments: Its Character and Its Origin." 1903. Trans. K. W. Forster and D. Chirardo. In K. W. Forster, ed., *Monument/Memory, Oppositions* special issue, 25 (1982): 20-51.

3. I did this research for my paper, "Ruins in Chinese Art: Site, Trace, Fragment," which I delivered to the symposium "Ruins in Chinese Visual Culture" held at the University of Chicago on May 17, 1997.

4. Alois Riegl, "The Modern Cult of Monuments," 31-34.

5. Stephen Owen, *Remembrances: The Experience of the Past in Classical Chinese Literature* (Cambridge, Mass.: Harvard University Press, 1986), 2.

6. The meaning of such projects changed when Huang Yong Ping continued them outside China. For example, in 1991 at the Carnegie Library at Pittsburgh, he showed "book ruins" made from hundreds of old art journals which he had soaked and put through a mincer. Divorced from the Chinese context, this project simply expressed his own negation of "book knowledge."

7. Craig Owens, "The Allegorical Impulse: Toward a Theory of Postmodernism," in Brain Wallis, ed., *Art After Modernism: Rethinking Representation* (New York: The New Museum of Contemporary Art, 1984), 204.

8. See Fredric Jamerson, "Postmodernism, or the Cultural Logic of Capital," *New Left Review*, 146 (July/August 1984).

9. Hou Hanru, "Towards an 'Un-Unofficial' Art: De-ideologicalization of China's Contemporary Art in the 1990s," *Third Text*, 1997, 50.

10. See Ibid.

11. Quoted from Li Xianting, "Pingmian er shuli di richang jingguan: Zeng Hao zuopin jiqi xiangguan huati" (Flat and detached scenes in ordinary life: Zeng Hao's work and some related topics, in *Zeng Hao* (Beijing: Zhongyang meishu xueyuan hualang, 1996), 1.

2

A CASE OF BEING CONTEMPORARY

1. The need to develop a "polycentric perspective to describe a polycentric situation" in studying industrial relationships is addressed in Peer H. Kristensen and Jonathan Zeitlin's new book, *Local Players in Global Games: The Strategic Constitution of a Multinational Corporation* (Oxford: Oxford University Press, 2004), 1-23.

2. I pursue this understanding not only through research and writing but also through actual intervention, mainly organizing exhibitions and discussions in multiple geographical and cultural spheres. For example, I have organized several exhibitions of contemporary Chinese art outside China. Some of these exhibitions introduced this art to a global audience (e. g. *Transience: Experimental Chinese Art at the End of the Twentieth Century* and *Between Past and Future: New Photography and Video from China*). Others focused on particular issues such as the meaning of art mediums, cross-cultural communication, contemporary aesthetics, or censorship (e. g. *Canceled: Exhibiting Experimental Art in China, Visual Performance: Five New-media Artists from Asia, Intersection: Contemporary Photography and Oil Painting from China,* and *About Beauty*). My three major exhibitions in China have taken place in different spaces, including a large public museum (*The First Guangzhou Triennial*), a non-exhibition space (*Tui-Transfiguration*), and a commercial gallery (*Tobacco Project: Shanghai*).

3. For a brief discussion of the applications of these two terms to contemporary Chinese art, see Wu Hung, "Introduction: A Decade of Chinese Experimental Art (1990-2000)," in Wu Hung, ed., *The First Guangzhou Triennial: Reinterpretation: A Decade of Experimental Chinese Art, 1990-2000* (Guangzhou: Guangdong Museum of Art, 2002), 11-12. Here I use them interchangeably in referring to the kind of new Chinese art discussed in this paper.

4. Lü Peng and Yi Dan, *Zhongguo xiandai yishu shi 1979-1989* (A history of modern Chinese art 1979-1989), (Changsha: Hunan meishu chubanshe, 1992).

5. Lü Peng, *Zhongguo dangdai yishu shi, 1990-1999* (A history of contemporary Chinese art; 1990-1999), (Changsha: Hunan meishu chubanshe, 2000).

6. For example, Gao Minglu, a key organizer of the avant-garde movement in the 80s, describes this movement in humanist terms. See his *Zhongguo dangdai meishu shi, 1985-1986* (A history of contemporary Chinese art: 1985-1986) (Shanghai: Shanghai renmin chubanshe, 1991).

7. See, for example, Gao Minglu, "From Elite to Small Man: The Many Faces of a Transitional Avant-Garde in Mainland China," in idem, ed., *Inside Out: New Chinese Art* (San Francisco and New York: San Francisco Museum of Modern Art and Asia Society Galleries, 1998), 149-66; especially, 154-56.

8. Li Xianting, "Major Trends in the Development of Contemporary Chinese Art," in Chang Tsong-zung, ed., *Chinese New Art, Post-1989* (Hong Kong: Hanart T Z Gallery, 1993), xx. For a short introduction to the '85 New Wave movement (85 Yishu xinchao) and its political context, see Wu Hung, *Transience: Experimental Chinese Art at the End of the Twentieth Century* (Chicago: Smart Museum of Art, 1999), 17-22. For a detailed documentation and analysis of this movement, see Gao Minglu, *Zhongguo dangdai meishu shi*, 1985-1986.

9. This exhibition is known in English as *China/Avant Garde*, a name fabricated later for the convenience of a foreign readership. For an introduction to the exhibition, see Lü Peng and Yi Dan, *Zhongguo xiandai yishu shi, 1979-1989*, 325-53.

10. As in the West, these two terms are often used interchangeably by Chinese artists and critics. But in China, such mixed uses became especially frequent from the late '80s to the early '90s. Toward the mid and late '90s, however, "contemporary art" clearly became the term for new Chinese art.

11. Lü Peng and Yi Dan, *Zhongguo xiandai yishu shi, 1979-1989*, 2-4; quotation from 4.

12. A representative book is Lang Shaojun's *A Discussion of Chinese Modern Art (Lun Zhongguo xiandai meishu)* (Nanjing: Jiangsu meishu chubanshe, 1988), which starts from the introduction of western art to China and ends with the '85 Art New Wave.

13. Entitled *China's New Art, Post-1989*, this show opened in January 1993 in Hong Kong and subsequently traveled throughout the world for several years.

14. Chang Tsong-zung, "Into the Nineties," in idem, ed., *China's New Art, Post-1989*, I-VII; quotation from I.

15. Lü Peng and Yi Dan, *Zhongguo xiandai yishu shi, 1979-1989*, 4.

16. I have discussed such domestic experimentations in greater detail in "Contemporaneity in Contemporary Chinese Art," forthcoming.

17. See Wu Hung, *Transience: Experimental Chinese Art at the End of the Twentieth Century*, 79-126.

18. I have discussed "experimental exhibitions" in a number of places, including *Exhibiting Experimental Art in China* (Chicago: Smart Museum of Art, the University of Chicago, 2000); "Experimental Exhibitions' of the 1990s," in *The First Guangzhou Triennial: Reinterpretation: A Decade of Experimental Chinese Art, 1990-2000*, 83-97; and "Tui-Transfiguration: A Site-Specific Exhibition at Factory 798," in Wu Hung, *Rong Rong and inri: Tui-Transfiguration* (Hong Kong: Timezone 8, 2004), 8-43.

19. Fourteen Chinese artists participated in this Venice Biennale, including Wang Guangyi, Zhang Peili, Geng Jianyi, Xu Bing, Liu Wei, Yu Hong, Feng Mengbo, Yu Youhan, Li Shan, Wang Ziwei, Ding Yi, Sun Lang, and Song Haidong. For introductions to contemporary Chinese art in mainstream art journals in the West, see Lauk'ung Chan, "Ten Years of the Chinese Avant-Garde, Waiting for the Curtain to Fall," *Flash Art* 25, no. 162 (January/February 1992), 110-14; and Andrew Solomon, "Their Irony, Humor (and Art) Can Save China," *New York Times Magazine*, December 19, 1993, 42-72.

20. Some of these works are created by, among others, Xu Bing, Cai Guo-Qiang, Huang Yong Ping, Chen Zhen, Wenda Gu.

21. One such exhibition is *Between Past and Future: New Photography and Video from China*, which I recently co-curated in New York and Chicago. It includes a section called "Reimagining the Self." The explanations in the galleries tend to emphasize this significance of the images.

22. One example is the Beijing artist Yin Xiuzhen, who has created a series of "suitcases" with fabric representing a dozen or so cities around the world where she has shown her work. Ironically, all these miniature cities look alike. Instead of representing reality, here Yin expresses her experience as a global traveler.

23. For Zhang's works, see Mathieu Borysevicz, ed., *Zhang Dali: Demolition and Dialogue* (Beijing: Coutyard Gallery, 1999). For a discussion of his site-specific project called *Dialogue*, see Wu Hung, "Zhang Dali's *Dialogue*: Conversation with a City," *Public Culture* 12.3 (2000), 749-68.

24. Leng Ling, *Shi wo* (It's me), (Beijing: Zhongguo wenlian chubanshe, 2000), 168.

1. Entitled *Reinterpretation: A Decade of Experimental Chinese Art (1990-2000)*, the First Guangzhou Triennial was held in 2002 at the Guangdong Art Museum in Guangzhou. Wu Hung was the exhibition's Chief Curator. Other curators included Wang Huangsheng (director of the museum), Feng Boyi, and Huang Zhuan.

2. Two versions of the catalogue, one in Chinese and one in English, were produced. Both edited by Wu Hung, the English version has the title *The First Guangzhou Triennial: Reinterpretation: A Decade of Experimental Chinese Art (1990-2000)*, co-published by the Guangdong Museum of Art (Guangzhou) and Art Media Resources, Ltd. (Chicago) in 2002.

3. The authors of these essays include Zhu Qi, Yi Ying, Karen Smith, Wu Meichun, Qiu Zhijie, Liao Wen, Yin Shuangxi, Pi Li, Wu Hung, Britta Erickson, Zhang Zhen, Chris Berry, and Wu Wenguang. See *The First Guangzhou Triennial: Reinterpretation: A Decade of Experimental Chinese Art (1990-2000)*, 20-138.

4. For these different opinions, see Bonnie S. McDougall, *The Introduction of Western Literary Theories into Modern China* (Tokyo, 1971), 196-213; Gao Minglu, "Toward a Transnational Modernity," in idem., ed., *Inside Out: New Chinese Art* (San Francisco and New York: San Francisco Museum of Modern Art and Asia Society Galleries, 1998), 15-40; Norman Bryson, "The Post-ideological Avant-garde," in ibid., 51-58.

5. For example, the art critic Gao Ling characterizes some major installations and art happenings in China as "experimentations without ideology." Gao Ling, "Zouchu pinmian di zhuangzhi yishu—jiushi niandai di shiyan yishu" (Three-dimensional installations—Chinese experimental art in the 1990s), *Xiongshi meishu* No. 297 (November 1995), 62. In my interviews with various artists from 1997 onward, they have frequently referred to their works as "*shiyan yishu*" (experimental art).

6. Renato Poggioli, *The Theory of the Avent-Garde* (Cambridge, Mass.: Harvard University Press, 1968), 131-37.

7. The rising field of "border studies" has produced many scholarly works. For some recent theoretical reflections on the basic concepts and issues related to "borders," see Scott Michaelsen and David E. Johnson, ed., *Border Theories: The Limits of Cultural Politics* (Minneapolis: University of Minnesota Press, 1997).

8. J. A. Gurpegui, ed., *Alejandro Morales: Fiction Past, Present, Future Perfect* (Tempe, Ariz.: Bilingual Review, 1996), 86-98.

9. The most detailed account of this art movement is provided by Gao Minglu's *Zhongguo dangdai meishu shi 1985-86* (A history of contemporary Chinese art; 1985-86), (Shanghai: Shanghai renmin chubanshe, 1991).

10. For a more detailed discussion about this "information explosion" and its impact, see my essay "A Case of Being Contemporary" in this volume.

11. In September 1986, for example, a number of groups in Nanjing organized a joint activity called "Baking under the sun" (*Shai taiyang*). More than 100 young painters, sculptors, and performing artists gathered in the Xuanwu Lake Park to show their recent works and to stage art happenings. The slogans of the activity included "The sun is the only energy source which cannot be polluted; the sun is just about to break through the clouds." The next month, many artists traveled to Nanjing from other cities, and in October 5th more than 1,000 of them appeared in the park. This kind of spontaneous gathering also appeared in other cities.

12. See, for example, Gao Minglu, "From Elite to Small Man: The Many Faces of a Transitional Avant-Garde in Mainland China," in idem, ed., *Inside Out: New Chinese Art*, op. cit., 149-66; especially, 154-56.

13. Li Xianting, "Major Trends in the Development of Contemporary Chinese Art," in *China's New Art, Post-1989* (Hong Kong: Hanart TZ Gallery, 1993), 5-22.

14. Zhang Zhen, "Building on the Ruins: The Exploration of New Urban Cinema of the 1990s," in this volume.

15. Andrew Solomon, "Their Irony, Humor (and Art) Can Save China," *New York Times Magazine*, December 19, 1993, 42-72.

16. See Wu Hung, "The 2000 Shanghai Biennale: The Making of a Historical Event," *Art AsiaPacific* 31 (2001), 41-49; reprinted with minor changes in Wu Hung, ed., *Chinese Art at the Crossroads: Between Past and Present, Between East and West* (Hong Kong: New Art Medium, 2001), 275-85.

17. Preface *Shanghai Biennale 2000*, exhibition catalogue (Shanghai Art Publishing house, Shanghai, 2000).

4
—
THREE THEMES OF EXPERIMENTAL CHINESE ART IN THE 90S

1. "Everyday Sightings: Melissa Chiu interviews the Chinese artist Wang Youshen," *Art AsiaPacific* 3.2 (1996), 54.
2. Sui Jianguo's letter to the art critic Gu Zhenfeng, provided by the artist.
3. Shen Jingdong, *100 ge yishujia miankong* (Faces of 100 artists), 2001. Private publication.
4. Dana Friis-Hansen, "Towards a New Methodologyin Art," in idem, et al., *Cai Guo-qiang* (London: Phaidon, 2002), p. 80.

5
—
REINVENTING BOOKS IN CONTEMPORARY CHINESE ART

1. "读万卷书，行万里路，胸中脱去尘浊，自然丘壑内营，立成鄞鄂。随手写出，皆为山水传神矣。" Dong Qichang, *Huachanshi suibi*. Baorentang edition, 1753, Juan 2, "Hua jue," p. 1.
2. "不行万里路，不读万卷书，欲作画祖，其可得乎？" Dong Qichang, ibid., Juan 2, p. 21.
3. Among these painters were Huang Binhong (1864-1955), Qi Baishi (1864-1957), Pan Tianshou (1897-1971), and Zhang Daqian (1899-1983).
4. Liu Haisu, "Duobian de Laimenghu (Le Lac Lema Varie), in Shen Hu, ed., *Liu Haisu sanwen* (Three discourses on Liu Haisu) (Guangzhou: Huacheng chubanshe, 1999), pp. 76-80.
5. Yuan Hua, *Xu Beihong shengping*. Zhonghua shufa wang (Web site on Chinese calligraphy), http://www.shxw.com/ReadNews.asp?NewsID=211.
6. Michael Sullivan, *The Arts of China*, 3rd ed. (Berkeley: University of California Press, 1984), p. 253.
7. This goal, first put into practice by Gao Jianfu in pursuing a new "national painting" style in the 1910s, was later summarized by Mao Zedong in the motto: *Gu wei jin yong, yang wei zhong yong*, or "Make the past serve the present; make foreign things serve China."
8. For the definition of "experimental artists," see Wu Hung, *Transience: Chinese Experimental Art at the End of the Twentieth Century* (Chicago: Smart Museum of Art, 1999), pp. 15–16.
9. The most detailed account of this art movement is provided in Gao Minglu, *Zhongguo dangdai meishu shi, 1985–86* (Contemporary art of China, 1985–86) (Shanghai: Shanghai renmin chubanshe, 1991).
10. See Gao Minglu, "Bawu meishu yundong di 'qianwei' yishi" (The 'avant-garde' consciousness in the '85 art movement), *Xiongshi meishu* NO. 297 (November 1995), pp. 16–21.
11. Pablo J. Rico, "Xu Bing and the 'Well of Truth,'" in *Xu Bing: El Pozo de la Verdad = The Well of Truth* (May–June 2004, Sala La Gallera), (Valencia, 2004), p. 268.
12. Ibid.
13. Ibid., 267.
14. Fei Dawei, "Two-Minute Wash Cycle: Huang Yong Ping's Chinese Period," in Philippe Vergne and Doryun Chong, eds., *House of Oracles: A Huang Yong Ping Retrospective* (Minneapolis: Walker Art Center, 2005).
15. Unless otherwise noted, all the artists' opinions herein quoted are excerpted from their full statements in Wu Hung, ed., *Shu: Reinventing Books in Contemporary Chinese Art* (New York: China Institute Gallery, 2006).
16. Karen Smith cited a similar statement in her *Nine Lives: The Birth of Avant-Garde Art in New China* (Zurich: Scalo, 2005), p. 335.
17. Xu Bing places extraordinary importance on the actual making of these nonsense books. See Wu Hung, "A 'Ghost Rebellion': Notes on Xu Bing's 'Nonsense Writing' and Other Works," *Public Culture* 6, NO. 2 (Winter 1994), pp. 411–19.
18. Huang Yong Ping, "Yishu buxiang zhiwu" (Art—an inauspicious thing), cited in Gao Minglu, *Zhongguo dangdai meishu shi, 1985-86*, p. 350.
19. A good introduction to Zhang Xiaogang's psychological state in that period can be found in Smith, *Nine Lives*, pp. 260–307.
20. For Zhang's debt to Surrealism and Expressionism, see ibid., pp. 266–85.
21. Li Xianting, "Wuliaogan he 'wenge' hou de disandai yishu jia" (Boredom and Third-Generation Artists in the Post-Cultural Revolution Era) (1991), cited in Lü Peng, *Zhongguo dangdai yishushi, 1990–1999 s* (Changsha: Hunan meishu chubanshe, 2000), pp. 95–96.

22. *China's New Art, Post-1989* (Hong Kong: Hanart TZ Gallery, 1993), p. 28.

23. Called *Reading Room*, this exhibition took place in Chambers Fine Arts Gallery in New York. For a review, see Edward Leffingwell, "Hong Hao at Chambers," *Art in America* (June–July, 2004), p. 176.

24. Lü Shengzhong, "Minjian meishu de jiben gainian" (Basic concept of folk art), *Meishu* (Fine arts), 1987, NO. 10. 52.

25. Cited in Lü Peng and Yi Dan, *Zhongguo xiandai yishu shi, 1979–1989* (A History of contemporary Chinese art, 1979–1989) (Changsha: Hunan Meishu Chubanshe, 1992), p. 320.

26. Zhan Wang, "Jia shan shi" (Ornamental rock), cited in *Shoujie dangdai yishu xueshu yaoqing zhan* [The first academic exhibition of Chinese contemporary art) (Hong Kong: China Oil Painting Gallery, 1996), p. 114. A manuscript dates this writing to November 26, 1995.

27. This book no longer exists. Before the opening of the exhibition Xu Bing sprinkled it with living tobacco insects, which would gradually consume the book during the exhibition. Impossible to be collected, the book was finally destroyed by Duke University.

28. The earliest such compendium was the *Wenfang sipu* (Four compendia of objects from a scholar's studio), written by the early Song scholar Su Yijian and published in 986. Among the four compendia, two are devoted to paper and ink, respectively; the other two are about the brush and the ink stone.

29. Martina Koeppel-Yang, Introduction to Yang Jiechang's exhibition held in 2001 in the Art Museum of Hong Kong University. Manuscript provided by Koeppel-Yang to this author.

6

—

BETWEEN PAST AND FUTURE

1. See, for example, Chen Xiaoqi, "Sheying xinchao gaiguan" (An overview of the Photographic New Wave), in You Li, ed., *Dangdai Zhongguo sheying yishu sichao* (Trends in the thought of contemporary Chinese photography). (Beijing: Buoji wenhua chuban gongsi, 1989) 40–50; Bao Kun, "Sheying xinchao de fa duan – lun Siyue Yinghui" (The beginning of the Photographic New Wave—On April Photo Society), ibid, 28–39. Writing in 1989, both authors dated the beginning of this movement to 1979, when some amateur photographers in Beijing established the April Photo Society and organized the exhibition *Nature, Society, and Man*.

2. For the concept of experimental art in the Chinese context, see Wu Hung, "Introduction: A Decade of Chinese Experimental Art (1990–2000)," in Wu Hung, ed., *Reinterpretation: A Decade of Experimental Chinese Art, 1990–2000.* (Guangzhou and Chicago: Guangdong Museum of Art and Art Media Resources, Ltd.), 2002. 10–19.

3. For example, Wang Zhiping made an album called *Funeral of the Nation (Guo sang)* and presented it to Deng Yinchao. Wu Peng and Luo Xiaoyun made similar albums and presented them to her through personal connections. Li Xiaobin titled his album *A Heroic Monument (Feng bei)* and presented it to Deng Xiaoping.

4. The seven members were Wang Zhiping, Li Xiaobin, Wu Peng, Luo Xiaoyun, Gao Qiang, Ren Shimin, and An Zheng.

5. Li Xiaobin, "Yongyuan de huainian" (Forever cherishing the memory), in *Yongyuan de siyue* (Eternal April), Beijing: Zhongguo shuju, 1999, 20. About the differing accounts of the number of collected negatives, see Wu Peng, "Cong 'Si Wu' Yuandong dao *Renmin de daonian*" (From the April Fifth Movement to *People's Mourning*), ibid., 11.

6. Editorial Committee, *Renmin de daonian (People's mourning)*, Beijing: Beijing chubanshen, 1979. Of the 500 plus photographs collected in this volume, nine are film stills produced by an official film studio and three are from unidentified sources. The rest were all made by amateur photographers.

7. Li Xiaobin, "Yongyuan de huainian," 23–24.

8. According to Lu Xiaozhong, who was a member of the salon, one such "exhibition," entitled *Silver Stars (Yinxing)*, was held in the winter of 1978 in Chi's house and included close to one hundred photographs. Lu designed a poster for the exhibition. See Lu Xiaozhong, "Xingqiwu shalong" (Every Fridays Salon), in *Yongyuan de siyue* (Eternal April), 66–67.

9. There are differing accounts of the numbers of the works in the exhibition. The number cited here is based on an official report of the exhibition in *People's Daily*, April 24, 1979.

10. Preface to the "First *Nature, Society, and Man* Exhibition," cited in *Yongyuan de siyue* (Eternal April), 88–89.

11. For the audience's reactions to the exhibition, see Ren Shulin, "Yinzhan shang de wenzi" (Writings in the photographic exhibition), in ibid., 78–84; quotation from 82.

12. Li Mei and Yang Xiaoyan, "1976 nian yilai Zhongguo sheying fazhan de xingtai yu jieduan" (Trends and stages

in the development of Chinese photography since 1976), in Wang Hebi and He Shanshi, eds., *Sheying toushi—Xianggang, Zhongguo, Taiwan* (Three photographic perspectives—Hong Kong, Mainland China, Taiwan) (Hong Kong: Hong Kong Arts Centre, 1994), 13–17, especially 14.

13. Li Yingjie, "Yipi xinxing de sheyingren" (A new type of photographer), in *Yongyuan de siyue (Eternal April)*, 86.

14. *Xiandai sheying* (In Photography), NO. 1 (1984), 3.

15. *Zhongguo sheyingjia* (Chinese photographers), NO. 1 (July 1988), 63. This is not a complete list of influential photography publications at the time. Other important journals include *Gong yu ying* (Light and Shadow), *Renxiang sheying* (Portrait photography), and *Sheying zhi you* (Friends of photography).

16. For brief overviews of these conferences, see Li Mei and Wang Wenyan, "1979 nian ylai Zhongguo sheying fazhan de xingtai yu jieduan;" "Huigu yiduan wangshi, xiangshi yidai xinren. Wang Miao, Peng Zhengge, Shibaoxiu tanhualu" (An Introspection on the past events—an introduction to a new generation: A conversation featuring Wang Miao, Peng Zhengge, and Shi Baoxiu), in Wang Hebi and He Shanshi, eds., *Sheying toushi—Xianggang, Zhongguo, Taiwan,* 104–6. Some of the papers presented to these conferences were later published in two anthologies: *Dangdai Zhongguo sheying yishu sichao (The trends of thought in contemporary Chinese photography)* edited by You Li, and *Sheying yishu lunwenji (A Collection of papers on the art of photography)* (Beijing: Zhongguo sheying chubanshe, 1994). This second volume also includes a comprehensive bibliography of Chinese publications on photography from 1989 to 1994. Essays by Bao Kun, Chen Xiaoqi, and Bao Mu in the first anthology are early attempts at an historical narrative of contemporary Chinese photography.

17. Some Chinese critics have called this type of photography "new documentary photography" (*xin jishi sheying*), to distinguish it from "social realist" documentary photography promoted by the Party. According to Wang Miao, an exhibition organized by the Modern Photo Salon in 1986, entitled *Flash Back—A Decade of Chinese Photography (Shinian yishun)* marked the dominance of documentary photography. See "Huigu yiduan wangshi, xiangshi yidai xinren: Wang Miao, Peng Zhengge, Shibaoxiu tanhualu" (An Introspection on the past events – an introduction to a new generation): A conversation featuring Wang Miao, Peng Zhengge, and Shi Baoxiu), in Wang Hebi and He Shanshi, eds., *Sheying toushi – Xianggang, Zhongguo, Taiwan,* 104.

18. For an introduction to Zhu Xianmin, see Gong Zhiming, *Zhongguo dangdai sheyingjia jiedu* (Reading contemporary Chinese photographers) (Hangzhou: Zhejiang sheying chubanshe, 2002) 35-49.

19. Wang Zhiping and Wang Miao, "Xibu Zhongguo manyou" (Wandering in western China), *In Photography* (1984.3, p. 34). For the reception of their writing as a manifesto of documentary photography, see Bao Mu, "Zhongguo xin jishizhuyi sheying zhi chao" (The wave of new documentary photography in China), in *Dangai Zhongguo sheying yishu sichao* (The trends of thought in contemporary Chinese photography), 61.

20. Bao Mu, ibid., 56.

21. The most authoritative record of this project is offered by Li Xiaobin himself. See his essay, "Guanyu 'Shangfang zhe' de paishe ji qita" (About photographing 'People Pleading for Justice from the Higher Authorities' and other matters), *Lao zhaopian* (Old photos), NO. 15, 126-33.

22. This image can be compared with Dorothea Lange's *Migrant Mother*. Graham Clarke analyzes Lange's image in *The Photograph* (Oxford and New York: Oxford University Press, 1997): "In this Lange creates a highly charged emotional text dependent upon her use of children and the mother. The central position of the mother, the absence of the father, the direction of the mother's 'look,' all add to the emotional and sentimental register through which the image works. The woman is viewed as a symbol larger than the actuality in which she exists. As Lange admitted, she wasn't interested in 'her name or her history'." (153) Similarly, nothing is known about the man in Li Xiaobin's photograph.

23. For some of these exhibitions, see Bao Mu, "Zhongguo xin jishizhuyi sheying zhi chao" (The wave of new documentary photography in China), 63; "Huigu yiduan wangshi, xiangshi yidai xinren: Wang Miao, Peng Zhengge, Shibaoxiu tanhualu" (An Introspection on on the past events – an introduction to a new generation: A conversation featuring Wang Miao, Peng Zhengge, and Shi Baoxiu), in Wang Hebi and He Shanshi, eds., *Sheying toushi – Xianggang, Zhongguo, Taiwan,* 104-5.

24. For an introduction to twelve leading documentary photographers and their subjects, see Gong Zhiming, *Zhongguo dandai sheyingjia jiedu.*

25. For Gu Zheng's images of Shanghai and his pursuit of an individual style, see his *Urban Sketch* series in *In-Photography* 12-13 (1988): 34-35, and his essay "Wo de Shanghai" (My Shanghai) in the same issue, 80. For Mo Yi's photographic series *Expression of the Street*, which represent the changes in Tianjin from the late 1980s to the early 1990s, see Wu Hung, *Transience: Chinese Experimental Art at the End of the 20th Century* (Chicago: Smart Museum of Art, University of Chicago, 1999) 60-65.

26. For an inspired discussion of Zhang Haier's photographs on this subject, see Yang Xiaoyan, "Jingtou yu nüxing—kan

yu beikan de mingyun" (Camera and women—the fate of seeing and being seen), *Dushu* NO. 279 (June 2002): 3-12.

27. As an pioneer of this emerging alliance, Zhang Haier established close ties with avant-garde artist. Similar to many experimental photographers of the '90s, he was first trained as a painters and then embraced photography. His works were later published in the avant-garde "Book With a White Cover" ("Baipi shu," a sequel to the "Book With a Black Cover") compiled by Ai Weiwei, Zeng Xiaojun, and Zhuang Hui.

28. I have discussed the concept of "experimental art" in *Reinterpretation: A Decade of Experimental Chinese Art (1990-2000)*, 11-12.

29. The four Bohemian artists featured in Wu Wenguang's documentary film *Bumming in Beijing: The Last Dreamers* (1990) include Gao Bo, a representative of emerging "experimental photographers" in the late 1980s.

30. For this definition of "Chinese photography," see Gu Zheng, "Guannian sheying yu Zhongguo de sheying" (Conceptual photography and "Chinese photography"), in Lo Qi and Guan Yuda, eds., *Zhongguo xingwei sheying* (Performance Photography of China) (Hangzhou: China Academy of Art Press, 2001) 5-10.

31. This situation changed after 2000, when mainstream museums, such as the Shanghai Art Museum and the Guangdong Museum of Art, began to include experimental art in their exhibitions. For the changing world of Chinese museums and exhibitions, see Wu Hung, E*xhibiting Experimental Art in China* (Chicago: Smart Museum of Art, 2001).

32. For a discussion of this phenomenon, see ibid., 14-18.

33. The real name of the village is Dashanzhuang, which was demolished in 2001 and 2002 and assimilated into the ever-expanding Chinese capital.

34. For a history of the East Village, see Wu Hung, *Rong Rong's East Village* (New York: Chambers Fine Arts, 2003).

35. For a brief introduction to publications and studies of experimental Chinese art, see Wu Hung, *Transience*, 176-79.

36. Only four issues of this serial have been produced. The first two issues had twenty copies each, and thirty copies were made for each of the last two issues.

37. This attitude is clearly demonstrated in the introduction to the first issue of *New Photo*.

38. For some images by Qiu Zhijie and Mo Yi featured in this exhibition, see Wu Hung, *Transience*, PLS. 6, 22.

39. Dao Zi, "Xin yingxiang: Dandai sheying yishu de guannianhua xianzheng" (*New image:* Important characteristics of the conceptualization of contemporary photographic art), *Xiandai sheying bao* (Modern photography magazine), 1998, 1, 2-13. The same issue also includes the preface of the New Image exhibition written by Dao Zi. 28-30.

40. Corinne Robins, *The Pluralist Era: American Art 1968-1981* (New York: Harper & Row, 1984) 213.

41. For a good discussion of this phenomenon, see Karen Smith, "Zero to Infinity: The Nascence of Photography in Contemporary Chinese Art of the 1990s," in Wu Hung, ed., *Reinterpretations: A Decade of Experimental Chinese Art (1990-2000)*, 35-50, especially 39-41.

42. For a discussion of this group of photographs, see Wu Hung, "Photographing Deformity: Liu Zheng and His Photographic Series *My Countrymen*," *Public Culture*, VOL.13, NO. 3, 2001. 399-427.

43. Partly due to this difference, some Chinese art critics have termed recent experimental photography "New Conceptual Photography" (Xin gainian sheying). See Zhu Qi, "Xinxiang zhiyi: guanyu ziwo lishi de jilu" (Images telling stories: Records of self-history), in *Images Telling Stories*, catalogue of the exhibition *Art of Chinese New Conceptual Photography*, Shanghai, 2001, 2-6.

44. For a more detailed discussion of this issue, see Wu Hung, "Contemporaneity in Contemporary Chinese Art," in John Rosenfield, et al., eds., forthcoming.

45. "Everyday Sightings: Melissa Chiu interviews the Chinese artist Wang Youshen," *Art AsiaPacific* 3.2 (1996), 54.

46. For a fuller introduction to this project, see Wu Hung, *Transience*, 54-59.

47. Ibid., 58.

48. For a detailed discussion of Xing Danwen's work, see ibid., 48-53.

49. Sui Jianguo's letter to the art critic Gu Zhenfeng, provided by the artist.

50. For a fuller introduction to this work, see Wu Hung, *Transience*, 60-65.

51. For an introduction to this project, see Wu Hung, *Rong Rong's East Village*,

52. For an introduction to this controversial exhibition, see Wu Hung, *Exhibiting Experimental Art in China*, 204-8.

53. For a fuller discussion of this project, see Wu Hung, *Rong Rong's East Village*, 111-14.

54. For a discussion of self-portraiture in experimental Chinese art, see Wu Hung, *Exhibiting Experimental Art in China*, 108-20.

55. Shen Jingdong, *100 ge yishujia miankong (Faces of 100 artists)*, 2001. Private publication.

56. For a discussion of these experiments, see Wu Hung, *Transience*, 168-74.

57. Qiu Zhijie, "Ziyou di youxianxing – 'Wo' de wenti" (The limit of freedom – Questions about "I"), 1994-96. Unpublished manuscript, 5.

1. William Pietz, "Fetish," in Robert S. Nelson and Richard Shiff, eds., *Critical Terms for Art History* (Chicago: University of Chicago Press, 1992), 197-207. Quotation from 203.

2. Although in actuality this publication is a quarterly, it is not defined as a "magazine" or "journal," which, according to Chinese publishing regulations, needs special permission and a "journal code" (*kan hao*). Rather, it is defined as a serial (*congshu*) and can therefore use a "book code" (*shu hao*).

3. Private communication.

4. The publisher defines the readership of the serial as "people with a high school and above educational background." See Feng Keli, "Lao zhaopian (congkan) chuban gouxiang" (A proposal for publishing the "Old Photos" serial). Original document. I want to thank Feng Keli for providing me with this text.

5. Some of these publications are discussed in Edward S. Krebs, "Old in the Newest New China: Publications on Private Memories as Sources of Individual Views of History," Paper presented to a conference on Chinese historiography, held at Heidelberg University in May 2001.

6. Another related 1997 publication is *Lao zhaopian: Xilie tuji* (Old photos: A series of picture albums) by the Jiansu meishu chubanshe. It differs from *Old Photos* and the two other 1997 publications in that it classifies and reproduces old photos without framing the reproduced images with written texts.

7. Feng Keli, "Lao zhaopian de chuangban" (The founding of *Old Photos*), *Chuban guangjiao*.

8. An example is *Lao chengshi (Old Cities)* series (Nanjing: Jiangsu meishu chubanshe, 1998-2000).

9. One volume of *Old Photos: A Series of Picture Albums*, for example, focuses on "customs and scenery" (*minsu fengguang*) another volume in the series focuses on "costumes and fashion" (*fushi shishang*).

10. An example is *Lao Xinwen* (Old news), (Tianjin renmin chubanshe, 1998).

11. An example is *Beida laozhaopian* (Old photos of Peking University), (Beijing: Zhongguo duiwai jingji maoyi chubanshe, date unknown).

12. This phenomenon, which is clearly reflected in the serial itself, was confirmed by Feng Keli in a private communication.

13. According to this author's private communication with Feng Keli, from the eleventh issue published in September 1999, about thirty-thousand copies have been sold for each issue of *Old Photos*.

14. See Krebs, "Old in the Newest New China." Other related discussions include: Geremie Barme, *In the Red: On Contemporary Chinese Culture* (New York : Columbia University Press, 1999); Xiaobing Tang, *Chinese Modern: The Heroic and the Quotidian* (Durham, N. C.: Duke University Press, 2000); David De-wei Wang, "Imaginary Nostalgia: Shen Congwen, Song Zelai, Mo Yan, and Li Yongping," in Ellen Widmer and David De-wei Wang, eds. *From May Fourth to June Fourth: Fiction and Film in Twentieth-Century China* (Cambridge, Mass., Harvard University Press, 1993); Rey Chow, *Ethics after Idealism* (Bloomington: Indianana University Press, 1998), 133-48.

15. For example, *Lao Shanghai guanggao* (Advertisements of old Shanghai) was published by the Shanghai Pictorial Press in 1995.

16. Tao Ye, "Minchu funü de xinzhuang" (New dresses of women in the early Republican period), *Lao zhaopian* 1, 1996, 104-5.

17. Feng Keli, " 'Lao zhaopian' (congkan) chuban gouxiang."

18. Ba Jin, *Suixiang lu* (Random reflections), (Beijing: Sanlian shudian, 5th printing 1996), 819-23. Here I follow the suggestion made by Krebs in "Old in the Newest New China."

19. Liu Xinwu, "Yingzi dashu" (Shadow uncle), reprinted in *Siren zhaoxiang bu* (Private photo album) (Shanghai: Yuandong chubanshe, 1997), 16-17.

20. When I asked whether the *Old Photos* serial was inspired by Liu's work, Feng Keli replied: "Before the appearance of *Old Photos*, Liu Xinwu had begun the feature 'Private Photo Albums' in *Harvest* magazine, and the Jiangsu Fine Arts Press had published the multivolume *Old Houses* (Lao fangzi). Although I cannot say that these publications had absolutely no impact on *Old Photos*, in truth we were not directly inspired by them." Private communication, May 8, 2003.

21. When these ten essays were published in 1997 as a book, Liu Xinwu wrote in the preface that these essays were among the most serious works he wrote after 1977, and encouraged literary scholars to pay more attention to them. Liu Xinwu, *Siren zhaoxiang bu*, 3.

22. *Lao zhaopian* 1, "Zhenggao" (Soliciting submissions).

23. New themes include, for example, "Shihongpianyu" or "Fragments from a vanished past;" "Yiyu shiqu" or "Anecdotes from foreign lands;" and "Sheying shihua" or "Conversation on the history of photography."

24. For a definition of "experimental" art and artists in post-Cultural Revolution China, see Wu Hung, "Introduction: A Decade of Chinese Experimental Art (1990-2000)," in Wu Hung, ed., *The First Guangzhou Triennial—Reinterpretation: A decade of Experimental Chinese Art* (Guangzhou: Guangdong Museum of Art, 2002), 11-12.

25. For a discussion of this artistic trend, see Wu Hung, "A Domestic Turn, Chinese Experimental Art in the 1990s," *Yishu* 1.3 (November 2002), 3-17.

26. For a detailed discussion of this project, see Wu Hung, *Transience: Chinese Experimental Art at the End of the 20th Century* (Chicago: Smart Museum of Art, 1999), 72-78.

27. "Everyday Sightings: Melissa Chiu interviews the Chinese artist Wang Youshen," *Art AsiaPacific* 3.2 (1996), 54.

28. This 1976 movement started from a mass mourning for Premier Zhou Enlai, who died in January that year. For many people Zhou had become the last hope for rationality amidst the madness of the Cultural Revolution. But he was attacked by the extreme leftist Gang of Four, led by Mao's wife Jiang Qiang.

29. Wu Hung, "Between Past and Future: A Short History of Contemporary Chinese Photography," in Wu Hung and Christopher Phillips, ed., *Between Past and Future: New Photography and Video from China* (New York and Chicago: International Center of Photography and Smart Museum of Art, 2004).

30. For example, many photographs made in the '90s document the surviving "courtyard" houses in Beijing and the activities associated with them. The pictures, typically black-and-white, are sometime mistaken for historical photographs.

31. One such artist is Han Lei. Some of his works look stressed like old photo. For examples, see Han Lei, *Mosheng* 陌生(Strange), (Shanghai: Aura Gallery, 2003). For a brief discussion on his work, see Wu Hung, "Intersection: An Exhibition of Contemporary Chinese Photography and Oil Painting," *Yishu* (Fall 2004): 5-14.

32. The artist Yin Xiuzhen, for example, documented traditional houses before they were demolished and their residents relocated, and then used the pictures in installations.

33. http.//www.a-cy.com/zhi_dwq photos.htm.

8

INTERSECTION

1. Chen Danqing, "An Informal Retrospective," in Ackbar Abbas, ed., *Chen Danqing: Painting After Tiananmen*, Cultural Studies Series 6 (Hong Kong: Department of Comparative Liteature, University of Hong Kong, 1995), 14-25; quotation from 24. The wording slightly modified with the artist's agreement.

2. For example, there appeared a "photography fever" among students in the Central Academy of Fine Arts, see Ibid.

3. For a discussion of Yu Hong's painting, see Wu Hung, *Transience: Chinese Experimental Art at the End of the Twentieth Century* (Chicago: Smart Museum of Art, 1999), 142-47.

4. Chen Danqing, "An Informal Retrospective," 22.

5. Wu Hung, "Once Again, Painting From Photos," in Ibid., 10-13; quotation from 13.

6. Chen Danqing, "An Informal Retrospective," 24.

7. See Wu Hung, "Photographing Deformity: Liu Zheng and His Photographic Series *My Countrymen*," *Public Culture*, VOL.13, NO.3 (Fall 2001): 399-428.

8. These two translations imply very different understanding of the series and the artist's self-identity. This is why I reject the second English title. I have discussed this issue in a forthcoming article, "Identities in Contemporary Chinese Art."

9. Cited in Bingman [pesud.,], "The Chinese art at the Turn of the New Millennium: A Review of Liu Zheng's Photographic Series 'The Chinese'" (manuscript, n.d.). Translation slightly modified based on the original Chinese text.

10. For an introduction to Shi Chong's art and theory, see Wu Hung, *Transience*, 88-93.

11. Cited in Huang Zhuan, ed., *Shoujie dangdai yishu xueshu yaoqing zhan* (The first academic exhibition of Chinese contemporary art) (Guangzhou, Guangdong lingnan meishu chubanshe, 1996), 58.

12. Shi Chong's art has been the subject of many articles published in Mainland China. Three representative discussions are Yin Shuangqi, "Chaoyue yuyang" (To go beyond language), *Meishu wenxian* (Art literature) 1994.2: 3-12; Peng De, "Shi Chong jijie" (A comprehensive interpretation of Shi Chong's work), in *Shi Chong* (Guilin: Guangxi meishu chubanshe, 1996), 2-9; Huang Zhuan, "Shi Chong yishu zhong di gudian yichan yu dangdai wenti" (The

Classical heritage and contemporary issues in Shi Chong's art), *Yishu jie* 1998. 1/2: 4-19.

13. Private communication.

14. I have discussed this issue in "'The Old Photo Fever' and Contemporary Chinese Art" in this volume.

15. Wu Hung, ed., *Reinterpretation: A Decade of Experimental Chinese Art* (Guanzhou: Guangdong Museum of Art, 2002), 142-45.

16. "Everyday Sightings: Melissa Chiu interviews the Chinese artist Wang Youshen," *Art AsiaPacific* 3.2 (1996), 54.

17. See "Old Photo Craze' and Contemporary Chinese Art" in this volume.

18. Gu Zheng, "Han Lei de beilun: Youguan Han Lei shying de zhongzhong yice" (Han Lei's Paradox: Hypotheses on Han Lei's Photographs), in *Han Lei: Mosheng* (Han Lei: Alienazation) (Shanghai: Aura Gallery, 2003), 10-15, quotation from 10.

19. For a general discussion of Chinese conceptual photography, see Wu Hung, "Between Past and Future: A Brief History of Contemporary Chinese Photography," in Wu Hung and Christopher Phillips, eds., *Between Past and Future: New Photography and Video from China* (New York and Chicago: ICP and Smart Museum of Art, 2004).

20. This attitude is clearly demonstrated in the introduction to the first issue of *New Photo*.

21. Robins continues: "To them . . . realism belonged to the earlier history of photography and, as seventies artists, they were embarked on a different kind of aesthetic quest. It was not, however, the romantic symbolism of photography of the 1920s and 1930s, with its emphasis on the abstract beauty of the object, that had caught their attention, but rather a new kind of concentration on narrative drama, on the depiction of time changes in the camera's fictional moment. The photograph, instead of being presented as a depiction of reality, was now something created to show us things that were felt rather than necessarily seen." *The Pluralist Era: American Art 1968-1981* (New York: Harper & Row, 1984), 213.

22. For a good discussion of this phenomenon, see Karen Smith, "Zero to Infinity: The Nascence of Photography in Contemporary Chinese Art of the 1990s," in Wu Hung, ed., *Reinterpretations: A Decade of Experimental Chinese Art (1990-2000)*, 35-50, especially 39-41.

9

—

VARIATIONS OF INK

1. *Variation of Ink: A Diaologue with Zhang Yanyuan.* Curated by Wu Hung. New York: Chambers Fine Art. May 16-June 16, 2002.

2. Michael Sullivan. *The Arts of China*. Third edition (Berkeley: University of California Press, 1984), 124.

3. Even the most adventurous painters of the *mo xi* (ink play) type in traditional Chinese art, such as Xu Wei and Zhu Da, still relied on brushwork to make shapes.

4. Two different English translations of this text can be found in William R. B. Acker, *Some T'ang and Pre-T'ang Texts on Chinese Painting* (Leiden: E.J. Brill, 1954), 185-86; Osvald Siren. *The Chinese on the Art of Painting* (New York: Schocken Books, 1963), 231-32. My translation in this and the following paragraphs consults and utilizes elements in these previous translations.

5. Pi Daojian. *Zhongguo shuimo shiyan 20 nian* (China: Twenty years of ink experiment) (Guangzhou: Guangdong Art Museum, 2001), 10.

6. The term *guohua* is often taken as synonymous to *shuimo hua* (ink painting).

7. "A stirring coalition" between Chinese tradition and contemporary art is an expression that Martina Koeppel-Yang uses to describe Yang Jiechang's work. See her introduction to Yang's exhibition held in 2001 in the Art Museum of Hong Kong University.

8. Ibid.

9. Ibid.

10

—

"EXPERIMENTAL EXHIBITIONS" OF THE 1990S

1. This proposal was made in an important conference held in the southern cities of Zhuhai and Guangdong in August 1986. Participants from various regions reviewed more than a thousand of slides of recent works by experimental artists and proposed to organize a national exhibition of experimental art in Beijing in 1987. This plan was

interrupted by the "Against Capitalist Liberalization" campaign mobilized by the government that year. When the campaign subsided, organizers of the 1986 conference returned to the drawing board and envisioned an even larger national exhibition of experimental art. A planning conference was held in October 1988 at Huangshan. The proposed location of the show was changed from the Agricultural Exhibition Hall to the National Art Gallery. Most of the seventeen members of the preparatory committee of the exhibition were young art critics, with Gao Minglu as the chief coordinator.

2. See Wu Hung, *Transience: Chinese Experimental Art at the End of the Twentieth Century* (Chicago: Smart Museum of Art, 1999), 23-24.

3. Andrew Solomon, "Their Irony, Humor (and Art) Can Save China," *New York Times Magazine*, December 19, 1993, pp. 42-72.

4. Some artists intend to keep their jobs, but have found it difficult or impossible. For example, Song Dong, who maintains his job as a high school art teacher, had to finish teaching a year's courses in the first few months in 2000, before he joined an international workshop in London. His wife, the installation artist Yin Xiuzhen, has finally lost her job, partly because of her frequent travels abroad.

5. Such criticism is expressed in essays such as Zhu Qi's "Do Westerners Really Understand Chinese Avant-Garde Art?" *Chinese-Art.com Bulletin* VOL. 2, Issue 3 (June 1999): 13-19.

6. I should emphasize that this survey only covers spaces that have been used for experimental art exhibitions in recent years. The varieties listed here thus do not represent all types of exhibition spaces in China.

7. The Red Gate Gallery was one of the earliest privately owned art galleries in Beijing. Its owner, Brian Wallace, an Australian, became interested in contemporary Chinese art in the 1980s, and began to organize exhibitions in Beijing's ancient Observatory in 1988. He subsequently opened the Red Gate Gallery in 1991. The Courtyard Gallery, located in a spectacular location across the moat from the East Gate of the Forbidden City, was established in 1996 by Handel Lee, a Chinese American lawyer. The Wan Fung Gallery is also located in a formal imperial building, in this case the former Imperial Archives. A branch of a Hong Kong art gallery, it was established in 1993.

8. It is important to note that the "non-profit" status of these galleries is defined by the owners of these galleries, who fund the galleries and their activities by using part of their business income. A gallery in this category usually does not have an independent license, and should be considered a "non-profit" enterprise within a larger licensed "business for profit" (*qiye*) sector.

9. It is true that some public exhibitions before 1993 featured experimental art works. For example, the influential "New Generation" exhibition was held in 1991 in the Museum of Chinese History. But participants of the this exhibition were all academic artists, and the show was sponsored by the official Chinese Youth Newspaper as part of the anniversary celebration of the May Fourth Movement that year.

10. One such project was Xu Bing's *A Case Study of Transference*, held in 1994 at the Hanmo Art Center, one of the first commercial galleries in Beijing.

11. These exhibitions include *Now, Dream of East: '94 Beijing. International Com-Art Show*, Beijing-Berlin Art Exchange (1995), *The First Academic Exhibition of Chinese Contemporary Art* (1997), *Demonstration of Video Art '97 China, It's Me* (1998), and *Art For Sale* (1999).

12. He Xiangning Art Gallery, brochure of the gallery.

13. Ren Kelei (Director of the He Xiangning Gallery), "Social and Academic Goals of the Second Annual Contemporary Sculpture Exhibition," foreword to *The Second Annual Contemporary Sculpture Exhibition at He Xiangning Art Gallery* (Shenzhen: He Xiangning Art Gallery, 1999), 8.

14. Zhang Qing, an organizer of the exhibition, told me this during an interview I conducted in April, 2000.

15. Shanghai Art Museum, "Announcement of Shanghai Biennale 2000."

16. For a critique of this exhibition, see Gu Chengfeng, "Lixiang zhuyi d gangfen yu pibei – Guangzhou shuangmianzhan, wenxianzhan texie" (The excitement and exhaustion of idealism – a close-up observation of the Guangzhou Biennale and the Documenta Exhibition), in idem., *Ganshou youhuo – zhongguo dandai yishu jingguan* (Experiencing temptation – a quiet observation of contemporary Chinese art), (Chongqing: Chongqing chubanshe, 1999), 7-13. For an introduction to this Biennale, see Lü Peng, *Zhongguo dangdai yishushi 1990-1999*, 124-33.

17. For a brief introduction to these and other semi-official galleries, see Ma Hongzeng, "*20 shiji woguo meishuguang de fazhan guiji yu sikao*" (Outlining and reflecting on the development of art galleries in China in the 20th century), *Meishu guangchai* (Art observation), 2000. 4: 58-61.

18. "Foreword" *Xianshi: Jintian yu mingtian* (Reality: Present and Future) (Beijing: Sungary International, 1996)

19. Deng Hong, "Cujin he fanrong Zhongguo bentu yishu" (Promoting native Chinese art), *Meishu guancha* (Art observation), NO. 53 (April 2000): 11-12.

20. Maryse Parant, "Foreigners Define Market: City Galleries Compete to Supply Contemporary Works" *Beijing This Month*, NO. 77 (April 2000): 42-43; quotation from 42.

21. *Zhuanshi shidai* (Time of revival) (Chengdu: Upriver Gallery, 2000), Chen Jiagang 6-7. English translation revised based on the original Chinese text.

22. These are the Upriver Art Gallery in Chengdu, Taida Art Gallery in Tianjin, and Dongyu Museum of Fine Arts in Shenyang. Among Them, Donyu Museum focuses more on building up a private collection of contemporary Chinese art. See Robert Bernell, "Interview with Wang Yigang, Managing Director of the Dong Yu Museum of Fine Arts in Shenyang," *Chinese Type Contemporary Art Magazine*, VOL. 2, issue 3 (May/June 1999): 19-22.

23. Leng Lin, "Yige zhide zhuyi de dongxiang" (A noticeable tendency), In Idem , *Shi wo (Is'I me)*, (Beijing, Zhongguo wenlian chubanshe, 2000), 67-81, quotation from p. 69.

24. An interview with Song Dong conducted by this author in February 2000.

25. Feng Boyi, " 'Shengcun henji' de henji – guanyu 'shengcun henji – '98 Zhongguo dangdai yishu neibu guanmozhan' de yizhong miaoshu" (The Path to Trace of Existence: A Private Showing of Chinese Contemporary art '98), *Shengcun henji – '98 Zhongguo dangdai yishu neibu guanmozhan* (Trace of Existence: A private showing of Chinese contemporary art '98), (Beijing: Art Now Studio, 1998), 9-11; quotation from 9.

26. For a published account of this exhibition, see Shu Kewen, "Mikailangjiluo jiepou de shiti" (Corpses under Michaelangelo's scalpel), *Sanlian shenghuo zhoukan (Sanlian life weekly)*, NO. 112 (May 2000), 70-71.

27. Typical examples of these exhibitions include the *Post-Sense Sensibility* exhibition curated by Qiu Zhijie and Wu Meichun, and the *Infatuated with Injury* exhibition curated by Li Xianting. The former took place in the basement of a large residential building, and the latter was presented as an "open studio" in the Research Institute of Sculpture. Both shows attracted many people to their openings and made a strong impact on Chinese experimental art.

<div align="center">

11

—

THE 2000 SHANGHAI BIENNALE

</div>

1. Preface to Shanghai Art Museum, *Shanghai Biennale 2000* (Shanghai: Shanghai shuhua chubanshe, 2000). English translation slightly modified based on the original Chinese text.

2. The curators of the exhibition, either consciously or unconsciously, seem to have shared this attitude. Thus when Zhu Qi interviewed Hou Hanru and posed his first question about Hou's evaluation of the exhibition's artworks, symposium, and infrastructure, Hou emphasized the Biennale's "impact" on the curatorial methods and exhibition channels in China: "The time has not only arrived, but the process has begun." "Zhu Qi, "We've Become True Individuals—An Interview with Hou Hanru—Curator of the Shanghai 2000 Biennale," *Chinese Type Contemporary Art Bulletin* VOL. 3, Issue 6, chinese-art.com.

3. Four of these unofficial exhibitions had stronger thematic focuses and published exhibition catalogues. These were *Buhezuo Fangshi (Fuck Off)* curated by Ai Weiwei and Feng Boyi, *Richang yu Yichang (Normal and Abnormal)* curated by Gu Zhenqing, *Youxiao Qi (Useful Life)* organized by Yang Zhenzhong, Yang Fudong, and Xu Zhen, and *Yu Wo youguan (About me)* curated by Lin Xiaodong.

4. See Wu Hung, *Exhibiting Experimental Art in China* (Chicago: Smart Museum of Art, 2000), "Introduction," 10-41.

5. For a discussion of the concept of "experimental exhibition," see ibid., 17.

6. Ibid. This publication is written as an independent book, with one chapter documenting the exhibition *Canceled: Exhibiting Experimental Art in China*, which this author curated for the Smart Museum of Art in Chicago in 2000.

7. Zhang Qing, "Beyond Left and Right: Transformation of the Shanghai Biennale," in Shanghai Art Museum, *Shanghai Biennale 2000*.

8. Ibid.

9. Zhu expressed this opinion in his speech given to the symposium held in conjunction with the 2000 Shanghai Biennale. For Gu's view, see his article "Xiangqi Guangzhou Shuangnianzhan" (Recalling the Guangzhou Biennale), *Shanghai Meishuguan tongxuan* (SAM magazine), 34 (2000), 5.

10. One can also find evidence for this attempt in Lü Peng's *Zhongguo dandai yishu shi, 1990-1999* (90s art China), (Changsha: Hunan meishu chubanshe, 2000). This most up-to-date narrative of contemporary Chinese art represents an individual Chinese art critic's point of view.

11. For definitions of these exhibition spaces, see Wu Hung, *Exhibiting Experimental Art in China*, 21-42.

12. This exhibition is introduced and documented in ibid., 135-41.

13. Forward to *The Second Yearlong Contemporary Sculpture Exhibition* (Shenzhen: He Xiangning Art Gallery, 1999), 8.

14. Clear evidence for this link can be found in the two issues of *Shanghai Meishuguan Tongxun* (NOS. 33 AND 34) that the Shanghai Museum published prior to the 2000 Biennale. Both issues focus on the role of individual curators in organizing public art exhibitions. The discussants include independent curators such as Huang Zhuan and Zhu Qi.

15. Ai Weiwei and Feng Boyi, "About Fuck Off," in *Buhezuo fangshi* (Fuck off), private publication, 2000, 9. English translation modified based on the original Chinese passage.

16. "'Buhezuo' shi yizhong licheng zitai – guanyu 'Buhezuo Fangshi' de duihua" ("Non-cooperation" is a standpoint and an attitude – a conversation about "A Way of No-Cooperation"), *Xiandai yishu* (Contemporary art), NO. 2 (January 2001), 31.

17. Li Wei's performance was cut short: he was invited to a side room in the Museum and was advised to leave his mirror there before walking out. But he told me that he was not mistreated and he had a civil conversation with some museum personnel in that room.

18. An exception is Gu Dexin's installation in *Fuck Off*, which clearly connects itself with the Biennale. In this installation, a red armchair stuffed with raw meat is placed in front of a frame painting. The painting is red and imageless; only the opening date of the Biennale is written on the canvas.

12
—
TUI-TRANSFIGURATION:

1. The full title of the exhibition is *Tui-Transfiguration: The Image World of Rong Rong and Inri*, September 17-October 20, 2003.

2. A third factory in the area, also assisted by the Soviet Union, would manufacture automatic converters.

3. Luo Peilin, "Recollections on the History of 718," in Huang Rui, ed., *Beijing 798: Reflections on Art, Architecture and Society in China* (Beijing: Timezone 8 and Thinking Hands, 2004), p. 10 (English section).

4. Ibid., p. 12 (English section).

5. Ibid., p. 4 (Chinese section).

6. Bureau of Urban Planning of Beijing, *Beijing zai jianshe zhong* (Beijing in construction), (Beijing: Beijing chuchanshe, 1958), original English text, no page numbers given.

7. Li Rui, "The 157th Democratic Republic Emerges from East Germany's Willpower," in Huang Rui, ed., *Beijing 798*, p. 19 (English section).

8. For an informative account of the factory's history, see He Wenchao, "718 gongchang, 798 yishu – yifen shehui shiyan baogao" (Factory 718 and Art 798 – a report on a social experiment), in Huang Rui, ed., *Beijing 798*, pp. 22-49 (Chinese section).

9. Ibid., p. 39 (Chinese section).

10. This summary is largely based on He Wenchao's article, pp. 30-49.

11. See ibid., p. 40.

13
—
SPATIAL NARRATIVES

1. Kao Ch'ien-hui, "Dangdai yitan de 'sanwei yiti'—Lun yishujia, yipingren yu cezhanren de jiaose chongdie" (The 'three-fold' body in contemporary art—On the overlapping roles of the artist, the art critic, and the curator), *Dangdai yishujia zhi yan* (The Journal of Taipei MOCA), 4 (2004): 26-35.

2. For a discussion of the notion of "experimental exhibition," see the essay "'Experimental Exhibition' of the '90s" in this volume

3. For a full documentation of this project, see Wu Hung, ed., *Xu Bing de "Yancao jihua"* (Xu Bing's "Tobacco Project"),(Beijing: Renmin daxue chubanshe, 2006).

4. Michel Foucault, *The Order of Things: An Archaeology of the Human Sciences* (New York: 1973), 16.

5. W. J. T. Mitchell, *Picture Theory* (Chicago: University of Chicago Press, 1994), 57.

6. Wu Hung, *Transience: Chinese Experimental Art at the End of the Twentieth Century*, 109-10.

7. Wu Hung, *Kongjian de xushi: sange shijianxing de zhanlan*.

1. J. Claretie, "Le Salon de 1874," reprinted in *L'art et les artistes français contemporains* (Paris, 1876). Cited in John Reward, *The History of Impressionism* (New York: Museum of Modern Art, 1946), 263. James T. Demetrion starts his introduction to the exhibition catalogue, *Regarding Beauty*, with this quotation. Neal Benezra and Olga M. Viso, *Regarding Beauty: A View of the Late Twentieth Century* (Washington D.C.: Hirshhorn Museum and Sculpture Garden, 1999), 7.

2. Hans Georg Gadamer, "The Relevance of the Beautiful," in Nicholas Walker, tran., *The Relevance of the Beautiful and Other Essays* (London and New York: Cambridge University Press, 1986), 18.

3. Xu Shen, *Shuowen jiezi zhu* (with commentaries by Duan Yucai), (Shanghai: Shanghai guji chubanshe, 1981), 146.

4. Jean Dubuffet, "Anticultural Positions," in Richard Roth and Susan King Roth, eds., *Beauty is Nowhere: Ethical Issues in Art and Design* (Amsterdam: G+B Arts International, 1998), 9-16; quotation from 12.

5. Wendy Steiner, "The Sublime Shudder," in Bill Beckley, ed., *Sticky Sublime* (New York: Allworth Press, 2001), 199.

6. Barbara Claire Freeman, *The Feminine Sublime* (Berkeley: University of California Press, 1995), 4.

7. Dave Hickey, "Enter the Dragon: On the Vernacular of Beauty," in idem., *The Invisible Dragon: Four Essays on Beauty* (Los Angeles: Art Issues Press, 1993).

8. Elaine Scarry, *On Beauty and Being Just* (Princeton: Princeton University Press, 1999), 51.

9. Ibid., 111. The quotation is from Simone Weil, "Love of the Order of the World," in idem., *Waiting for God*, trans, Emma Craufurd (New York: Harper & Row, 1951), 159.

10. Ibid., 18.

11. Scarry makes this clear in saying: "Beauty always takes place in the particular, and if there are no particulars, the chance of seeing it go down." Ibid.

12. In the story, the character of a young woman starts to change when she is tattooed. Here is what the tattooer said to the woman: "'To give you beauty I have poured my whole soul into this tattoo,' Seikichi murmured. 'From now on there is not a woman in Japan to rival you! Never again will you know fear. All men, all men will be your victims.'"

13. Junichiro Tanizaki, *In Praise of Shadows*, trans. by T. J. Harper and E. G. Seidensticker (London: Jonathan Cape, 1977). I want to thank Akaba Abbas for bringing my attention to this essay.

14. See Luo Zhufeng, ed., *Hanyu dacidian* (A comprehensive dictionary of Chinese) (Beijing: Hanyu dacidian chubanshe, 1992), VOL. 9, 158-64.

15. Li Zehou, *The Path of Beauty – A Study of Chinese Aesthetics*, trans. Gong Lizeng (Beijing: Morning Glory Publishers, 1988), 260.

16. The exhibition did feature works by four Japanese artists, but did not explain why they were chosen while artists from many other countries were not. Perhaps the organizers consider Japan part of the "western world."

17. James T. Demetrion, "Forward," Neal Benezra and Olga M. Viso, *Regarding Beauty*, 8.

18. *The Shorter Oxford English Dictionary* defines "to negotiate" as "to confer with one other" and "to discuss a matter with a view to a settlement or compromise." (London: Clarendon Press, 1973), 1,393.

19. Quoted in the Department of State Bulletin, October 29, 1956, 670. Cited in Barbara M. Lane, "The Berlin Congress Hall (1955-1957)," *Perspectives in American History*, New Series, 1 (1984), 133.

20. Howard Eichenbaum to Eleanor Dulles, July 20, 1955, RW papers, Berlin Files, "AIA Committee." Cited in ibid., 161.

21. Barbara M. Lane, "The Berlin Congress Hall (1955-1957)," *Perspectives in American History*, New Series, 1 (1984), 175.

22. House of World Culture web site.

23. Interview with Jens Hanning by Cristina Ricupero. Exhibition guide, Institute of Contemporary Art, London, January 2003. http://www.aleksandramir.info/texts/ricupero.html

24. Dave Hickey, "Enter the Dragon: On the Vernacular of Beauty," 17.

25. In one place he does mention commodity advertising and pornography, but defines them as "extremes" of "that accumulated shifting, protean collection of tropes and figures that comprise 'the rhetoric of beauty'." Ibid., 57.

1. Kenneth Clark, *Landscape Into Art*, new edition (New York: Happer & Row, 1976), 230.

2. Umberto Eco's *History of Beauty*, trans. A. McEwen (New York: Rizzoli, 2004). For his brief discussion of "the sublime in nature," see 281-84.

3. Cited and discussed in Elizabeth K. Helsinger, *Ruskin and the Art of the Beholder* (Cambridge, Mass.: Harvard University Press, 1982), 117-19.

4. Edward Lucoe-Smith, *Movements in Art since 1945*, new edition (London: Thams & Hudson, 2001); Zoya Kocur and Simon Leung, eds., *Theory in Contemporary Art since 1985* (Malden, Mass.: Blackwell, 2005).

5. Clark, *Landscape Into Art*, 231-41.

6. Cited in Neal Benezra and Olga M. Viso, eds., *Regarding Beauty: A View of the Late Twentieth Century* (Washington, D.C.: Hirshhorn Museum, 1999), 20-21.

7. Charlie Finch , "Time and Barnett Newman," http://www.artnet.com/magazine/features/finch/finch12-6-99.asp

8. For a discussion of these two aspects of contemporary Chinese art, see Wu Hung, "A Case of Being 'Contemporary' – Conditions, Spheres, and Narratives of Contemporary Chinese Art," paper presented at the conference *Modernity & Contemporaneity: Antinomies of Art and Culture after the 20th Century*, held in Pittsburgh from November 4 6, 2004. This paper will be published in the conference volume.

9. For examples, many papers presented to the conference *Modernity & Contemporaneity: Antinomies of Art and Culture after the 20th Century* reject a single narrative of modern and contemporary art, and call for new analyses of modern and contemporary art traditions in different regions and cultural traditions.

10. See Wu Hung, "Negotiating Beauty," in *About Beauty* (Berlin: House of World Cultures, 2005).

11. For example, it has been noted that some representatives of Earth Art, such as Hamish Fultong and Andy Goldworthy, have responded to the tradition of Romantic landscape in their works.

12. There have been many such exhibitions in recent years. One of them is the major touring exhibition *Between Home and Heaven: Contemporary American Landscape Photography* organized by National Museum of American Art in Washington, D.C.

13. Roland Barthes, *Camera Lucida: Reflections on Photography*, trans. R. Howard (New York: Hill & Wang, 1981), 59.

14. Dave Hickey "Enter the Dragon."

15. Ibid.

16. Statement the artist's web site, http://www.kcaf.or.kr/art500/kangun/ebiography.htm.

17. Cited in http://news.empas.com/show.tsp/200040210n05014.

18. Statement on the artist's web site, http://www.yooseungho.com.

19. Michael Sullivan, *Symbol of Eternity: The Art of Landscape Painting in China* (Stanford: Stanford University Press, 1979), 69.

20. Zhan Wang, "Jia shan shi" (Ornamental rock), cited in *Shoujie dangdai yishu xueshu yaoqing zhan* (The first academic exhibition of Chinese contemporary art) (Hong Kong: China Oil Painting Gallery, 1996), 114. A manuscript dates this writing to November 26, 1995.

21. Naofumi writes: "Every now and then we see the crack of a dream in an everyday scene. It may be a hope or a memory of the past. Because of it we can go on living and making – frequently - mistakes."

22. This untitled project is part of the FIH FESTIVAL at Insel Hombroich, Germany, held in September 2003. The participating artists included Markus Kartiess, Aron Mehzion, Mariko Sugano, Takahiko Suzuki, Yurihito Watanabe, Susanne Kerssenboom, Mirjam Niemeyer, Kisho Mukaiyama, Yoshiko Nishimura, Momo Obuchi and Tetsuo Furudate.

23. Chang Tsong-zung, "Preserved with Fire," http://www.hanart.com

24. See Susan Stewart, *On Longing: Narratives of the Miniature, the Gigantic, the Souvenir, the Collection* (Durham: Duke University Press, 1993), 65.

16

—

CONTEMPORARY ASIAN ART AS GLOBAL ART

1. "Weaving through History: Allan deSouza interviews Dinh Q. Lê," in http://www.cepagallery.com/cepa/exhibits/ EXHIBIT.19971998/relocatingasia/AS03.site/ASO3.08.le.html)

17

—

DE FLATTENING "REGIONAL" CONTEMPORARY ART

1. Fourteen Chinese artists participated in the 45th Venice Biennale, including Wang Guangyi, Zhang Peili, Geng Jianyi, Xu Bing, Liu Wei, Yu Hong, Feng Mengbo, Yu Youhan, Li Shan, Wang Ziwei, Ding Yi, Sun Lang, and Song Haidong. For introductions to contemporary Chinese art in mainstream art journals in the West, see Lauk'ung Chan, "Ten Years of the Chinese Avant-Garde, Waiting for the Curtain to Fall," *Flash Art* 25, NO. 162 (January/February 1992), 110-14; and Andrew Solomon, "Their Irony, Humor (and Art) Can Save China," *The New York Times Magazine*, December 19, 1993, 42-72.

2. Christie's Hong Kong holds the first sale by any auction house devoted exclusively to contemporary Chinese academic-style oil painting. A painting by Mainland artist Chen Yifei fetches a record HK $1,375,000 (close to US $200,000).

3. See Dipesh Chakrabarty's discussion in *Provincializing Europe*: *Postcolonial and Historical Difference* (Princeton University Press, 2000)